P<small>RAISE FOR</small>
House Thinking

"'How do the decisions we make about our domestic world both reveal and influence our inner world?' That question animates this stylish book, arranged room by room. Even if one is hostile to the realm of interior design, Winifred Gallagher approaches the idea of personal environment more like Margaret Mead than Martha Stewart, and her deconstruction of domesticity is captivating."
— *Chicago Tribune*

"In her engaging new book . . . Gallagher gives us a room-by-room architectural history—a tour that, of course, turns out to involve fascinating points of sociology, economics, culture, and politics. . . . *House Thinking* is a book full of tenderness and care. It's wonderfully generous with information about everything from health to pets, to plumbing. Enthusiastic and unpretentious. . . . Gallagher's work is valuable because of her own thoughtfulness, imagination and insight, and for the range and quality of observation she brings to a subject that's dear to the heart: home."
— *New York Times Book Review*

"An engaging book. . . . Enlightening and helpful."
— *Los Angeles Times*

"Winifred Gallagher is one of that invaluable breed of creative journalists who investigates the complexity and significance of essential yet easily overlooked aspects of life. . . . A skilled synthesizer of diverse sources of information and a thoughtful interpreter with the fortitude to extract the gold from documents and studies that would put most of us to sleep, Gallagher performs what she calls 'house thinking,' that is, figuring out how and why a house either meets our physical and psychological needs, or fails to do so."
— *Speakeasy* magazine

"Gallagher writes fresh and nuanced interpretations of the subtler aspects of life. In her latest work of creative synthesis and interpretation, she conducts a tour like no other of the American house, excavating its fascinating history and covert psychological influences." —*Booklist* (starred review)

"Ms. Gallagher is neither a design practitioner nor a scientist but a cultural collector, serving up tasty morsels of research and history that ask what we think about when we think about our homes." —*New York Times*

"Four out of four stars: *House Thinking* is that rare book about homes and houses that dispenses with how houses look in favor of how houses feel—and how they make us behave. In her psychological home tour, Gallagher considers afresh such questions as: Why are so many great rooms not so great? Why is a second home the ultimate dream for so many people? And why do men like basements but women prefer bathrooms? . . . What makes *House Thinking* a better read than other books on housing and its effects—not that there are so very many of those—is Gallagher's reliance on research and history to buttress her arguments. . . . If our homes aren't our castles, exactly, then *House Thinking* proves they can be our souls and our soul-shapers."
 —*Detroit Free Press*

"[Gallagher's] book takes us through our homes room by room, tracing how each has changed over the centuries and how those changes reflect our priorities, our feelings of competition with one another and the realities of our modern lives. . . . Gallagher tells us to consider not only how our houses look but also how they make us feel. Your living space should play a role in your sense of well-being, she says, it should 'make you feel at home in the world.'" —*Arizona Republic*

"How our living spaces affect our behavior—that is, how they support or hinder our lives—is the question explored here. . . . Between chapters, [Gallagher] inserts brief essays about her own home and the changes she made once she began examining it from an environmental-behavioral point of view, a technique that goes far toward reassuring the reader that making one's house more you—reflective and more user-friendly—is no big deal." —*Publishers Weekly*

"Winifred Gallagher's done it again. Her latest book, *House Thinking*, is a must-read for anyone interested in why houses are the way they are, as well as how to create a 'just-right house' for you. There's a wealth of information contained within its pages, combining history and insight into the psychology of living well, all woven together by the eminently readable prose of a true teacher and story teller. I loved every page and learned a lot in the process." —Sarah Susanka, FAIA, architect and author of *The Not So Big House*

"Winifred Gallagher has written a fascinating book that investigates and explains the emotional impact our homes have on our lives. *House Thinking* takes the reader on a virtual tour of Gallagher's own family home, as well as many historic houses, and in doing so guides the way for us to live out our most creative selves at home." —Wendy Goodman, interior design editor, *New York* magazine

house
THINKING

A ROOM-BY-ROOM

LOOK AT HOW

WE LIVE

Winifred Gallagher

HARPER PERENNIAL

NEW YORK • LONDON • TORONTO • SYDNEY

HARPER ● PERENNIAL

A hardcover edition of this book was published in 2006 by Harper-Collins Publishers.

P.S.™ is a trademark of HarperCollins Publishers.

HarperCollins books may be purchased for educational, business, or sales promotional use. For information please write: Special Markets Department, HarperCollins Publishers, 10 East 53rd Street, New York, NY 10022.

FIRST HARPER PERENNIAL EDITION PUBLISHED 2007.

The Library of Congress has catalogued the hardcover edition as follows:
Gallagher, Winifred.
 House thinking : a room-by-room look at how we live / Winifred
Gallagher.—1st ed.
 p. cm.
 Includes bibliographical references and index.
 ISBN-10: 0-06-053869-4
 ISBN-13: 978-0-06-053869-9
 1. Housing—United States—Psychological aspects.
 2. Architecture, Domestic—Psychological aspects. 3. Identity
(Psychology)—United States. I. Title.
 HD7293.G35 2005
 747'.01'9—dc22 2005046122

ISBN: 978-0-06-053880-4 (pbk.)
ISBN-10: 0-06-053880-5 (pbk.)

07 08 09 10 11 ❖/RRD 10 9 8 7 6 5 4 3 2

TO MIKE, THE FOUNDATION

Live with the gods.

MARCUS AURELIUS, *Meditations*

CONTENTS

Contents

Why There's No Place Like Home

How does your home not only reflect but also *affect* who you are? How you feel? What you think and do? I became absorbed in these questions several years ago, when I returned from a long reporting trip to Asia. Like many a traveler, I reconsidered my dwelling with a fresh eye and saw that it had become both dysfunctional and dull. Oh, the house seemed all right at first glance, but after years of routine housekeeping and not much house thinking, it wasn't really supporting our needs, much less engaging our minds or delighting our hearts as it should. We needed to feel more at home at home.

Ten years ago, my husband, Mike, and I bought our hundred-year-old row house in an urban neighborhood witheringly described by the chic as "family-oriented." With our five kids, two cats, battered station wagon, and washable wardrobes, we fit right

in. We turned its warren of studio apartments back into the rooms they had once been. We painted, sanded, and fixed what was broken. Then we plopped down our motley furnishings—mostly yard sale finds, family hand-me-downs, treasures from trash-collection days, and kids' equipment—and relied on serendipity to turn the house into our home.

Fresh from the Himalayas, I suddenly saw that the gracious welcome of our entry, with its fine woodwork and pretty tiles, was obscured by sports gear and recycling bins, backpacks and umbrellas. I realized that the reason I spent so much time sprawled on my bed was that, although we could seat lots of guests at occasional parties, we didn't have a single really comfortable, well-lit chair downstairs for reading, which we do every day. The living room that once seemed delightfully eclectic, with its bits and pieces from our Victorian, modernist, Eastern, and country phases, was in fact arranged creepily like my aged aunt's; the only thing missing was the African violet. Just one person could work in the smallish kitchen because much of the counter space was occupied by supposedly essential stuff. I could go on.

We needed to "do something" about our home, but the mere thought was paralyzing. With a mortgage and tuitions, we had no extra money for new furniture, much less a renovation. More important, we had no clear idea of how to make a home that would be just right for us—that would help us feel and function at our best.

The solution to our domestic dilemma began with a chance meeting at a party. Robert Ivy, the editor of *Architectural Record*, said that he liked a book I'd written called *The Power of Place: How Our Surroundings Affect Our Thoughts, Emotions, and Actions*. Its subject was the way in which diverse settings—Inuit villages and neonatal intensive care units, open schools and sensory deprivation tanks—influence our behavior: our thoughts, emotions, and actions. Bob asked me to write an article that introduced his architect-readers to the largely untapped wealth of environmental-behavioral research, which could help them to design buildings that aren't just handsome but also improve the quality of daily life.

Albeit belatedly, I was soon rethinking my own ailing house from this feel-good rather than merely look-good perspective.

Long before discovering the science of place, I had learned something about how where we are affects how we feel from my parents. Their swashbuckling position was that a house or apartment is not just a piece of real estate but a place that provides important experiences—that can change your life. Mom and Dad loved to think and talk about different kinds of homes and the opportunities they afforded. What would it be like to live by the water, they wondered, or in the country? In a city high-rise or a suburban Tudor? To find out, we tried them all and then some, including my own favorite, a prerevolutionary farm in Andrew Wyeth territory.

My parents, like many Americans, were artists of the home. What they lacked in money and design background they made up for with the imagination and enthusiasm that they brought to transforming a handyman's special into their dream house. Their goal wasn't to copy some decorating vogue or produce a showcase kitchen or bathroom, but to generate lots of what they called "atmosphere"—in other words, environmental influence on behavior.

A prescient believer in the cheering power of sunlight, Dad liked to knock down walls and replace them with picture windows. I still inhale sharply at the teenage memory of returning from church one Sunday morning to find some Holstein heifers poking their heads into our farmhouse kitchen. In the conformist, pastel 1950s, Mom struck decorative blows for individuality. When she boldly painted our dining room a very atmospheric dark spinach green or did inventive things with Indian bedspreads, she showed us that we didn't have to follow the crowd.

Of course, your home is not just your address but also a state of mind that somehow encompasses a lifetime's dwellings, including some of your loved ones' and perhaps a few only glimpsed yet always remembered. My early sense of home first extended to the different houses—and contrasting ways of life—of my two sets of grandparents. My paternal relatives' suburban house was a sunlit,

well-ventilated, spit-and-polish shrine to the home economics movement, and behavior there was likewise regular, sensible, and healthful. At my maternal grandmother's ornate Edwardian urban lair, however, light filtered through heavy drapery, and emotions ran high; like the decor, daily life was full of drama. In time, my domestic horizons were expanded by weekend real estate excursions with Dad, whose observations—on the desirability of east-facing windows for early rising, say, and west-facing ones for cocktail hour—often connected environment and behavior. Gradually, I absorbed the idea that not unlike medicines, places have effects, and that when accurately "prescribed," they can make us feel better.

When I struck out on my own, I too lived in a variety of places— apartments, a loft, an urban carriage house, a rural schoolhouse— and soon learned to use my homes as therapy. I alternated country and city life to prevent boredom, cleaned out a closet or moved furniture to raise low spirits, and celebrated milestones by painting a room or two. Only when I began to write *The Power of Place*, however, did I realize that the connection between behavior and environment, which my parents and many others have intuited, is one of the oldest perspectives on the ways human beings feel, think, and act—and the subject of important yet underremarked scientific research.

Until a hundred years or so ago, the connection between our inner and outer worlds was considered obvious. Ancient societies that lived intimately with nature developed ways to be in the right place at the right time. Tribal groups knew where to go when seeking healing or insight. Practitioners of feng shui, or the Chinese art of geomancy, corrected imbalances in a place's chi—the universe's ubiquitous energy. Doctors, including Hippocrates, often prescribed changes of scene to restore their patients' well-being. In the second century, the physician Aretaeus observed, "Lethargics are to be laid in the sun, for the disease is gloom."

For most of the twentieth century, however, both psychotherapy, which stresses the individual's experience, and psychopharma-

cology, which focuses on his or her neurochemistry, looked inside the person for explanations of behavior, mostly ignoring the world outside. The awareness of place's role in our well-being quietly began to resurface in the 1960s and '70s. The new field of environmental psychology asserted that our behavior and its setting form an integrated unit—so much so that it's inaccurate to talk about a person outside of his or her context. In the 1980s, psychiatry officially recognized Aretaeus's connection of sunshine and mood when it defined *seasonal affective disorder*, or the depression caused by inadequate light. Today, even real estate brokers blithely discuss properties in the behavioral terms of feng shui and SAD.

When Bob Ivy invited me to revisit the science of place—and indirectly to consider my house's experiential deficiencies—I expected to find lots of environmental-behavioral research on the home. Along with its special significance, houses and apartments comprise most of the built world. I found studies of particular issues, such as the impact of crowding, cultural differences, and gender on the home, and on the needs of special groups, such as children and the aged. But I was surprised to see how little research concerned how the average home could improve the average person's daily experience. Thus, this book, which is the result of three years of sifting through diverse studies for insights relevant to the home, interviewing psychologists, architects, and historians, and best of all, visiting lots of houses and apartments and their residents.

Early on in this process, I began to focus less on my home's looks than on two larger questions: How do the decisions we make about our domestic world both reveal and influence our inner world? How can we make better choices? A week's stay in the anti-home that is a hospital confirmed the importance of making the most of the home's peculiar power over our bodies, minds, and spirits. Like most patients stripped of control, privacy, individuality, and sleep, bombarded with unpleasant sights and sounds yet deprived of the soothing sort, I developed a malaise beyond my diagnosis. Two days ahead of schedule, I tottered out of the hospital,

up the stairs to my bedroom, and into my familiar nest of pillows and quilts.

In my room's dappled sunlight that was so different from the hospital's fluorescent glare, I took in the photographs, art, and emotion-laden flotsam and jetsam that remind me of who I am and what it's all about. I smelled lavender in my soft old sheets and watched the shadows move across the apple-green walls I had painted myself. My daughters brought me tea in my favorite cup and sprawled across my bed. For the first time in many days, I felt just right. If a doctor had sat on my bed and monitored my metabolism, I'm certain that he or she would have watched my level of cortisol, heart and respiration rates, and other signs of stress drop as my spirits rose and I relaxed into at-homeness.

If a good witch could, with one wave of her magic wand, improve all of our domestic lives, she wouldn't give us new four-star kitchens or baths to rival Caracalla's, but the habit of house thinking, or approaching our homes from an environmental-behavioral perspective Unfortunately, most of our information about the home comes from profit-driven experts, media, and merchants, who insist that how our houses and apartments *look* is more important than the less commercial but more crucial issue of how they make us *feel*.

Despite insistent messages that a house or apartment just like the ones in the catalogs and cable shows is the portal to the good life, feeling at home at home is not a matter of costly renovations, chic sheets, or some decorator's formula. Rather, it's about living spaces that support the way you actually live, which might only involve rearranging your furniture, and that complement who you really are, which could mean just sorting your stuff, tossing what's no longer relevant, and giving more prominence to what's especially meaningful. In short, true home improvement can require more thought than trouble or expense.

In the psychological house tour of the American home that winds through these pages, each chapter focuses on a room and some of the environmental-behavioral dynamics that are especially

relevant to it. The bedroom chapter centers on intimate activities, for example, and the bathroom chapter on the connection between our homes and our concerns about our bodies. Many important principles, however, apply to more than one room. Our personalities shine brightest in our living rooms, so self-expression is the main subject of chapter 3, yet is not limited to that space. The dining room has long been a kind of gallery for our status symbols and collections, from granny's candlesticks to the wedding china, so chapter 5 explores our relationship to our special stuff, which is also scattered throughout our homes.

The overarching insight that unifies our dwellings and this book alike is that home exists as much between our ears as in a building. That is, what really makes a house a home is how successfully it supports our daily activities and expresses and nurtures our best thoughts, memories, feelings, and patterns of behavior—our way of life, of which our current residence is one manifestation. From childhood through old age, we move through many "Mc's" and dwellings. With some informed thought, however, we can ensure that although its shape shifts, home helps knit up our changing selves into a coherent identity, connect our past to our present and future, organize our days, and carry us forward on what Samuel Johnson called "the smooth current of domestic joy."

house
THINKING

The well-thought-out home has much less to do with a piece of prime real estate or the latest decorating trend than with its responsiveness to deep evolutionary needs, personal preferences, and cultural influences that we're often only subliminally aware of. We may not have words for these satisfactions, but they infuse our favorite houses and apartments and make us feel at home.

Home

When We See It, We Know What We Like

Some places just feel like home. As soon as you walk through the door, you want to stay. You want to curl up by the fireplace, throw a party in the loft space, lounge on the old porch, or follow that staircase to wherever it goes. These special homes come in all sizes, shapes, and styles, from twee country cottages and grand prewar apartments to rambling suburban ranch houses and small beach condos. What they have in common is a tonic effect on your behavior: how you think, feel, and act. One indication that you're in such a home is that you feel both interested and relaxed.

As soon as you enter the modest house in the vertiginous, verdant Forest Hill section of San Francisco that was designed for a couple in 1914 by the architect Bernard Maybeck, you're intrigued. This seductive home courts you with an array of different

spaces—big and small, open and sheltered, extroverted and inti-mate—that you can choose from, depending on how you're feeling at the time. Moreover, Maybeck insured that your pleasure in wherever you decide to settle down will be amplified by the con-trasting alternatives.

The most obvious example of Maybeck's artful juxtaposition of the house's spaces is the contrast between the interior and the glo-rious natural setting. You are almost compelled to enjoy the larger world while savoring the smaller private one. There are the daz-zling views of the bay, of course. But even seemingly small details—the "French-Dutch" half-doors that frame both horizontal and vertical vignettes or the clerestory windows whose moving light functions like a sundial—play variations on the theme of inside and outside, culture and nature, that draw you toward involvement and delight in your surroundings.

One particularly beguiling example of the Forest Hill house's ability both to captivate and comfort you is its intricately carved interior balcony. Opening off the second-floor master suite and overlooking the living-dining area, this romantic perch especially designed for a couple must summon thoughts of Romeo and Juliet. Depending on your mood, you might feel drawn to this lofty micro-environment, from which you can survey the "public" zone below and savor the options of retreating, watching, or descending to take part in whatever's going on. On the other hand, if you choose to socialize or read in the big downstairs space, your expe-rience will be enriched by the sight of the enchanting balcony and thoughts of the private realm beyond. Offering this combination of shelter and outlook is the hallmark of what environmental psy-chologists call "a womb with a view"—an excellent brief definition of home from a behavioral perspective.

The reasons why we feel at home in certain homes, whether a farmhouse or a penthouse, and delight in certain features in them, such as the fireplaces Maybeck mandated, have less to do with aes-thetic fashion than with evolutionary, personal, and cultural needs of which many of us are mostly unaware. Some elements of a just-

right home are strictly individual, but even there, we're apt to focus on secondary matters—the love or avoidance of beige or modern design—rather than on more essential ways to personalize our dwellings. Other deep feelings about our habitat are particular to our species; still other inclinations and aversions, to our society. A homelike home fulfills these profound individual, human, and cultural needs, becoming a place that shelters and fascinates—a womb with a view.

"Home improvement" summons thoughts of renovating the master suite or installing a restaurant-style kitchen, but evolutionary psychology and architectural history suggest some more basic criteria for creating just-right houses and apartments. To the architect Grant Hildebrand, such dwellings exemplify what he calls "innately appealing architecture." Many homes built before World War II, when most development was on a small scale and craftsmanship was less expensive, have this likable quality. However, over half of America's houses and apartments have been built since the 1970s. The huge modern housing industry's low-overhead, mass-production orientation, combined with much of modernist architecture's emphasis on public buildings rather than private dwellings and on aesthetics and novelty over behavior, means that truly contemporary homelike homes are in short supply.

Concerned about this predicament as a designer, teacher, and scholar, Hildebrand decided to search for the integers of inherently likable buildings. He began with a very basic question: Why might *Homo sapiens* be drawn to some places and repelled by others? To survive, the first human beings needed food, water, and protection, and their descendants eventually inherited a taste for supportive environments. Our enduring fondness for the combination of field, stream, and grove of trees—hunting range, water, and shelter—is abundantly illustrated in the paintings of old masters, the terrain of many parks, and our scenic kitchen calendars.

As an architect, Hildebrand wanted to identify the man-made equivalents of that archetypal meadow bisected by a brook and

edged by trees that so deeply attracts us. Then designers could build those innately appealing features into our homes, thus improving our quality of life and perhaps even our mental health. With colleagues at the University of Washington at Seattle, including the geographer Jay Appleton, the biologist Gordon Orians, and the psychologist Judith Heerwagen, he eventually distinguished five characteristics—prospect and refuge, enticement, peril, and complex order—that, more than a spa bath or three-car garage, enhance our experience of home.

The most important evolutionary elements of an appealing home are the paired features of prospect, or a big, bright space that has a broad, interesting view, and refuge, or a snug protected haven. As in the Maybeck home, when you settle down by the fireplace in Frank Lloyd Wright's house for Edwin Cheney, designed in 1904 in Oak Park, Illinois, you immediately feel at ease yet engaged. Wright ensured that you would simply by lowering the ceiling in the area around the hearth, which created the cozy, cavelike refuge from which to survey the living area's loftier, brighter, open prospect. Having the option of occupying either the snug or the expansive space while enjoying the contrast between them is the kind of simple yet important design feature that makes a house or apartment feel like home.

As a Wright expert, Hildebrand attributes much of the maestro's mastery to his skillful manipulation of refuge and prospect, which Wright called nesting and perching. At Taliesin, his own Wisconsin home, the fireplace refuge opens onto a double prospect: a high-ceilinged space that in turn overlooks a valley. Even in a bedroom in a simple house in Issaquah, Washington, Wright contrasted the bed's darker, more enclosed area with a bright, floor-to-ceiling corner window that surveys the garden—a model for the kind of modest renovation that yields a big behavioral payoff.

There's no single formula for the right proportion of refuge to prospect. A house in the open desert of Arizona or New Mexico needs more refuge than a cabin in the dense woods of Maine or

Michigan, which might be short of prospect. Different tempera-
ments and other groups, including the two sexes, often prefer dif-
ferent ratios of prospect and refuge. Some of men and women's
conflicts over how to use a space they share lie deeper than mere
personal taste. Among Hildebrand's architecture students, women
designed more refuge into their projects, and men, more prospect.
In a complementary study of paintings, half of the female artists'
works referred to refuge, but only a quarter of men's did. The
women were also likelier to put both male and female figures in
sheltered settings, while men put nearly two-thirds of their males
and fewer than a third of their females in wide-open spaces. (Many
new great rooms—large, open spaces that combine the functions
of the living, dining, and family rooms—are almost all prospect;
that they frequently include a lavish kitchen, which is now often
the cozy core of family life, may help make the macho space more
appealing to women.)

The pleasures of perching and nesting are amplified when
they're contrasted. Largely to cut builders' costs, however, many
newer homes have the wide-open floor plans, constant ceiling
heights, and monotonous lighting that create too much bland
prospect and not enough refuge. Like many great rooms, for exam-
ple, trendy two-story entries often lack the contrasting low-
ceilinged vestibules and alcoves necessary to appreciate the lofty
space. Worse, a home that lacks refuge can't offer what Hildebrand
calls "the dark place of concealment that's our haven in times of
vulnerability, from sleeping to making love to recovering from ill-
ness."

Everyone loves a surprise, and the quality of enticement gives a
home some innately appealing frisson. In nature, this feeling is
evoked by winding trails and clearings that are partly screened by
leaves—a teasing combination of risk and safety. To find out
what's around that bend or beyond that foliage, we must investi-
gate, but we can do so from a clear path or behind greenery. Be-
cause it must first and foremost be a safe haven, a home needs just
the right degree of enticement. A window or porch rimmed with

tendrils of ivy or wisteria is delightful, but one that's nearly over-grown is creepy. When you walk down a long, dimly lit hallway toward a glowing room, moving from darkness into light is entic-ing. On the other hand, traveling down a brightly lit hall toward a dark space can produce anxiety rather than anticipation. This unease is warranted because, as Hildebrand observes, being seen by unseen others is truly dangerous in a violent setting—and the scariest part of the haunted-house movie.

At first glance, peril doesn't seem like a fun feature for a home. As long as you're in charge, however, you can experience a poten-tially hazardous stimulus as thrilling rather than terrifying. From your temperature-controlled living room, for example, the broil-ing desert or icy mountains are beautiful, not life threatening. Indeed, the contrast between indoors and outdoors adds to our pleasure. Safe at home, we even enjoy perilous heights and pay extra for dramatic views, balconies, and staircases to prove it.

The innate appeal of "complex order" explains why older varie-gated suburbs have more charm than new subdivisions made up of nearly indistinguishable "units." Our big brains evolved to take in lots of information from the world and sort it according to fine dis-tinctions. Thus we're bored by overly homogeneous places, such as cookie-cutter housing tracts. On the other hand, we're uneasy in a slapped-together shantytown, with its differently skewed ratio of spontaneity to design. We feel best in places that, like the venerable suburb and the tidy room that has some books, pillows, and every-day things scattered about, balance variety and stability.

Few of us live in Maybeck or Wright houses, but the principles of innately appealing architecture can be applied to a quotidian home, or even a room, without undue effort or cost. In one down-to-earth assignment, Hildebrand's architecture students redesigned a generic 950-square-foot, two-bedroom apartment of the sort that exists all over America. The flat's poor ratio of refuge to prospect meant that right from the front door, you could see most of the apartment—often including a toilet—in a single glance. The main living area's boxlike shape, even lighting, and uniform eight-foot

ceiling eliminated any sense of enticement or complex order. Even the nice amenity of a balcony—a potential source of benign peril—was diminished by its shallowness, which made it little more than a glorified window ledge.

The thoughtful, behavior-inspired remodeling of this formulaic, soulless apartment shows how even people with few resources can move toward a just-right home. Most of the project's modest cost went for materials that added more surfaces to existing walls and ceilings. In an inspired twofer, the students first reorganized the kitchen to make it smaller but more efficient. Then they used the extra space to reconfigure the entry, so that it fostered feelings of refuge and anticipation for the prospect about to unfold.

To produce more innately appealing contrasts, the team lowered some ceilings, then added enticement by turning the conventional circulation pattern into what Hildebrand calls "intriguing trails that disappeared around luminous bends." They distinguished the private bedroom refuges by lowering ceilings over the beds and installing smaller, more view-oriented windows. Finally, the young designers added two feet to the balcony, so that it even accommodated dining. "This plain little apartment is a long way from being Chopin's Third Scherzo," allows Hildebrand, "but now there's an analogy to a simple melody."

Although he's a modern architect, Hildebrand is not interested in more homes the like of which have never been seen, he says, but in dwellings that, informed by a few design principles, "serve ordinary human actions and emotions." He laments the architectural establishment's emphasis on homes as objets d'art or cultural symbols. "They are that," he says, "but that is not all they are. Home is where we live and work, alone and with others. Where we eat, sleep, entertain, and recover. Where, if we are lucky, we die. My approach is dedicated to this other dimension of architecture, which concerns not how we differ from each other but how we are alike."

Some of your domestic likes and dislikes have evolved with our species, but from early childhood, personalizing a special place

that's just right for you has been important to developing and supporting your personality. To that end, Bernard Maybeck made sure that every home he designed was unique and a perfect fit for its residents. He created the so-called Music Studio House, in Berkeley, California, for Alma Kennedy, a music teacher, and Milda Nixon, her kindred spirit, to support their unconventional way of life. To underscore its identity as home and workplace, the house has a public and a private wing, which are connected by an interior bridgelike staircase over an exterior courtyard.

Right from the front door, Maybeck establishes what really matters to the owners of this home: music. The smallish, low-ceilinged refuge of the entry leads to the dramatic open prospect: the 1,250-square-foot, double-height, redwood-paneled music studio. The space's acoustics are so good that long after Kennedy's young students, many professional musicians have played concerts and recorded here, including the artists from the "Live at Maybeck" jazz series.

This home was tailor-made for a live-in working musician, and Gregory Moore, the current owner, is a composer. He finds that the house has completely reorganized his way of life. Previously, he suffered from erratic sleep patterns and trouble with scheduling his time, but the Music Studio House changed all that. To illustrate, Greg leads the way through the private wing up to the top of the house—and the hill on which it sits—where the kitchen and breakfast nook are situated. "I'm always drawn here in the morning by the bright sunshine," he says. "Then I just move with the sun through the house and do different things in different places at different times."

After breakfast, Greg lays out his sheet music on the dining room's sunlit table and works on his compositions. After lunch, he moves downward and westward with the now golden glow and does research in the library. By 2 p.m., Greg says, "the studio is full of light, so I sit at the piano and do music. I follow both the sun and hill down through the house all day long."

Many would find the multilevel layout of the Music Studio

House—to say nothing of details such as its ratio of five bathrooms to one conventional bedroom—simply too eccentric for a home. (It's rumored that the comedian Whoopi Goldberg considered buying it, then said, "I'm crazy, but not this crazy!") Yet the house is just right for musical, intellectual Greg. He even uses the steps of the four interior staircases to help him sort sheet music, messages, and the like. Seated in the library, he points to an interior window through which he can watch different people simultaneously moving through different areas. To most people, this view would be just a pleasant detail, but to Greg, it speaks of the era when the house was built, "when Einstein, Picasso, Stravinsky—and perhaps Maybeck—were transforming ideas of time and space."

That the Music Studio House feels just right to Greg Moore—and all wrong to many others—suggests the environmental implications of personality, which is formed by the influence of nurture, or past experience, on nature, or one's biologically based temperament. Leaving aside different kinds of personalities, such as Greg Moore's artistic, sensitive sort, even a single one is more complex than most people imagine. We like to think of the self as one unchanging Me, but a personality is actually a group of related selves that mesh together, forming a complex individual. Not merely "psychological," each of these component Me's is tied to a physical, emotional, and cognitive state, creating Affectionate Me or Competitive Me.

The home and other important settings in which we have significant emotional experiences help activate the personality's different selves and states. According to a dynamic called state-dependent learning, we remember best when we're in the same state we were in when we first absorbed the material. Environmental cues help evoke that condition, and thus the memory, which is why we perform better on a test that's given in the same room in which we learned the subject. In a more extreme example of state-dependent learning, victims of trauma, such as war, can experience flashbacks when they encounter sights, sounds, or smells that were stored in the brain along with the upsetting emotional memories. A place

that's associated with drug use can even trigger the *physiological* changes that create craving. Where home is concerned, state-dependent learning helps explain why visiting a past dwelling can be such a powerful experience. Suddenly we're surrounded by environmental cues that call up feelings and memories—particularly of very happy or sad times there.

We routinely depend on our homes' signals to shift our selves and states as daily life requires. We return after a hard day at work and spend five minutes in the shower or the garden to "feel like another person" for the evening. To get down to business, we head to our desk or home office. To summon the romantic Me, we turn the bedroom lights down low and put on some soft music. To relax into the soft, contemplative Me, we collapse into the hammock or pull up a chair to the dancing light of the fireplace. Without being particularly aware of it, all day long we help manage our experience by exploiting the links between where we are and the Me we need to be there.

The good fit between Greg Moore's personality and the Music Studio House helps him to be the right self at the right time and exemplifies environmental psychology's most important, and deceptively simple, principle regarding home: yours should meet your physical and psychological needs. Many of us, however, don't know exactly what kind of support we require from our houses or apartments. For example, says the environmental psychologist Sally Augustin, who creates "life-enhancing" spaces with designers, manufacturers, and individuals, tall people like herself may have to "right-size" their rooms, as in changing the heights of counters and tables, so they don't feel out of place in their own homes. This kind of basic house thinking, which few people engage in and most shelter media ignore, is crucial to making a homelike home.

Our houses and apartments require psychological as well as physical customization. A "people person"who most values socializing needs a dwelling that makes it easy and fun, says Augustin, while someone who's very concerned about status "might display

her seventeenth-century family Bible in the living room. Your home should meet *your* needs, whatever they are."

From this environmental-behavioral perspective, the first step toward a home that's just right for you isn't leafing through magazines or collecting paint chips but listing the things that you've loved and hated in past and present homes, and the activities that are and aren't important in your daily life. Does Victorian a delight you or give you the creeps? Do you want to recapture the aura of a beloved childhood home or create the exact opposite of an unhappy one? Do you love to throw fiestas or prefer curling up by the fireplace? Does your family have regular meals in the dining room or eat on the run? Do you practically live in your bed, or do you gravitate to the kitchen table? How much do you value your home's outside spaces, from an apartment's view to a farmhouse's back forty?

According to psychology, your answers to such basic questions should shape your decisions about your home. The great room, for example, is a must-have feature in new houses and a popular renovation in older ones. This large open space suits many sociable Americans, but you and your family may be quieter and more introspective. If so, you might be much better served by using that floor area for smaller personal spaces for each of you to recharge in, says Augustin, or "by adding little pockets or inglenooks to the large space." Then, too, you might like a more traditional living room, "even if it's just a vestigial one to show that you've 'made it.' Merely possessing such a room, even if you never go into it, can be a psychological benefit—a comfort."

Psychological comfort also depends on being surrounded by the meaningful objects and sensory stimuli that summon your desirable inner states—seemingly small things that help make a house or apartment feel like home. "If your grandfather's carving reminds you of how you want to live, you should display it, even if others see only an ugly hunk of wood," says Augustin. "What's popular or fashionable is secondary to what works for you." Many people feel that blue is soothing and lemon's smell is energizing,

for example, but if something unpleasant happened to you in child-hood that involved blue or lemons, you won't respond in the general way. If floral scents relax you because they remind you of long childhood vacations, she says, "make your home smell like flow-ers—but only if you want to relax there. Using the home in this way provides you with a great deal of psychological support."

No matter what its price tag or cachet, a house or apartment that fails to provide enough physical and psychological support can't be a true home. This sad situation often arises when an idea—early American, Louis XV, Bauhaus—takes precedence over the re-ality of how we live. Augustin illustrates with the story of a "green" college dormitory in California. Because it had no "ineffi-cient" carpets or curtains that absorbed sound, the new dorm echoed; because closets are "heat sinks," residents ended up hang-ing their clothes on ropes strung across their rooms. In pursuit of a philosophical goal, however laudable, the supposed home-away-from-home failed on both the physical and psychological levels to serve its fundamental purpose. As Augustin says, "The building was green, but almost unlivable." (To avoid such nightmares, the process of behavior-based architectural programming uses obser-vations, questionnaires, interviews, and other information to guide the design of user-friendly institutional settings.)

No matter how lavish, our homes, too, can feel unlivable if they don't suit our true personal needs. To that end, Augustin suggests that rather than following the media or a decorator, "ask yourself what works for you and makes you feel good, and then go with that. The home is your most private environment, so you can ex-press your identity fully there in a way that you might not be able to anywhere else. And that's a great psychological benefit."

Good house thinking means considering not only our evolutionary legacy and personal requirements but also the influence of our cul-ture. Like many other creatures, our early ancestors first lived in caves. As we moved up in the world, we developed an increasingly sophisticated sequence of dwellings, from simple hutlike structures

that, like the teepee, were built by their occupants and fairly vulnerable to nature, to variations on a common building type constructed by craftsmen and more insulated from the outdoors, to high-tech modern homes in many styles that are relatively natureproof and require major professional and material resources.

In the West, until the late medieval era, the rich lived in castles centered on a large, multipurpose "hall," and most people in crude shelters. For them, as in much of the world still, *home* didn't just mean the place where you ate and slept, but your whole social milieu, such as your village. As the poet Robert Frost put it, home is "the place where, when you go there, they have to take you in."

Home as we understand it—not just a roof over our heads but, as architect Witold Rybczynski has written, a private refuge that provides comfort, meaning, and beauty—is a surprisingly recent development. This complex environment evolved along with major cultural advances, including the rise of a prosperous middle class, the spread of democracy, and the increased importance of the individual. Europe's first bourgeois houses consisted of a few flexible open spaces that residents used for both living and working. By the seventeenth century, however, as the person gained in dignity and rights, the home too became more individualized and developed additional separate rooms, tellingly called *privacies*.

America's first homes were farms—powerful symbols of freedom and self-sufficiency for settlers who had fled Europe's oppressive class system for a better life. Outside Norfolk, Connecticut, there's a sprawling white clapboard farmhouse that began as an eighteenth-century cottage. Such houses typically had one room "for good" that often doubled as the parental bedroom, a hall that, like its baronial predecessor and the modern great room, was used for cooking, dining, and casual socializing, one or two upstairs sleeping rooms, and an outdoor privy. A century later, its now more prosperous owners turned this modest home into the rear wing of a more imposing "eyebrow Colonial." Even from the road, it's clear that many of the house's windows are shot and that if its maze of a floor plan ever made sense, it no longer does. White ele-

phant it may be, but despite its high price, it wasn't on the market for long before its most recent sale, because it's an authentic example of America's most beloved home.

Relatively few of us till the soil these days, but the farmhouse still occupies a special place in our collective unconscious. Our suburbs are based on its descendant: the detached single-family house in a natural setting that's America's overwhelming housing preference. In the first half of the twentieth century, the strenuous entrepreneurial efforts of Wallace Nutting, who was a master at exploiting the powerful connections that link American culture, homes, and behavior, helped popularize the "quaint" countrified suburban home with the picket fence as the American dream house. As the Rockefellers took on the restoration of Williamsburg, Virginia, the former Congregational minister devised ways for average folk, including first- and second-generation Americans, to give their homes a rustic yet genteel colonial spin. He manufactured products, from reproduction furniture to hand-tinted photographs, to make America's dreams of the good olde days come true, and promoted his wares in books, articles, and remodeled farmhouses that he opened to the public—for a price.

Whether we're aware of them or not, we have strong cultural associations with certain types of homes. Stone and brick houses have conveyed higher status for a hundred years, for example; in comparison, a wood house is linked with "emotional," "tender," or even "weak" occupants. The environmental psychologist Jack Nasar takes a scientific approach to "what buildings say" to us through the symbolic language of their appearance. In a fascinating study of the meanings we ascribe to housing styles, Nasar first showed people from different regions and socioeconomic groups some sketches of six common types of houses—Mediterranean, Colonial, Tudor, contemporary, Cape Cod, and farmhouse—that were comparable in interior layout and cost. Then, to identify the most popular home, Nasar asked his subjects which one they'd choose. To ascertain which house seemed most benign, he asked which one they'd try if they had a flat tire and needed help. To de-

termine the home with the highest status, he asked which one a leader would live in. Most people not only preferred the farmhouse but would also seek assistance there. As Nasar puts it, "This home says 'friendly.'"

The farmhouse's good-natured reputation is not based on mere nostalgia. Friendly, helpful responses are indeed likelier in the country than in the city. In a classic experiment, a researcher knocked on urban and rural doors and asked to use a phone. In response, 75 percent of city folks shouted through the door, and 75 percent of country people opened it. Nor is it surprising that Americans highly value the quality of friendliness and buildings that express it. After all, we're a nation of immigrants—by definition, individuals extroverted enough to take on a new country.

If the farmhouse says "popular" and "friendly," the Tudor and Colonial say "prestigious." Nasar's subjects correctly identified these homes as the likeliest to have upper-class owners. It's no coincidence that both evoke English manor houses. French aristocrats liked the city and its diversions, but British peers preferred their rural seats and outdoor pursuits. In the eighteenth century, the gentry and new meritocracy took up the fashionable Georgian house, which was based on the classical villas of the Renaissance architect Palladio. To British eyes, the light, symmetrical, geometric Georgian style proclaimed the Age of Reason, and to Americans, also the high ideals that their young republic shared with ancient Rome. In England and its rebellious offspring, a fine country home was the domestic gold standard.

By design, America's first iconic home combined the messages of the popular, friendly farmhouse and high-falutin' Georgian manor. George Washington's skill in turning Mount Vernon from a simple one-and-a-half-story house on a family farm into an English-style estate shows both his political savvy and the way in which psychological and sociological influences shape our own taste in homes. Determined to establish his personal status and his new nation's, too, he reconfigured his farm into the picturesque meadows and wooded "wildernesses" favored by the English gentry and added

to his house a white-pillared, two-story, ninety-six-foot-long piazza, or porch, where he and Martha enjoyed the new British vogue for drinking tea.

Inside as well as outside, Mount Vernon was meant to impress. A visitor first enters a big room that the Washingtons used for dining and dancing. It's larger than an entire average colonial house, and its walls are painted an eye-watering grass green that was all the rage in Europe. Yet Washington took care to emphasize that his home was also an honest American farm, not some decadent European palace. The room's fine plasterwork depicts wheat and agricultural tools, not scepters and coronets, and it was here, observes Dennis Pogue, Mount Vernon's curator, that the gentleman-farmer accepted the presidency in 1789. Every previous revolution in history had failed because the leaders couldn't let go of power, but like the Roman hero Cincinnatus, says Pogue, "Washington won the war, then gave up control and returned home to his farm."

Most important in a new nation of hardworking farmers, Mount Vernon celebrated popular contemporary taste. Just eighty miles away lies the country home of another founding father, which Pogue describes with a certain edge as "a strange, contrived place that reflects Thomas Jefferson's personality and intellectual ideas about architecture." In contrast to quirky Monticello, he says, Mount Vernon is less about aesthetics than "ostentation with a purpose. Washington personified the Revolution, and his house says to the world, 'I've arrived.'"

Just as the father of the country had wished, his fancy farmhouse became *the* emblematic American home. Sparked by the 1876 centennial, a revival of such Georgian-style Colonial houses helped the nation reaffirm a common heritage after the brutal Civil War. A major tourist attraction, Mount Vernon has been copied in every form from Christmas tree ornament to full-scale reproduction. More important, its unifying cultural symbolism lives on in the pillared porches, weather vanes, green lawns, white cladding, and dark shutters of countless American homes.

In the second half of the nineteenth century, America's agrarian

life and sober, classically inspired homes were profoundly trans-
formed by the double whammy of the industrial and romantic rev-
olutions. To us, Victorian means "old-fashioned," but the era was in
fact a time of radical economic, scientific, and social change. Artists
and writers exalted emotion over reason and brooding medieval
towers over Colonial and Greek revival farmhouses. The lure of
burgeoning cities and employment in their new central workplaces
turned a previously stable rural and small-town society of neigh-
bors into an urbanized culture of hustling, bustling strangers. At
the same time, stunning new domestic technology, such as plumb-
ing, central heat, and gaslight, was beginning to transform the
American home.

Trying to balance so much novelty and change with their
yearning for some order and continuity, the Victorians rethought
domestic architecture.

Their housing styles may have old-fashioned names such as Ro-
manesque and Gothic Revival, but these homes were sophisticated
responses to the era's conflicts between innovation and tradition,
individual and society, thought and feeling. As in the popular Shin-
gle style, inspired by New England's coastal farmhouses, the Victo-
rians bundled radically new mechanical systems into retro-looking
exteriors that evoked soothing, presumably simpler bygone times.
To help insulate the home from the tumultuous larger world, they
shifted from the layout of older classical houses, which had rela-
tively few rooms that were used by many people for many pur-
poses, to houses that had more rooms used by certain people for
certain purposes.

The later nineteenth century also gave birth to an American
home that wasn't just a new architectural style but also a new
lifestyle. By 1870, it was plain that the hordes of people, including
the bourgeoisie, who poured into the crowded cities to cash in on
the industrial revolution's new economic opportunities, would
have to live *someplace.* Paris already had fine apartments, but to
date, American cities had only the crowded, unsanitary multifamily
tenements of the poor, which had poisoned the whole apartment

concept. (In *The Age of Innocence*, Edith Wharton conveys the iconoclasm of Mrs. Manson Mingott by situating her bedroom next to her parlor; readers knew that "nice" people didn't sleep on the same floor as the home's public rooms, as apartment dwellers did.) Deliberately upscale design, aggressive marketing, and the provision of convenient in-house services—plus practical developments including fireproof steel framing, elevators, and safety codes—eventually persuaded the nervous urban middle and upper classes that the "French flat" could be a respectable home. Nevertheless, the majority of Americans remained biased against the apartment in favor of the private house, as they are today.

By the turn of the twentieth century, the corseted, petticoated Victorian house seemed anachronistic in elite circles, where a home for the new modern age was well under way. Simpler, less formal, and more practical, this new, unfussy house jibed with the era's increasingly sophisticated technology, relaxed manners, and forward-looking orientation. In this brave new world, the Chicago architect Louis Sullivan declared that "form follows function," but it was his young employee Frank Lloyd Wright who applied that rule to the American house, making it truly contemporary. He and peers such as Maybeck literally opened up the home both inside and to the outdoors and replaced the small rooms that predated central heating with flowing, multipurpose living spaces that complemented Americans' increasingly casual way of life. These once radical design concepts were later mainstreamed by the postwar housing shortage and consequent boom, which churned out cheap, easy-to-build homes with fewer walls, such as the open-plan suburban ranch house and urban apartment.

European architects, too, helped push the house toward becoming what Le Corbusier famously defined as "a machine for living." When Walter Gropius, Ludwig Mies van der Rohe, and other modern masters fled Nazism for the United States, they tutored a generation of young architects in their less-is-more principles. The émigrés' design schemes for war-torn European cities later inspired the largely lamentable housing projects of Amer-

ica's "urban renewal," but on a smaller scale, their stripped-down minimalist aesthetic helped to streamline and modernize the home.

Colonial Americans produced our classic farmhouse, Victorians the enduring Queen Anne and Shingle styles, and midcentury moderns the open-plan ranch and apartment, but we early twenty-first-century Americans have no comparably fine dwelling that expresses and supports who we want to be and how we want to live. Regrettably, the home most identified with our era is the pseudo-historical McMansion. As the term implies, these vast houses, which are concentrated in metropolitan suburbs such as those of Washington, D.C., Salt Lake City, and Minneapolis, range in size from 6,500 to 10,000 square feet and have at least six bedrooms, but they offer more generic calories than environmental nourishment.

Albeit smaller than a McMansion, America's typical home is a relatively new, single-family detached house of three bedrooms, two and a half baths, and big garage. The long period of relative prosperity that has enabled a record 68 percent of us to own a home has also dramatically increased its size to 2,200 square feet, up from 980 square feet in 1950 and 1,500 square feet in 1970.

Particularly important from a behavioral perspective, the average American home is located in the suburbs or, increasingly, the exurbs beyond. Certain cities, such as New York, San Francisco, and some Southern towns that, like Birmingham, avoided destructive urban renewal schemes, enjoy residential renaissances. Members of certain groups, particularly some young adults and older empty-nesters, prefer urban life. For most Americans, however, especially adults with children, lack of money is the major reason for not living in a suburban house. Its popularity is based on everything from backyards to tax breaks, but its most important advantages are the same behavioral benefits of privacy, freedom, and control that Americans have cherished since colonial days, when the national character was formed, with the least inconvenience in terms of access to goods and services.

Where architecture is concerned, the typical home is neotraditional, meaning that its exterior soothingly evokes the past—a farmhouse, say, or a Tudor—while the more or less open-plan interior accommodates our ever-evolving technology and increasingly casual way of life. Like the Victorians, we want our homes to be havens in a rapidly changing, complicated, uneasy world. We want both the latest home offices and entertainment centers, and a sense of continuity and familiarity amid vast social shifts, including the marked increase in nontraditional households, from unmarried childless couples' to single working mothers'. It's no coincidence that although we reckon with the changes wrought by the sexual and communications revolutions rather than by the industrial and romantic ones, genuine and neo-Victorian homes are remarkably popular in postmodern America.

Art critics tsk-tsk over new homes that have what many people describe as an "old-fashioned" and "genuine" quality, but this stubborn preference is more complicated than it first seems. Most people don't necessarily want an actual Cape Cod cottage or plantation house per se. Rather, they crave the older home's innately appealing features—alcoves, interesting windows, custom woodwork, fireplaces, inviting porches—which give a house or apartment character. For much of the twentieth century, however, the cost-driven housing industry and architectural establishment gave short shrift to the deep evolutionary, cultural, and personal needs that most people want their homes to meet.

Some avant-garde individuals can thrive in a glass house like the late Philip Johnson's or one that uses asphalt as flooring and cyclone fencing as a decorative element, as one of Frank Gehry's does, but this is a small, rarefied population. In fact, in Jack Nasar's research on America's taste in homes, only one group preferred the modernist house: architects. "They aren't trained to produce what most people like, but to create new artistic forms," he says. "If you want a friendly, appealing home or street, we know what to design, but architects go for novelty and the unusual. It's comfort versus creativity." Other research, too, reveals a gap in how architects and

civilians often think about buildings. Designers wonder, "How does it look?" The rest of us ask, "How does it make me feel? Does it meet my needs?" As a result, even residents in what seems like a "better," newer, more efficient home can feel powerless and stressed.

The aesthetic conflicts and communication problems that estrange designers and householders have serious consequences for both groups. Some architects work for housing developers and manufacturers, but they create only about 2 to 5 percent of homes for individual clients—an economic loss for their profession. Many people who could afford a custom-designed home instead end up with expensive ersatz log cabins and southwestern adobe houses that are produced by builders based on a generic neohistorical blueprint. American households are becoming smaller, older, and less traditional; barely half now consist of two married parents and their kids. Nevertheless, builders make money by the square foot, so the average house is geared to a nuclear family, bigger than ever, and often poorly proportioned, sometimes seeming like an appendage to its own great room or garage. Because land is expensive, the building is likely to dwarf its lot. As the noted architect and home designer Robert A. M. Stern observes, "everyone wants the same things in a house—light, coziness, spaces for the family to gather, and other areas that let each person hide out, have a cry, read a book. It doesn't seem like a lot to ask, yet so many of us end up buying the house we hate the least."

Like Wright, Maybeck, Hildebrand, and Stern, some modern architects are determined to design homes that are both unabashedly contemporary and innately appealing. Like his biblical namesake, the architect Jeremiah Eck is a zealot with a cause—in his case, what he calls a "distinctive" home. Stylistically, such a house or apartment is truly modern yet informed by American tradition; on a deeper level, it helps give meaning to life. Since graduate school, when he used a grant meant for foreign travel to drive around America looking at houses instead, Eck has insisted that a great new home needn't shock, as his professors professed, nor re-

produce the past. Rather, he says, "it should make you say, even if you can't explain exactly why, 'This house has character.'"

Talking about such homes, Eck uses words like *timeless, meaningful,* and even *spiritual.* These houses and apartments create "a feeling of shelter that goes beyond just keeping the rain and snow off your head," he says. "A sense of being in control over whether to be separate from the world or connected to it." Like most Americans, he is not particularly interested in whether a home is labeled modern or traditional. He quotes the painter Eugène Delacroix, who said that genius was "less often the expression of new ideas than the work of those who felt that a great deal more needed to be said about what had already been said."

Our finest homes—the New England saltbox, California bungalow, prewar "classic six" apartment, modern artist's loft—represent a uniquely American place and its people. "These homes come out of a spiritual investment in where and when they were built," says Eck. "A classical colonial in the middle of the frontier speaks of the Declaration of Independence. A shingle-style house reflects the characteristics of confidence and exuberance that Americans celebrated in the late nineteenth century. We love these domestic icons because of their metaphysical qualities."

To say more about what America's iconic homes have already said in a thoroughly contemporary voice, Eck designs houses that vary stylistically, but are alike in being profoundly livable and closely related to their location and its vernacular building tradition. One of these modern variations on traditional themes is a luminous white New England country home that recalls the region's clapboard Shaker farmhouse while asserting a sharp modern edginess. A very different home on a rocky Atlantic cliff seems poured into its steep, weather-beaten site; its jutting, prowlike roof evokes the fishing boats that work this coast and promises shelter from nature's extremes. Following the site's contours, the visitor passes into a low-ceilinged entry that Eck calls "the appetizer before the main course," steps down toward a mysterious glow, then finally encounters the explosion of the living space and its panorama of ocean.

Such distinctive homes have less to do with a particular style than with a few basic design principles that profoundly affect our experience. From the outside, their forms reflect the interior plan and take full advantage of the larger setting, rather than being just plopped down in the middle of the lot facing the street, says Eck, "as if watching cars go by were our favorite pastime." Inside, a distinctive house is based on human behavior rather than an architectural formula. Instead of thinking "kitchen," Eck urges his Harvard architecture students to imagine what a "food prep and social area" should look like. Rather than fixating on "living room" or "den," they consider whether a certain space is public or private, formal or informal. A person who does lots of fancy entertaining might indeed need a traditional living room, while one who doesn't could be better served by a casual hangout or family room. Looking at an existing home through behavioral spectacles can also produce breakthroughs, such realizing that a small, unused formal parlor could be a great office or that what's required isn't a living room but a "living porch."

Our individual needs and differences aside, homes that support the way many Americans live now often have a few features in common, starting with a welcoming front *and* car-oriented back entry. Most homes that Eck designs also include a great room and what he calls a "closed withdrawing space, where you can go when the kids are in the big room and read the Sunday paper and have a quiet cup of coffee. Like a piece of music, a house has highs and lows, different keys." Finally, in a distinctive home, as Mies famously said, "God is in the details": the nice moldings, railings, bookcases, and the like that add to a home's innate appeal. Skilled craftsmanship is costly, but some features that give a home character—a step down into the living area, say, or a window placed to frame a special view—require more thought than expense.

Most of us don't have the luxury of building a brand-new behavior-inspired home but must work with the house or apartment we have, warts and all. Indeed, Americans spend $200 billion per year on renovations. Eck finds that instead of automatically in-

creasing a room's square footage—the most expensive option—more is often gained from adding volume; a higher ceiling, dormers, or a window alcove can enliven both a dull interior and exterior and provide character. In his own house's recent "quadruple bypass surgery," he says, "we only added seven hundred square feet, but it feels like two thousand."

When discussing the typical new American house, Eck allows that it's technologically advanced and more efficiently built, but says, "from a spiritual point of view, the home is kind of in the Dark Ages. We're talking about a huge phenomenon of places that don't seem like a real part of our lives, that don't seem authentic. If one fundamental part of life, such as food, can affect our well-being, so can shelter. How do you calculate the effects of poorly proportioned houses and ill-conceived, ugly spaces that don't fulfill your functional needs? Think of how a set of clothes that's three sizes too large, in colors you hate and fabric that scratches would make you feel. The home is somehow like the envelope of clothes. You wrap its skin around you."

A house or apartment that doesn't just look good, but also helps us feel good is called "distinctive" by Eck, "innately appealing" by Hildebrand, and "personalized" by Augustin. They variously attribute its attractions to art, evolution, and what psychologists call a good "person-environment fit." No matter how it is described or whether it leans toward farmhouse rusticity or international-style urbanity, such a home is a haven of relaxation and fascination—a womb with a view—that positively affects and reflects you and your daily life.

Our house dates to 1880, back when innately appealing features were still routinely built into homes. Taking full advantage of them, however, is an ongoing process of experimenting with small changes that sometimes yield big benefits. The other day, suffering from cabin fever in my home office, I took a manuscript downstairs into the much nicer living room and pulled a comfortable chair into a corner window, facing out. Now, when I need a change of scene, I have a pretty, sunny spot for reading or working. Thinking in this environmental-behavioral way means that the dream-house fantasies that Mike and I spin increasingly focus on what kind of experiences we'd want to have in our ideal home—me gazing at a fireplace from bed, perhaps, or Mike playing his sax and drums as loud as he wants to in a truly soundproofed room—rather than on what it would look like.

When searching for ways to approach our experience of home, I often think of the theater. After all, our houses and apartments are the stages on which much of the drama of daily life is enacted. Beginning with the very important entry, the home's spaces are a series of sets that influence how we'll play our parts. It only makes sense to ensure that our rooms cue the kinds of thoughts and feelings that help us to be happy and productive.

The Entry and Plan

*Who You Are
Is Where You're At*

The glorious experience of Monticello begins well before you cross its threshold. Most great southern houses of the day, like Mount Vernon, overlook a river. Thomas Jefferson's home sits on a specially leveled hilltop with a jaw-dropping 360-degree view of Virginia's soft blue hills. At a time when there were still sharp distinctions between inside and outside, Monticello extends its arms, in the form of two vast side terraces, deep into its natural surroundings. Even the French were impressed in their way. As the Chevalier de Chastellux, a contemporary academician, sniffed, "Mr. Jefferson is the first American who has consulted the Fine Arts to know how he should shelter himself from the weather."

Already awed by the unusual setting, Jefferson's visitors approached Monticello's great northeast door and looked up to

admire some high technology. The large two-faced clock could be read inside and outside the house, and the wind vane dial was monitored by one of America's first compulsive weather watchers. Next, they stepped into the grand reception room and museum that Jefferson called the Indian Hall. (In prosperous houses, as domestic life grew more private and its spaces more specialized, the big, open, all-purpose, medieval-style hall had divided into several rooms used for different purposes; one of them was a smaller entry hall used for receiving and screening visitors, some version of which appears in most homes today.)

Jefferson's two-story, partially galleried entry hall is a premier example of how a room can influence how we'll think, feel, and act in it. With a psychological insight that matched his architectural talent and dramatic flair, Jefferson designed Monticello as a great stage whose different sets established the tone for scenes to unfold according to his script. Like other wealthy men, he used his home to impress others with his social and economic status. As a public figure, however, he also wanted them to grasp his intellectual, cultural, and political importance, which he spotlighted in the Indian Hall.

As one of Jefferson's many callers, you would have entered the hall, found a seat among its twenty-eight Windsor chairs, and settled down to await the great man. With no magazines or cable TV news to help you pass the time, you'd occupy yourself with Jefferson's artworks and large natural science collection. You'd wonder at the mastodon's jaw, stunning Indian artifacts, including feather headdresses and a buffalo robe sent back by Lewis and Clark, and rare maps of the new nation, to say nothing of the Old World's paintings and busts of historical figures. In fact, this carefully constructed environment gave you no choice *but* to marvel at it—and the person who had assembled it. As William Beiswanger, the director of restoration at Monticello, says, the hall provided Jefferson with "a way to represent himself to the public. The house would perform for Jefferson. It was self-centered, really, and an expansion of what a house can be."

The Indian Hall filled with mightily impressed visitors is just the first in a calculated sequence of Monticello's psychoactive settings. If the entry was designed to evoke awe, the adjoining parlor was meant to promote sociability. As graceful as the hall is imposing, this elegant room was the setting for parties large and small, including the marriages of Jefferson's daughters and his chess matches with his friend and neighbor James Madison. Just as the hall underscored his intellectual and political standing, his festive parlor showcased his role as a gentleman of fashion. His contemporaries would have admired trendy touches such as moldings that reproduce a frieze from the Roman temple of Vespasian and Titus and silk window valences that cost three hundred dollars—then a huge sum.

A very fortunate caller might have been invited into Monticello's dining room, a setting that Jefferson designed for intimacy with family and friends. A Georgian version of the high-tech "smart house," Monticello is full of innovations, and the dining room's most notable ones guarded Jefferson's cherished privacy and ensured that his companions would feel they were among the happy few. So that not even his slaves need intrude on this exclusive setting, dumbwaiters delivered wine directly from the cellar, and a revolving door was equipped with shelves that held platters of food. (Despite Monticello's environmental filters, at least one stranger managed to penetrate the dining room. One day Jefferson invited a Mr. Briggs, a Quaker friend, and the man he was chatting with in the Indian Hall to join him for dinner; after the meal, when the second man departed, Jefferson asked Briggs who the fellow was. Briggs said that he didn't know, either.)

Monticello's public rooms were meant to influence others, but Jefferson designed his private suite, which he kept locked and called his "sanctum sanctorum," as a series of settings that helped him regulate his own inner states and selves. This apartment within the house is actually a sequence of flowing spaces organized around his different interests and personae. His bedroom area opens directly onto his "cabinet," or study, where the extroverted introvert who

wished to stay at home while changing the world wrote thousands of letters—ninety to John Adams alone—and experimented with his scientific instruments. The scholar prevailed in the adjoining "bookroom," whose volumes of law, history, politics, and languages comprised one of America's largest private libraries. The pragmatic countryman emerged in the "piazza," or greenhouse, where Jefferson indulged his passion for gardening and his pleasure in making keys, locks, chains, and other useful items at his workbench.

As is true of more of us than might admit it, Jefferson was obsessed with his home—in his case, from the age of twenty-five until death at eighty-three—and never saw it as quite finished. Like many a do-it-yourselfer, he declared, "Architecture is my delight, and putting up, and pulling down, one of my favorite amusements." Acknowledging Jefferson's mastery of his hobby and passion, the United Nations placed Monticello on its exclusive list of World Heritage Sites—the only American house so honored. Testifying to his satisfaction with a unique home that was just right for him, he wrote, "I am happy no where else and in no other society, and all my wishes end, where I hope my days will end, at Monticello." On the Fourth of July in 1826, just as he wanted, a great architect of the nation and one of its finest homes died in his beloved sanctum sanctorum.

The idea that where you are influences who you are and what you'll do sounds so simple that you have to go over it several times before its import really sinks in. What it means is that, thanks to the synergy between your accumulated experience and your environment's cues, whether you're outgoing or shy, aggressive or phlegmatic, you, like Thomas Jefferson, are inclined to be more businesslike in your home office, convivial at your dining table, and industrious in your workshop. On some level, we all realize this, yet most of us could do a much better job of thinking about and then working the connections between our behavior and our familiar environments, such as our homes.

Some of the best—and most overlooked—research on how places influence what we do and how we do it was conducted by the late psychologist Roger Barker. After extensive observations of how people go about their business in everyday places—a rare enough endeavor in the experiment-oriented discipline of psychology—he identified what he called a *behavior setting*, which he defined as "a standing pattern of behavior and milieu." Despite his rather dull terminology, what Barker had discovered was the environmental component of a simple, profound principle described by William James, the father of American psychology: "Habit is the enormous flywheel of society."

We like to think of ourselves as quirky individuals very much in charge of our own doings. Nonetheless, as Barker found, no matter what our personalities, we usually behave like customers at the mall, passengers at the airport, and students in the classroom. We revert to standard operating procedure in such settings not because of a simplistic environmental determinism, so that shops or lobbies *make* us do this or that. Rather, such familiar, structured environments combine with our habitual ways of reacting to them to create a third entity: the person-environment dynamic of a behavior setting.

Our experience in our entry halls or kitchens is not quite the same thing as the general public's response to one of the big institutional environments that Barker mostly studied. However, the core principle of what he called ecological psychology—that a person and his or her environment aren't separate entities but form an interdependent behavior setting—offers important insight into daily life. Our houses and apartments also send us strong cues that combine with our long experience of bedrooms and basements, parlors and breakfast nooks to create an environmental-behavioral dynamic that influences how we feel and what we do. With this principle in mind, it's an interesting exercise to walk through your home while asking yourself a question: Does this room or closet or patio help me to be the right self at the right time?

• • •

When you consider your home from science's environmental-behavioral perspective, your entrance takes on a particular significance. Architects are trained to pay particular attention to this transition between the public and private worlds because it literally and figuratively frames your impression of what's to come—environmental feast or famine—and first impressions are always important. A good entry tells you that you've left the mad world behind for a private haven and invites the expectation of pleasures to come.

Instead of welcoming and enticing you, a poor entrance creates uncertainty if not distaste and prepares you for further disappointment. Some modern homes, particularly apartments, don't "waste space" on a real entry and more or less dump you right into the living area, leaving you feeling subliminally awkward and unprepared. Even splendid halls, however, are often turned into no-man's-lands of coats, bikes, junk mail, boots, and other debris by oblivious householders. An inauspicious entry is a sad waste of the home's precious behavioral capital, but many younger people who've never experienced the graceful progression from street to porch or lobby to front door to hall, which was one of daily life's pleasures into the mid-twentieth century, don't even know what they're missing.

The Emlen Physick House, in Cape May, New Jersey, might have been specially designed to illustrate the behavioral impact of a carefully designed entrance. The sprawling Victorian Stick–style "cottage" of 1879 was probably designed by the wonderful architect Frank Furness. Emlen Physick II, its owner, was quite the fellow: a wealthy civic activist, sportsman, and bachelor about town who shared his home with his mother and aunt, who were proper Victorian ladies.

Victorian homes both reflected and affected important transformations in the era's everyday life. To buffer the family from the hectic new urbanized world and its crowds of strangers and jumbled social classes, the bourgeois residence became a fortress and retreat, as well as an instant declaration of status in a suddenly topsy-turvy society. This fussier, more cloistered home had an es-

pecially profound impact on middle- and upper-class women. Instead of being out and about in the world, as they were in the old rural order, Victorian ladies were essentially restricted to what Robert Heinly, the Physick museum's education coordinator, calls an "unquestionably and unquestioned paternal benevolent dictatorship," in which their only spheres of influence concerned socializing, children, and servants. (Examining Victorian prissiness from this perspective, his colleague Elan Zingman-Leith, an architectural historian, points out that the colonial country woman saw animals breeding, but the urbanized Victorian woman "might have no idea about how sex worked." He also sees intriguing parallels among the cocoons of Victorian women's social roles, homes, and clothing—particularly their layers of undergarments.)

To help maintain a sense of order at a time of dizzying change, the Victorians developed a zeal for categorizing everything from ferns and butterflies to social groups: males and females, adults and children, servants and masters, strangers and friends. When they applied this passion for sorting and separating to the plan of the home, they turned the house into what Heinly calls a honeycomb. What had been the multipurpose domestic spaces of agrarian early America were segregated into public, private, and service areas, which were divided up into many rooms reserved for certain classes of people and functions. The keystone of this complex environmental-behavioral scheme was the central entrance hall.

The Physick house is an architectural illustration of a home that was just right for its status-conscious, tightly regulated, highly segmented Victorian culture. In this pre-telephone, pre-e-mail world, paying calls was a major social activity, but not one suited to the fainthearted where upscale homes were concerned. Even before getting in the door, the visitor had to pass through the increasingly private barriers of gate, yard, and porch—an important semipublic space for Victorians. Once admitted by a servant, the caller entered the hall, which was a screening station beyond which many never passed. He or she presented a card to be given to the appropriate family member, then awaited evaluation.

From its ornate carved staircase to the coffered ceiling to the massive mirrored hallstand, the Physicks' hall was designed to impress the caller not only with its owner's importance but also with his or her own provisional status. Like the looming big game heads, everything seems larger than life and meant to express the wealth and puissance of Emlen Physick and his dependent females, with one exception: the odd little chair reserved for the caller.

Perched on this inhospitable seat, the visitor would have picked up on status signals that the modern eye glides over. The American home, with its central heating and lighting and plumbed kitchen and bathroom, was already the world's most advanced, and new domestic technology was fashionable as well as practical. The hall's odd, asymmetrical gaslit chandelier proudly displays three kinds of innovative fixtures. Parts of the walls and ceiling are covered in a stylish, high-relief alternative to wallpaper called Lincrusta, which was developed by the inventor of linoleum. Moreover, the Lincrusta's Asian-inspired sea anemone pattern shows the Physicks' up-to-the-minute taste for the exotic "Anglo-Japanese" decor that was part of a backlash against the West's industrial products and mind-set.

While the visitor was left to contemplate the Physicks' grandeur, a member of the family inspected the calling card, then proclaimed the caller's status in architectural terms. At one end of the spectrum, an unlucky person heard a "not at home" from behind closed doors. At the other extreme, a resident was impressed enough to make an especially grand entrance by leaving one of the downstairs rooms, taking the back service stairs to the second floor, and then, framed by carved columns and filtered by an ornate wooden screen, descending the great staircase into the hall.

In the next phase of this environmental-behavioral process, the successful visitor moved from the hall and its dwarfish chair into the space that best represented his or her relationship with the Physicks. Special or less familiar callers were ushered into the formal parlor—the showcase for the taste and hospitality of the ladies of the house. Such elegant rooms were also used for enter-

taining at occasions from tea parties to funerals (until the advent of the first commercial "funeral parlors") to musicales. Making music was the Victorians' major form of entertainment—more homes had pianos then than now—and some of the Physicks' guests would have brought their own instruments to the music room that opens from the formal parlor.

Just as we invite close friends into our cozy dens or even kitchens, the Physicks welcomed their intimates into their informal family parlor. Its comfortable ambiance partly derives from the upholstered furniture—then considered "Turkish," as in *ottoman* and *sofa* (from *sufah*, Arabic for dais)—and Oriental rugs, whose muted colors were a fashionable reaction against the late nineteenth century's gaudy artificial dyes. This rather dim, cozy, eclectically furnished room and its clutter of classic Victorian bric-à-brac told members of an uptight society that here, at least, it was okay to "let your hair down" and be yourself.

Like the Victorians, modern Americans have needed homes whose entries and layouts reflect and support the way we really live. In the first years of the twentieth century, when Frank Lloyd Wright and Bernard Maybeck were designing innovative homes for a few forward-looking clients, many average Americans' houses and apartments were benefiting from the pragmatic house thinking of journeymen architects, who were also keeping pace with rapid changes in technology and ways of life. To illustrate, Jan Jennings, a professor of design and architectural history at Cornell University, pulls out some plans for "Cheap and Tasteful Dwellings," which were produced in competitions run by *Carpentry and Building* magazine between 1879 and 1909. To support the efficient household management advanced by the new field of home economics, the kitchen and its equipment were properly configured. For a nation suddenly faced with a shortage of servants, rooms were designed to be easy to clean. For these anonymous practical modern designers, says Jennings, "the big thing wasn't architectural fashion, but to get the planning right."

The popularity of the ready-cut "mail-order" houses that first appeared around the turn of the twentieth century attests to the appeal of well-designed, reasonably priced early modern homes. Between 1908 and 1940, Sears Roebuck alone sold 100,000 house kits in some 400 different models, ranging from modest bungalows to statelier homes and priced from $650 to $5,000. The average kit, which included a detailed manual and about 30,000 well-crafted pieces, was delivered to its buyer in a boxcar.

By the mid-1940s, some remarkable West Coast architects were experimenting with the plan of the modern home in the famed Case Study houses. Produced into the early 1960s, each of these twenty-five homes was based on the "case" and needs of a specific client. *Arts and Architecture* magazine, which sponsored the project, wanted to prove that the new industrial techniques and materials used to construct factories could also produce spacious, handsome, reasonably priced houses. On a more philosophical level, the Case Study houses were meant to show how a more easygoing, outdoors-oriented way life should be lived in modern midcentury America.

With their flowing, unobstructed living areas, expansive window walls, and indoor-outdoor spaces, the Case Study houses are among Jennings's favorite 3-D experiments in figuring out how Americans can live well. "Those houses explored questions about the use of space and advanced modernism with a capital *M*," she says. "Their architects tried things that didn't seem particularly domestic—large open spaces, dematerialized walls, flat roofs—but suited the way modern Americans live better than an old-fashioned gabled cottage."

To Jennings, skilled architects and designers, whether famed or not, are "social engineers" who use the home to answer questions raised by demographic changes showing "that we don't live like our parents or grandparents did. Questions about how to make a home better in terms of how people talk to each other, circulate, arrange their furniture, think about family. There really *is* a difference between the nineteenth-century Victorian 'cottage,' which was about

formality and receiving visitors, and a house that's about how modern Americans want to live. Homes done by professional designers change more over time than average builders' houses do, because they're almost laboratories for experiments in how to live."

Not all homes whose layouts suit our twenty-first-century lifestyle were built in the modern age. Across town from her alma mater, the avant-garde Yale School of Architecture, Melanie Taylor did some gentle, behavior-inspired remodeling of the rambling Victorian house in which she lives and runs her architectural practice. A recent review of one of her projects was titled "Musical Rooms," which Taylor believes is exactly what's happening to the plan of the American home. People want layouts that jibe with their daily lives, she says, "and that's always changing. On the other hand, most don't want something that's never been seen before, something cold and hard, alien and alienating. We're creatures who like to snuggle into warmth. We connect home with our hearts and souls. Most modernist architecture doesn't speak to that."

Somehow, it's not surprising when Taylor says, "I came to architecture through a garden gate." That particular entry belonged to the Katsura villa, one of Japan's national treasures and a stunning example of how an entrance and layout can be designed to affect behavior. Navigating its series of orchestrated settings, Taylor first had to wind her way through gardens "on path after path after path." Nearing the house, she came to a rushing stream in a bamboo grove, which made a wonderful sound that increased her sense of anticipation. Next, she crossed the water on stepping stones that had been deliberately placed just far enough apart that she had to watch her feet—forcing her, in Buddhist parlance, to be here now.

When Taylor finally got to the other side and was able to look up, there was the dazzling Katsura pavilion. To her, this complex entry as a process of discovery illustrates a "Zen ideal of giving up something—in this case, your impatience to see the villa—and

thereby attaining presence in the moment, so that seeing the pavil-ion becomes a mere bonus. That experience was a wake-up call. I thought, 'Wow, I'd like do that!'"

When Taylor discusses the home, she talks more about plan-ning behavior-inspired settings, such as Zen-moment entries, than about conventional rooms: "Most of all, I think in terms of giving you a sequence of experiences in your home. I want you to be both really comfortable in a haven and to have the unexpected delights of a 'secret garden' experience."

Taylor's own house/workplace illustrates the just-right home's balance between shelter and fascination. From the outside, the big wood building, which was cut up into four apartments when she bought it, still looks like a Victorian house. Beginning with the entry, however, she subtly has modified an old-fashioned residence to support some increasingly common developments in postmod-ern society, from running a business from home to single parenting.

Standing at the original handsome front door, Taylor says that largely for behavioral reasons, such as pleasant feelings derived from quality and security, even people on tight budgets will spend thou-sands of dollars for a fine, heavy door with good hardware. As the ancient custom of holiday decoration suggests, an inviting door is a powerful psychological symbol. (In pre-Christian times, the ever-green wreath, which represented life after death, was hung on the *janua coeli*—"door of the gods"—at the winter solstice, which intro-duced longer days.) In our outgoing, friendly society, a welcoming entrance is "the most enduring feature of our home—part of the American dream," says Taylor. "We have long loved that sequence from inviting porch to nice solid door to spacious hall."

Preserving the architectural and experiential basics of her house's fine Victorian entry, Taylor adjusted it to insulate her pri-vate world from her professional one and to keep behavior from one setting from creeping into the other. First, she designed a sep-arate entrance for her firm that's off to one side of the broad porch. Then she equipped the vestibule just behind the house's front door

with cubbyholes for business mail, paperwork, and other things that don't belong in the family dwelling. "Entering your home should be a series of filters," she says. "As you come in, you should dispense with all the everyday things—coats, sports gear, boots, car stuff, mail—so that they don't clutter up your home."

When she designs a brand-new house, Taylor creates a behaviorally minded, Katsura-like entry that sets the stylistic tone for the rest of the home. She likes to include a "cleansing experience" of calming sights and sounds—the tinkle of wind chimes, perhaps, and a glimpse of a fountain or pool—that smooth the transition from world to haven and connect the home with nature. Different personalities enjoy different interpretations of this welcoming experience. Taylor recently designed two seashore houses that both have front porches and water views. A man who likes big open spaces and rugged Adirondack furnishings got a bold octagonal porch with robust columns, whereas a woman who likes Laura Ashley floral prints and a sheltered feeling got a light, graceful porch screened by a delicate trellis. "You take in all the information about the person and percolate it," says Taylor. "Then you establish that aesthetic at the entrance and underscore it throughout the house."

If an inviting entrance has traditionally been the glory of the American home, a thoughtless one is apt to be the typical new house's worst aesthetic and behavioral failure. As Taylor says of the currently fashionable two-story entry whose height is often disproportionate to its smallish floor area, "You feel like you're at the bottom of a mine shaft. Your instinct is to jerk your head up, as if watching out for falling objects. The visceral response is not to feel welcomed, but intimidated." The mine-shaft entry is just one example of the popular but misguided bigger-is-better approach to the home. "You won't even appreciate big open spaces unless you have some little ones, too," says Taylor. "The McMansion trades quality of space for quantity of space."

In contrast to ungainly new McMansions, many older homes such as Taylor's were designed according to the so-called classical

proportions. These ancient ratios, which were calculated by the Greeks, revived in the Renaissance, and later promoted by Le Corbusier, base the size and proportions of basic architectural elements on the human figure, which automatically inclines us to feel easy and secure. Thus, the calm, inviting atmosphere of a well-proportioned entry frees us to focus on the experiences of greeting and homecoming, rather than on scanning for falling objects. As Taylor says, "We know how high and wide things should be to make us feel comfortable. That doesn't have to be invented!"

The tradition of an auspicious, well-proportioned entry leading to a series of thoughtfully laid out rooms, which is manifested in different ways at Monticello, the Physick cottage, and Taylor's house, is jeopardized by modern life's thralldom to the car. Until the early twentieth century, many Americans still depended on a different kind of horsepower. Dobbin and his carriage were kept in a barn near, but not too near, the house. In the city, the rich had private stables, and others made do with the commercial sort or rented rides as needed.

By 1918 and the end of World War I, the automobile was already changing the home and domestic life. At first, barns were recycled as garages. The horseless carriage didn't require a hayloft or produce manure, so new smaller garages were soon erected close to the house and designed to harmonize with it. After the Depression and World War II, cars became plentiful and, combined with improved roads and the postwar building boom, fueled suburbia's midcentury explosion. The home surrendered to the car, and the next wave of garages were attached to the house. The carport was invented by Frank Lloyd Wright.

In the twenty-first century, for the first time, America has more cars than drivers. More than three-quarters of us drive to work and nearly everyplace else. Garage space is increasingly important, and for apartment dwellers, pricey. Nearly one in five new houses has a three-car garage, which can make the home itself look like an appendage—a so-called snout house. People who want to add to their home's size, status, and value for relatively modest cost even

disguise the garage's exterior to look like living space and gussy up the driveway with cobblestones and plants.

Where the experience of entering a home is concerned, however, even the grandest garage is a poor substitute for the old-fashioned front door and hall that suburbanites increasingly ignore. Their houses generally have fine entries, but only Jehovah's Witnesses and the UPS guy are likely to see them. The car-oriented lifestyle means that residents mostly pull into the garage, traipse past the trash cans and tools, and slip into the house through a metal utility door that leads to the laundry room, pantry, or other service area. This dispiriting experience sublimminally primes them and their callers for an undistinguished, perhaps even unpleasant, home in which good manners might almost seem pretentious.

Rather than pretending that people don't live as many of us do, skilled architects increasingly provide homes with a second, informal entrance that's geared to the car but also welcomes the person. After leaving the garage but before entering the house, says Taylor, if you stepped down onto a small balcony that frames a nice vista, for example, "you'd get the chance to have this little Zen moment of separation. You can leave your car and daily cares back in the garage, connect with your surroundings, and get that quiet feeling of 'I'm truly home.'"

Compared to the eye-popping versions at Monticello and the Physick house, Taylor's own entry and layout are modest, yet they set the tone for the relaxed but civilized behavior that she expects in her home. Past the filter of the vestibule lies the house's original large, gracious center hall. Unlike Jefferson or the Physicks, most modern householders don't need a big room devoted to vetting visitors. To make better use of her hall, Taylor added a powder room, computer, and a convenient interior private stair to her firm's office.

Regarding the rest of her home's original, well-considered layout, Taylor adopted the principle that if it ain't broke, don't fix it. Because the parlor that opens off the hall is only separated from the dining room by leaded glass doors, the space functions much

like a modern open-plan great room, and Taylor left it nearly un-changed.

Not all of a home's important entries are external ones, and Taylor finishes her tour at a small interior door in the rear of the house that sets the tone for an important personal behavior-in-spired setting. To emphasize its private nature, this door, which opens into her bedroom, is partly veiled by a curtain. Inside, the bed is positioned in an arch that divides the room into a boudoir space and a small, glassed-in conservatory of the do-it-yourself sort, complete with luxuriant plants and a small fountain. To move into the greenhouse, you must pass through yet another kind of entry—a narrow opening between the bed's ornate headboard and the wall—that widens onto the conservatory. The room seems more magical than modern, but its every detail was carefully planned to provide refuge and delight.

As Taylor's house-cum-workplace shows so well, a just-right home often requires less labor or money than house thinking and cues that whisper that here, beauty, order, comfort, and good be-havior are valued. Paraphrasing Winston Churchill on buildings, Taylor says, "We shape our homes, and thereafter they shape us."

Some of the domestic spaces and layouts that most affect us aren't even rooms or sequences of them, but special microenvironments. Indeed, the true heart of a house or apartment can be a nook or fireplace, porch or furniture arrangement that architect Donlyn Lyndon, a designer of the Sea Ranch, a famed Northern California coastal community of 1,700 homes, calls an *aedicula*. The Latin word originally referred to a miniature house or shrine, sometimes imagined as a hearth surrounded by four posts, that formed the an-cient Roman home's spiritual center. A modern *aedicula* can take many forms, Lyndon says, but it too is always a well-defined place that can accommodate several people.

An *aedicula* requires some serious thinking. As Lyndon explains: "It's a little house within a house that helps you understand the larger one. That marks a place in the home that you care about, or

that your life moves around, or where you put the stuff you like best. You just like knowing it's there. The *aedicula* sets up a counterpoint between the fluid, improvised, changeable aspect of domestic life and this thing that keeps saying, 'There's something central that's always here.'"

The *aedicula* in Lyndon's home in Berkeley, California, is a sunny, south-facing bay window with tree-filtered light and a cushioned seat that overlooks the street. This wonderful behavior-inspired setting is the kind of "extra" that, like a fireplace or a breakfast nook, makes many older homes charming and flexible enough to feel just right to a succession of owners. For one person, the bay window is a place to read, while for another it's a perch for people-watching, and for still another the site for an altar. Because it's both bowed and several feet above the sidewalk, Lyndon's bay also adds to his home's "good outlooks," he says. "By reaching out and letting you see farther up and down the street, it lets us live out of our house."

One reason that the bay-window *aedicula* is such a nice place to be is its light, which is always a crucial behavioral element in a well-planned home. Indeed, a very different sort of window illuminates the *aedicula* in Lyndon's second home at the Sea Ranch. When he designed it, Alice, his wife, who's a sculptor and photographer, was becoming blind. The big skylight in the house's center helped her see better and still landmarks her place at their long white dining table, which is also a kind of shrine for the couple's special objects—currently a big model airplane. "The table is both a gathering place and display piece that's in the middle of our lives," says Lyndon. "It's our *aedicula*."

A fortunate few have the help of a talented designer in planning their home from entry to *aedicula*, but Lyndon insists that anyone who cares enough can create what he calls a "house of great worth." The first step is to "pay attention to what goes on in your daily life," he says, then to ask yourself the same questions that designers put to their clients: How do you come and go from your home? Enter your rooms? Where do you like to sit? What parts of

the home do you most enjoy? How often do you really use outdoor space? Would you use it more if there were a door in a certain wall? If a window were bigger, could you see more of something you like? Lyndon also encourages everyone to think about light— "a really, really important factor in making a house feel good." Once you get an idea of what you really care about, he says, "have the courage to go after it, to persist. To have what you really like requires some choices in how you invest."

In his own 1920s California bungalow, Lyndon made only subtle changes that accentuate the positives of its plan and gently correct the negatives and anachronisms. His most important intervention was a low-key but transformative renovation of the entry. Originally, the front door opened onto a small vestibule that led to the living and dining rooms to the left and right. Unfortunately, the dark, stingy space was sealed off from the kitchen and the sunlit backyard just beyond it. Lyndon removed the light-obstructing wall, opened the entrance to the kitchen, and filled in a door that had joined the kitchen and the dining room. This modest fix provides three rather than two choices of where to go next, as well as more sunshine and activity in the entry area. "The easier interchange between the rooms means we're back and forth through the vestibule all the time," says Lyndon. "Many people don't use their 'good' entries because it's more convenient to take the back door into the kitchen, but we can enter ours through our nice front door."

With the kind of thoughtful planning that Lyndon applied to what was an ordinary older house, the average apartment, too, can offer "much more than it typically does," he says. "There are many great apartments, and great mansions that are effectively apartments. Basically, you want your home to express where you are and who you are, and an apartment can do that."

Getting the most from a flat usually involves making it feel bigger. Lyndon finds that one simple way to do that is to use furnishings and equipment that can be "joined in the mind." Instead of having five small bookcases in different places, for example, you

could have a huge wall of shelves that runs through the whole apartment, including the kitchen, which creates a larger feeling. "Design often means finding relationships between things that they didn't immediately have, so that they become something more," says Lyndon. "Things that can group together can transcend their individual identities and become part of a larger picture."

A well-designed layout extends to the furniture arrangement. In his own long living room, Lyndon uses furnishings to break up the space into what almost function as mini-rooms. Past the window/*aedicula*, a big red couch and chairs pulled up to the fireplace define the social area. Instead of allowing it to dominate the room—a common behavioral disaster—the TV occupies its own corner, faced by two chairs. "A lot of people think that furniture has to be against the walls," says Lyndon, "but it should be an element of composition. Even the right placement of a few well-chosen flea market chairs can have a kind of coherence together that transcends those units and focuses attention on what you really care about, such as the company of family and friends, thus becoming an *aedicula*."

Because our new ways of working and entertaining ourselves and others mean that many of us spend more time at home than ever, Lyndon believes that our houses and apartments should be planned to provide us with more and better kinds of experience. "Home should enable people to be more private and public, to have more sun, to hang more things on the wall, to have different spaces," he says. "Home should be more of an enrichment, because it now plays a very large part in our lives."

Our home's entry is no Indian Hall, but it looks and feels a lot better since we rearranged it with behavior in mind. First, we eliminated clutter. Assorted gear went into storage tubs in the closet, recyclables into a new bin beside the stoop, and mail either into a sorting rack or right into the wastebasket below it. We found a nice old coat-tree for the kids, who are allergic to hangers. Finally, we hung some family photographs, put down a sturdy raffia rug, and moved in the piano, which maximizes the use of the space and allows music to set the tone for our home.

After improving our entry experience for relatively little cost and effort, I was eager to take on another behavioral home-improvement project. The next obvious challenge was the living room, which has long been the domestic shrine of personal expression. Searching for some inspiration beyond paint colors and throw pillows, I decided to think of the room in a traditional yet behavior-oriented way: as the place where our family defines and displays for ourselves and others who we are, where we came from, and what we value.

CHAPTER THREE

The Living Room

Decoro Ergo Sum

N̲o one would suspect that the sunlit living room
overlooking Sherman Canal, in Venice, Califor-
nia, is a psychology laboratory. Much of its charm lies in the way
that casual, summery furnishings—green wicker chairs, a glass-
topped iron garden table—somehow complement more formal
Asian pieces, like the silky peach couch, Oriental carpets, and
Japanese art. This hard-to-categorize yet harmonious room isn't
organized around any particular decorating style, but according to
the principles of what its co-owner the psychologist Connie For-
rest calls design psychology. "We've all walked into certain homes
and instantly thought, 'No, I could never live here!' or 'Yes, I could
be happy here!' " she says. "Design psychology answers the ques-
tion: How do we get to 'Yes'? "

The living room or area is the home's most expressive space,

which makes it the perfect place to experiment with what creates that "Yes." Like many people, Forrest shares hers with family: her husband and her sister Susan Painter, a developmental psychologist and interior designer who is also her professional partner. Buying their spacious house with its separate bed-and-bath wings made plenty of economic sense, but it also forced the women to distill two households' lives—and stuff—into one common living room. What unifies this space isn't just their shared taste for Asian art but their shared past and its places, which continue to shape who they are and how they like to live.

In this living room, a seat is not just a seat but is, like Proust's madeleine, a key that unlocks a trove of memories and associations. The wicker chairs evoke the rattan furniture of the sisters' childhood summers at the New Jersey shore. The luxurious, Indian-looking sofa marks Painter's transition from grad student to professional life. The room's three sculptures of the female figure reflect their family's history of strong, supportive women. Two large copper lamps had belonged to a beloved aunt who recently died. Even the fence around the waterfront deck that extends the living room into the outdoors subtly imbues the present with the past. "Right away, we loved that fence," says Forrest. "It just feels *good*." One day, her husband figured out why. The new fence has a wide top rail for leaning on, just like the one at the boat club where the sisters spent much happy time in their youth. As Forrest says, "The home you create reflects your experience—both internal and external."

Traditional interior decoration and design mostly focus on aesthetics and efficiency. Since the later twentieth century, however, different kinds of research have helped illuminate the importance of the connection between the individual's personality and meaningful places from the past in creating a just-right home. From this perspective, the living room's goal is not shelter magazine perfection but a deep, gut-level feeling of identification and comfort.

The evolution of environmental-behavioral research and a long-ago home's continuing way of shaping her inner and outer worlds inspired Forrest to inform design decisions with insights

from psychology. Early in her psychotherapy career, she located her practice in the glassed-in porch of a New Jersey house that was being converted into offices—a seemingly poor choice in a region of cold winters and hot summers. Nevertheless, the sunny room gave her the "Yes" feeling, she says: "I just said, 'This is it. I have to be here.'" Before long, Forrest and her patients noticed that treatment seemed both easier and deeper in the new office. "They just loved being in that light-filled space," she says, "and I did, too." Eventually, she realized that the office evoked her life's "best place," or the environment in which she had felt her absolute greatest: a loving aunt's house, where wonderful light poured through long glassed-in porches on both sides. Decades later, she had instinctively turned to another sunlit porch and enjoyed the same "Yes" response.

Before the advent of environmental psychology, modern science paid little attention to place's psychoactive effects. To Sigmund Freud, certain settings and things symbolize psychological issues. Thus, a man who can't settle on which couch to buy for the living room might be reacting to a childhood experience with harsh, perfectionist parents. A wife who never gets around to decorating the living room could be ambivalent about marriage. Taking a more sanguine view, Carl Jung saw the home as an archetypal place that was the source of comfort, belonging, and other psychological riches. In *Memories, Dreams, Reflections*, he devotes a chapter to his own beloved Tower, the home that he began to build just after his mother's death. The original hut with a central hearth soon grew into a two-story "dwelling tower," which Jung described as "maternal." The next addition was a private "retiring room" where, he wrote, "I could exist for myself alone." When his wife died, the elderly Jung added an upper section that represented his mature "ego-personality." Looking back over the evolution of his small castle, Jung concluded that the Tower was the "concretization of the individuation process." In the home created with his own hands, he wrote, "I am in the midst of my true life, I am most deeply myself."

Modern research on memory has helped shed scientific light on the profound emotional connections between our pasts and our present homes that Jung describes. We like to think of memory as a mental video, but it more closely resembles a cognitive and emotional collage. When we recall an experience—say, learning a song at a holiday gathering in a bygone living room—our brains call up fragments of the event, its setting, and our emotional response. Thus, our recollection will be more vivid if we entertain it during the holidays in that same living room or one that resembles it. The phenomenon of state-dependent learning also suggests that if we learned the song when we were in one condition, such as inebriation, and then try to recall it later when we're sober, we'll perform less well than if tipsy.

Science's growing understanding of the influence of emotion and environment on memory suggest why we're so deeply stirred when we return to places—childhood home, vacation spot, alma mater—that we've loved or hated. Like the sled "Rosebud" in *Citizen Kane*, a living room rocker, a window that frames a mountain range, a certain flowered couch, the scent of lilacs, or the crash of surf whisper not just of a long-ago home, but also of who we are and how we got here from there.

Like science, the world of design has begun to pay more attention to the psychological power of our past places. In 1979, Clare Cooper Marcus, then a professor of architecture and landscape architecture at Berkeley, began asking her students to compose an "environmental autobiography" as a means of helping them to see the connections between significant settings from their pasts and their vocational and design decisions. Their childhood environments proved to be especially important influences. Marcus had also noticed that when clients consulted her about their gardens and homes, their emotional issues often came to the fore—so much so that she sometimes recommended psychotherapy.

To investigate the emotional bonds between us and our past and present homes, described in her book *House as Mirror of Self*, Marcus enlisted some sixty volunteers to make a graphic image

that expressed their feelings about their dwellings. Then, in a role-playing exercise, her subjects talked to—and for—their domestic images. The deep, often unrecognized feelings that surfaced led her to conclude that we often use our homes to express an aspect of the self and to recreate or reconcile ourselves to our pasts. Persons whose earlier domestic lives had been disrupted by frequent moves, for example, often repeated that pattern. One man suddenly saw that he lived in a house that was poorly suited to his present needs because it replicated a boyhood home—one that he was still emotionally struggling with.

Our homes and our relationships to them become especially important and revealing when our lives are in a state of transition. When Marcus asked a newly divorced woman to talk to and for the image of the home she had just left, the woman said that she had never liked the place—and added that the house was equally glad she was gone! Another subject finally realized that she was unable to buy a new home because she hadn't yet grieved for the loss of her old one.

Many of us are similarly unaware of our deeply personal, often subliminal feelings about our homes and other important environments. (Judging by their waiting rooms and offices, even most psychotherapists seem oblivious to place's silent, eloquent language.) According to environmental psychologist Lynne Manzo, who studies place attachment and the home's meaning, popular beliefs about our dwellings not only tend to oversimplify place's impact on our behavior but especially to gloss over our ambivalent or negative feelings about such emotionally freighted settings. "When people talk about their residences, they automatically focus on the positive affective relationships," she says. "They're too ready to avoid looking at the shadow side. The home as solely a haven is a cultural myth. It's not that the myth is without merit. But it's romanticized, doesn't include the full range of our experiences, and raises unfair expectations about what the home is and should provide."

When discussing the environmental autobiography, pioneered

by Marcus, that she assigns to her students in the department of landscape architecture at the University of Washington in Seattle, Manzo says that their insights into places from the past emerge "almost in free association. Someone will say something like, 'Hey, come to think of it, my current living room is black and red, and the one I had as a kid was black and red. I loved that room, because my aunt and uncle would come over on holidays, and we'd have these little cocktail wieners . . .'"

That many designers' sketches show their subconscious efforts to recapture an archetypal place from their pasts strongly suggests that each of us has at least one experience of a particularly meaningful environment that our hearts and minds always return to. Illustrating with a poignant example, Manzo brings up a young woman who grew up in a strife-ridden, crowded house, in which her only sanctuary had been the bathroom, which at least had a door that locked. The young woman described being in despair as she sat there on the edge of the tub, crying and looking out the window. "She felt trapped in the bathroom," says Manzo, "but it was also her safe spot." The student may have been understandably ambivalent about this "safe trap," but in her work, she refused to design the windowless bathroom that so many apartments have.

Such environmental autobiographies suggest that if you used to play on your home's staircase landing, for example, you might grow up to prefer a two-level house. If you also happen to be an architect, you may even integrate that landing experience into your designs, thus extending it to others. Manzo finds that although many of these archetypal settings are favorite places, others are linked to powerful lessons of what to avoid. Either way, she says, "we have very pivotal experiences, thoughts, and feelings around very precise architectural elements."

The important element in how our past homes affect our present ones is not the places themselves, but our experience in them. That doesn't mean just the sensory input of sounds, light, temperature, or the feeling of a pillow beneath our heads, says Manzo, but also "what

the setting elicits from us emotionally and psychologically—a host of phenomena, some conscious, some not, that swirl together to create experience. Really understanding the home means allowing people to explore their ambivalent and negative feelings and experiences there, too. That kind of information is usually swept under the rug by researchers who don't want to challenge cultural myths."

It may not be possible to psychoanalyze a living room, but the level of house thinking that the geographer and designer Denis Wood and the psychologist Robert Beck applied to the one that belongs to Wood, his wife, Ingrid, and their two sons must come close. Like most of our living rooms, the Woods' first appears to have that serendipitous quality that arises from a blend of new purchases, secondhand finds, travel souvenirs, and totemic objects, such as the painting by Denis's artist brother that the couple would rush to save in a fire. However, after studying each of its seventy objects, from the potted plant to the couch's throw pillows, the team found that far from being a random assortment of a little of this and a little of that, the Woods' living room is a three-dimensional representation of their identity. Moreover, they saw that by teaching their children how to behave in this special room, Ingrid and Denis provide the next generation with an on-going, hands-on tutorial in the Woods' way of life. As Denis says, their living room "flows from choices we have made, is not just the way a room is, naturally or by chance. We live the room—pass down generations of rules that are in fact culture."

Even the living room's secondhand wicker rocker illustrates a rule—namely Ingrid's assertion that "I will not have a living room that looks like something in an architecture magazine." Far from being just any old chair, however, the rocker is a historical artifact that quietly represents, to themselves and to others, the kind of people the Woods are: believers in plain living and high thinking. The chair may have been rescued from a trash pile, but it has a pedigree: it's a hundred-year-old Hayward Brothers and Wakefield Company piece whose imported Chinese reeds were handwoven in

Massachusetts. Handsome and comfortable, antique yet unpretentious, the rocker epitomizes life chez Wood.

As it turns out, there are no fewer than 223 rules about how to live the Woods' living room: a complex code of behavior that communicates and perpetuates the family's values. The edicts begin at the screen door, whose nine prescriptions range from "Don't open it to strangers" to "Don't talk through it to guests or friends." Some of the Woods' practical rules would apply in any living room: "Don't throw up on it [the couch]—go outdoors or in the bathroom" and "Don't take the shade off and use it as a space helmet." Other, subtler regulations, however, concern the kind of people the Woods are and how to do things their way. "Don't leave *Tintins* [classic French comic books] on the table," for example, and "There is no leaving of shoes around in this house."

Once the ear is attuned, this living room rings with "voices," such as High Culture (the records, the paintings), a Certain Easy Formality (an implicit asceticism, its violations), and even the "murmur of a smothered anger." Perhaps the most influential voices belong to the family's forebears, whose passed-down code of dos and don'ts is "remembered" by the living room, thus incorporating Ingrid's and Denis's childhood homes into their present one.

Just as your living room expresses your personality and past, it's also, as Wood and Beck see it, "a memory of how to live that goes back generations." To them, the family's values, meanings, and rules are the room's "alternative forms," and the room is one of many ways in which those concepts are expressed: "Since for us a room is but an aspect of a life, just as we speak of 'living a life,' so we speak of 'living a room.'"

One night, students in the design psychology course that Forrest and Painter team-teach at UCLA present collages that represent their efforts to create a place that invites that "Yes!" response. Their colorful boards filled with pictures from magazines are the first stage of the semester's main assignment: the design of a four-hundred-square-foot personal retreat, or a kind of living room

sans home that expresses their personalities. Using themselves as guinea pigs, the students are learning how to identify and interpret the environmental cues that trigger the subconscious memories and joyous states that help produce just-right homes.

Many of the young people's collages are tropical getaways, but there are striking personal variations on this theme. Emily's poster shows lots of pictures of the open sky and sea (whose sparkle prompts Painter to suggest that Emily might consider putting a shining hardwood floor in her refuge). Emily sees herself as very sociable, so she's surprised when Forrest points out that her poster is filled with pictures of solitary women gazing out of windows, which suggests a contemplative, private person—and retreat. Courtney's tropical haven is as psychedelically colored and emotionally intense as Emily's was reserved and cool. Alex's sturdy, earth-toned imagery suggests that his refuge would be no straw shack but a secure, durable structure. Vivacious Rebecca shows a cabana that, judging by the multiple images of beds and handsome young men, isn't intended for solitude.

To arrive at their very different rooms, the students have gone through the same three-step process that Forrest and Painter's clients do. First comes a "developmental place history" that briefly describes a person's important experiences, the feelings they inspired, and the places where they occurred. "We want to know that Mommy and Daddy got divorced in the white-shingled house in New England, so we can avoid those references," says Forrest. "But the major focus is on what the person loves, so we can find doable ways to create a space that triggers good feelings."

Next, the client names five beloved objects, which portray the physical world as he or she sees it. A woman might not be aware that she's drawn to lavender blue, for example, until she sees that several of her favorite things are that color, and then recalls a wonderful trip to Provence and its lavender fields. Finally, the client describes the place where he or she has felt the absolute best. "Whether it was in grandmother's dressing room or the woods," says Forrest, "that favorite setting gives very specific clues about

the kind of space—its light, texture, aroma, proportion—that are the unconscious triggers for the way a person wants to feel in a space." When combined, this input yields a "sensory portrait" that points the way us to "Yes."

Brain research, conducted by the UCLA psychologist Allan Schore, that shows what happens when we recognize someone's face suggests to Forrest what might occur when we have that instantaneous positive or negative reaction to a place. Before we're even consciously aware that we've seen a certain person, the amygdala—a brain structure that helps regulate emotions, including the so-called fight-or-flight response—signals either "friend" or "foe," depending on our past encounters. Place recognition is also processed in the amygdala, so reminders of important environments from our pasts may trigger a similarly rapid, subconscious identification process.

Based on a client's feedback, Forrest and Painter come up with a design prescription for the way the person wants to feel in the space and a concept or image of a place that evokes those feelings that will be translated into a real environment. By way of illustration, Forrest describes the "Zen garden" living room created for a woman who was dealing with serious illness in the family. Her favorite place was her grandmother's house at the seashore. "Walks on the beach, objects she found, the light on the water, the big open sky—all those things were very powerful for her," she says. "Her whole family relaxed and felt united there." Her prescription of "serenity, optimism, and groundedness in tradition," combined with Forrest's own love of all things Asian, led to the concept of a Zen meditation garden, with its tranquil atmosphere and beautifully raked sand.

Turning an abstract concept into a a real living room is a more metaphorical than literal endeavor. "You don't actually have to put a sandy Zen garden in the house," says Forrest. "That image just symbolizes a place that, like the beach, is uncluttered, simple, and serene, and that has a certain quality of light and connectedness to nature." For her beach lover's space, Forrest found a pale flecked carpet that evokes raked sand; a lamp made from a transparent

blue-green vase that recalls beach glass; an unpolished travertine marble tabletop that whispers of seashells; an antique greenish Japanese screen that's almost like a view of the ocean. The Zen garden room elicited the client's immediate "Yes" response and later reports of feeling more energetic yet calm.

While going through a big professional transition, another woman undertook a renovation that became psychological as much as environmental. When the project began, she had rather drab hair and nondescript clothes. While her building's interior was being remodeled, she worked with Forrest not just on design issues but also on refining her vision of her inner self and her dreams of where she wanted to take her career. During the renovation of the exterior, the client lightened her mousey hair to her childhood blond and bought more colorful clothes. By the time the project was finished, the woman had altered her way of working, acquired a more vibrant, nature-oriented environment, and developed an exuberant personal style. "She looked fabulous," says Forrest. "Working on her space had paralleled working on her self."

Like these two women, we're especially likely to want to change our homes when our lives are in flux, whether through a trauma, such as sickness or divorce, or a normal transition, such as marriage or retirement. To Forrest, this urge is a healthy reaction: "The assumption that your home is always going to be a certain way doesn't reflect the reality that change is part of life. If you consult a designer, you're in a state of transformation, perhaps deeper than you realize. Something within you is saying 'I need to change,' and the design process can further that evolution. Space, colors, the placement of objects, light—these things actually matter. An environment can be counterproductive in terms of your growth toward who you want to be, or it can be catalytic."

The personality that your living room in particular expresses was formed not only by your nurture, or your past experience, but also by your nature—your biologically based temperament. Bob Young, a former Special Operations soldier turned naturalist mountain

man, makes his home on a remote Montana ranch where he is the caretaker. His log cabin's living room's style might be called au naturel. The honey-colored unpainted walls give off a soft golden glow, and the furniture, door latches, and much of the other "hardware" are made of wood. The decorative elements are Bob's guns and knives, bones and antlers, snowshoes and fly rods.

Like most living rooms, Bob's expresses who he is by creating a certain atmosphere—in his case, that of a campsite. As he puts it, "My idea is to make the indoors more like the outdoors—here or in Alaska, Canada, or anywhere that allows me to live in a natural way in an unnatural world." It doesn't take a psychologist to look around and conclude that the soldier turned frontiersman has the fearless, thrill-seeking disposition that behavioral scientists call the "bold" temperament. As all those magazine quizzes attest, it's fun to speculate about which personality type should have which style of decor. The soundest research on the subject, however, concerns the introvert's and extrovert's very different needs for familiarity and novelty—Frank Lloyd Wright's nesters and perchers.

Scientists wrangle over the number of personality types and traits, but they pretty much agree on humanity's two most basic inclinations. One is the outward-looking, thrill-seeking boldness that we associate with politicians, entrepreneurs, and adventurers like Bob. The other is the inward-looking, sensitive nature that's characteristic of many artists and scholars. These introverted and extroverted temperaments bespeak different kinds of nervous systems, which function best in different sorts of places.

Bold, shy, or somewhere in between, we all find that too much environmental input is agitating, and too little is boring. However, depending on our temperaments, we vary greatly in where we set those bars. Each of us is naturally attracted to places that offer just the right amount of stimulation: enough to keep us interested but in control. To achieve that comfortable state, the extrovert might head off to the nightclub or mountain peak and the introvert to the concert hall or hearth.

Where the home is concerned, the adventurous individual's

low-idling, laid-back nervous system requires lots of environmental feedback—more prospect than refuge—in order to avoid boredom. Someone whose boldness is primarily social, like Bill Clinton, would prefer an action-oriented, outward-looking living room that's geared around social gatherings and lots of entertainment options. Physically bold types, like Bob Young, might enjoy a living room that at least metaphorically evokes a campsite or playing field, as do many classic male dens.

Far from adventurous Bob's cabin, Ann-Judith Silverman, a brain researcher who, like many scientists, has a rather shy, sensitive nature, has a very different sort of living room in her home in rural New York. Her cozy parlor is more refuge than prospect. Instead of antlers and fishing gear, her room features books, needlework, a padded rocker, and two big cats by the fireplace. Although her house is Victorian, her high-strung, naturally revved-up brain can be swamped by too many tchotchkes and other stimuli, so Ann-Judith's decor has a Shaker simplicity. In this calm, familiar setting, her nervous system gets a much needed respite from her busy days in a bustling university laboratory.

Bob's wild and woolly percher's living room and Ann-Judith's sheltering nester's parlor illustrate one of behavioral science's most interesting and useful discoveries: different personalities seek and thrive in different environments, which in turn reinforce their natural inclinations. From his early childhood in the rural South, Bob's naturally fearless disposition has inclined him toward the very places, from barn roofs to bears' dens, that make him even bolder and tougher. At the age when he dropped out of college to go buccaneering, Ann-Judith was well on her way toward a Ph.D. and has remained in the secure world of the lab ever since.

Most of us are neither very sensitive nor bold by nature, but rather, somewhere in between. We're most comfortable in homes and other places that provide a moderate level of sensory stimulation and balance our needs for privacy and sociability, familiarity and novelty. No matter what our basic temperamental inclinations—party animal or shy violet—and environmental prefer-

ences—Broadway's boogie-woogie or a Zendo's calm—when we ignore them, we make trouble for ourselves and others.

The popularity of the classic television show *The Odd Couple* attests to the widespread predicament of the sensitive nester and sanguine percher who try to make a home together. Bold Oscar and delicate Felix are poster boys for another great principle of environmental psychology: depending on our personalities, some of us *adapt* to our environments by changing our response to them, while others *adjust* the setting itself. Confronted with the same cue—say, a living room rug covered with crumbs—an adapter like Oscar flops on the couch to read the newspaper and add more debris. An adjuster like Felix runs for the vacuum cleaner. Considering how common the odd-couple syndrome is—"He doesn't even *see* the dirty dishes!"—behavioral science has paid little attention to it per se. However, personality research makes clear that different individuals seated in the same living room really can experience different worlds, and that the best approach to such environmental conflicts combines communication and compromise.

Your living room is a personal expression, but it also reflects the larger culture. At the most basic level, this space illustrates the human tendency to set aside a room "for good" in any home of at least two. In early American houses, the "best room" was often the parental bedroom and was also used for many ceremonies, such as marriages and funerals, for entertaining important visitors, and for storing prized possessions. This special room's special contents, from a watercolor bought on a honeymoon to the bronzed baby shoes to great-granny's porcelain vase, are especially likely to trigger our powerful emotional states and memories. Psychologist Mihaly Csikszentmihalyi regards these artworks, photographs, heirlooms, and other special possessions not as mere *stuff*, but as icons of our identity. Indeed, he describes the home as a "storehouse for the objects that have shaped one's personality and which are needed to express concretely the affective self one values." Just as we choose

flattering photographs of ourselves and discard the lemons, he says, we edit our possessions, giving prominence to those that evoke the "good self" and that "tell us things about ourselves that we need to hear in order to keep our selves from falling apart."

The formal living room as we know it descended from the upper-class drawing room: the refuge to which English ladies withdrew from the masculine prospect of the medieval hall—a big, drafty, smoky chamber evocative of Beowulf. By the eighteenth century, as women's status increased and the new leisure class expanded, the old halls and reception rooms of bygone days seemed too large, formal, and macho for new pastimes like tea parties and playing cards. These congenial pursuits soon migrated to the ladies' smaller, daintier drawing room, where men were welcome but women were in charge. Moreover, they designed their space with feminine elegance and comfort in mind. The room's lightweight, portable furniture could be arranged for easy conversation, and its chairs and couches were upholstered to allow for prolonged periods of sitting.

The feminine drawing room and its intimate style of socializing created the field of interior decoration, which, along with the term *living room*, came into its own in the nineteenth century. Then as now, large homes might have two parlors—one a casual family room and another for important visitors and formal occasions. (Despite women's improving status, anxiety about the connection between their behavior and their homes' decor lingered. In "The Yellow Wallpaper," published in 1899, the feminist writer Charlotte Perkins Gilman tells the story of a woman suffering from what we recognize as postpartum depression, who is sent for a rest cure to a relative's country house; isolated and confined to a bedroom covered in a particularly florid wallpaper, she goes mad.) By the early twentieth century, Elsie de Wolfe, America's first woman interior designer to the elite, combined simple, comfortable chairs and couches with artworks, antiques, and imported pieces to create the classic American living room that's still very much in evidence.

By the mid-twentieth century, the living room began to drop its traditional walls and ways and turn into the opened-up living-dining area. From modernist homes designed by haute architects and industrial lofts renovated by beatniks and artists, this laid-back, flexible living space soon found its way into new suburban houses and urban apartments alike. The stuffy parlor of olden days told its occupants that they had better conform to their formal surroundings. The free-flowing modern living area urged everyone to, as a '60s expression put it, "do your own thing." In the early twenty-first century, some new homes still have smaller traditional living rooms, but others have only a loftlike multipurpose great room.

From a behavioral perspective, the eclectic postmodern decor of the living room or area is especially interesting. Not so long ago, after all, Americans took pride in having a suite of matching couch and chairs much like the neighbors'. In our I-gotta-be-me era, however, the worst decorating sin is following the crowd. This mix-instead-of-match approach seems new, but like most trends, it filtered down into the mainstream from the homes of the avant garde. When most people sought the foolproof respectability of a suite from Sears Roebuck or Ethan Allen, the American designers Charles and Ray Eames combined industrial, folk, and fine-art furnishings in their home. The stolid "matchy-matchy" look remains popular in business settings, but no longer in living rooms with any aspirations to chic.

The idiosyncratic dwellings in Chris Smith's documentary film *Home Movie* might appall designers, but these "outsider houses" are the ultimate in personalized environments. There's an all-electronic home, in which even the most mundane objects have a life of their own; a missile silo turned into new age digs; a tree house in a Hawaiian rain forest; a bayou houseboat complete with alligator neighbors, and a home turned into a paradise for cats. Some of the movie's exhilarating effect derives from the outsiders' utter disregard for playing by the rules laid down by professionals, who often stress a certain look over easy living and allow for less privacy, coziness, and junk than most people like.

Our eclectic living rooms also reflect important economic changes, especially the expansion of global trade and improved techniques of mass production. Instead of having a few sofas, lamps, or doorknobs to choose from, we can now browse through a multitude of hip shops, catalogs, and Web sites that offer hundreds of products from all over the world. More tasteful goods at cheaper prices have helped turn decorating into an amateur's art form, which is increasingly hyped by media that, like *Elle Décor* and many other magazines, connect personal style in fashion and the home.

Americans' increasingly adventurous decor not only bespeaks a new confidence about expressing individuality but also an increased awareness of design's behavioral considerations first. An advertising booklet for Ikea, the Swedish firm that produces trendy furniture for the masses, asks, "Can you shop for a better life?" The text goes on to describe furniture as if it were a lover: "Do you spend quality time together? Is its presence soothing or intrusive? Are your silences comfortable or awkward? Does it match your personality?" Even "Have you ever been turned off by its smell?" If you answer yes, says Ikea, you may have to "break up" with that old furniture you've kept out of guilt, fear, or "misguided loyalty," because its "creeping tendrils won't let go until you do." As if talking about unsavory lovers or roommates instead of couches and chairs, the ad urges you to "see them off when they no longer enrich your life."

At the other end of the spectrum from Ikea, top interior designers at New York City's 2002 Home Design Show urge their audiences to throw away the rule book and decorate from the gut. Stressing his own lack of formal training, Vincente Wolf says, "My greatest education has been going to museums. Afterwards, I always ask myself which piece I'd take home and why." Not surprisingly, Wolf and the other designers show many slides of living rooms. Clicking to a soothing, elegantly pale version that he designed for a house in Taos, New Mexico, Wolf comments, "I said no to the usual Indian or Ralph Lauren southwestern thing. I got

these colors by taking some baggies out into the desert around the house and picking up different soil samples." In short, he advises, "Don't just look at some decorating magazine. Look around you and see what appeals, what's important to *you*."

The living room's lighting might strike many of us as a matter of a few lamps and a central overhead fixture, but the Irish interior designer known only as Clodagh tells the audience never to follow a formula, her own included. "Go out and buy a work light on a big orange extension cord like builders use," she says in her lilting brogue. "Then get some different kinds of lightbulbs and experiment in your house. You can have the most beautiful room in the world, but if the lighting is no good, it's a dead duck. Light means life." Lest anyone still be thinking about matching lamps on end tables flanking the couch, Clodagh produces some mind-expanding slides. One shows a ceiling that has been screened over by loosely spaced wooden slats, so that the light filters down into the room through the cracks, casting a mysterious glow. Urging listeners to shed their inhibitions, she says, "Don't be embarrassed! In every room, ask yourself, 'How am I going to light what I do in *my* life?'"

Giving short shrift to the lighting can prevent you from making the most of the living room's behavioral potential. Of all the home's spaces, you're likeliest to read there, for example, yet you may sacrifice the right kind of chair and lighting because of style. Then too, you might stick a sixty- or seventy-five-watt bulb in every lamp, even though research shows that intimacy is fostered by a soft glow, and the performance of precise tasks, such as needlework, by bright light.

If the postmodern living room is eclectic and personalized, it's also multicultural. Back from India in time for the Home Design Show, the interior designer Sherri Donghia is dressed in a richly embroidered coat and piles of old ethnic jewelry. She shows slides of living rooms that combine antique and handmade furnishings, fabrics from China, Japan, Venice, and Turkey, and modernist pieces to produce what she terms opulent minimalism. As she tells her listeners, the goal of decor has become what the Japanese call

wabi sabi, variously translated as the "perfect imperfection" or "never the same" quality that certain old things have. Just returned from the Himalayas, Stephanie Odegard explains her approach to rug making and describes her profitable business almost as if it were an NGO. Each of her handsome carpets, which are woven by hand in Nepal, bears the Rugmark label, which certifies that no child labor was involved in its production, and the company is committed to the welfare of its workers and the environment. As she says, "It's all about sustainable, natural, one-of-a-kind."

The living rooms furnished by Donghia and Wolf—and Pottery Barn and Crate & Barrel—are the decorative equivalent of fusion cuisine or world music. In an age of dual-income households and cheap flights, Americans travel as never before, so that even a trip to Thailand or Kenya barely rates a raised eyebrow. Then too, since the immigration reforms of the 1960s, America has become a much more pluralistic society. The 2000 census shows that one of nine residents is foreign-born. Between 1980 and 2000, for example, the Chinese-American population tripled, which among other things popularized feng shui. These big social changes also make decor that sticks to one period or cultural style seem provincial.

Whether one's taste runs to Early American or *wabi sabi*, creating a pleasant living room is worth the trouble. Research shows that we feel more comfortable in a decorated room than in a bare one, for example, and that the good mood induced by being in a pleasant setting increases the odds that we'll perform helpful deeds. Even in a hospital, patients in a newly refurbished ward are more sociable than others.

Perhaps the simplest and cheapest way to improve a dreary room is to repaint it. We link certain shades with perceptions of temperature, so that an amber living room feels warm and one done in blues and greens cool. A shade that researchers call by the pedestrian name "Baker-Miller pink" has a soothing effect—at least on the submariners and prisoners on whom it has been tested—but hard facts about color's effects on behavior are surprisingly few. That it could influence us seems reasonable; after all,

we turn green with envy, white with fear, red with shame, blue with sadness, and black with rage. Because it can be quantified and because our eyes respond physiologically to different shades, color even lends itself to study. So far, however, scientific research has yielded only modest results, such as confirming every decorator's maxim that if you paint a room in a light color, it will feel more spacious than it would if painted in a dark hue.

Perhaps the classic proof that nice places like living rooms help us to be nice comes from an experiment conducted back in 1956 by the psychologist Abraham Maslow, who studied mental health instead of illness and coined the happy term *peak experience*. First, he stationed volunteers in one of three very different settings; then he asked for their impressions of photographic portraits. Subjects who examined the photos in a pleasant, well-appointed room rated the portraits most benignly. Those who were put in a utilitarian office were less kind, and those stationed in a janitor's closet gave the harshest evaluations. Considering the importance of how we see the people who share or visit our homes, it seems wise to frame them in attractive living rooms.

Much as psychoanalysts undergo analysis themselves so they won't unconsciously replay their own pasts with their clients, we can benefit from considering how our earlier homes illuminate—or haunt—our present ones. From this perspective, we found that our living room already contained a surprising number of things from our pasts that express who we are and what we care about. There's my grandfather's coffee table, a Navaho blanket and pots from trips to Mike's family in Santa Fe, my Russian icon, the fat photo album. Such possessions just needed to be rearranged and given more prominence to make the room feel especially ours. When we finally recovered the four Morris chairs, picked up at yard sales for prices ranging from five dollars to thirty dollars, and drew them up to the coffee table, they formed an aedicula.

On a more pragmatic level, we made some small but significant changes that encourage us to spend more time in the living room, rather than "saving it" for special occasions. Mike got a hassock, which means he can put his feet up after a hard day without going to bed. Two big throw pillows and a brighter lightbulb turned one end of the couch into a great place for me to read.

We usually show our guests into the living room, but an increasing number of Americans invite friends right into the kitchen. This behavior would have seemed preposterous in the middle- and upper-class homes of yore. On the other hand, it's not your grandmother's, or even mother's, kitchen anymore. In fact, this room has expanded and improved in tandem with women's lives. As long as they had few rights, the kitchen was a nasty, inefficient, dangerous place of endless drudgery. Today, many women doctors and teachers, lawyers and entrepreneurs have big, lavish kitchens that they're too busy to frequent.

The Kitchen

Woman's Work
Is Never Done?

With its rumbling truck traffic and industrial ambience, the town of Quincy, Massachusetts, seems an unlikely place for not just one but two presidential birthplaces. In 1735, Susannah Adams, the wife of Deacon John Adams, a religious, civic-minded farmer and shoemaker, gave birth to their son John in a two-story saltbox, or a four-room farmhouse shaped like the slant-lidded containers that stored salt. In 1764, after graduating from Harvard and "gallanting" various ladies, the young lawyer John married the twenty-year-old, self-educated Abigail Smith. He brought his bride to a "stone color" saltbox just seventy-five feet from his own birthplace, where he launched his law career, helped draft Massachusetts's constitution, which greatly influenced America's, and fathered his children, including John Quincy Adams, the sixth president.

Abigail's kitchen—a re-creation, as the need to modernize makes finding a very old authentic kitchen nearly impossible—suggests something of the daily life of the remarkable woman who called herself a "domestic patriot." (When she and little John Quincy saw the smoke from the nearby battle of Bunker Hill, she declared it a "momentous day in history.") While John was gone during the Revolutionary War, Abigail not only conducted the sparkling correspondence with her husband for which she's celebrated, but also ran the farm, educated her children, spun wool, and even sold the butter she churned in her kitchen.

The colonial kitchen was hardly high-tech, but like eighteenth-century women's lives, it was an improvement on medieval days, when cooking was done in a chimney-less central hearth. By the sixteenth century, British artisans rediscovered the ancient Romans' use of brick to make chimneys and fireplaces. This big advance freed the home from much smoke and smut and also allowed for a second floor, which made the house more compact.

Abigail's kitchen was fashioned from an earlier "summer kitchen," which had a separate chimney that permitted cooking in hot weather without heating up the whole house. She fed up to twenty people per day during the war, many of them at a dining table made from a single wide plank, or "board," as in the expression "bed and board." (The fellow who sat at its head eventually became the "chairman of the board.") Her walk-in fireplace has an oven niche for baking, iron hooks for suspending soups and stews, spits for roasting meat, a rack for toasting bread, and even a reflector oven. Abigail's long hours in the kitchen must have been cheered by her precious blue and white china, sent by John from The Hague, which she displayed in an open cupboard. Fine dishes notwithstanding, her kitchen, like her legal rights and social standing as a female, left a lot to be desired.

Throughout history, the kitchen's status has closely paralleled women's. Until relatively recently, even women the likes of Abigail had no official public voice or vote, and the kitchens in which they

labored were inefficient, dirty, and unsafe. Abigail's walk-in fireplace charms the modern eye, but for many colonial women, these quaint hearths were literally death traps. Their long skirts and petticoats could easily brush the embers as they checked on the bread or stirred the stew, and burns ranked second to childbirth as the leading cause of women's deaths.

By the mid-nineteenth century, American women's lives, homes, and kitchens began to change for the better. Sarah Josepha Hale, one of the era's several proto–Martha Stewarts and the publisher of *Godey's Lady's Book*, even made Thanksgiving a national holiday oriented around the bounty that women provided from their kitchens—new recognition for their mostly thankless tasks. The main impetus for this improvement, as for so many of the era's changes, was the accelerating industrial revolution. The mass production of cast-iron wood-burning stoves for cooking and heating and insulated iceboxes that preserved blocks of ice cut from lakes, along with formerly homemade goods such as bread, soap, cloth, and candles, improved the kitchen and relieved women of much labor. New kinds of jobs drew huge numbers of people from farms to the cities. There, many men spent the day in factories, offices, and shops, literally and figuratively distanced from domestic life. Finally home alone with some time on their hands, middle-class women observed the wonders of technology and industrial efficiency and decided that like the new male workplace, the traditional female domestic one must also be modernized.

We may assume that women have always been in charge of the home if nothing else, but for most of history, men controlled that, too. (Indeed, both Washington and Jefferson took the keenest interest in furnishings and decor.) By the mid-nineteenth century, however, housewives as plucky as Abigail Adams had been were no longer willing to do all of the work in the home without a voice in its planning. They might not have a say in public affairs, but they at least wanted some power under their own roofs. Their successors in the next generation would profoundly change women's lives with the

revolutionary house thinking of new "domestic science" and particularly its kitchen, which was designed with women's safety, productivity, and well-being in mind.

For most of history, the kitchen illustrated George Bernard Shaw's remark that "home is the girl's prison and the woman's workhouse." Its improvement changed women's lives both inside and outside the domestic milieu—a heroic task that was greatly advanced by home economics. Most contemporary Americans have only a vague notion of what this movement was really about. Women who took home ec classes in high school might recall sewing an apron, perhaps, or making a meatloaf, while the boys were building a birdhouse or bookshelf in "shop." Some might also remember the scorn later heaped on home ec by modern feminists who accused it of keeping women busy with trivial pursuits. In fact, new insights into women's history portray home economics as an important step in bettering the lives of women and families, popularizing scientific breakthroughs, improving health, and propelling women into higher education and the public sphere

The home-ec movement was rooted in land-grant colleges that, like Cornell University, had strong links to farm communities. In 1990, the Cornell historian Joan Jacobs Brumberg, who studies women, children, and family life, which she describes as "what's going on in all those houses," organized a big home economics conference at the university. Setting the stage for the movement, she stresses the role of earlier female reformers whose writings appeared just as books, thanks to the industrial revolution, became plentiful and cheap. In *A Treatise on Domestic Economy*, Catharine Beecher, a suffragist and advocate for female education who was Harriet Beecher Stowe's sister, boldly asserted that women needed efficient homes so that they would have more time for ... themselves! In 1869, Catharine and Harriet expanded on their modern ideas in their best-selling book *The American Woman's Home*, which advanced inventive floor plans for houses that had plumbed kitchens and baths, central heat, and lots of the new built-in closets.

Female reformers such as the Beechers were powerful public figures in newly industrial America, but they were not feminists in the modern sense. Indeed, they preached that women's place was in the home. Along with codifying the rules of efficient household management, however, these pioneers made two radical social assertions that would dignify and transform women's lives as well as their kitchens.

Like the male workplace, the Beechers said, the female domestic one must be modernized and respected. If men wanted the home to be a serene refuge from the industrial world, women could at least have clean water and a window over the kitchen sink. Moreover, they asserted, far from being mere bed and board, the home was America's *spiritual center.* Thus, the women who cared for it were not drudges but priestesses. "Catharine Beecher was a major nineteenth-century figure whose enormous name recognition was all about women embracing domesticity as the symbol of their cultural power," says Brumberg. "She locks it in. Women's power is in the home, and they are the spiritual and moral counselors to the nation. That's a big claim."

The domestic science movement that followed the Beechers' crusade really caught on around the turn of the twentieth century, as agrarian America struggled with the consequences of urbanization and industrialization. City homes increasingly had municipal water supply, central heat and lighting, indoor plumbing, and gas stoves, as well as electrically powered refrigerators, vacuum cleaners, fans, and other mechanical helpers. These comforts and conveniences helped to advance the home economists' goal of making housework, and women's lives, as easy, even pleasant, as possible.

In country communities, however, the home remained in the Dark Ages—especially the archaic kitchen, which was a rambling, inefficient, unplumbed room equipped with odd pieces of furniture stuck in inconvenient locations. Not surprisingly, young rural women stampeded to the cities. In response, in 1901, Martha Van Rensselaer, a country teacher whose mother was a suffragist, developed a reading course for farm wives under the auspices of Cornell's

agriculture school. Tellingly called *Saving Steps*, the pamphlets advanced ideas from the larger social, technological, and medical worlds as the means to ease rural women's backbreaking labor. As Brumberg says, "*Saving Steps* tried to make the farm woman's work more rational, systematic, and modern, so she didn't give out by the age of forty. It was an immediate hit."

For women urban and rural, rich and poor, home economics became the intersection of science and the home in general and the kitchen in particular. Whether carefully measuring how many steps a chore required or preaching cleanliness to kill germs, says Brumberg, "the home economists see themselves very consciously as doing domestic *science*." Just as the Beechers had underscored the homemaker's spiritual importance, the home economists stressed her intellectual capacity to absorb the latest research findings and put them into practice in daily life.

As the new "efficiency experts" analyzed how factory workers could do their jobs more productively, home economists studied housework with the same objective. As a result, the design of the home, especially the kitchen, began to change. This modernized house was more compact than the sprawling Victorians and Colonials that preceded it and included features such as built-in furniture, adequate storage, and well-organized bathrooms—sometimes even a prototypical powder room. Partly because the gas and electric stoves that replaced the messier wood- and coal-burning models were smaller and better insulated, the kitchen could shrink and become more tightly organized, which by "saving steps" reduced the time and effort required by its endless chores. Many of the home economists' ideas about the ideal sizes and placement of its cabinets, counters, and appliances remain the standard.

Domestic science helped modernize not only American homes and kitchens but also women's lives—not just homemakers'. The new field produced a wave of female professionals who leveraged their college educations in home ec into careers in the larger worlds of the academy, government, and industries from hospitals to restaurants. By 1907, when few women received higher educa-

tion, much less at a coed university, Van Rensselaer established a full-fledged department of home economics at Cornell, which she administered with the nutritionist Julia Rose (who was also her lifelong companion). As Jean Robinson, an emeritus economics professor at Cornell, points out, their rural students didn't want to return to the farm, "but to become something else—a teacher or a dietician. And their professors here were very well educated. It was women teaching women, like at Vassar or Wellesley."

Something of the mettle of these pioneering professional women and of the support they got from the home economics movement comes across in the fragile personnel records, first handwritten, then typewritten, of Cornell's Helen Binkert Young (1877-1959). After studying architecture at the university around the turn of the century, which was a tremendous achievement in itself, Young went on to win an architectural prize—and to write *The Lincoln Hall Cookbook.* In 1910, however, she was unable to support herself in an overwhelmingly male profession and joined Cornell's department of home economics. In her courses on "household arts," she taught students how to apply architectural principles to planning and furnishing the home, and thus influenced the era's interior design.

Just as it had responded to the need to make the kitchen more efficient and hygienic earlier in the twentieth century, home ec reacted to the Depression and World War II by ensuring that it produced more nutritious meals. Americans were very concerned about rationing and managing with less, so the Cornell department responded with popular "enriched" recipes, such as a bread that used high-protein soy flour. This effort was championed by Eleanor Roosevelt, who had often visited her Cornell friends Van Rensselaer and Rose when Franklin was governor of New York; she even persuaded him to fund the home ec department's handsome building. Eleanor did radio commercials to promote products such as Milkorno—a combination of grain and powdered milk that was distributed to impoverished Americans. In her patrician tones, she would say, "It's lip-smacking good!"

Toward midcentury, technology, education, and prosperity had steadily upgraded the physical environment of home and kitchen, so Cornell's home ec department, along with millions of American women bent over their copies of behavior-minded Dr. Spock's child-rearing manual, began to examine domestic life from a more social and psychological perspective. (In its popular marriage course, an instructor known for her enthusiasm for "companionate marriage" got into hot water for telling freshmen that the campus didn't offer enough "dark places for quiet talking.") Coeds studying home management could spend a half-semester living and learning about family life in Cornell's "practice house," which they had to run on a very tight budget. To get hands-on experience in nurturing and child development, the young women even raised "practice babies," some of whom were orphans. After an average stay of three months, the orphaned infants, having had the best medical and scientific care, were eagerly sought by adoptive parents into the 1950s.

A hundred years after its birth, the movement that changed women's lives, starting with their kitchens, has evolved into the "consumer science" that we take for granted. Cornell's home ec department became the College of Human Ecology, whose students major in fields from nutrition to child development to interior design. (The Statler Hotel on Cornell's campus, run by students in the university's hotel management program, still serves some dishes invented here during home ec's heyday.) A few high schools still offer courses like Health, Marriage, and Careers, but most of our information on domestic science, from product safety to coping strategies for teething, now comes from the media: magazines, TV shows, advertising, cookbooks, and child-rearing, consumer, gardening, fix-it, and housecleaning manuals.

Most important, the basic principles of domestic science have been institutionalized in America's houses and apartments, especially its kitchens. "Home ec is in our safe, efficient, hygienic homes," says Brumberg, "It's in washing our hands after using the toilet, theories about raising our kids, defrosting the chicken in the

fridge—all sorts of ideas that had an enormous impact on public health in the twentieth century. Home ec's legacy is all that scientific information that we women bring to caring for our families."

Around the turn of the century, the tandem transformations of women's lives and kitchens were also accelerated by seismic socioeconomic shifts that forced the bourgeois home to become more efficient and user-friendly. Stressing the differences in the home lives of different classes, the architectural historian Elizabeth Cromley points out that at the time, much of the urban working class lived in tenement apartments of two to four rooms, in which the living room lived up to the term by continuing the old blue-collar tradition of cooking, eating, socializing, and sometimes even sleeping in a single space. At the other end of the spectrum, the mistress of the spacious upper-class home spent very little time in her kitchen, which was far from the living area and further insulated by secondary rooms such as pantries that buffered "upstairs" from "downstairs." As long as only poor women and servants spent much time at the sink and stove, the kitchen had a low status

Between the tenement and mansion, however, lay the burgeoning middle class's middle-sized home, which suddenly faced a crisis. Many women once destined for domestic service now took better jobs in the new factories, especially in the textile and garment industries. The rich could afford to pay their staffs competitive wages, but the vast majority of American homes were suddenly without the cheap help long taken for granted. Faced with doing their own housework, middle-class women needed a compact, well-designed house with a tight, efficient kitchen.

Bourgeois women's hands-on experience of the kitchen helped to upgrade its image. One sign of this improvement, says Cromley, was that appliances initially associated with the once-lowly room, such as electric fans, began to appear in other places in the house. Nevertheless, good manners of the time still demanded that the kitchen, with its unseemly sights and odors, be insulated from the

home's living areas. Thus, the isolated housewife was left alone in the back of her house or apartment to produce meals as if by magic.

Anyone aware of Betty Friedan's *The Feminine Mystique*, published in 1963, and the feminist revolution that ensued knows that even for educated women in most of the twentieth century, there was a lag between improvements in the home and women's opportunities beyond it. Efficient, modern homes and kitchens spared women much of their mothers' and grandmothers' drudgery and gave them more time for themselves and their families and friends. However, they were still largely limited to the role that Charles Dickens described as "ministering angels of domestic bliss." Moreover, America's growing prosperity filled the home with more and more stuff, from clothing to "labor-saving" machines such as waffle irons, that had to be tended to by women who were told that a ring around the collar or the bathtub was a moral failing. Notwithstanding the gap between the modernization of the home and women's lives outside it, even the sitcoms of the 1950s, such as *Ozzie and Harriet* and *I Love Lucy*, show that like their kitchens, women were assuming a higher profile. Lucy and Harriet were not "career gals," but they had minds of their own and spoke them. As women grew less willing to stay in the rear of their homes, the kitchen's boundaries grew more permeable—Frank Lloyd Wright had even used glass shelves for its walls—until the room started to feel more like the home's engine than its caboose.

The evolution of the new superkitchen that's now the core of many homes began in midcentury suburbia, when the dining room became endangered by the new child-centered lifestyle occasioned by the postwar baby boom. Preparing, serving, and cleaning up after family meals was more convenient in an "eat-in" kitchen. By the 1970s, just a serving island often separated the kitchen from what had become the dining "area." Twenty years later, in many new homes, the kitchen and living and dining rooms were merging into the great room.

Designers are usually credited with opening up the kitchen to

the home's living area, so Cromley was surprised to discover that the change wasn't caused by "architects figuring out how to make space 'flow,' but midcentury women saying, 'Get that wall out of here! I have to see my family while I'm cooking.' " Musing about this last generation of stay-at-home mothers, she speculates that their indulgent brand of domesticity helps explain their baby-boomer offsprings' desire to put a big, cozy kitchen at the center of their homes. "The comfort kitchen—a place where Mommy will be waiting with milk and cookies," she says. "Maybe that idea lasted."

The home and its "ministering angel" have come a long way from the days when the kitchen and its mistress were veiled from sight. A few statistics tell the story. U.S. Department of Labor figures show almost 80 percent of women work outside the home, compared to 85 percent of men. Women now earn more than half of all bachelor of arts diplomas and nearly half of doctorates and law and medical degrees, and they have the paychecks to prove it. It's no coincidence that in 2002, according to the National Association of Homebuilders, Americans spent $6.6 billion on renovating their kitchens, at an average cost of $43,800.

Just as women emerged from the home to compete in the larger world, the kitchen emerged from its lowly position the back of the house into the domestic spotlight. Suggesting the magnitude of the change, Cromley says that "there's even an idea that when guests come over for dinner, they might participate in making the meal. The kitchen has become a theater, and cooking a performance."

The costly new superkitchen is offered as prime evidence of our supposed obsession with the home, but as this ambivalent word suggests, postmodern domesticity is a complex matter. For one thing, says Joan Brumberg, Americans have always been very interested in their homes, which after all have long been most people's greatest possessions. What *is* new is that we're more materialistic about domesticity—certainly compared to Catharine Beecher, who portrayed the home's importance as largely spiritual. Even the later domestic scientists' focus on how to make the home work more ef-

ficiently was "a different thing than worrying about the thread count of a sheet," she says. "What has changed is that today the home has a larger commercial significance, in terms of all of its accoutrements."

It's hard to disagree that we're more materialistic regarding the home, considering the explosive growth of businesses, from Home Depot to Bed, Bath & Beyond, that provide us with those accoutrements. From a behavioral perspective, however, this spending spree is more complicated than it first seems—part prosperous exuberance but also part postmodern angst. If a professional-quality kitchen or wine cellar is required to keep up with the Joneses, maintaining the consumer culture's escalating standard for the good life and its must-have possessions can increase our anxiety along with our social standing. As Brumberg says, "Our homes are increasingly not about shelter, but all kinds of lifestyle issues, especially status and success."

Just as a hundred-thousand-dollar kitchen can raise expectations about our social standing, it can up the ante on our culinary skills. Many domestic goods and services, from pasta makers to gardeners, imply that our homes should compete with four-star hotels and restaurants. Far from adding to our leisure time, "labor-saving" bread mixers and floor waxers can devour it. Even the effort to hire, manage, and pay an array of working-class people to care for their complicated homes and properties adds to busy professionals' stress.

Along with status, the megakitchen that's all ready for its close-up but is empty most of the time and largely used for microwaving frozen meals by people on different schedules raises other concerns. Some guilt-ridden dual-career couples lavish their children with luxuries rather than time, and something similar seems to be going on with houses and apartments. A little "retail therapy" at Williams-Sonoma or Linens 'n Things may temporarily assuage their anxiety and burnout. Especially in two-income households, says Brumberg, "less time in it, more money on it."

Despite our increasingly lavish kitchens and array of foods— grocery-industry figures show that stores that sold an average of

7,000 products in 1969 offered 50,000 in 2004—Americans actually cook less and less. On average, we make only about a third of our dinner entrees, including sandwiches, from scratch. One in four of the meals we eat at home is frozen or pre-prepared; sales of hot foods made by supermarkets are up 40 percent since 1997. The typical American ordered 118 take-out meals in 2002, which is a 64 percent increase from 1984. If Abigail Adams's family life centered around her open hearth, ours seems oriented to the microwave.

In an era when "So much to do, so little time!" seems like a national mantra for children as well as working adults, in many homes food is more often heated up than cooked, and the dinner hour that was the traditional core of family life is a sometimes thing. The "meal" may start early when small children are fed by a babysitter, segue into the return of ravenous older kids from music lessons and soccer games, and wind up with late-arriving commuter parents. Not only do these family members eat at different times, but they often eat different things. As Cornell's Jean Robinson points out, somewhere along the line, "we lost the concern about family time, relaxation, reading. It bothers me that families don't have time to sit down to a meal together. We want too much! Life is not just about *things*. We work too hard to get the kitchen we don't have time to cook in."

Time pressures are especially acute for the increasing number of single working parents. The psychologist Roger Barker's research on so-called staffing has a special relevance for this overburdened group. To maintain business as usual in a particular environment, he found, the people who regularly use it will assume more or fewer roles as needed. Many hands make light work. But when a setting is understaffed, each person takes on too many roles to do anything really well. Worse, because these extra exertions don't bring more rewards, but more failures, the stressed-out person experiences guilt and self-doubt, and possibly over time the "learned helplessness" that invites depression.

Even in two-partner homes, despite their professional gains, women are still likelier than men to be doing the cooking—or re-

heating—and other chores. A U.S. Department of Labor survey of 21,000 people conducted in 2004 showed that about two-thirds of working women cook or wash dishes daily, compared to about a third of working men. More than half of those women also did other household work, such as cleaning, compared to 20 percent of men. Not surprisingly, women who spent more time on domestic chores and child care spent less on their professional work and leisure activities.

Of the many explanations of the gender gap in doing household chores, some focus on nature: men evolved to be better suited to hunt, build, and protect, women to care for the young, garden, and cook. Others stress nurture, particularly the fact that men have not been taught to do their fair share. For whatever reasons, research shows that most men feel less responsibility for homemaking than most women do.

Much has been made of the fact that since most women have taken jobs outside the home, men do more cooking. In response to this behavioral change, increasing numbers of houses and apartments have "gender-neutral" kitchens, in which two workstations and sinks allow collaboration on producing a meal. However, in the 1980s, when dual-career couples and upscale "foodies" emerged in force, only about 15 percent of men cooked, and according to the federal study, their number rose to just 20 percent by 2004.

The modest increase in male interest in culinary matters reflects not only more egalitarianism, but trends such as the increased status of fine food and wine, the celebrity of certain chefs, and rampant consumerism. Aggressive marketing aimed at the male gearhead's love of gadgets has sold many men on the latest espresso machine, omelet pan, or backyard smoker, which don't contribute much to the grind of producing day-in, day-out meals. On the other hand, some men would spend more time in the kitchen if women didn't subtly or overtly discourage them. "I'd be rich," says Brumberg, "if I had a dollar for every woman who said to me, 'You like to be home with your husband? How do you share the space?'"

As a peek into the postmodern kitchen suggests, the sexes' different relationships to the home is a complex business. Research shows that women feel more burdened by the home than men, for example, but they also get more satisfaction from it and see it as more expressive of their identity. Even though women spend more time and energy on the home, they're also less emotionally dependent on it, both because they're likelier to have close friendships outside it and to see a dwelling in terms of work, not freedom.

Perhaps many women will always have complicated feelings about the kitchen. Having made it in a man's world, they feel liberated to indulge in traditional girly stuff, from sexy French lingerie to high-end French cookware. Whether for lack of time or interest, however, many career women spend little time in their souped-up kitchens, and when they do, they may be alone. Abigail Adams's and Catharine Beecher's contemporaries cooked in inefficient, even dangerous quarters, but the meals they made were the center of an orderly domestic universe, eaten with family and friends, and free of business calls and postprandial stints in the home office.

Their combination of bristling technological splendor and air of nostalgia gives some up-to-the-minute superkitchens an odd poignancy. In many, the centerpiece is the stove, which has been a domestic cult object since the nineteenth century, when the new and gorgeously decorated cast-iron wood-burning models appeared. Their successor is the new restaurant-calibre stove. Fred Carl, founder of the Viking company, which makes them for home use, finds that although his customers like his product's look and heft, few are serious cooks who actually need such size and power. Most are what he calls "look, don't cook" people—busy professionals who like to dream about the day when they'll finally be able to devote themselves to domesticity.

Where their kitchens and careers are concerned, American women have indeed come a long way since the days of *Saving Steps*, yet their homes still create as well as alleviate stress. Sobering statistics on divorce, domestic abuse, and other dysfunctional behav-

ior have made it plain that, as Brumberg says, "Home isn't neces-
sarily a 'haven in a heartless world' anymore." On the other hand,
the kitchen has become a spiritual center for a group of women
that Abigail Adams and Catharine Beecher could barely have
imagined. "If I've been on a business trip and eaten out for five
nights," says Brumberg, "I want to roast a chicken when I get
home. A lot of women professionals, and I'm one of them, now use
domesticity as a form of relaxation. The enormous growth of the
cookbook industry and the interest in comfort food are all about
this phenomenon." In short, she says, "It's still 'Home sweet home'
for a lot of people, but there are concerns."

In an intriguing new parallel between the histories of women and
the kitchen, just as the former now move freely in the larger world,
the latter increasingly moves about the home. Some of this migra-
tion is literal. In a seminar called The Kitchen: The New Living
Room, some top designers update a crowd of householders and
decorators about recent trends. Kitchenettes increasingly appear
in home offices, says Michael Love, and with its minifridge and cof-
feemaker, the master bedroom often resembles a hotel suite. The
architect Alexander Gorlin agrees that the kitchen is "explod-
ing—not just in size but in satellites throughout the home."

The exploding kitchen is a good example of what the environ-
mental psychologist Jamie Horwitz calls "distributed domesticity."
According to this theory, we now do many things elsewhere that
we used to do at home, from manicures to naps. Horwitz is partic-
ularly interested in the dimension of our far-flung daily lives that
she calls "the hookups between environmental design, individual
households, and what we eat."

The much-remarked fast-food phenomenon is the most obvious
example of distributed domesticity. Long before McDonald's and
Domino's got the idea, social reformers in the earlier twentieth
century recognized the appeal of reducing the enormous amount
of time and energy that go into producing three meals a day. They
came up with strategies such as neighborhood kitchens and com-

munal food services; some apartment buildings even offered cooperative dining and home delivery of meals cooked in a central kitchen. Such socialist-style experiments, however, foundered on the deep-rooted American ideals of individualism and the independent household, which even the home economists espoused.

When women began to spend more time in the workplace than the kitchen, something had to give, and America's eating habits—and waistlines—underwent a profound change. Working mothers found it difficult to churn out twenty-one family meals per week as their own stay-at-home mothers had done. Much of the production of affordable, convenient meals shifted to the now $500-billion-per-year food industry. That we currently eat a quarter of all meals in restaurants, and that even at home, two-thirds of them are take-out or preprepared foods, suggests the food industry's impact on our ever more "distributed" home life. We all know about KFC, but Horwitz points out the increase in developments such as corporate dining rooms that provide low-priced individual dinners that employees can order in the morning and carry home that night.

The food industry not only encourages us to eat more meals away from home but also puts more distance between us and our food. Globalization means that much of what we eat has traveled thousands of miles to our plates, but even the space between cooking and eating is being stretched. Just as we bring warm roasted chickens home from the supermarket, some big chains prepare their food at a central location, then send it out to what we think of as conventional restaurants but are really just tables and chairs. As Horwitz says, Taco Bell's K-minus restaurants are "minus the kitchen."

Considering the amount of time that many spend in Burger King and Chuck E. Cheese, distributed domesticity raises particular concerns regarding kids. At the very least, these restaurants have expanded the traditional concept of the child's "home range," which was once limited to yards, playgrounds, and other nearby environs. To explore children's new territory, Horwitz's students in the department of architecture at Iowa State University in Ames do some unconventional fieldwork. In one assignment they monitor how

much time parents really spend with their children when they visit restaurants that are equipped with play areas. Pointing out one behavior that differs from a traditional family dinner at home, Horwitz says, "I want the students to notice how the kids run to the table, take a bite, then run back to play."

As the restaurant-cum-playground illustrates, Americans are often drawn to such places for reasons other than a quick burger and fries. In a study of what home means for children whose divorced parents have joint custody, Horwitz found that fast-food restaurants were very popular "switch places," where one parent dropped off a child for the other to pick up. "The kids are happy to be there, and if there's a time lag, they've got the play area," she says. "For parents, McDonald's is convenient—right off the highway." It's for such complex, under-remarked reasons, she adds, that "the fast-food monoculture is transforming much of the American landscape."

Working women's busy lives and the distributed domesticity that supports them have helped to change not just where and what Americans eat, but also how. For example, dining is now more often the gustatory equivalent of what Harvard's Robert Putnam calls "bowling alone." For most of history and in most of the world still, mealtime has been a social activity. To illustrate how we're diverging from this tradition, Horwitz describes NASA's efforts to create a real home for the crew of the International Space Station. The agency consulted Raymond Loewy, a famous French interior designer, who decided that to feel homelike, the station needed three things: a porthole to the outside, a private place for sleep and personal time, and face-to-face dining. After the first generation of trips, however, the American astronauts refused to eat in the companionable manner. "They just hated it," says Horwitz. "The nutritionists explained that reaction by saying things like, 'Americans are really comfortable with eating on the go,' which is funny, considering where the astronauts were. The crew's Europeans would still prefer to eat face-to-face."

Like our astronauts in space, we in our homes are gravitating

toward eating alone and on the fly. What Horwitz calls an "encapsulated experience of eating" is a "massive phenomenon," she reports. The evidence lies not just in the plethora of take-out meals and single-serving items in grocery stores but also in the increasing number of our "strange, no-place places to eat": the stool by the kitchen counter that faces the wall, the table by the TV, the computer desk, the car (outfitted with increasingly elaborate cup holders and the like). Recently, when doing some research on nutritionists' own dining habits, Horwitz was struck by one doctor's assertion that to her, the most important part of the meal was no longer the protein or carbs per se but sitting down with her family and spending time together. "That eating's social aspect can become a nutritionist's priority is really powerful," says Horwitz. "Over time, I'd bet that that family will also be eating better-quality food than they would if dinner weren't cherished as a time together."

Like the lives of women and families, the kitchen has undergone tremendous changes since Abigail Adams's days. In one back-to-the-future respect, however, the new superkitchen resembles her old hearth-centered one. Some two hundred years later, the kitchen is once again often the home's busiest room, used not just for cooking—or microwaving—and eating but also for catching up on the day, paying the bills, and getting help with homework.

The interwoven histories of women and the kitchen give me a new appreciation of my small urban version. I had always thought of it as merely cramped, but in fact, the room is exactly the kind of tightly organized, efficient workspace that the home economists advocated. When the time came to renovate, instead of enlarging to get more work area—the costliest option—we recycled some friends' good-quality cabinets, which we installed in a lower and upper row along the entire length of the high-ceilinged room. Much of our clutter disappeared into the shelves overhead—space that had previously been mostly wasted. With nearly double the countertop area, Mike and I can now cook together in comfort, which is a big improvement in our daily life.

Like many older houses, ours has a dining room—the traditional kind that's left out of many new homes. As the environmental psychologist Amos Rapoport says, "What finally decides the form of the dwelling and molds the space and relationships is the vision the people have of the ideal life." For our family, that vision includes eating together complete with candles, most nights in the dining room, which has traditionally been a showcase for the special possessions that help establish our place in the world.

The Dining Room
Status and Stuff

Like many Americans before and since, the poet Henry Wadsworth Longfellow, author of "Hiawatha," a mid-nineteenth-century celebrity, and resident of Cambridge, Massachusetts, was proud of his fine dining room. Like many an eminent Victorian, he was an avid collector who enjoyed arranging his favorite things—in his case, about 25,000 of them. As his daughter Alice wrote, "Papa occupies most of his time in putting up bookcases and pictures, and then changing their places." For his dining room, Longfellow carefully chose possessions that portrayed his standing in the world: famous writer, Harvard scholar, art connoisseur, and member (through marriage) of a rich, distinguished family.

To present himself to others, Longfellow filled his dining room with fine furniture, a selection of his four thousand books, busts of

Euripides and Raphael, and in particular, fine paintings. Owners of family portraits often hang them in the dining room, and Longfellow's included two by Gilbert Stuart. His contemporaries would have been most captivated by the painting of his three little daughters, which was widely reproduced when his hugely popular poem "The Children's Hour" was published. Surrounded by special things skillfully edited to display his fame, erudition, wealth, and class, Longfellow wined and dined lots of guests, from his extended family to the scholarly members of the Dante Club on Wednesday nights.

The dining room à la Longfellow was a relatively recent domestic development. For much of history, simple people ate by the hearth and the wealthy in various parts of their large homes. The dining room as we know it came into its own in the eighteenth century with the growing leisure class, whose new padded chairs allowed them to eat and drink in more comfort and style, and at length. The dining room became more important and elaborate—and strongly associated with the ownership of fine things and the capacity to appreciate them.

As the bourgeoisie expanded in the nineteenth century, the dining room became an increasingly important stage on which the drama of class was played out. In the Victorian era, the fashionable rich stopped serving "family-style" meals at the table in favor of restaurant-style *service à la Russe*. Dinner became a marathon of perhaps ten courses, each of which was presented by servants and involved a new place setting; a single meal might require dozens of pieces of tableware per person. The Victorians attributed their embrace of *service à la Russe* to the new awareness of germs, but the real point was to establish who had the requisite wealth and etiquette to sustain the new style and who didn't. As the poet-playwright Noel Coward put it in his *Oprerette* of 1938, "The Stately homes of England/ How beautiful they stand/ To prove the upper classes/ Have still the upper hand."

Today when we ask ourselves, "What kind of people are we, and what kind of home do we want?" our different answers are often

reflected in our dining space. If we think of ourselves and homes along the lines of "practical, friendly, and casual," we may decide that it's silly to waste space on a dining room when most meals are eaten informally in kitchens and great rooms. If we see ourselves as the kind of people who do things the *right* way, we may prefer to eat in a handsome formal dining room gleaming with silver. Some of us may take most meals in the great room but keep a ceremonial dining room for special occasions. Even if it's only used for Thanksgiving, its table may be kept set year-round with the fine linens, silver, china, and crystal that have long been status symbols.

The idea that we may be judged by our dining room or even our wineglasses, or that we care about such judgments, is discomfiting. Yet at mealtime, most of us take some trouble—setting the table, pouring wine, making conversation, lighting candles—to remind ourselves and others that if we're not to the manor born, we weren't born in a barn, either. These efforts are warranted, according to research that shows that status is a serious matter that has profound effects on our well-being. Studies of primates reveal that a troupe's low-ranking monkeys are more prone to heart disease and high cholesterol. In his extensive analysis of the impact of status on health, the British epidemiologist Michael Marmot found that irrespective of income, education, and other factors, even seemingly small differences, such as living in a slightly "better" suburb, can add years to life expectancy. Similarly, Oscar winners live about four years longer than Oscar nominees. Marmot concluded, "Where you stand in the social hierarchy is intimately related to your chances of getting ill and your length of life."

Each year at the Winter Antiques Show, the upper strata of New York City's social hierarchy promenade through Park Avenue's vast Seventh Regiment Armory, examining some very high-status objects indeed. In 2002, as Upper East Side gents in blazers and bow ties usher ladies in fur coats and Belgian shoes among the glittering prizes, dealers wear their game faces, hoping that regardless of the current economy, people will continue to invest in precious

objects whose value has held up over time. Many of their wares, such as two tall Grecian urns that turn out to be wooden knife holders, are meant for the dining room. Some of the costliest, most admired pieces belong to the category that one little girl calls "old brown furniture": the glowing dining tables and fine cabinets that instantly proclaim wealth and social standing, epitomized by a $325,000 Queen Anne highboy made in eighteenth-century Boston.

The huge increase in wealth among the richest 5 percent of Americans means that more people than ever before can afford such furnishings. Yet research on happiness shows that these extraordinarily privileged folk typically derive little or no more satisfaction from their lives than members of households that get by on the nation's median annual income of $43,000.

The question of why more is not always more has provoked some interesting theories. According to sociology's concept of reference anxiety, we are content with our status as long as it's as good as the Joneses'. If our friends and neighbors acquire lavish new great rooms, however, our dining rooms may suddenly seem cramped and old-fashioned. Thus, no matter how much we have, we're always vulnerable to the feeling that it's not enough. Even if we buy that Queen Anne highboy, we can feel second-rate in a dining room full of Chippendale. The Princeton psychologist Daniel Kahneman thinks that our satisfaction is closely tied to whether our future looks rosier or not. Thus, even if we "have everything," we may be anxious about sustaining, much less increasing, our prosperity. His research also confirms that real happiness mostly doesn't depend on other usual suspects—money, beauty, youth, and so on—and suggests that instead it lies in having good daily experiences, such as meals and commutes, many of which involve the home.

The social critic George Will has observed that the American economy depends on "endless inculcation of envy," but even people who have the same amount of money and live in the same town can have different ideas about what's enviable. A famous study conducted at the University of British Columbia examined how homes

of Vancouver women with similar incomes reflected their class differences. Those who belonged to the city's old aristocracy stuck to their friends' and forefathers' tried-and-true decorating styles, while the more socially diverse strivers used their homes as vehicles for self-expression. The casual aristocrats might mix Sears and Sèvres, but the upwardly mobile meritocrats were more concerned about maintaining "good taste." Whether expressed in ancestral portraits or a Swedish modern table and chairs, however, it's a safe bet that their dining rooms and furnishings reflected the wish of the women in both groups to be seen as comme il faut by their peers.

We may sometimes be embarrassed by our zeal regarding our special possessions or see it as a sign of our base materialism, but the lofty philosopher William James insisted these valued things are nothing less than part of who we are. To the father of American psychology, the self is the "sum total of all that a man can call his"—not just his body and mind but also "his clothes, his house, his wife and children, ancestors and friends, his reputation and works, his lands and yacht and bank account. All these things give him the same emotions ... not necessarily in the same degree for each thing, but in much the same way for all."

An hour or so up the coast from James's Boston, in the seaport town of Gloucester, lies Beauport, the early twentieth-century summer home of Henry Davis Sleeper, an interior designer. His particularly vivid sense of self embraced the seemingly countless things, from rare antiques to colored glass bottles, displayed throughout the house's forty theme-based rooms, including the Norman Book Tower and the Chinese Trade Room (whose wallpaper, hand-painted in China and brought to America in the 1780s, was discovered in a local attic).

Not surprisingly, Beauport has five dining rooms, which were showcases for Sleeper's professional skills, beloved stuff, and eccentric self. With its fireplace, brick floor, array of pewter, and choice examples from his great collection of hooked rugs, the Green Dining

Room exhibits Sleeper's personal vision of America's pre-Revolutionary past. (He wrongly thought the room's apple green color was one of the era's authentic shades, but his fantasy of colonial decor caught on with the public and remains influential.) The Golden Step Dining Room highlights Sleeper's collections of green majolica pottery and white Wedgwood china, which complement the room's color scheme of white and "seafoam green"—another of the shades he popularized. The ordinary aquamarine glass fisherman's floats displayed among the valuable ceramic pieces testify to Sleeper's lighthearted conviction that a collection needn't be some rigid, scholarly affair but can be organized around a color, vision, feeling—or its owner's one-of-a-kind identity.

As an expert on the relationship between us and our stuff, Russell Belk, a globe-trotting professor of business at the University of Utah, would be in his element at Beauport. He's one of an increasing number of serious scholars who studies consumer, or material, culture. This new field is a response to two important social developments that profoundly affect our behavior and homes. As members of history's most affluent society, postmodern Americans simply have more money and leisure to spend on spending. And since mass production really surged in the 1920s, there have been increasingly more and more things to buy. That we shop for an average of six hours each week suggests that acquiring things isn't just a necessity but a popular pastime—even a hobby.

We stoutly maintain that we are the content of our characters, not our closets. Nevertheless, many years of conducting research convinced Belk that the bond between us and our things is both important and often misunderstood. In fact, he asserts that "we are what we have"—a startling statement that he calls "the most basic and powerful fact of consumer behavior." Like James, he describes an "extended self" that includes not just the persons and places but also the things that one is attached to and supported by. "Possessions are a major contributor to and reflection of our identities," he says. "'Mine' is 'me.'" Some see "having" as a trivial pursuit, but to Belk, along with being and doing, it's one of our three basic states

of existence. As he puts it, "Our accumulation of possessions provides a sense of the past and tells us who we were, where we have come from, and perhaps where we are going."

The philosophical argument that what we call ours is part of us is supported from various perspectives. Anthropology shows that we invest things with the self in many ways, including the creation, purchase, giving, and use and control of objects. The dead have been buried with special objects for 60,000 to 100,000 years. The last will and testament creates a sense of a self that lives on through our heirs and treasures, or even in our homes, like Elvis at Graceland. Our most important possession, the home has been linked to the person by rituals from burying foreskins or even shoes in its foundations to our own housewarmings and spring cleanings. Many cultures have personified the home as a body with a private interior and social exterior, complete with front and back, top and bottom, and clean and dirty parts, and vulnerable to attack, even rape.

Psychology offers evidence, much of it from the negative perspective, of the deep importance of our special stuff. Certain institutions, such as prisons, monasteries, and the military, deliberately use the surrender of possessions to conform the individual to a new group-oriented self. When our precious things are lost or damaged, our reactions range from nostalgia to grief not unlike that over the loss of a beloved person. One study of victims of a terrible flood showed that they were still acutely bereaved six weeks after losing their homes or special belongings. By losing parts of the self as well as control over their lives, they had undergone what James described as "the shrinkage of our personality, a partial conversion of ourselves to nothingness."

Because the home is such a critical part of the extended self, the former's increasing complexity has intriguing consequences for the latter. For most of history and in many places still, most people have lived in a room or two, affording them little privacy. Modern homes in the West, however, are divided into public parts that are meant to be seen by visitors, such as the dining room, and more se-

questered personal spaces, like the bedrooms. This level of spatial differentiation invites different public and private expressions of the self to manifest in a way that's difficult or impossible in many cultures. In America, this individualization is promoted by our increasingly larger homes and proliferating possessions. As Belk says, "There used to be a family radio, car, phone, and television, but now each person in a household might have his or her own."

Whenever we travel, we run a telling experiment on the relationship between our identity and our possessions. In the comedian George Carlin's album *A Place for My Stuff*, a tourist goes to Hawaii with a big suitcase that's what Belk calls a "minirepresentation of his home." When someone invites him to Maui for the weekend, the traveler packs a smaller bag that's an even more condensed representation of who he is. Whenever we're on the move, says Belk, we, too, can "look at what happens when we don't have that support system for the self."

Our special things play an important role in our house thinking, particularly for those of us who are collectors. Two out of three of us are content just to buy things, but the other third, like Longfellow or Henry Sleeper, collect. Their identities are bound up in their treasures, and their homes become museums of a sort. The storehouse of Historic New England, formerly the Society for the Preservation of New England Antiquities, is bursting with evidence that many Americans have been enthusiastic collectors since pre-Revolutionary times. Some of HNE's 110,000 objects are on view in its historic houses, but most are stored in an anonymous-looking factory building in the gritty old industrial town of Haverhill, Massachusetts. This treasure trove contains everything from crude black "concealments"—shoes made to be immured in a home's walls to ward off bad luck—to a famed archive of 8,000 to 10,000 pieces of wallpaper, which has been an important status symbol from colonial times, when it had to be imported. Observing that one old house in Salem had between twenty and thirty layers, the curator Nancy Carlisle says that wallpaper was an enduring

middle-class institution by the nineteenth century, partly because, compared to buying new furniture, it's "a cheap way to keep up with the Joneses."

Many things in HNE's warehouse, including lots of the 700 chairs, came from dining rooms. Rows of cyclone fencing are hung with fine paintings—mostly family portraits like the ones that stared down on Longfellow's dinner guests. Aisles of metal lockers hold table linens, bottle stoppers, and fork rests. Some parts of HNE's collection are themselves collections of the sort often displayed in the dining room, such as Margaret Jewel's 1,200 children's mugs, decorated with animals, alphabets, and exhortatory maxims, such as "The slothful boy foretells an idle man." There are shelves and shelves of the blue and white English china produced between 1820 and 1860 that is still proudly arrayed on many dining tables and breakfronts. Although made in Britain, these dishes often showed American scenes, such as Niagara Falls, which helped spark a major collecting vogue by the early twentieth century.

The fact that most children collect at some point suggests to Belk that it's a broad human orientation, whose rewards include at least two forms of self-expression. First comes the opportunity to employ what biologists call the taxonomic eye in finding that special gravy boat or bit of significant silver at a yard sale. Then the victor gets to situate the new object at home, perhaps in the dining room, which is frequently a showcase for collections.

One aspect of collecting has particular appeal in our era of rapid social change, high mobility, and global unrest. In such a time, the orderly realm of ceramic figurines or English silver on display in the dining room is stablizing and comforting. "It's a big world out there," says Belk. "Within the little world of your collection, however, you're in charge. You can control what enters it and what doesn't."

Collecting's other rewards vary with individual enthusiasts. Because it's a way to extend the self through possessions, a collection can be a metaphor for personal wholeness. When one collection is complete, its owner often starts a new one. A dining room that in-

cludes a dazzling array of John Marin's watercolors or Chinese porcelain means a step up the social ladder for some, and for others, a satisfaction that's missing in their human relationships. For still others, a certain treasure can be an adult's version of a small child's "security blanket," which psychologists call a transitional object.

Some collectors savor the social side of their pursuit in the bonhomie that only fellow fans of Vernon Kilns pottery, say, or 1982 Bordeaux wines can share. Belk agrees that a common interest can transcend class barriers, but, as he says, "it's a narrow community"—so much so that collectors can have trouble finding heirs for their treasures. Because children and spouses often see them as rivals for attention and affection, collections sometimes skip a generation, for example, and go to a grandchild.

That Belk applies the term collector even to people who acquire dirt shows that his criteria are generous. One of his few rules is that a collection must have variety. "If all your objects are the same, you're a hoarder, not a collector," he says. "But as long as you perceive differences, even if some others can't, I think there's a collecting opportunity."

Regarding the person who can't seem to let go of anything, including what seems like junk, Belk says that the stronger someone's core self, the less need for such behavior. "Hanging on to useless stuff is often due to a fear of losing your present history and identity—your anchor," he says. "That's why it's easier to get rid of stuff when you're in the midst of a life change, like graduation, marriage, or divorce."

Of all of collectors' professed motives, Belk is skeptical of only one. He finds that people who claim to be "in it for the investment" are usually just trying to rationalize their passion. In fact, he sees collected items as an "antidote to the market, in that they're usually above price—unless they're replaced by a better item. There's always some yet more fabulous object, so the collector can be in perpetual pursuit."

Certain precious objects, such as a silver coffeepot made by Paul Revere in 1760, have a special allure for collectors because of a

mysterious quality that Belk calls contagious magic. This so-called positive contamination derives from the identity of a thing's maker or previous owner. Simply owning Marie Antoinette's watch, or your grandfather's, enhances your sense of self. Longfellow's house was his most beloved "collector's item" because it had been George Washington's residence for nine months during the Revolutionary War. As Longfellow did with early America, many collectors strongly identify with a particular historical era—the antebellum South, say, or the Wild West—and like to imagine themselves living in that other, more glorious realm. In this nostalgia, Belk sees a longing for a better past—perhaps one's lost childhood—which is yet another of our psychic tools for maintaining identity. The anthropologist Grant McCracken's theory of displaced meaning posits that because our deep values, beliefs, and aspirations may be too fragile to confront in the risky here-and-now, we project them to another time or place. Whenever we refer to "the good old days," the bright future, or other paradise somewhere over the rainbow, we may be displacing meaning. Often, we express these complicated emotions in our homes.

In the late nineteenth and early twentieth centuries, the popular decorating vogue of Orientalism expressed a widespread longing to escape from the harsh, mechanized world of the industrial revolution into another, more poetic realm. Indeed, Longfellow's dining room contains a sideboard that was made from a Buddhist altar sent home to Cambridge from Asia by his much traveled son. In a similar way, seeking relief from complex postmodern society, many Americans displace meaning onto "primitive" cultures, which become the focus of their travel, reading, and perhaps the art and crafts displayed in the dining room.

From its early days, America has been of two minds about us and our stuff. The dining room at Tryon Palace, built in 1767 in New Bern, North Carolina, as the governor's residence, boasts a mahogany table and chairs, silver epergne and candlesticks, carpet, looking glass, and cut-glass chandelier. All of these costly status

symbols were imported from abroad and displayed as proof of the prosperity of the balmy, upwardly mobile colony and its ruling class.

A very different early American attitude about earthly things is illustrated by the Ephrata Cloister, outside Lancaster, Pennsylvania. One of many unworldly utopian communities, its Protestant members embraced a monastic life of work, prayer, and holy poverty. The Saron, or "sisters' house," built in 1743, was a women's residence of three floors, each of which had two workrooms, a dozen single bedrooms, a kitchen, and an "eating room." In this austere, undecorated dining space, the sisters in their long hooded habits gathered around a sober plank table set with plain utensils and took their only meal of the day, which was small and vegetarian.

The number of our ascetic utopian communities has declined, but many Americans remain ambivalent about the materialism that's so evident in our increasingly elaborate homes and proliferating possessions. This feeling is understandable, considering our conflicted cultural heritage. We're history's ultimate consumers, striving to create our own versions of Tryon Palace. Yet we're also heirs to the Puritan tradition, which says that attachment to worldly things is shallow, even immoral, as it was regarded at Ephrata Cloister.

One way to approach if not resolve this conflict is to distinguish between different types of materialism. What Belk calls the "good" sort concerns the acquisition of meaningful things, such as photographs of and gifts from dear ones. The best things in life may be free, but anyone who has discovered a new and better world upon buying a home, a piano, a computer, or the first item of a collection has benefited from good materialism. Far from being greedy indulgences, "good" possessions help us express our values, relish our accomplishments, enjoy family and friends, and feel satisfied with our lives and selves.

In contrast, "bad" materialism is all about showing off or looking for satisfaction in the wrong directions. In fact, compulsively

buying one in every color or using shopping as an antidepressant correlates with unhappiness. This kind of inappropriate acquisitiveness can be more of an effect than a cause; insecure people plagued by self-doubt are likelier than others to define success by what a person owns, such as a big house or car. Summing up a lot of behavioral science as well as religion, Belk says, "People who believe that possessions are a source of happiness tend to be less happy."

The Bible says that the love of money is "the root of all evil," and most great religions are officially antimaterialistic. As Belk puts it, "They try to create intangible rather than tangible sources of hope." On the other hand, he believes that even the religions have become more materialistic over time. For example, where the home is concerned, although Christmas wasn't a major holiday in early Christianity and the Puritans even forbade its celebration, Santa Claus has become what Belk calls a "god of materialism." Moreover, the generosity advocated by the holiday's great popularizer Charles Dickens, which extended to those less fortunate, has largely been directed inward to the family. Throughout eastern Europe and parts of the developing world, Belk points out, Protestantism is increasing not least because it often adopts a decidedly upwardly mobile "do good *and* do well" cast that would have shocked John Calvin.

Contemplating our deep feelings about certain possessions invites analogies to other passionate interests, such as sex or religion. In fact, Belk wonders if our materialism might sometimes be a substitute for them. After all, since the days of the grand early department stores, such as Macy's and Wanamaker's, with their full choirs and pipe organs, shopping centers and malls have been pilgrimage sites. A recent newspaper advertisement for ABC Carpet and Home Store, a posh Manhattan furnishings emporium, might be announcing a religious lecture series or retreat rather than goods for sale. The illustration shows a statue of a vague deity that's draped in strings of beads and seated amid Asian-looking cabinets and bowls. The accompanying text reads:

Spirit East
create a sacred space at home
a rare opportunity to select from the largest, most beautiful
inventory of asian antiques and vintage furniture in new york.
altar tables
wedding cabinets
herbal chests
tea tables
wedding beds
[and other more pedestrian stuff thrown in]

To Belk, regarding material goods as a source of hope is some-what analogous to looking to deities or interpersonal relationships for the same reason: "We have a desire to desire—and underlying that, perhaps a hope for hope—which is a fairly basic human process that might attach to things."

Our complicated feelings about our stuff and our homes—too much? not enough? just right?—are manifested in the vogue for faux simplicity. Comparing her Fifth Avenue duplex with her new, stripped-down flat in Paris, the wealthy socialite Lee Radziwill says that her French home was designed to create "an extraordinary sense of calm. I don't know if you'd say *cluttered*, but it [the New York apartment] is extremely full. So it's wonderful to have the contrast here of having it totally Zen, totally peaceful."

Far from Fifth Avenue much less Paris, Martha Stewart built a spectacular career by marketing faux simplicity to the masses. Her aesthetic is based on an artful plainness that blends the principles of modern design with the rustic, antique, and monastic. On the book cover of *Good Things*, Martha, in a subdued taupe turtleneck, stands against a pale green wall holding a plain white dish. She's ready to serve refreshments from an old weather-beaten wooden table whose peeling paint is partly covered with a white, unironed vintage cloth. The table holds some homemade goodies, a pitcher of water, and some old glasses. Perhaps to the amusement of actual

farmers and monks, such spare, faded, seemingly rural or ascetic settings and their time-worn, yet perfect-in-their-way furnishings have not only made Martha several fortunes but also inspired a veritable industry of copycat designers, merchants, and media.

The most interesting thing about faux simplicity is that it's anything but simple, actually requiring more trouble and expense than most decorating styles. The aesthetic isn't based on giving up possessions but on having lots of custom closets and cabinets that conceal them from view. In a presentation titled "Creating Calm," the interior designer Russell Groves, whose clients include Giorgio Armani and Donna Karan, shows his audience a slide of an urban apartment, in which the closets, baths, and life's less attractive necessities are hidden inside three big wood-paneled "boxes" that blend perfectly with the flat's serene beige and taupe color scheme. Along with intelligent planning, Groves's recipe for domestic relief from the external world's chaos and overload includes natural or soft, even lighting, a subdued palette, clean lines and shapes, natural materials, and, he says, "storage, storage, storage!"

Like storage units that disappear into the walls, simplicity that looks perfect rather than utilitarian costs big money. Moreover, once the simple look has been achieved, maintaining it requires ceaseless effort and discipline. A ketchup bottle on the dining room table ruins everything.

The minimalist aesthetic's recent excesses can obscure the style's honorable roots. Early and midcentury modernist architects felt that the brave new world called for a compact, easy-to-care-for house of open, uncluttered spaces. After all, families were smaller and did more activities outside the home; technology and convenient shopping had eliminated the need for the crammed attics, cellars, and sewing rooms of yore. Instead of a staid formal dining room, Marcel Breuer and Walter Gropius gave James Ford's house, in Lincoln, Massachusetts, a table and chairs in a cheerful, open living-dining area whose wall of windows overlooked a pretty pond and cut the heating bills. This livable home's sensibility is one of practical modern good taste, not opulent faux simplicity.

From a philosophical perspective, Buddhist condos and Shaker beach houses hardly bespeak the voluntary poverty embraced by monks and other advocates of simple living. Even outside religious communities such as Ephrata, some Americans have long upheld the notion of trading income and possessions for free time and spirits. Not all of his contemporaries admired Longfellow's status-conscious dining room, particularly the austere Transcendentalists of nearby Concord, who expressed *their* importance in plain living and high thinking. "If Socrates were here, we could go & talk with him," Ralph Waldo Emerson complained to his journal, "but Longfellow we cannot go & talk with: there is a palace, & servants, & a row of bottles of different colored wines, & wine glasses, & fine coats."

In the twentieth century, the Transcendentalists' idea that a lot less is more was advanced by the Voluntary Simplicity Movement. Founded by Richard Gregg in 1936, this secular creed upholds plain living as a social duty. In the 1960s, the back-to-Eden counterculture made heroes out of elderly off-the-grid practitioners Scott and Helen Nearing and a best-seller of their 1954 book *The Good Life.* Young baby boomers going through their hippie phase liked the Nearings' idea of the simple life in nature, but they added what has proved to be an enduring passion: the love of good stuff. Their often conflicting tastes for the simple *and* the best, whether organic sheets or hand-thrown pottery, was first manifested in the *Whole Earth Catalog* and later those of L.L. Bean and other canny merchants. The boomers' special brand of high-minded, aesthetic, even virtuous consumerism, chronicled in David Brooks's *Bobos in Paradise,* created a huge new market for goods, some of them invested with an almost spiritual aura, such as Eileen Fisher's plain, earnest clothing, and the garden equipment of Smith & Hawken. In response, in the 1980s, the frugal living movement was rejuvenated, in part by Duane Elgin's *Voluntary Simplicity,* which he revised again in 1998.

Reflecting on Americans' current absorption in the home and its stuff, Belk speculates that the short-run reason might be terror-

ism, which inclines us to retreat into the womblike security of the home. His long-range, more benign take is that as the world continues to turn into a vast, complicated global village, we're trying to reckon with confusing outside forces while safe at home. Gathered around the dining table with family and friends, we grapple with a diverse world in a small but significant way: Korean or Mexican or Japanese meals, either take-out or homemade.

To Belk, our penchant for what not all that long ago most Americans would have regarded as very exotic—even risky—dining is an example of a *positive* type of the negative contamination we can attach to certain stuff. In the wealthy West, for example, our washers and dryers allow us to enjoy getting contaminated by dirt when we're mucking around in the organic vegetable patch, unlike a Mexican peasant, for whom gardening is a job and cleanliness difficult to maintain. Just as our affluence lets us regard literal dirt more playfully, we can enjoy foreign cuisines, which are "other" and thus figuratively "dirty." Whether we use our dining rooms as snug cocoons or labs for experimenting with the new and strange, he says, "we're increasing our levels of comfort and homeyness as a way to gain solace in and distance from the greater world."

Everyone knows that sharing a good meal is among the home's most satisfying experiences, but insight into the less appreciated importance of the special things that gravitate to the dining room or table can even make polishing the silver less onerous. Instead of waiting for Thanksgiving, we now use my grandmother's china for everyday meals. When I gathered some pieces of midcentury California pottery that were scattered around house and lined them up on the dining room mantel, they suddenly became a collection—and a small statement of who we are in the world and what we like.

To people who are fond of the dining room's traditional furnishings and rituals, the new great room that often replaces it seems like the architectural symbol of the past three decades of cultural upheaval: a "space" in which anything goes and that undermines venerable social customs and ties. To others, the new get-real great room is a good-natured attempt to gather the household together—even if its members are doing different things—in an increasingly hectic world.

The Great Room
Same Time, Same Place

Even by California standards, Venice is unusual. With its eclectic architecture, sea-water canals, and lush flora and fauna, it's a densely populated town that feels like a tropical island. Renovated bungalows, ultramodern trophy houses, and neohistorical McMansions elbow each other from small, wildly expensive lots. If these homes have any architectural feature in common, it's likely to be the great room—a gathering place where, thanks to its entertainment center and adjoining megakitchen, there are lots of things to do.

The great room seems new, but it's the latest development in a hundred-year-long experiment in which American culture has gradually shed traditional manners and mores to become more informal and open, while the home dropped walls and doors to the same end. Just as old-fashioned living and dining rooms were de-

signed for paying calls and proper dinners, the great room is oriented around 24-7 electronic communications and casual, catch-as-catch-can meals. The space is an architectural illustration of the conflict between the ancient human need for community and the postmodern desire for autonomous choices, which has created a new definition of togetherness: being in the same place at the same time, but no longer necessarily doing the same thing.

After thirty years of unprecedented cultural change that promises to keep on coming, an open, flexible domestic space that offers behavioral options and doesn't impose many rules makes practical sense. Evolving ideas about gender roles and family, the communications revolution, Americans' dizzying rate of mobility, and other big social shifts make the midcentury nuclear household, in which Dad spent the day at work and Mom stayed home with their two children, and its traditional architecture seem quaint.

In today's typical family, both parents work, and when they come home, they need a place to relax, fix dinner, and make calls while the kids do homework or watch a DVD—at least an approximation of "quality" time. Moreover, barely half of American households belong to married couples, while the number of nontraditional households—single adults, single parents, unmarried and gay couples, parents and adult children—has markedly increased. This growing demographic diversity also augurs for a flexible domestic architecture that, like the great room, can be many things to many people. Even for busy professionals who spend little time there, just *having* the trendy symbol of domesticity and togetherness can be a comfort. As one mobile, high-profile academic puts it, "I don't have time for friends, but at least I have a space for them that I can think about."

The architect Mark Mack makes the argument for what he calls "loose-fit environments" in his own stylish great room overlooking one of Venice's canals. All that differentiates the double-height living area from the dining area is the latter's lower ceiling—a nice balance of bright prospect and sheltered refuge. He regards this kind of open, flexible room, "where different stuff, from lying on the

floor to dancing at a party, can happen," as the type of space that's just right for modern life and its home. A recent exhibition of his work was titled "Easy Living," which calls for "an informal architecture that lets you evolve your experience of life without preconceived rules about where you have to fit in," he says. "Your home should be true to your own lifestyle. If you like your car in your great room, why not?"

Clearly, he's all for individual expression in the home, but Mack believes that it's best achieved in dwellings that are simple, open, and not too defined. Then residents can customize their spaces with furnishings, color, or even cars without imposing limits on later use. "The building's external structures and the person's internal structures can overlap, but one shouldn't determine the other," he says. "The home is not meant to be stuck in history. Considering the energy and money that go into a building, the fashionable, spectacular, and immediate in our lives should happen in other ways, like crazy clothes or furniture. I wouldn't want to live in a fussy Victorian house—and we have some superfussy homes today—but I could live in a Palladio house. The spaces are big, and I can do whatever I want with them."

Despite the edgy modern look generated by its concrete floors, orange walls, and furniture of his own design, Mack's great room also has an archaic quality that partly reflects his background. In his native Austria during the postwar housing shortage, his family lived in two huge rooms in a former monastery, one of which became a true great room. Later, Mack traveled extensively in Asia and the Middle East—his wife is Arabian—where traditional houses also have simple, open spaces and surfaces that serve many functions. In Egypt or China, "you might eat and sleep in the same room on the floor," says Mack. "Certain elements, such as the bath, have to be separate, but most rooms shouldn't be as static and custom-tailored as they are here. I see the house not as a piece of art, but something more conservative and generic, in which a room can become this or that. "

In theory, the open, flexible great room sounds great. From a

behavioral perspective, however, although the space works well for a group of people who want to socialize or a single person reading a book or watching TV, there are problems if both parties want to use it at the same time. From the aesthetic viewpoint, a great room done without help from a skilled designer can look like a huge annex to an otherwise miniaturized house, whose small, empty formal living and dining rooms are kept for appearance's sake. In Mack's sanguine opinion, "People should just get rid of all those unused spaces. They should say, 'We just want the great room!'"

The architectural and behavioral evolution that produced the great room began in forward-looking circles of the later nineteenth and early twentieth centuries, when technology and the desire for a more relaxed way of life began to free up domestic spaces and manners. The most remarkable feature of Stonehurst, a Shingle-style mansion designed by H. H. Richardson, is called the Great Hall, but it really anticipates the great room. The architect's presciently modern genius has been called the "power of simplification," and he preferred to work on public buildings, such as libraries, that allowed him to mass large open spaces. In 1883, however, Robert Treat Paine, a wealthy philanthropist, prevailed upon Richardson to focus his clarifying powers on a single private home high above the gritty town of Waltham, Massachusetts—the birthplace of America's industrial revolution—surrounded by 109 acres partly sculpted by Richardson's friend Frederick Law Olmsted.

Contemporaries accustomed to chopped-up Victorian interiors must have been flabbergasted by the Great Hall. The room is as wide as the whole mansion yet, thanks to an ingenious truss system hidden in the attic, free of obstructing supports. The Paines furnished the hall sparsely, so there's little to distract from the beauty and luxury of its pure space. The major exception is the glorious staircase, which the art historian Henry Russell Hitchcock described as pouring down into the room "like a mountain cataract."

A hundred years before the great room would become the

center of many American homes, Stonehurst's early version was a stunning innovation. As the Yale architectural historian Vincent Scully said, Richardson freed the central hall from its traditional role as a mere circulation space and made it "an open and informal main living area" that was the "living core of the house." Suggesting the parallel behavioral freedom, the large Paine family used the room for chatting, smoking, reading, roughhousing, and hosting large gatherings. In a diary entry for June 7, 1902, Robert Paine wrote that despite poor weather that kept everyone indoors, a party for 150 guests had been "quite merry," partly thanks to "bean bags in hall."

Unlike his predecessor Richardson and many celebrated architects since then, Frank Lloyd Wright, the father of the open, modern American home, loved to design houses. ("The house of moderate cost is not only America's major architectural problem," he said, "but the problem most difficult for her major architects.") In the hard new industrial world, Wright regarded the home as a spiritual refuge, focused on the ancient comfort of the hearth. Over his seventy years in practice, he created many domestic sanctuaries for average folk as well as privileged clients. Even in the first years of the twentieth century, as American culture shook off lingering Victorian constraints, his relaxed, flowing living-dining areas anticipated the cozy, flexible great room.

By the 1940s, European-born architects who emigrated to the United States were joining in the experiment of opening up and modernizing the American home. The wealthy Bostonian Helen Storrow made the Bauhaus architect Walter Gropius, his colleague Marcel Breuer, and Walter Bogner, their American colleague at Harvard's architecture school, an offer they couldn't refuse. She would provide building sites in a former orchard in Lincoln, Massachusetts, and pay up to $20,000 each for the construction of four cutting-edge modern houses, which she would then rent back to their designers. All of the resulting homes had open living-dining areas in the so-called International style. Yet Bogner's version has

a special modern charm that derives not just from its interior space but also from its extension into the outdoors.

From the house's small entry, you step down into a delightful surprise. The open living-dining area is bounded by a window wall that frames a gorgeous stand of birch trees, which almost feels like part of the room—shocking fenestration in the rustic New England of the time. Indeed, Walter Bogner, the late architect's son, recalls that curiosity-seekers would peer through the windows as the family ate dinner. Nevertheless, he says, "my father's attitude was 'Why can't we put the windows where we want them?'" This proto-great room, with its panoramic view, has plenty of prospect, but unlike many newer versions, its cozy fireplace alcove with built-in couches and bookshelves provided a comforting refuge that helped to make it what Bogner calls "distinctly livable."

As the Harvard architects were designing the Lincoln houses, their West Coast peers, aided by their region's balmy climate and easygoing, outdoors-oriented way of life, went even further in pushing the envelope of home's exterior as well as interior spatial barriers. Pacific Palisades, just outside of Los Angeles, is a mecca for devotees of the famed Case Study houses. Just past the lush shrubbery veiling House No. 20, designed by the architect Richard Neutra, lies No. 8, where authorized visitors can peer right into the high-spirited home of Charles and Ray Eames. Its red, blue, and white stucco panels and industrial windows of different sizes divided by black-painted steel frames make it look like a jazzy playhouse designed by Mondrian. Much like an open factory, it's based on a 20-foot-by-7.5-foot modular unit, or bay, that's repeated eight times. The legendary husband-and-wife team, who designed furniture, graphics, industrial products, and toys as well as architecture, set their 1,500-square-foot, two-story box into the hillside amid fine old trees.

Judging by their house, the Eameses fervently believed that modern life should be no-fuss, stylish, outdoors-oriented, and just plain *fun*. Their home's wow feature is the two-story-high living area, which the Eameses emphasized by suspending all kinds of

things, from a toy French horn to a Hans Hofmann painting, from the ceiling. The space has its owners' famous furniture, of course, a true wall of books (accessed by a specially designed extension ladder that's a sculpture in its own right), and a sitting-room alcove with cozy couches. Perhaps the great space's most prescient feature, however, is the terrace that opens from it. Created by an overhang that shelters what would have been the house's final modular bay, it extends the living area into the outdoors.

The Lincoln and Case Study houses were designed for a handful of aesthetically adventurous individuals, but millions of other Americans, reacting to the same postwar spirit of progress, prosperity, and change, soon embraced vernacular versions of the relaxed, opened-up home. The young parents of the incipient baby boom needed housing, and between 1944 and 1947 alone, the GI Bill gave more than a million returning veterans low-interest loans to buy homes, costing about six to eight thousand dollars, with no down payment. To stimulate the economy, however, the houses had to be new—a policy that caused the great suburban explosion and dealt American cities a blow from which many never recovered.

In response to the call for new homes, the revved-up housing industry, now run by big developers who bought huge tracts of land, used mass-production and assembly-line techniques and new materials generated by the war to construct houses quickly and cheaply. These new homes were short on old-time customization and craft, but long on modern amenities, such as efficient kitchens, baths, and heating. Paradoxically, decisions that their big developers made to cut costs, such as reducing the number of interior walls, helped to mainstream elite architects' concepts of the open living-dining area and the increasingly accessible kitchen.

The new ranch houses and split-levels with their flowing living-dining areas appealed to thousands of young midcentury couples who rejected both urban and rural life, old-fashioned row houses and Victorians. The avant-garde houses of Lincoln and Pacific Palisades would have struck many of them as weird and futuristic, but the modified versions that appeared in the new

democratic subdivisions looked fresh and up-to-date. In an America giving birth to the baby boom, the focus was on an easygoing, family-friendly way of life and style of architecture, rather than formal manners and separate rooms for this and that.

By the 1960s, the home in the burgeoning suburbia made increasingly accessible by highway expansion had grown larger and more technologically advanced. Even in the Northeast, the casual, outdoorsy California influence was generating more picture windows, sliding glass doors, and patios. The average home increased to 1,700 square feet. Anticipating the great room, the kitchen doubled in size and nudged closer to the now familiar living-dining area.

After decades of gradual architectural and behavioral opening up, the communications revolution finally pushed the great room into the center of the new American home. Starting with television, electronics had already undermined the traditional living room, which was organized around visiting and socializing, not watching a screen. In new homes, when they're included at all, living rooms, like dining rooms, are smallish and little used. When families or friends get together these days, they mostly have casual meals or watch a movie or a sports event—or do both, as in the popular Superbowl and Oscars parties. Informal eating and watching some sort of screen—often at the same time—are the twin pillars of postmodern home life, enshrined in the great room.

In an era of tremendous cultural change that has weakened traditional ties and rituals, from family dinner to neighborly coffee klatches, the great room expresses our need for what the environmental psychologist Harry Heft calls enforced togetherness. Architecturally orchestrated interactions may be necessary in an era of electronic communication when many American adults and kids just aren't home as much they used to be. All day long, busy parents commute, work, and run errands, while equally tightly scheduled children move from school to ballet and soccer, tutoring and music lessons. When they reach home, both generations monitor

their cells and PCs. As Heft says, "Families used to cluster together around the fireplace at night in order to stay warm and to see, but now, everyone is parked in front of different screens."

From Heft's behavioral perspective, the great room's potential for enforcing togetherness while permitting different individual activities—TV watching, chatting, e-mailing, phoning, cooking, studying—is the source of its postmodern appeal. In a dialectic view of the tension between our needs for socializing and autonomy, he says, "flexibility is crucial. The great room is all about having choices *and* connection."

Staying connected to others may be challenging these days, but there's no doubt about our need to do so. Summing up some of behavioral science's strongest, simplest findings over recent years, the Harvard Medical School sociologist Ron Kessler says, "Living alone is dangerous to your health. It's the single biggest predictor of early death and a risk factor for mental illness, substance abuse, TV dinners, and all kinds of bad stuff." Domestic companionship has certain obvious practical benefits, such as daily routines, regular meals, and care when ill. But much of the good comes from "just having another person around," says Kessler. "Your environment is bouncing back at you—that's what gives meaning to life."

They may be loathe to admit it, but plenty of professionals seem to find life's meaning at the workplace. Judging by the amount of time they spend there, they feel that home is a nice place to visit, but they wouldn't want to live there. When Arlie Hochschild, who first identified the working woman's "second shift" of housekeeping chores, later studied the lives of employees at a Fortune 500 company, she found that most parents logged overtime less for the money than because office life was easier and more fun than being at home.

Especially for parents, home is the place where life is unpredictable and the demands never end. As Kessler puts it, "If the roof falls in, you can't say, 'That's not in my job description.'" His research has also turned up some gender inequities in this regard. Men's traditional domestic chores, such as mowing the lawn or

washing the car, can often be put off, so after a hard day at the office, they can decide to watch TV instead. Women, however, do more time-sensitive chores, such as picking up the kids and making dinner, so they must soldier on regardless of workplace stress. Even mothers who stay at home face hassles that employed fathers are spared. A man who has a cold can go wheeze in the controlled setting of the office, where he's buffered from dirty laundry and car pool pickups, then collapse on the couch after dinner. A sniffling, hacking mother still has to care for the kids, do routine chores, and face the annoyances, from a ringing doorbell to a leaky ceiling, that perturb the home's much less foolproof environment.

The challenges of domestic life make Kessler skeptical about certain decisions that, like overtime, are ostensibly made "for the good of the family." For example, commuters often insist that their kids have to have big suburban homes, he says, "but with their longer workdays, the parents don't actually have much family life. It's complicated."

Social scientists such as Heft and Kessler are concerned not just about our hectic postmodern personal lives but also about larger cultural trends that affect our homes and communities. Our unprecedented mobility tops many of their lists. A nation of immigrants, Americans have always been a footloose people in search of a better life. With the Homestead Act of 1862, the government even gave pioneers 160 free acres to relocate. (Not that those covered wagons were driven by the poor; equipment for the trek cost between five hundred and one thousand dollars—a huge sum then.) Over the past twenty to thirty years, however, Americans have been on the move as never before. According to the 2000 census, almost 20 percent of us changed residences within the previous fifteen months; other surveys show that perhaps as many as 50 percent do so at least once every five years. Only 60 percent of us live in the state where we were born, and fewer than 10 percent of households have occupied the same home for more than three decades. In contrast to three moves for an Irishman and seven for a Japanese, the average American moves fourteen times in a lifetime.

America's recent burst of restlessness has produced a huge new group of people who lack the traditional social support systems, from grandmothers to friendly neighbors, that are strongly linked to good physical and mental health, as well as to sound communities. As a result, says Heft, "all of our social energy and longing for connection has to be expressed within the confines of the home." If staying connected within the home isn't easy—that's what the great room's enforced togetherness is for—making and maintaining friendships in the community can be downright difficult.

Research shows that basically, adults are friends with the relatively few people they see a lot. Sheer propinquity—parents in the school yard or commuters on the train platform each morning—fosters bonding. Living in close proximity even increases the tendency to see the other person's good side and to make the relationship work.

The stable hometown America of yore almost ensured that everyone had a solid network of family, neighbors, colleagues, and friends who would stay put. People who move every few years, however, may barely get to know their neighbors. The newer, ever more car-oriented suburbs, where there are no sidewalks and you can go from the garage to work or the mall and back without ever setting foot in the neighborhood, offer few chances of bumping into potential friends. The decline in community is such that predictors of good adjustment to a new home now include the availability of favorite chain stores and TV shows.

Although he's a Harvard professor, Kessler admits to a certain envy of blue-collar people who, unlike many mobile professionals, are still deeply rooted in their neighborhoods. Referring to his colleague Robert Putnam's book, he says that "the whole 'bowling alone' thing that's happening in many American communities is about an enormous bifurcation between middle- and working-class people into movers and non-movers." Unlike the college graduates likeliest to work for big companies and move frequently, "the carpenters, painters, and plumbers who work on my house live in the same old neighborhood with their mother, grandmother, and sev-

enteen cousins," he observes. "Community gives them inexpensive entertainment, barter and exchange, and other stuff that white-collar people make up for with money. Your cousin the plumber does your kitchen for free, then you do his plastering. In comparison, money isn't nearly as good. It gets you the material stuff, but not the sense of security and connectedness."

Just as we need to feel connected to other people, we benefit from having strong bonds with our homes, which are also disrupted by frequent moves. Large-scale environmental disasters, such as hurricanes or toxic spills, offer extreme examples of the behavioral consequences of losing a beloved home. In one intensively studied tragedy, which occurred in Buffalo Creek, West Virginia, in 1972, a dam built by a mining company broke, killing 125 people, destroying some five thousand houses, and badly disfiguring the community's whole valley. Most of the population suffered from problems such as anxiety, a sense of numbness, depression, stress-related illnesses, anger, nightmares, and in children, regression. It's too soon to assess the emotional damage wrought by 2005's Hurricane Katrina, which deprived hundreds of thousands of southerners not only of their homes, but also their towns and communities, but previous research suggests the catastrophe will exact a psychological toll.

In the face of individual and social challenges to our traditional ties to people and places, the great room, like the pioneers' circle of wagons each night, is a structure designed to foster some security, warmth, and sociability among people on the move and searching for a better life in an uncertain world.

The enforced togetherness that's the great room's greatest behavioral benefit is also its worst drawback. In a Colorado McMansion that resembles a chalet on steroids, no expense was spared where the great room is concerned. Massive beams and posts support the double-height ceiling. With the touch of a button, a movie screen drops from a wall. The fireplace could accommodate the roasting of an ox. There are enough oversized tables, chairs, and sofas for

several conventional living and dining rooms. Despite its opulence, however, this great room is nothing but great—photogenic and terrific for big parties but not for dinner *à deux*, curling up with a book, having a heart-to-heart talk with friend.

All prospect and no refuge, many great rooms lack the contrasts between big and small, high and low, and exposed and private that make a large space attractive and appealing. Many have no place where one person really wants to be. Moreover, despite their size, they're almost impossible to share by people who want to do different things. One person watching a movie or listening to opera monopolizes all one thousand square feet of space, so that someone who wants to read, chat, or daydream must go elsewhere. Behavior-setting studies of so-called open-plan schools, which dispensed with many interior walls, highlight the problems that arise from inadequate boundaries between quiet and active settings and help to make the argument for dividing too-great great rooms into, say, a communal space and a smaller den.

Unlike many people around the world, when Americans want to be alone at home, most can go someplace and shut the door. However, privacy is a much more complicated state than simply being by yourself in a room. Its potential increases with a home's size, but privacy also depends on the number of interior walls and doors, the arrangement of spaces, and their proximity to the entrance. America's average home is the world's biggest, but its halls, doors, grilles, and screens make France's far more private. (When discussing the great room, Mark Mack brings up what he sees as an American ambivalence about privacy. When he arrived in the United States from Europe, where soundproofing is "an obsession," he says, "it seemed so crazy when the host of a party would say, 'Oh, just put your coat in the bedroom.' You immediately enter the home's most private place!" He sees the great room's popularity as an expression of Americans' willingness to "live in the open," which he connects to a "puritanical idea about being naughty. The presumption here is that everything is clean, there are no secrets, and no one will do anything 'wrong.' A very American attitude.")

To Irwin Altman, who is environmental psychology's great theorist of privacy, it's "the selective control of access to the self or one's group." In this light, privacy includes both the option of seclusion—shutting a door or otherwise physically getting away from it all—and the increasingly important regulation of personal information, from our thoughts and feelings to our answering machines and e-mail. Fifteen minutes in a busy great room illustrate some of privacy's many dimensions, even on the most immediate sensory level. We think first of the visual and auditory sorts, but if someone is frying onions, everyone in proximity *must* be distracted, because smell is the strongest memory inducer of all the senses.

To allow householders to enjoy togetherness while engaging in various pursuits, well-designed great rooms have what environmental psychologists call stimulus shelters, which provide different kinds of privacy. A nook for a computer or books limits visual distractions, for example, but allows a summons to the dinner table. An alcove behind glass doors allows one adult to read while keeping an eye on the kids and a partner who's cooking, but without hearing the children or smelling the garlic.

In a wide-open great room that lacks ells and alcoves, one's sense of "personal space," or the invisible, portable bubble that immediately surrounds the body, is important to a feeling of privacy. In an especially inventive investigation of the subject, researchers who overtly occupied a stall in a men's restroom found that their mere presence violated the users' personal boundaries and caused stress, as measured by the delayed onset and decreased duration of their urination. In the great room, you might defend your personal space by pointedly focusing on a book, say, or moving to the other end of the couch, so that your body language proclaims, "Do not disturb."

The great room is a good place to experiment with the way that the amount of personal space we need varies according to our companions, our gender, what we're doing, and our level of stress. Its bubble shrinks when we're around nice people in nice places and

expands under the opposite circumstances. On average, friends maintain a distance of one and a half feet to four feet; acquaintances, from four to twelve feet. Women who like each other move closer together than men do, perhaps because of a male fear of being thought homosexual. Different activities can also call for more or less psychological elbow room. Simple tasks, such as mending, are not hampered by sharing close quarters, but complex activities, such as studying, are. In stressful circumstances, "Give me some space!" is no mere metaphor. If we can't physically retreat from social unpleasantness, we try to cope by breaking eye contact with the offending party or taking other distancing measures. In contrast, when our ability to communicate is hampered by too much personal space, we try the opposite maneuvers.

Just as there are many kinds of privacy, individuals differ in their ideas about what it is and how much is necessary. The great room feels just right to some people, particularly the sociable extroverts who dominate American culture and are more temperamentally disposed to enjoy togetherness and other forms of excitement. Reserved, sensitive sorts, however, can be discomfited by too much stimulation and blurred boundaries, and they may prefer smaller, traditional rooms for different functions to the bustling, multipurpose great room. Like individuals, families, too, can be outgoing or shy, and thus prosper in different kinds of homes, so that a household of extroverts won't require as many closed doors and off-limits zones as introverts might like. We're not accustomed to paying attention to place's effects on our behavior, however, so most of us, including architects, ignore even these broad psychological orientations when planning our houses and apartments.

Whether we're sociable extroverts who love the great room or sensitive types who prefer a quiet den, the right amount of privacy is essential to our well-being. Research showed that in an urban ghetto's typical cramped apartment, the living room became an inadequate great room by default; it had to be used for eating, visiting, homework, and entertainment. To signal a need for privacy, residents had to rely on body language, such as in sitting with elbows

out and legs extended or turning their faces away. The overstimulation and lack of privacy in such homes is hard on marriages and other relationships and has particularly dire consequences for children trying to study—a finding that highlights the greatly underestimated role of environmental factors in social and domestic problems.

The magic of a home that balances our needs for privacy and sociability, as even a well-designed great room should do, depends on how its furnishings as well as its spaces are arranged. After investigating what he calls small-group ecology, the pioneering environmental psychologist Robert Sommer discovered that friendly interactions are likeliest when furniture is clustered in a so-called sociopetal configuration, which orients people toward one another and promotes comfortable eye contact and conversation. In contrast, a sociofugal arrangement, which lines up chairs and couches along the walls, as in many homes, or in rows, as in many institutions, is far less friendly. Even in corporate settings, the sociopetal configuration augurs for better meetings, teamwork, and brainstorming.

From a behavioral perspective, a great room or other living space should offer different kinds of furniture arrangements for different sorts of social interactions. Friends will sometimes sit side by side, says Sommer, but they usually prefer a right angle, or kitty-corner, situation. If two strangers sit right across from each other, however, the direct eye contact can signal competition, as the expression "going head to head" implies. Indeed, while working as a seating consultant for the Bay Area Rapid Transit system, Sommer found that because direct eye contact invades privacy, two strangers are far more comfortable when sitting side by side than across from each other.

Some furniture arrangements help almost all of us feel at ease, but each of us also has certain personal preferences. These seemingly small but important spatial likes and dislikes often surface at the dinner table, observes Sommer. "I had a very authoritarian

father, for example, and I don't like to sit at the head of the table. I also don't like barriers between me and other people, so we have a low coffee table that's a bridge, not a barrier, and not a lot of bric-a-brac that gets in the way." At home, Sommer serves as resident environmental psychologist, he says. "When we have guests, my wife always says, 'You're the expert—you figure out the dinner table seating.'"

When discussing the great room, Sommer laments that watching its big TV or drop-down movie screen has become "'family time'—even though the whole family isn't there very often." While working on the design of mental hospitals, he made an important observation that applies to the home in general and the great room in particular. The so-called dayrooms that served as the patients' great rooms invariably had all the chairs lined up in rows facing the TV. As Sommer says, *"That's* the most desocializing arrangement imaginable!" If there's one thing we can do to improve our homes from a behavioral perspective, he adds, "it's getting the TV out of the living area!"

The interior designer Nadia Ghaleb intuitively uses the environmental-behavioral principles of small-group ecology to improve her clients' all-too-real-life houses and apartments. Standing in a duplex apartment in a hundred-year-old Manhattan brownstone, Ghaleb surveys the large living and dining rooms—separated only by pocket doors that disappear into the walls—which are in effect a great room. Her clients want to freshen up the tired-looking space without undertaking a major renovation—what Ghaleb calls "design on a dime." Even before taking off her coat, she frowns at the TV prominently perched on a large table by the fireplace and sets it on a small, low table in a less conspicuous corner. "The point of this room," she says, "shouldn't be watching television, but enjoying friends and family."

To that end, Ghaleb studies the couch, armchairs, and coffee table, which are arranged in a conventional rectilinear way, with the fireplace as the focal point. "This room looks like a funeral parlor," she says, and gets to work. She leaves the couch where it is

but shoves the long, low table close and perpendicular to the fireplace. Then she draws up the chairs around the table, making an almost circular grouping for four people in the middle of the room, which can expand to include the couch's occupants at a bigger gathering. With some house thinking that mostly called for pulling the furniture away from the walls and into a circle, the wannabe great room starts to look great. As Ghaleb says, "Instead of practically having to yell to each other, people have a place to gather and talk intimately. Now the room is warm and inviting, as if we're meant to enjoy being together."

Our old house has no great room, but its first owners would have used the dining room as a family room, where they'd read, write letters, and play games after dinner. Indeed, our dining room is larger and finer than the living room, yet like many householders, we're prone to overly narrow definitions of our spaces and their functions. We decided to nudge our dining room in the direction of a great room by making it more amenable to just hanging out. The key element was putting an old sofa in a nook beneath one of the windows. Now conversations begun at the table can migrate to more comfortable seating, and we also have a pleasant place to read when the living room is too noisy and it's too early for bed.

Set apart from the "public" home by a flight of stairs or a hallway, the bedroom is much more than just a place to sleep. It's a refuge within the refuge of the home—a snug nest from which we're meant to emerge restored and ready to face the larger domestic and outside worlds. As the home's most private, mysterious space, however, the bedroom is sometimes the darkest. Its door can conceal loneliness and suffering as well as comfort and pleasure.

The Bedroom

Behind Closed Doors

Most visitors to The Mount, Edith Wharton's forty-two-room summer home in Lenox, Massachusetts, know her as the fine novelist who chronicled the Gilded Age and its victims. This hardworking socialite also wrote many nonfiction works, however, and as the co-author of *The Decoration of Houses*, was an acknowledged authority on domestic design. "Decidedly," she wrote, "I'm a better landscape gardener than a novelist."

Edith Wharton's symmetrical white mansion was inspired by English variations on the Palladian villa, but it must have seemed starkly modern to contemporaries accustomed to Victorian ruffles and flourishes. Edith's reason for building it was equally advanced. At a time when women writers weren't quite proper, she wanted a workplace retreat that offered more solitude than summers in

Newport afforded. Aided by the architects Ogden Codman Jr. and Francis Hoppin, she turned 130 acres of farmland into an elegant private sanctuary for herself and Teddy Wharton, her sporting husband.

In her public role of lady of letters, Edith was often photographed in the lavishly paneled, handsomely furnished room called Mrs. Wharton's Library, which is the house's most beautiful space. Yet the bedroom just above it, which also overlooks her magnificent gardens, was the true locus of Edith's creative life, and this private space tells a more complicated, personal story than the triumphal library.

The Mount's three guest bedrooms, including one used by Edith's friend Henry James, are rather plain. Teddy's bedroom, bathroom, and dressing room are not much grander. As *The Decoration of Houses* explains, "Since bedrooms are no longer used as salons, there is no reason for decorating them in an elaborate manner; and, however magnificent the other apartments, it is evident that in this part of the house simplicity is most fitting."

Edith's private sanctum at the very end of the hallway is a stunning contrast to the simplicity she prescribed for others. Her suite, inspired by the great homes of France, spans the entire north side of the house's third floor. Her boudoir, or personal sitting room, is intimate in scale, yet with its paintings, elaborate plasterwork, and marble fireplace, it's nearly as elegant as the parlor. Despite its privacy and pretty desk, however, Edith wrote next door in her bedroom—in fact, in her bed.

There are "bed people"—Hugh Hefner famously ran the *Playboy* empire from his—and Edith Wharton was one of them. Even while traveling, her bedroom had to be just so. She loved morning light and situated her room on The Mount's northeast side to catch it shining on the five thousand perennials in her "Oriental carpet floating in the sun." Research shows that people whose bedrooms face east generally rise earlier than those whose rooms are oriented to the west. Between 5 and 6 a.m., Edith began to write in her special sanctuary.

Gaillard Lapsley, a close friend, described the typical early morning scene at The Mount, with Edith propped up in bed and hard at work: "She would have her writing board perilously furnished with an ink pot on her knee, the dog of the moment under her left elbow and the bed strewn with correspondence, newspapers and books." When she finished a page in long-hand, she dropped it to the floor for her typist to collect later. Lapsley adds that Henry James also found the quiet early morning hours at The Mount to be "a choice opportunity for him to do beautiful work of his own, in such a fostering atmosphere." By 11 a.m., Edith was dressed and "ready for friends and engagements, for walking or garden-work."

Her bedroom was the fertile setting for Edith's literary life, but it was also the barren nest of an unhappy marriage. In a short story called "The Fullness of Life," Edith alluded to the connection between her bedroom sanctum and her secret loneliness and sexual frustration. Comparing a woman's nature to a "great house full of rooms," she wrote that far beyond its hall and salon lie "other rooms, the handles of whose doors perhaps are never turned; no one knows the way to them, no one knows whither they lead; and in the innermost room, the holy of holies, the soul sits alone and waits for a footstep that never comes." The couple's initial ties of social class and love of home, horses, and dogs could not compensate for their sexually cold and perhaps even unconsummated union. Both Teddy and Edith suffered from emotional breakdowns, but his mental health was more precarious and, during the years 1902 to 1910 that they spent at The Mount, it steadily deteriorated as her fame increased.

In 1913, following their divorce, as she crossed the Atlantic by steamer, Teddy broke his promise to Edith and sold The Mount without her consent. She lost her beloved home, but Edith Wharton would always have *The House of Mirth*, *Ethan Frome*, and the many other works that she had written in her complicated bedroom.

Like Edith Wharton, we look to our bedrooms to be what psychologists call a secure base, or familiar, cozy nest. In your private

lair that's equipped with just the right bed and pillows, pictures and books, you can replenish your inner self, attend to your most personal business, and feel truly at home in your home.

Primate research at a rural station of the National Institutes of Health suggests that a personal refuge isn't just a pretty idea from shelter magazines but is essential to our ability to feel and function well—and more so for some than for others. Periodically, the NIH primates leave their indoor quarters—bedrooms, if you will—to cavort in a playground equipped with hanging tires and, well, monkey bars, much like kids in a park. The boldest animals enter the outdoor space first and explore it most adventurously, while the timid are more cautious and stick to the perimeters. The research psychologist Stephen Suomi can often identify what he calls temperamentally "uptight" and "laid-back" monkeys at birth. Despite their differences, however, all the primates periodically charge back to their home cage, he says, "as if they are making sure it's still there. Once they 'touch base,' they go out again, always in the same order and always some more often than others."

The almost tangible pull that the secure base exerts on even the most daring individuals attests to the deep primate need for what Suomi describes as "a safe haven to explore from and return to when the world gets dicey." His research reveals a stunning fact: even a brief respite in such a refuge produces physiological as well as behavioral changes. That is, once in its nest, as a monkey visibly calms down, its levels of cortisol and other quantifiable measures of stress also decrease.

How an environment, from a monkey's nest to a person's bedroom, affects behavior depends not only on the setting but also on the individual's genetic and experiential background. If the primates were deprived of their secure bases—in effect, rendered homeless—they'd all become upset. Then the boldest ones would begin adjusting to the stress. Sensitive individuals—worriers always alert for novelty and trouble—would have a harder time because they depend more on their home base's soothing familiarity to modulate their neurochemistry. "You can't help picking up that

the familiar place—home—generates a secure feeling, and the novel one—playground—generates a sense of potential danger," says Suomi, "and that individuals differ in how great they want that mix to be."

Like other primates, we members of *Homo sapiens* differ in our temperaments and preferred ratios of home and world, calm and stimulating settings. Like them, we can't always control external events, but at least we are the masters of our nests. Particularly when we're under stress, we too are restored by a respite in our safe base, where we're surrounded with stimuli that invite us to relax and feel at home.

From a cultural perspective, the bedroom's evolution from nest to master suite parallels the rise of the individual and the right to privacy. In upper-class medieval homes, the first rooms to be differentiated from the great hall were a kind of protokitchen at one end and the solar, or master and mistress's secluded chamber, at the other. By the seventeenth century, as the middle class expanded, special sleeping chambers had become more widespread but by no means universal and were often shared by a number of people.

Imbued with the idea that function determines the use of domestic space—that is, we sleep in bedrooms, bathe in bathrooms, dine in dining rooms—we must strain to imagine that for much of history, the home's environment was organized around status instead. In colonial America, for example, the most illustrious person got to bed down in the nicest but not necessarily most private room, so that the head of the household often slept in the first-floor "best chamber." Persons of lower standing slept upstairs in a room or rooms that had several beds, which were shared regardless of gender and often with visiting strangers; servants usually bunked over the kitchen. As the architectural historian Elizabeth Cromley points out, this tradition of linking rooms to rank lives on: "People still buy the idea that the 'master' should have a suite."

We highly value privacy and think of the bedroom as very personal, but in well-off early American homes, the sleeping chamber

was also the site of important social experiences, from visiting to sharing events such as birth and death. (Before the advent of funeral homes, bodies were laid out in the bedroom; until the hospital's reputation improved around the turn of the twentieth century, one of its most important functions was to serve as the sickroom.) In the early eighteenth century, families who could afford to be concerned about status often took particular trouble over the bedroom's décor and draped their beds with hangings, which displayed wealth and taste as well as adding to the room's comfort and privacy.

The gradual shift from status to function as the home's organizing principle dramatically changed the domestic environment and behavior. As society grew more concerned with the individual, the private, upstairs realm became more sequestered from the ground-floor public spaces. Bedrooms served as the locus for intimate pursuits such as hobbies and writing letters as well as for sleeping and were decorated less to impress others than to express individuality. By the late nineteenth century, a woman's room might have a couch, and a man's, an armchair, and both sexes usually had a desk, books, and personal touches. Wealthy husbands and wives such as the Whartons generally occupied adjoining chambers connected by an interior door that could be left open or closed. For the first time, even many children had special rooms, which were decorated according to their gender.

Along with becoming more personal and private, the bedroom also grew simpler and more hygienic. The epidemics fueled by the burgeoning industrial cities and the new awareness of the germ theory of disease made the late Victorians very anxious about health. (Until about 1900, only the poor went to a hospital, where treatment was often worse than the disease.) Females spent more time in the sickroom than males; in addition to problems associated with pregnancy and birth, middle- and upper-class women were assumed to suffer from "nerves," which required quiet rest. Indeed, as Cromley points out, the woman was regarded both as the protector of her family's health and as a source of disease and

danger, particularly during childbirth, which took place in the bedroom.

Reflecting the culture's concerns about both the individual and health, the Victorian bedroom was both a refuge and a dangerous place that harbored microbes. To deal with the latter, by the early twentieth century, many people slept "in the fresh air," whether by opening a window, retiring to a "sleeping porch," or even bedding down outdoors in special clothing and tents. The new domestic scientists also urged women to wage warfare on elusive, ubiquitous dust, which was mistakenly thought to harbor germs, with a wet mop, broom, oily cloth, and eventually the vacuum cleaner. By discouraging dust collectors such as overstuffed furniture, large carpets, wallpaper, and bric-a-brac—and even replacing wooden bedframes with supposedly more sanitary iron ones—the new domestic hygiene helped shift home decor away from the cluttered Victorian look to the modern aesthetic of shining wood floors, spare furnishings, area rugs, and painted walls that is often aptly described by designers as "clean."

By the early twentieth century, function had definitively trumped status, and the bedroom's transition to a private place meant for sleeping and recouping was complete. This change presented a problem in the increasingly popular apartments and one-floor houses, however, says Cromley: With no upstairs, where to put the now very private bedroom? The solution was the hallway that still distances and separates the bedrooms from the living areas in many homes.

When discussing the question of whether we shape our bedrooms—and homes—or they shape us, Cromley comes down on the side of reciprocity. Using our bedroom's greatest attribute as an example, she says, "Once you have something, such as privacy, you begin to exploit and desire it more. In a house where parents enjoyed some privacy in their bedroom, they might say, 'Privacy is really great, so let's give some to the children, too.' " When it comes to making such changes in the home, she continues, "culture is more important than function." She illustrates the point with the

saga of the zipper, which spent thirty years doing odd jobs such as closing sailors' money belts and galoshes before "suddenly" appearing everywhere. As with privacy, Cromley says, "even such a handy item had to fill a need in the culture before it became functional."

As in bygone eras, ours has put its particular stamp on the bedroom, in that our unprecedented consumerism has mainstreamed the "master suite," once the province of the rich. Some domestic versions of the deluxe hotel's penthouse suite include a spa bathroom, dressing room, fireplace, balcony or patio, gym, and minikitchen, as well as a private hall or walkway to set this space apart from the rest of the home. Two of the master bedroom's must-have features, however, are the walk-in closet and the souped-up queen- or king-sized bed.

Like so many things we take for granted, the bed as we know it didn't exist until the industrial revolution of the late nineteenth century, when metal inner springs for mattresses could be readily manufactured. These new mattresses were a vast improvement over what had been a crude sack stuffed with straw, cotton or the like and supported on ropes hung from a wooden frame; tightening these ropes inspired the expression "sleep tight." Because it was often vermin-infested, people about to retire for the night announced they were "hitting the hay," or thumping the mattress to scare away the bugs. The well-off had the comforts of a cushioning featherbed and heavy curtains hung from the bedposts that trapped their body heat in what was often the home's only truly warm place.

Like the modern mattress, the built-in closet was a by-product of the accelerating industrial revolution. We each now require a minimum of several feet of hanging space for clothes, but until the burst of mass production in the later nineteenth century, average people just didn't own very much stuff. The rich had dressing and storage rooms, from which servants fetched clothing or other

items as needed, but most homes had no built-in closets. People stowed their few possessions in cabinets and chests or hung them from hooks and pegs, which were sometimes concealed in an early shallow version of the closet.

When mass production enabled people to buy inexpensive ready-made clothes, they wanted to store their new wardrobes properly and compactly. This need was met by the new wire coat hangers and closets that were deep enough to accommodate them. These first closets were often located under the hallway staircase and in the bedrooms. More than a century later, designing and arranging closets has become a near science, presided over by special merchants, such as the booming chain The Container Store, and consultants who advise householders on equipment once associated with dry cleaning establishments.

One reason the American home in general and bedroom in particular grow bigger as our households become smaller is that the spoils of our unparalleled consumerism require more and more storage space. There are entire television shows, such as *Clean Sweep* (TLC) and *Clean House* (Style), that are devoted solely to the "problem" of coping with too much stuff. After they've forced people to face their jammed closets and drawers and figure out what has to go, the host-experts freshen up the suddenly spacious home. There's even a special show called *Merge* (Lifetime) that teaches newlyweds how to shed some of their belongings and combine the rest.

A specialist in how places and spaces affect behavior, Kathryn Anthony, who is the chairperson of the design faculty at the architecture school of the University of Illinois at Urbana-Champaign, distinguishes between the person who closely identifies with the home in a very visceral way and someone who's just taking part in a massive cultural buying binge. The true homebody temperament has always existed, but our domestic splurging dates to the prolonged spell of affluence that began in 1980s, she says. "When people have money to burn, they look for ways to spend it. For so

many families, it's just buy, buy, buy. Why *not* keep remodeling your bedroom and bath? After two or three years, it's time for a change! We're getting out of control."

"Affluenza" isn't limited to the bursting homes and closets of the well-off but extends to the spending sprees of the third of Americans who can't afford a home or many other big-ticket possessions. As real estate prices have soared, improved mass-production technology and global trade have made home decor much more affordable. The disenfranchised who can't buy a house or an apartment can at least compensate with some increasingly nice stuff from big discount stores like Target, says Anthony, "or Tar-jay, to give it a French twist as some people do. These stores suggest that your home is never good enough and needs constant improvement."

The high- and low-end domestic buying binges that have clogged America's closets have also cost the bedroom some of its traditional serenity. In her own home, Anthony tries to practice a simple rule: what comes in must go out. "You can't relax and clear your mind if you're looking at a lot of clutter," she says. "If I buy a new book, I give away an old one," she says. "At Christmas, I received thirty-one gifts, so I gave thirty-one items to Goodwill. It's ritualistic, but it's a good way to not accumulate more stuff."

Feng shui masters would approve of Anthony's ritual. From their perspective, the ideal bedroom has well balanced chi, or the flowing energy that pervades the world. Feng shui is not science, and some of its principles are merely superstitions. Many are commonsensical, however, and support environmental-behavioral research, such as studies of the effects of high and low levels of stimulation.

In general terms, feng shui posits that places that have too much chi—a chaotic bedroom that's full to bursting—agitate us, while places that have too little—the dark, bare bedroom that overlooks an air shaft—are boring. The messy bedroom must be purged of clutter, and the dull one must be enlivened, perhaps with some lamps, mirrors, and plants. Then the furniture must be prop-

erly configured. When you're lying in bed, you should be able to see the door, so that you won't be startled, yet not be lined up with it, which suggests a dead body being carried out feet first. Nor should the bed be placed between a door and a window or two windows, which could cause a draft, inviting poor health. The space under the bed should not be used for storage, because clutter interferes with chi's flow and the mind's clarity. If the bedroom opens onto a bathroom, the door should be kept closed and the toilet seat down, lest chi go down the drain. Finally, it's important that a couple not sleep beneath ceiling beams that symbolically divide the bed, suggesting separation.

The bedroom is where most people have sex most of the time, but in our supposedly eros-crazed culture, little or no thought goes into suiting the environment to the behavior. The room's role in our love lives is rarely talked about, but sometimes you encounter a special bedroom that speaks louder than words. In 1909, Bernard Maybeck designed the Roos House, in San Francisco's Presidio Heights, as the setting for a lovely gem. This modern mansion was a wedding present from wealthy, artistic parents to their only child, a beautiful nineteen-year-old bride. There's a grand dining room with its own fountain and a vault-ceilinged salon that holds eighty-five guests at concerts and parties. But the house's glittering public rooms are separated from its private parts by a staircase whose handrail is not accidentally covered with rose velvet.

With its marble fireplace and deluxe bathroom, the belle's large boudoir is fit for a queen more like Marie Antoinette than Victoria. The entrance is dramatically constricted by flanking closets and a dressing room, which create an aisle that leads to the centrally placed bed. With a psychologist's understanding of his client, Maybeck created a luxurious jewel box for a pampered darling, whose charms were set off equally in her sociable salon and her intimate bedroom. At first, it seems odd that a young bride's home should have only one other family bedroom, but Maybeck seems to have understood his young client, who eventually had one child,

very well. Jean Roos, her daughter-in-law, says simply that her mother-in-law was "very beautiful, and a lovely person, but not the type to have lots of babies."

The mere mention of the bedroom as a sensual setting elicits surprised looks from scholars and designers alike. As one architect says, "Nobody, including the person who obsesses about the home's every other detail, including the toilets, ever talks about sex. The closest you get is a mention of acoustical privacy. Americans have a puritanical streak, and as a result, bedrooms are not romantic enough." The only historical references to the relationship between sex and the bedroom are repressive and medical in tone, reports Cromley. The husband should move to another room when the wife is pregnant, for example, and parents shouldn't let the baby sleep in bed with them, because they could roll over and crush it. As she says, "It was really Freudian repression or denial in another guise!"

The paradox of a seemingly sex-obsessed culture's unsexy bedrooms partly reflects men and women's different ideas about what makes for a sensual setting. When late-nineteenth-century middle- and upper-class women were told to stay home and be domestic goddesses, their control over the home's decor gradually increased until, by the mid-twentieth century, they thoroughly dominated the interior. Not everyone liked the results. In 1956, *Playboy* published a defiant two-part article, complete with blueprints, of the ideal bachelor pad. Unlike most homes, said the magazine, "this is *his* place, to fit his moods, suit his needs, reflect his personality."

The *Playboy* pad's resident seems to be a hard-drinking, womanizing gearhead. His swinging apartment is very high-tech, featuring a space-age kitchen, a hi-fi system with speakers in all rooms, and rheostat lighting, lest the click of a light switch "send the fair game fleeing." The living room has a manly fireplace and a "lord-of-the-domain" chair and footstool. The adjacent study is a "sanctum sanctorum where women are seldom invited."

The playboy's bedroom's "huge" bed "dominates" the room and is conveniently near a bar and fridge, should the bachelor feel like

getting "sozzled" or "mixing a cool one for his intended quarry." Its seven-foot-tall headboard holds multiple controls that operate lights, close and open the drapes, and even turn on kitchen appliances. The pad's overall theme is "masculine richness," expressed by the rugged stone hearth, cork floors, rough bricks, vast window walls, and "primitive" paintings. In case some reader still doesn't get it, *Playboy* observes, "There is a complete absence of bric-a-brac, patterned fabrics, pleats and ruffles."

The *Playboy* pad is one of the environments explored in an iconoclastic architectural anthology called *Stud*. In his introduction, the architect Joel Sanders writes that architecture, by which he means the total ensemble from walls to wallcoverings, contributes to the "performance" of our identity in general and our gender identity in particular. He sees the bachelor pad as just one example of how a home's materials and surfaces can enable the enactment of male identity. Because rugged simplicity has come to mean "male" and complex artifice "female," corporate headquarters favor heavy club chairs and wood paneling rather than rococo and chintz. Like the steel, glass, leather, and stone surfaces in the *Playboy* pad, says Sanders, the message is that "less is more *masculine*."

Technology may be one exception to that rule. Like its *Playboy* predecessor, Rock Hudson's bachelor pad in the 1959 hit movie *Pillow Talk* tacitly acknowledges the bachelor's iffy status in family-oriented 1950s America and suggests buffing his image with settings and possessions that "accessorize his virility." In an apartment that's "a space in which the playboy performs his heterosexual masculinity," Rock, who in real life of course was gay, merely has to flip a switch for the lights to go off, the mood music to turn on, and the sofa bed to spring open, ready for his seduction of Doris Day.

Like Rock and Doris, even Tarzan and Jane had different ideas about decor. In some respects, men and women just plain perceive environments differently—and not always for cultural reasons. For example, perhaps because the care and feeding of the young require great sensitivity to sound, smell, touch, and taste, women are keener in four of the five senses. Sound asleep at 3 a.m., the father

really often *doesn't* hear the baby first. On the other hand, perhaps because provide-and-protect activities such as hunting and building—as well as picking up on sexual signals—require it, men generally have sharper sight, as well as better spatial skills. (Perhaps this male sensitivity for tracking objects in space, such as foot-, base-, and basketballs, helps explain the popularity of the den and recliner focused on a giant TV.) Although men are generally better at finding their way when outdoors, women are indeed more adept at locating keys, socks, and other misplaced objects—an ability that the comedian Roseanne Barr attributes to the "uterine tracking device."

Visual and spatial acuity notwithstanding, many men seem little concerned with domestic matters such as bedroom decor. This attitude is usually attributed to their supposed insensitivity, but the environmental psychologist Jerome Tognoli suspects an ambivalence about the home's association with femininity, intimacy, and homosexuality. As a result of these lurking fears, he says, "at home, men have been limited to caring for large pieces of equipment, making repairs, and taking out the garbage. This taboo has also constrained men in core human experiences, particularly socializing, which they often feel can be done only with their wives or in ritualized events such as poker or bowl games." However, in the postmodern era, such trends as later marriages, a high divorce rate, and an increase in the number of women in the workplace—to say nothing of *Queer Eye for the Straight Guy* and *Girl*—mean that more homes are no longer so exclusively female-oriented. As Tognoli says, "men are doing some child care and cooking—the kitchen is no longer solely the woman's domain—and are even becoming more involved in decisions about how the home looks."

Like the megakitchen with its two workstations, the master suite is often attributed to the needs of the dual-career couple, such as simultaneous grooming rituals that require two bathroom sinks. Where their sex life is concerned, however, simply having a bathroom that opens directly off their bedroom is the biggest boon. This convenience creates an atmosphere that, if not overtly sen-

sual, at least supports intimacy by eliminating a trip down a "public" hallway after lovemaking, as happens in many houses and apartments. This sort of low-key but important amenity is likely to come up when architects are pushed to think about how they would respond if a client asked them to design a sexy bedroom. When pressed further, instead of evoking images of bordellos or Las Vegas hotels, they tend to mention fireplaces and views of sunsets and use adjectives such as *comfortable* and *serene.*

The bedroom's serenity and privacy also make it the home's likeliest place for prayer or meditation. Householders of the nineteenth century's industrial revolution sought domestic refuge from their new anonymous, automated world. Many Americans who suffer from the postindustrial version of this angst also look to their homes, rather than to churches and synagogues, for life's meaning and renewal. For many of those who define themselves as "spiritual, not religious," a just-right bedroom includes a statue of Buddha or St. Francis, a yoga mat or zazen cushions.

Of course, in other cultures, the home has always been a spiritual center. The environmental psychologist Sanjoy Mazumdar, in collaboration with his wife, Shampa Mazumdar, follows how some post-1965 immigrants, many of whom are from Asia, modify their new American homes for religious purposes. For Hindus, for example, "going to a temple is just one component of religious practice and not necessarily the most vital one," he says. "The individual's personal communion with God, not praying together, is most important. Much of this occurs at the home, where altars are created, which makes it a sacred place."

Some Hindus devote a room to a shrine, which might have images of deities, special objects, such as stones from the Ganges, and incense or flowers. Its location is especially important because a Hindu home has sacred, intermediate, and profane spaces of high, medium, and low degree. (The bathroom is the lowest level of profane space.) In India the altar is often at the top of the stairs, near the door to the rooftop, so people couldn't unintentionally defile it, say, by wearing shoes. In one American home, the altar was in a se-

questered space underneath the stairs, which seemed ideal until a toilet on the floor above broke. After the plumber had to snake out the blocked drainpipes near the shrine—while also wearing shoes—the family moved the shrine. Despite such complications, says Mazumdar, "many people become more involved in religious practices and shrines in America than they were back in the old country. Here, without the social and environmental supports available back home, that extra effort is needed to maintain their religious life. They might have nothing but that."

The privacy that suits it to be the home's personal sanctuary and romantic getaway also makes the bedroom the likeliest setting for the expression of negative emotions, from loneliness and sadness to the anger that fuels fights and even violence. As the psychologist Susan Painter, who practices design psychology with Connie Forrest, puts it, "The bedroom is ground zero for intimacy. If it's happening, intimacy happens there, and if it's not, the lack is probably most deeply felt there. There's a profound loneliness in being in a room that's meant for intimacy but not having it."

Loneliness is one thing, but in her previous work on the prevention and treatment of domestic violence, Painter found that the bedroom is a frequent site for abuse. The sexual assault of children frequently occurs in their rooms, and forced sex is often a part of spousal violence. Even for those who aren't direct victims, such a home offers no sanctuary. "It's almost as if the walls dissolve," says Painter. "The children lie in bed listening to their parents fighting at night. There's no place to hide. Everyone pretends that no one can hear and that the children don't know what's going on, but that's completely untrue. There's very little refuge, particularly for children."

The popular notion of the happy home notwithstanding, past trauma or present conflicts mean that many people have or have had a very negative experience of domestic life. Moreover, says Painter, "each time such a person comes home, he or she gets that feeling of dread, even if it's subtle. That's why people need to know

how to recognize and avoid the environmental cues that retrigger their bad experiences."

To illustrate how the shadows of a past home can cast a pall over the present one, Painter describes a young woman who had been happily married for six years before moving to a new house. Suddenly, she started fighting with her husband. She recalled that when she first entered the house, it had seemed familiar, and with Painter's help, she realized that her new home had the same floor plan as the house where she had lived during her parents' ugly divorce.

Because the bedroom is one of the home's affective hot spots, it's worth considering how those of the past influence the present version—particularly for the traumatized, who can subconsciously feel drawn back to the "scene of the crime." According to a phenomenon that psychologists call repetition compulsion, when someone subconsciously repeats a destructive experience, as when the child of an alcoholic marries an alcoholic, he or she may be trying to re-create the situation in order to correct it by "getting it right this time." Thus, the layout of her new house prompted Painter's client to reenact her parents' battles with her own husband, in a vain attempt to resolve that old conflict. When she stopped blaming the fights on her own marriage—the obvious catalyst—and considered the house's role, says Painter, "her question became whether they could now live there happily or whether they should move to a new home."

Such house thinking is particularly important—and often overlooked—during life's challenging or downright dark times. Soon after her husband died prematurely, Kathryn Anthony got a fresh, firsthand perspective on the role of our homes in general and bedrooms in particular in the way we cope with stress. When she joined a support group for the widowed, one member confessed that she couldn't even open the door to the bedroom in which her husband had been ill, while another said she had immediately replaced her queen-sized bed with a twin. An important part of Anthony's own environmental-behavioral adjustment to widowhood

was dealing with a house full of her late spouse's worldly goods. "He was the original pack rat who saved everything," she says. "Going through it was so painful, but it was part of my grief process."

Using domestic imagery to explain the connection between the home and our ability to deal with serious stress, Anthony says that right after losing a partner, "you feel like your life is a rug that has unraveled under your feet. You have to figure out whether you want to weave it back together or get a new rug. You experience a major identity crisis, and how you treat your home is an important part of how you resolve that." One in recovery is to think about how the loss is manifested in the environment and whether the home is helping or hindering the bereavement process. Recalling how the two widows in her support group reacted to their bedrooms, Anthony says that the extremes are "the home that's frozen in time and the one that has become unbearable and must be left quickly."

The distress caused by a suddenly desolate home and bedroom can be experienced by the divorced or rejected as well as the widowed. In fact, in her research on the home's role in family breakups and conflicts, Anthony found that frequent arguments about the home itself were a predictor of divorce. For people who ended up parting, the house or apartment was not the only problem, she says, "but often the straw that broke the camel's back. A lot of the issues concerned control, territoriality, privacy—who has how much closet space, power over the TV or music system, and so on. If other things are not going well, stress about the home can tip a couple over the edge."

Offering an example, Anthony describes a professional woman who was an absolute perfectionist about her home, which was in a state of constant redecoration. She and her husband would paint a bedroom one day, then repaint it the next. For a long time, the man just went along—"it was her way or the highway," says Anthony—until he finally got fed up, and they divorced. "The house was a symbol of their marriage. Maybe the lesson is that a home that

looks perfect from the outside comes at a hidden price."

Even from a purely environmental perspective, trying to "cure" a sad, lonely bedroom with a hasty move to a new home can have profound and often unsuspected behavioral consequences. If you leave a high-rise apartment that provided a lot of natural light and views for a dark loft overlooking an air shaft, the physical setting could add considerably to your emotional misery, although you'd be likely just to blame the lost relationship. The impact of such environmental changes is easier to see and study in the less complex workplace, where switching from a windowed office to a windowless cubicle, for example, produces immediate grumbling, decreased productivity, and increased absenteeism and turnover. The same thing happens in houses and apartments, but it's harder to interpret, says Anthony. "The distress caused by the environment gets translated into depression, feeling uncomfortable in or avoiding the home, not entertaining—a whole array of reactions."

If the person in average circumstances needs the refuge of a supportive home and bedroom, that comfort is even more important for someone who's stressed or troubled. Yet mental health professionals, who should understand how their clients actually live, rarely ask, "What is your home like? Can you show me some pictures? Can I make a house call?" says Anthony. "A client might say that she was living in one room with two or three kids, but unless the social worker pays a visit, she won't really grasp the kind of pressure that setting places on a family. She wouldn't see the context in which her client's problems occur, which includes trying to cope in that tiny room." Nor would the professional be able to suggest some seemingly small, low- or no-cost changes that can yield big benefits, such as increasing privacy and efficiency by rearranging furniture, using overhead storage to reduce clutter, or adding multipurpose pieces, like a sofa bed.

Perhaps thinking of a master suite whose vast walk-in closets are crammed to bursting, Anthony describes a couple who enter marriage counseling but "kind of skirt around their real problems." In sessions, even if one partner brings up their messy, chaotic

home, say, or hoarding—"very common among academics," reports Anthony—the therapist won't necessarily understand the problem's magnitude. During a house call, however, he or she could actually see the impact of collecting magazines and newspapers for the past twenty years, to the point that they block circulation and take up a whole bedroom—or three. Then, says Anthony, "the problem at home becomes part of the treatment. How is the couple going to deal with the mess? And, by extension, their other conflicts?"

The bedroom's private nature should encourage us to make it exactly the way we want it to be. That the reality often falls short of the potential is just one example of the disconnect between our homes and our awareness of the kind of daily experience we *could* have there. "People simply aren't accustomed to thinking about why they feel certain ways in certain places and not in others," says Susan Painter. When they do, they perhaps realize that despite what's in fashion, *their* bedrooms must be purple. As she says, "Just doing the room in Laura Ashley or Santa Fe or some other style from a TV show or magazine is to miss a chance to do something that could have a huge impact on your life."

Although I don't work in bed or have Edith Wharton's staff, after the kids are off to school, I put my breakfast on a tray, grab the newspaper, and go back to my nest to caffeinate, read, and get my thoughts together. One day, I looked up from my mound of pillows and realized that the bedroom had taken on the fuzzy look of a place that has too much stuff in it. Rather than a tranquil refuge, the room felt like a big closet. Over a weekend, Mike and I went through our drawers and closets and came up with a carload for the Salvation Army. I attacked the teetering stacks of magazines and papers and dispatched another load of books to the library. Freed of the visual static, the room felt harmonious again. Mike contributed the pièce de résistance to our minor makeover: a latch on the door—a dollar's worth of hardware that ensures priceless privacy in a busy home.

One of the best things about our bedroom—one of the home's oldest, least changed places—is that it opens onto a bathroom one of its newest. The bathroom offers many benefits, from hygiene to spalike refuge in a stressful world, but it's a complicated place that can be the site of much anxiety, particularly concerning our bodies.

The Bathroom

Mirror, Mirror on the Wall

The sprawling "Old House" in Quincy, Massachusetts, which was occupied by four generations of the increasingly prosperous Adams family, is a different world from the humble saltboxes across town where Presidents John and John Quincy were born. Most visitors to this later, much statelier home are drawn to the lovely formal garden or John Quincy's handsome library with its 12,000 books. Some pragmatic sightseers, however, must be intrigued by the laundry room and its equipment, which date to Charles Francis's tenure in the 1850s. The room's most interesting items aren't meant for washing clothes, however, but bodies.

To us, bathing means reclining in a long tub or standing beneath a pounding shower in a special room. In the days before indoor plumbing, the Adamses had different options. The short, deep sitz

bath was designed for a seated bather. A kind of protoshower, the "hat bath" resembles an overturned top hat; a servant would drizzle the bather with water, which was caught by the upturned brim. The comical-looking huge metal boot soaked sore or cold feet. The Adamses didn't bathe in the laundry, of course, but in their bedrooms, to which servants lugged the necessary vehicle and hot water.

Later in the nineteenth century, the accelerating industrial revolution ushered plumbing into the home in two ways. The crowds who flocked to the cities for the new jobs overwhelmed the old backyard privies, which often sat next to wells and pumps; the resulting typhoid and other deadly diseases speeded the development of municipal water and sewage systems. On the technological plane, there were mass-produced metal pipes and the new sanitary ceramics used for inexpensive toilets modeled on the trusty privy seat; similarly, sinks were based on the old washstand and basin, and tubs on the portable version.

By the 1870s, many wealthy Americans had indoor plumbing and flushing toilets. Many average citizens had also sampled the wonders of modern plumbing in institutions, notably hotels, which proudly advertised centrally located hygienic baths and toilets, much as our motels boast about their hot tubs and swimming pools. Around the turn of the twentieth century, when the Adams family transformed a small upstairs bedroom into a plumbed bathroom equipped with a full-sized zinc bathtub, such amenities were no longer just for the rich, but standard parts of the American home. Practicality dictated that the pipes and equipment for both elimination and ablution should be in the same room or at least an adjacent one. The increasing value placed on privacy mandated that this new bathroom should be upstairs—in older houses such as the Adamses,' often in a bedroom converted for the purpose.

One of the home's newest major developments, the bathroom quickly became a sine qua non that inspired profound changes in domestic behavior as well as architecture. For most of American

history, most homes didn't have special rooms for elimination or washing the body—nor had people particularly associated the two functions—yet they contained the bathroom's prototypical components.

Before the toilet's triumph, people eliminated either outdoors in a privy or indoors, usually in a bedroom, into a ceramic chamber pot, which might be kept in a closetlike "closed stool." (In eighteenth-century England, George Hepplewhite even designed a special dining room cupboard that concealed a vessel for men's use after the ladies left the table.) The chamber pot's contents were generally dumped in the street, the privy, or on a backyard dung heap. Elimination was inconvenient, unsanitary, and not even necessarily private, considering that sleeping quarters were generally shared. European royals sometimes asked courtiers to attend them and even converse during such moments, a practice called "the French courtesy."

Considering its simplicity and utility, it's hard to believe that the flushing toilet, which can operate with mere gravity and water, has only been part of the home about as long as electricity. In the eighteenth century, the French produced flush toilets—Thomas Jefferson had one in Paris—but they were rarities. (The invention was perhaps overshadowed by a celebrated mechanical fowl that "ate" food, then evacuated it, causing Voltaire to remark, "Without the shitting duck, there would be nothing to remind us of the glory of France.") By 1861, the Englishman Thomas Crapper could brag of his eponymous product, "A certain flush with every pull," and Martin Van Buren, the eighth American president, would install a newfangled toilet at Lindenwald, his estate in Kinderhook, New York.

One reason for the prolonged scarcity of toilets is that like most things before industrialization, they had to be made singly by hand and thus were very costly. On a more philosophical, if for us disconcerting, plane, people weren't eager to have human waste in the home because they thought it simply too unclean (as it is still regarded in much of the developing world). The general aversion to

body wastes and their stink helps explain why even the rich technophile Jefferson didn't install toilets in any of Monticello's three indoor privies, and why his personal privy was carefully vented. (Of course, like the other wealthy people who could have afforded a toilet, Jefferson had others to deal with such infelicitous aspects of domestic life.) Our Victorian forebears were especially sensitive to odors and presumably unhealthful "bad air." In well-off homes, disgust even at the cooking smells that we relish helped banish the kitchen to the basement, the back of the house, or to separate service quarters.

We smile at our forebears' own notions and customs, but our feelings about the intimate care of our bodies and the modern bathroom in which it occurs are no less complicated or fraught with anxiety. Indeed, since its debut around the time of widespread awareness of the germ theory of disease, the bathroom has been a locus of anxiety. In the mid-nineteenth century, illnesses such as tuberculosis, typhoid, pneumonia, diphtheria, and scarlet fever, which were then leading causes of death, were linked to "ferments" in the air and water, which Louis Pasteur would identify as microbes. Before modern drugs, however, prevention in the form of high heat or chemical disinfectants was still the best cure for many diseases.

Once the germ theory was established, hygiene became both a virtue—"Cleanliness is next to godliness," declared the nineteenth-century evangelist John Wesley—and a science. MIT opened a laboratory devoted to sanitary research, and even primary and secondary schools began to teach health practices. On the community level, new laws regulated municipal garbage collection, sewage systems, and water filtration. In the home, however, women waged the war on germs. Because rampant illness among the poor threatened all classes and because all women wanted to protect their families, they were unified against a common enemy. Depending on her station, each woman could do *something*, from serving on a public health committee to scrubbing the home.

The housewife as hygienist was a radical image. As the histo-

rian Nancy Tomes points out, women themselves had always been regarded as somehow unclean. Even in the early twentieth century, a public health official could write, "The infectious diseases in general radiate from and are kept going by women." If housecleaning was science, however, women must be able to grasp "male" subjects—another heretical notion. Hostility and condescension notwithstanding, women proceeded to become hygiene experts through such channels as ladies' clubs, magazines, doctors, and rural education programs.

On the home front, like the kitchen, the bathroom was a major battlefield in the war on germs. The toilet was thought such a threat that it had to be disinfected daily; even its odors were deemed infectious "sewer gas." Farm women who didn't have indoor plumbing were urged to demand a sewage-tight, screened, sanitary privy that was well away from the home's water source. Some poor women, whose lack of resources made cleanliness a backbreaking endeavor, felt guilty about causing disease through inadequate housekeeping. Tomes quotes a farm wife who had enrolled in a home extension course: "Poor me. I know if everything had been kept properly my children would be alive and well."

By the 1920s and '30s, municipal and domestic technology had brought about better living conditions that lessened the need for exhaustive home sanitation. Fighting heart disease and cancer, now leading causes of death, replaced the war on germs, which came to seem "quaint," if not worse. Tomes's more sanguine view is that although some theories, such as the dangers of dust, proved incorrect, in an era in which prevention was the only weapon against infection, the cleanliness campaign curbed disease.

Despite the addition of many new functions, from contact lens maintenance to stress relief, the average bathroom's layout and fixtures have changed remarkably little since the 1920s. When the Cornell architecture professor Alexander Kira took a behavioral look at the bathroom, he found much to be desired. Sinks are too low for comfortable washing. The bathtub's back is often not properly sloped to promote relaxation. Showers are too constricting

and lack seats. The toilet is too high, which can produce splashing during urination and interferes with the ideal method of defecating: in a squatting position, with thighs pressed to the abdomen.

If our bathroom fixtures are far from perfect, so is our behavior there. Regarding perineal hygiene, Kira writes, "Of all the normal body cleansing activities, these are undoubtedly the least understood, the least discussed, and the least performed." He remarks on the inadequacy of the male practice of post-urinary "jiggling" and the folly of not using a bidet after defecating, particularly considering generally poor wiping skills.

After years of research, Kira concluded that the bathroom is the single most undeveloped area in the average house today. After all, the kitchen, which was historically the home's lowest-ranking room, has become its social center, so we might take seriously his suggestion that we consider the bathroom's "living room potential."

Just as our forebears waged their war on germs, we express our health anxieties in our homes in general and bathrooms in particular. Part of the recent phenomenon of "sick homes," mold became a household concern in the 1990s, when fungi were detected behind wallboard dampened by leaks or poor construction. The mold was blamed for numerous health problems, but many of these claims remain controversial. Nevertheless, thousands of householders filed lawsuits, and insurance companies increasingly refuse to cover mold problems. Despite the aggressive marketing of expensive new antifungal products and techniques, the best ways to prevent mold remain sound building practices and prompt attention to leaks.

Our anxiety about healthy homes feeds a huge market for products that can make things worse. Toxiphobics worried about biological warfare and new diseases such as SARS can build dream homes with steel that's coated with AgION, a compound said to kill bacteria, fungus, and mold, and install door handles and faucets specially treated to kill microorganisms. Average Americans, too,

pony up for more than 1,000 unnecessary "antibacterial" household products, from telephone swabs to liquid soaps. Rather than producing a decline in infections, however, these agents contribute to our vulnerability to drug-resistant "superbugs." What *does* help prevent illness is vigorous handwashing with regular soap before meals, after using the bathroom, and at other obvious times—as recommended a hundred years ago by sanitation scientists. However, only 58 percent of men and 75 percent of women follow this simple, very effective health practice.

The Greeks and Romans wallowed and lolled in their baths for the sheer pleasure of it, but for those who came after them, cleaning the body was long a source of anxiety. Indeed, early Christians regarded dirtiness as a sign of unworldly piety. From the medieval era to well into the nineteenth century, as the Adamses' array of vessels suggests, washing the whole body was considered unhealthful by most, inconvenient by many, and sinful by some. True immersion in a tub was rare, and bathing meant cautiously daubing body parts with water. Even soap was not widely used until it was linked to preventing disease and could be mass-produced.

As full bathing became more popular, well-off families like the Adamses washed in their bedrooms, and average folk periodically immersed in a portable tub, often in the kitchen, where the stove or fireplace warmed bather, room, and water. As in so much of home life then, status dictated who got the first dip, so the household's lowest-ranking and often dirtiest person climbed in last. This parsimony is more understandable if you consider that gallons of water had to be procured, heated, transferred to the tub, and then emptied out again by hand.

In our well-plumbed culture, a daily bath or shower is the norm. Thus ensuring personal daintiness is harmless enough, but for some people who suffer from obsessive-compulsive disorder (OCD), the bathroom and its sink and tub are sites of tortured rituals meant to relieve truly debilitating anxiety. As one such person puts it, these individuals seem to "just feel sort of dirty somehow."

We all have disturbing, intrusive, repetitive thoughts some-

times: "What if my hands are still germy after I've washed them?" Most of us are able to shrug off these nagging ideas and think about something else. However, a neurological glitch causes others to get stuck in the notion, replaying it over and over. In a desperate but futile attempt to relieve the repetitive idea—the obsession—they come up with an action meant to quell it—the compulsion. Many compulsions involve cleaning, such as washing the hands ten, or a hundred, times instead of once, or taking multiple showers each day.

Freud traced this chronic feeling of dirtiness to early childhood's bathroom, where a toddler's hostile Oedipal feelings were aroused during toilet training. By Freud's lights, someone who feels compelled almost to live in the bathroom wants to spite his or her parents and play with feces but must repress this awful desire. (One theory about why many people read in the bathroom is that the activity distracts them from such unseemly conflicts, which can interfere with *le moment juste*.) Because psychoanalysis and psychodynamic therapy are almost completely ineffective in OCD's treatment, however, researchers eventually looked for a biological cause and pharmacological cure. They traced the trouble to the brain's caudate nucleus, which is involved both with anxiety and with animals' repetitive movements, such as grooming and nest making, and found that a versatile antidepressant called clomipramine gave most patients striking relief. Like other psychiatric disorders, OCD is an extreme on a behavioral spectrum on which all of us appear someplace. Even cultures have devised ways, such as India's caste system and Judaism's kosher diet, to help people deal with our inevitable anxiety about contamination.

Technology that helps us obsess about our skin, weight, or other real or imagined imperfections ensures that our up-to-the-minute bathrooms prompt new worries. Through most of the nineteenth century, only the wealthy had a so-called looking glass, so most people simply couldn't fret about their appearance and complexions. By the 1880s, however, many people could buy cheap mass-produced mirrors. Not coincidentally, the Cornell historian

Joan Jacobs Brumberg traces the modern anorexia culture back to the emergence of technology that "enhanced our capacity for self-scrutiny."

Just as staring into a mirror had long been limited by the means to do so, getting weighed used to be something that happened once in a while, perhaps in a store, gymnasium, or doctor's office. As soon as bathroom scales hit the market after World War II, however, "weight became more important to self-definition," says Brumberg. "The historical record shows that the kind of preoccupation with the body that leads to eating disorders has an inescapable technical and domestic side." When she examined girls' diaries from the colonial period to the present, chronicled in *The Body Project*, Brumberg found that over time, girls' interests "move from good works to good looks," she says. "That shift has to do with broad social, economic, and cultural changes in society, from which anorexia nervosa eventually emerged as a modern disease." Nor are girls today the only victims of an "anorexia culture" supported by homes in which "you can never be too rich or too thin," adds Brumberg. "These days, boys have more eating disorders than they did in the past."

Considering the way in which products that facilitate the hyperscrutiny of our bodies are flooding the market, it's no wonder that Brumberg calls the bathroom a "site for adult narcissism and adolescent anxiety." A simple bathroom scale is one thing. The Matsushita toilet, which not only automatically weighs users, but also checks their body fat ratio and analyzes the sugar in their urine, is another. Narcissus of Greek myth was limited to gazing at his reflection in a pool. We have full-length and magnifying mirrors with which to compare ourselves to advertising and media images of physical perfection that only sap our confidence. In one study, young men who were shown some TV commercials that featured fit, muscular hunks felt more depressed and anxious about their bodies afterward than those who watched neutral ads.

Most of us know a perfectly normal-looking person who's convinced that an imagined or slight physical imperfection, such as

thin hair or a large nose, is a serious deformity. According to the American Psychiatric Association, such a person may have body dysmorphic disorder. Underscoring the connection between environment and behavior, the APA's *Diagnostic and Statistical Manual of Mental Disorders* notes that one symptom is spending considerable time in the bathroom, which affords the privacy and means for examining and brooding over flaws: "Frequent mirror checking and checking of the 'defect' in other available reflecting surfaces can consume many hours a day. Some individuals use special lighting or magnifying glasses to scrutinize their 'defect.' There may be excessive grooming behavior (e.g., excessive hair combing, hair removal, ritualized make-up application, or skin picking)."

The bathroom doesn't *cause* emotional problems such as eating, obsessive-compulsive, and body dysmorphic disorders, but its environment can passively support such skewed behavior. If its scales and mirrors are the props of anorexia, the room with a locking door—sometimes the home's only one—is also essential to the practice of bulimia. That some parents and other householders are unaware of such disturbed behavior under their own roofs suggests the important role that the private domestic environment can play in such "secret" illnesses.

Fortunately, the bathroom's seclusion can relieve as well as foster angst. As mothers of small children or teens making personal phone calls know, its locked door guarantees a few minutes' peace and quiet. A study of 200 households showed that regardless of a home's size, half of the residents who had only one bathroom felt stressed by their perceived lack of living space, as opposed to 20 percent of those who had more than one.

Although the bathroom can be a disturbing place that helps some of us feel dissatisfied, for others it's increasingly an environmental solution to stress—an almost a spiritual refuge after a hard day. Advertisements now often use terms like *oasis* and *retreat* when promoting big "soaker tubs" that accommodate Americans' chubbier bodies and "chromatherapy showers" that beam rays of color

as well as water. The huge Kohler company advertises a design scheme for a Japanese-shrine-like bathroom called "the Purist" that's all about "the art of water." Even the high-priced, aromatherapeutic products for scrubbing these bath-spas have names like Pure Grass and Beach Home, which sound more like poems than cleansers.

Not all nice, relaxing bathrooms look like ads in a plumbing-fixture catalog or a honeymoon hotel brochure. After their kids left for college, the architect Bryan Grunwald and Judy, his wife, wanted a bigger, nicer bathroom that, he says, "wouldn't stick out like a sore thumb" from the rest of their vintage Bay Area Craftsman house. First, Grunwald turned two small baths into a single large space and installed new high-end plumbing fixtures, a handsome glassed-in shower, and a custom vanity cabinet with a stain-resistant polished granite top. Then, determined to avoid the common sci-fi, Vegas, and old-timey bathroom clichés, he focused on seemingly small design elements that convey a quiet sense of quality and serenity that complements the house's style without copying it.

The tiles of the bathroom's upper molding, which portray curving fish, were designed by the Arts and Crafts designer William Morris, whose work helped inspire the Craftsman house movement. The lower molding's dark blue tiles are slightly thicker than the wall's white ones, which creates a subtle lip. Grunwald extended the wooden molding, used for hanging pictures, that runs throughout the house into the bathroom, both unifying it with the other rooms and shading the overhead lighting. The result of this painstaking care is a spacious, handsome bathroom that harmonizes with the rest of an old home yet gives busy people a tranquil modern space for getting away from it all.

Environmental psychology has several conceptual models to explain how places, from subway platforms to spa baths, create and relieve life's inevitable stress. According to the arousal theory, in response to external stimuli, a brain structure called the reticular formation becomes more or less active, which in turn causes corre-

sponding changes in heart rate, blood pressure, and other metabolic measures. Therefore, when we want to relax, we head for a quiet, soothing place like the tub that won't set the brain churning. When we want excitement, we go for bright lights and loud music. Too much stimuli overwhelms us and can make us aggressive or interfere with our level of performance. That's why we're likelier to be cross in a hot, cramped kitchen with several pots on the boil than when in the shower, for example, and to excel at chess in a tranquil setting that might otherwise bore us.

By the lights of the environmental load theory, we can only process so many incoming stimuli before we short-circuit and long for the sanctuary of the spa. If Jane is reading, and her daughter turns on some music, Jane can refocus. If her son then barges in with a friend just as the neighbor's car alarm goes off again, Jane's nervous system is overloaded, and she slams down the book. The more intense, unpredictable, and uncontrollable the noxious stimulus—the alarm, for example—the less we're able to ignore it, and the more prone we are to botch or abandon our chosen task. Unfortunately, the effects of environmental overload, from irritability to head- and neckaches, affect us even after we leave the troubling setting, which explains why we may need to unwind in the tub or shower after a tough day.

Fans of the sauna or steam room intuitively sense the stress-relieving potential of understimulating environments. Research on restricted environmental stimulation shows that time spent in low-arousal environments—usually dark, soundproof chambers—can be therapeutic, particularly for those suffering from hyperactivity, high blood pressure, and nicotine addiction. If some of us delight in tuning out the world in a spa bath, however, others avoid lingering in such low-stimulation settings. Without external distractions, they look inward and end up ruminating on their worries. As the increasing popularity of phones in the bathroom suggests, many people regard solitude as a negative experience.

According to the adaptation level theory, we seek places that,

like a deluxe bath, offer pleasant levels of sensory and kinetic stimuli, such as moving water, as well as the social sort supplied by people and bathroom phones. Too much of any of these three types of input frazzles our nerves, and too little leaves us bored. Sensory, kinetic, and social stimuli each vary according to intensity, diversity, and pattern, which are the elements that determine an environment's ratio of predictability to surprise. The utilitarian cookie-cutter bathrooms of old—especially the windowless ones in many apartments—have too much of the former, while a customized bathroom with a nice view has just the right amount of the latter.

Having to share a bathroom is a good illustration of the control-constraint model of environmental stress. According to this theory, when something in our environment goes awry—say, a rent increase requires us to get a roommate—we first devise a coping strategy to take charge of the situation. To deal with the roommate, we set up psychological and perhaps even physical limits, such as designated shelves or times of use, meant to give us some psychic space. If our efforts work, we feel more in control, but also possibly less able to cope with yet more stress. If the roommate is a needy narcissist who ignores our signals concerning privacy, however, we might give up and sink into the passive state called learned helplessness that's linked to depression. The control-constraint model is particularly relevant to the very young and old, who have less command over their living conditions.

The person who comes home after a brutal day to discover that a recurrent plumbing problem makes it impossible to have that long, soothing shower illustrates the environmental stress theory. Its thesis is that home and other places can present us with many different chronic aggravations, which are made worse when several converge. If the shower we just had repaired trickles to a halt again just as the kids start a fight and the neighbor blasts some rap music, our stress level really soars.

These scientific frameworks for understanding the interplay

between our environments and behavior are highly conceptual and often overlap, but they offer useful ways to experiment with house thinking. If you tend to feel crabby in the kitchen and tranquil in the bathroom, looking at those settings through the lenses of some environmental-behavioral theories and trying out some changes makes lots of sense.

Thinking about the impact of the bathroom on behavior inspired me to make two changes in ours. First, I got rid of the scale--too much information. Then I bought a space-age Japanese toilet seat that functions as a bidet--a luxury I've wanted ever since that first trip to Europe. If our bathroom is going to have technology, it's going to be the kind that makes us feel good.

One of the best things about our house is that the kids have a bathroom upstairs, to say nothing of their own bedrooms, which are important for the privacy and sense of control that foster healthy identity and development. Generally, the home has become a much better place for children than it was during most of history. However, the domestic environment also poses new behavioral risks for kids, particularly from excessive consumerism and chronic overstimulation. Whether from long hours before the computer and TV or the noise and crowding in cramped apartments, many children are barraged by stimuli that can tax their immature nervous systems and invite behavioral problems.

The Child's Room
A Place to Call One's Own

The David Gamble House, in Pasadena, California, designed by the architects Charles and Henry Greene in 1908, is one of America's most beautiful homes. Visitors to this icon of the Arts and Crafts style inevitably ooh and aah over the house's glorious craftsmanship and detail. There's the famed central staircase, the dining room's "art glass" window depicting a blooming rose bush that opens onto the real thing, and the carved wooden frieze of a night scene, complete with bats, in the living room's darkest corner. Distracted by such poetic delights, visitors can easily overlook some of the house's more prosaic but behaviorally and socially significant features, such as the unusual bedroom of the family's children.

The Gambles' two sons shared a room that the Greenes designed especially for young males. The era's swashbuckling view of boys, illustrated by the swords over a simple brick hearth, rustic

cabinetry, and lanternlike lighting fixtures, was strongly influenced by the macho, roughing-it style of President Teddy Roosevelt. (The bedroom's most remarkable feature, however, is its lack of beds. At a time when sleeping in the fresh air regardless of the season was thought to be both healthy and manly, the rich young Gambles bundled up and bedded down in a simple outdoor sleeping porch.)

Throughout most of history, people would have been astonished at the idea of going to such trouble to make domestic spaces especially for children. Even in well-off homes, they often shared sleeping chambers that weren't much nicer than the servants'. Children were regarded as what Evelyn Waugh later called "defective adults," who should drop their perverse ways and act like grown-ups as soon as possible.

In the Victorian era, middle- and upper-class children's lot in life improved. Romanticism helped to upgrade their status by idealizing them as angelic innocents, à la Dickens's Little Nell. For the first time, kids even had special bedrooms and quarters called the nursery. New mass-produced articles, such as prams and high chairs, made them safer and more comfortable. Yet Victorian children were neither indulged nor allowed to wander freely through the home. Keeping much of it off-limits to them preserved adults' peace and quiet, protected their fine possessions, and saved the children from many accidents.

By the turn of the century, the modern view of childhood as a developmental process and of children as individuals with particular identities was profoundly changing home life. Like the Gamble sons, many boys now had rugged, martial, or outdoorsy rooms, while girls got ruffles and gingham or the equivalents. The extremes of gender-specific decor may strike us as overdone, but back then, such attentions signified children's improving status—particularly for girls, who were also benefiting from serious reforms such as high school education.

The young were now also allowed to roam the home—a policy that has drawbacks as well as rewards. Their new freedom gave children more kinds of experience and varied opportunities for

play, which is the real "work" of early childhood. On the other hand, kids are too small, weak, and inexperienced to function well in many settings, which accounts for their high rate of accidents. Parents of small wanderers had to reorganize and childproof their homes and no longer had a sacrosanct living space all to themselves. (Partly as a result, by the 1920s, when cleaner furnaces and other technological improvements made it more habitable, some basements were converted into a play area, or rec room.) By the postwar era, the casual family room or den that's oriented around the TV further diminished the importance of the formal living room that had been the last adult refuge.

The child's home has improved over the past century or so, but it's not perfect. Children under the age of about twelve remain an environmentally underprivileged group in a world that's mostly designed for adults, which puts them at risk, particularly where sudden confrontations with cars are concerned. Their spatial needs still get sandwiched in around those of adults, so that kids often get the least private, smallest bedrooms; even in today's spacious homes, the average child's room is shrinking as the master suite inflates.

Greater awareness of health risks, consumer safety, and crimes against children mean that they're more heavily supervised for more years than in days of yore. From protective gear for the playground to electronically monitored bedrooms, this intense postmodern concern about safety is a new, under-remarked domestic behavior. Whether it's a reasonable response to what may be a more dangerous world or just an increase in anxiety that gets communicated to kids remains unclear. There's growing concern, however, about the impact on kids of the culture's unbridled consumerism and thraldom to electronics, which can chronically overstimulate immature nervous systems.

The idea that even a child deserves a room of his or her own accords with the high value that American culture places on individuality and independence—right from life's start. A survey of twelve cultures shows that only in the United States do infants

often have their own bedrooms, to say nothing of beds—a degree of spatial indulgence that requires more wealth and fosters a different domestic life than prevail in most of the world.

The house that the architect Walter Gropius built for his family in Lincoln, Massachusetts, in 1938 is mostly admired for its living area's vintage modernism. With its flexible open design and fine furnishings, including Gropius's own bentwood chaise longue covered in fluffy white sheepskin, the public zone is certainly classy. From a behavioral point of view, however, one of the house's best spaces lies up the curvy sculptural staircase on the family's private second floor, where Gropius designed a bedroom especially for Ati, his daughter.

Unlike many young people's rooms, Ati's is no afterthought or second-best space left over after the adults' needs had been met. The large room is in no way ostentatious, but it was created with a particular client in mind. Ati loved the outdoors, so her room opens onto a deck. Even small details, like the fishnet curtains that soften glare but don't obscure daylight or views, increase her access to the countryside. Most important for a young lady who especially valued her privacy, her architect designed a special alcove for the bed, which Ati could curtain off from the rest of the room.

As anyone knows who ever made a hideout from a blanket and clothesline or a big cardboard box, children delight in creating private refuges. Describing one of his earliest recollections in his autobiography, *Speak, Memory*, Vladimir Nabokov recalls playing in a "primordial cave" behind the drawing room couch: "History begins (with the promise of fair Greece) not far from one end of this divan, where a large potted hydrangea shrub, with pale blue blossoms and some greenish ones, half conceals, in the corner of the room, the pedestal of a marble bust of Diana."

Nabokov's cave and Ati Gropius's simple, well-considered bedroom illustrate the fact that the real riches of a child's special place have little or nothing to do with lavish decor and gadgetry. For kids no less than their elders, exploring the world is more appeal-

ing when they can venture forth from and retreat to a secure base. As the works of John Bowlby, D. W. Winnicott, and other researchers show, particularly between the age of four through adolescence, children benefit from having a stable, sheltering place to call their own that supports their development of a sense of self, a consistent way of life, and feelings of mastery. Even the ability to decorate and otherwise personalize their rooms—our first experiments with house thinking—boosts children's sense of well-being.

Where development is concerned, children who have rooms of their own enjoy the privacy and control over their own experience that are two pillars of a healthy identity. The great benefits of having the power to be alone when desired are often overlooked in sociable, extroverted American culture, which assumes that children are best off in groups. The large experiment of raising children communally on Israeli kibbutzim, however, caused some behavioral scientists to question whether such children, who indeed grew up to be well socialized, sometimes lacked certain subtle refinements in their inner lives and intimate relationships. As the environmental psychologist Gary Evans, who studies how the physical environment affects children and families, puts it, "The door is an incredible invention. We take it for granted, but open or closed, it's the ultimate way to regulate social interaction."

Of course, many American kids don't have their own bedrooms but share one with a sibling, as the wealthy Gamble boys did. In that case, says Evans, parents should encourage the kids to be appropriately "territorial," such as helping them find ways to "own" and control part of the room. Certain types of space, such as an L-shaped room, are inherently easier to share than the usual rectangle.

In some important ways, a child's room is more like a studio apartment than an adult's bedroom. Children spend a big chunk of their time—20 to 30 percent—just hanging out, talking, and fooling around, and much of this social activity takes place in their rooms, where they often prefer to entertain friends. Then too, like artists in

their ateliers, children in their rooms can "work" undistractedly at play, particularly the imaginative sort. There's no evidence that expensive toys are required. In fact, research shows that kids play most creatively in natural settings and "adventure" or "junk" playgrounds, where they can fashion their own worlds with odds and ends like sticks and old tires.

The early lives of some of America's most beloved young women suggest that the simplest equipment, such as pencils, books, and paints, and access to nature may serve children's creativity best. In 1858, Bronson Alcott, a struggling educator, social reformer, and Transcendentalist, and Abigail May, his wife, settled their family of three daughters—Elizabeth had just died—in Orchard House, an old farmhouse in Concord, Massachusetts, that soon became one of that advanced town's spiritual and intellectual centers. At a time when "brain work" was thought to endanger female health, the poor but progressive Alcotts had educated their girls and encouraged them to be confident, expressive, and altruistic individuals. They borrowed books from Ralph Waldo Emerson and took nature walks with Henry David Thoreau. Two of the Alcott offspring became well known: May, a painter, who studied in France and was especially admired for her watercolors, and Louisa, the author of *Little Women*.

Orchard House still rings with the voices of Jo (Louisa) and Amy (May) March and their sisters acting out one of their plays. The home's most interesting places, however, are Louisa's and May's bedrooms, which weren't just boudoirs but creative sanctuaries. Long before she got a proper workshop downstairs, teenaged May's bedroom was her first studio. She was even allowed to draw on its walls; these early sketches, some of them copied from artwork owned by Emerson, are still intact. To accommodate tall May's height and encourage her creativity with light and air, her father gave her room a vaulted ceiling.

Louisa's large, sunny front bedroom, adorned with May's painting of a wise old bird symbolizing Louisa's role as "owl of the

family," was also her study. Here she wrote for hours on end, bent over the little half-round writing desk—just a shelf, really—that her father made especially for the purpose. Louisa suffered from joint pain, and when one hand got sore, she used the other, driven not only by literary ambition but also to help support a family that often teetered on the edge of poverty. "I will make a battering ram of my head," she wrote, "and make a way through this rough and tumble world." Notwithstanding her grit, Louisa had an emotional, romantic nature, which made the privacy of her bedroom-study especially important to her.

When she set out to write her masterpiece, Louisa envisioned a girls' book based on her own youth, hoping that "our queer plays and experiences may prove interesting, though I doubt it." In her bedroom amid her photographs, books, and sewing, she sat down at the desk her father had made for her and quickly wrote *Little Women*. Well over a century later, her girlhood and book are so esteemed that Orchard House is open to visitors from all over the world seven days a week, twelve months a year.

As with the rambling Alcott girls, many children's "rooms" extend into the outdoors near their homes. Like their bedrooms, these natural places support play, provide privacy, allow control, and offer refuge from social pressures. In fact, kids' favorite places are their rooms and outside, especially secret nooks, woods, hills, and "forbidden" spots. For them, the outdoors—even nature—isn't limited to sylvan scenes but can include driveways, alleys, streets, and urban playgrounds. (America's first was a "sand garden" built for Boston's poor children in 1885.)

In their outdoor spaces, children feel less stress and experience more fascination, compatibility, and imaginative play than they do indoors. Boys tend to like being outside more than girls, have larger "home ranges" to wander in, and are better at mapping their turf. On the other hand, many girls aren't allowed to go out as often or as far. In his research on how boys and girls are depicted in children's books, the environmental psychologist Jerome Tognoli

found that just as boys were shown as having many career options and girls' were limited to "queen, witch, or princess," the boys in books were mostly shown outdoors, and girls inside the home.

A room of one's own is especially important during adolescence, when emotional turmoil is a given, privacy and control become increasingly crucial, and sharing a space becomes more difficult. As the Beach Boys intone in their venerable anthem of teen angst, "There's a world/ Where I can go/ And tell my secrets to/ In my room/ In my room." When stressed by a setback of some sort, teenagers often try to calm down by "getting away from it all" in their special refuge. Surrounded by positive cues, from vacation souvenirs to prom photos to sports trophies, their stress levels begin to fall and sense of mastery and self-esteem rise, making it possible to reconsider the crisis and regain perspective.

Their emotional dependence on their rooms adds to the distress of kids who lose their homes because of divorce or an unwelcome move. In a study called "Breaking Up Is Hard to Do," however, the behaviorally oriented architecture professor Kathryn Anthony found that taking pains to make sure the new home either provides continuity or symbolizes a fresh start helps ease the adjustment to divorce. That so many Americans have now experienced this kind of disruption in domestic life, she says, helps explain "why the home-as-sanctuary seems so important to us now."

Adolescents require privacy, but one excessive manifestation of that need suggests a widespread increase in their emotional vulnerability. Reversing a long tradition, many high school students across the nation have become too modest to undress and shower in the boys' or girls' locker rooms after gym or sports practice; they wait until they get home to bathe. The reasons for this degree of modesty in an era of bold body piercings, tattoos, and suggestive clothes are unclear. Bigger homes and more bathrooms may have raised young people's expectations about privacy; the culture also pays more attention to the individual's rights and to sexual orientation. Especially at a time when record numbers of American

youth are overweight, however, teens' ultra-modesty may be rooted in a insecurity about their appearance in comparison to the media's bombardment of erotic images of slender, flawless, nearly naked bodies.

Like privacy, control is very important to teenagers, who straddle childhood's restrictions and adult freedoms and often describe places where they have little power, such as the classroom, as "depressing." Unlike peers in most of the world, many American teens have bedrooms that are theirs to command. Graffiti, weird color schemes, and gross posters may offend adult sensibilities, but research supports allowing adolescents as well as younger kids to design their own rooms as a relatively benign way to assert independence and express the evolving "real Me." Similarly, cacophonous music from a teen's room may drive parents crazy, but research shows that it has the opposite effect on their offspring, to whom it provides emotional release and regulation.

Their music notwithstanding, teens' rooms should provide an atmosphere for adequate rest—particularly considering that their rate of sleep deprivation has reached epidemic proportions. Although they need ten hours per night, many young people, especially teens, only get between six and eight hours. For still unclear neurobiological reasons, teens' internal "body clock" tells them both to stay up and to wake later than in earlier childhood. Because they really don't feel tired enough for bed at 9 or 10 p.m., they should sleep later, in time to start high school at 9 a.m. However, a competitive academic atmosphere means that the school day starts earlier and earlier, often at 7 or 8 a.m. As a result, many fatigued teens live in a kind of glassy daze that correlates with crankiness, anger, immune problems, inattentiveness in school, and traffic accidents.

One group of offspring finds their rooms and homes so congenial that they can't seem to leave. According to the 2000 census, 14 percent of twenty-something adults now live in their parents' home, which represents an increase of 50 percent from the 1970 census. These young people, seemingly caught between adolescence and adulthood, are also taking their time in graduating from college, set-

tling on full-time careers, and marrying. Practical considerations, from the accelerating cost of higher education and housing to the increase in unpaid internships, foster this philosophical shift toward taking more time to "find yourself" and assume adult responsibilities. When fledglings delay leaving the nest, however, parents have to be parents longer, lose privacy, and often incur expense.

The modern child's bedroom confers many benefits, but it also harbors certain new risks, particularly by encouraging and enabling excessive consumerism and use of electronics. As the young fans of *MTV Cribs* and the eighty Pottery Barn Kids stores make plain, like their parents, children today have lots of notions about their homes and furnishings. Also like their parents, kids have lots and lots of stuff.

Having at least *some* belongings is important to children's development, and storing and displaying their possessions is one of their rooms' significant functions. Certainly the urge to own is primal, as babies less than a year old prefer certain toys. On the simplest level, giving or withholding a desirable object conveys emotion and can be a way of controlling behavior. The influential psychoanalytical theorist Karen Horney traces adult greed not to toilet-training, as does Freud, but to a childhood that combined inadequate affection and competition over possessions and power.

From the perspective of well-meaning parents, the modern baby's room, with its musical mobiles, talking toys, and alphabet murals, is an "enriched" environment that will lead to the gifted school track and an Ivy League college. According to developmental psychologists, however, such gadgets neither accelerate development nor substitute for the time spent with a parent—the optimum form of stimulation. For a baby, mother or father is not just a person but also an environment, whose sights, sounds, smells, feel, and temperature help regulate them and their responses to the larger world.

The discovery that severe sensory deprivation causes developmental problems in the young has led to a widespread misunderstanding about the role of stimulation in a child's development.

Stimulating settings are said to be good for kids, and they are—but only if the level and timing of the input are just right. Just adding more willy-nilly is not necessarily beneficial. In fact, their neurological immaturity means that kids' nervous systems are easily overexcited and overwhelmed. When too much is going on—a serious problem for preemies in neonatal intensive care units—children don't take in and turn on, but shut down and turn off. Kids' tendency to be swamped by stimuli is the reason that most of the attractive "open schools" without walls, which were popular in the 1960s and '70s, were later modified to be less exciting and distracting.

The computer is the latest and most potent source of overstimulation in the home in general and in the child's room in particular. Much is made of the PC's educational value, and its greatest enthusiasts are kids, who are much likelier than adults to consider themselves tech-savvy. About 70 percent of their homes have a computer, and most of these also have Internet access. When their computer use is combined with watching TV and playing video games, however, kids spend an average of five hours daily slumped in front of some sort of screen.

Considering its potency and ubiquity, precious little is known about the computer's effects on children's well-being. On the most obvious level, hours of sedentary electronic stimulation each day detract from time spent on the active pursuits that are important to children's health and development, such as inventive play, socializing with friends, exercise, sports, and other interactions with the real world.

In a serious shift in behavior in the home, about half of Americans now say that computers cause them to spend less time with their families and friends. Domestic life has always centered on the personal interactions that are at the very least quantitatively reduced by time spent in electronic company. Subtler qualitative issues include, say, the possibility that at the family dinner table, children—or adults—eager to get back online may not bother much with actual conversation. "Go to your room" used to be a punishment, but now a young exile simply resumes instant messaging.

If some parents complain that their kids spend all their time in their rooms hunkered over their computers, others are too absorbed in their own screens to notice. The pioneering environmental psychologist Daniel Stokols is concerned by the ways in which the home's real and virtual settings can conflict. "Imagine a parent who's working on a computer, and a toddler who's tugging on the adult's sleeve, wanting attention," he says. "The responsiveness of the environment, particularly the social one, is a very important developmental factor for the young child." For kids and adults alike, "when the physical and social environments connect well, there are positive effects on health and well-being, and when they don't, there are a lot of negative effects."

There are many more questions than answers regarding the computer's possible negative effects on kids, from obesity and repetitive strain injury to social maladjustment and depression, but behavioral scientists generally agree about some ways to minimize problems. First, adults should supervise and limit children's computer use. Nearly a third of kids from computerized households—and almost half of older teens—have at least seen a pornographic Web site; those likeliest to view such matter have Internet access in their bedrooms, where adult scrutiny is limited, rather than in a "public" spot, such as a den. The fact that parents are likelier than children to say that kids' computer use is regulated suggests that despite what they preach, many adults don't practice this commonsense principle.

The computer is the newest source of overstimulation for children at home, but noise and crowding are long-standing behavioral risks, especially for kids growing up in cramped houses and apartments. Noise, or sound we don't like, is an overwhelmingly man-made phenomenon that almost never occurs in nature. How much it disturbs us depends not only on its loudness but also on its predictability and the degree of control we have over it. That's why the racket your kids make bothers you, not them. At toxic levels, noise can cause physical problems that include hearing loss, de-

creased immune function, and increased gastrointestinal problems, but its psychological effects are more immediate.

As parents forced to listen to Barney tapes or hip-hop well know, noise can make us mean—or as psychologists put it, increase aggressiveness and decrease helpfulness. One carefully staged experiment called for an actor to drop a box of books while getting out of a car, both with a cast on one arm and without it, and when a lawnmower roared nearby and when it was silent. The percentage of passersby who helped the man when he was wearing the cast dropped from 80 percent when the mower was silent to 15 percent when it was turned on. Either by distracting them from the man's predicament or by inducing a bad mood, the din made people less kind—not a good thing for home life.

Whether by demanding our attention or making us waste energy on ignoring or eliminating it, noise decreases our ability to remember, our level of performance, and our productivity—especially serious problems for a child trying to learn or study. Much research shows that early in life, a noisy home interferes with the ability to learn language; later on, children who attend noisy schools have lower verbal skills. That the kids from high-decibel homes and schools are probably not even aware of the ambient noise is a symptom of their problem. They have become physiologically habituated to the continual racket, so that their neural receptors fire less often in response to it. They've also psychologically adapted, so that they no longer pay attention to a stimulus long ago dismissed as insignificant. Unfortunately, in the process of screening out "bad" background noise, the children also seem to register fewer "good" sounds, such as a parent's or teacher's voice. It's as if the neurological resources meant for learning are sapped by damping down distractions such as TV or traffic. Moreover, noise's harmful effects are magnified when combined with other behavioral toxins, such as crowding. For these reasons, having a quiet place to study and do homework, such as a bedroom, is really important for schoolkids.

A crowded home is less about head count and square footage

than the sense that there are too many people in not enough space. A child's room that's very small but private is better than a larger but overpopulated one, because it's mostly the inability to control our social interactions that makes us feel crowded. Merely dividing a long dormitory hallway with a set of double doors midway made college students feel less cramped, friendlier, and likelier to make good use of the shared facilities. Such efforts at prevention are the best cure for crowding. Quick fixes, including assertiveness, rushing, withdrawal, and adaptation, are ill suited for a chronic problem at home.

Crowded homes in which children have little privacy and control over their experience pose developmental and behavioral risks, including decreased well-being, poor academic performance, social withdrawal, and aggressiveness. Crammed into a small apartment with too many other people, perhaps able to claim only a drawer or two and a portion of a closet, a small child can learn to see the world as an overwhelming place in which he or she has little influence. At home, this child may react by turning inward for relief, becoming secretive and avoidant. In school, he or she is likelier than kids from uncrowded homes to be inattentive, aggressive, and badly behaved. One simple reason kids from crowded homes do worse academically is that most literally have no place to study.

To see how growing up in a crowded, noisy apartment or house can undermine kids' development and well-being, Gary Evans puts on what he calls "the glasses of the stress framework." When kids can deal successfully with a problem, they feel competent and in control. When they can't, their sense of mastery over life weakens. Thus, children who live in homes in which studying is almost impossible, for example, are apt to fail repeatedly, then stop trying. Underscoring how such a home can affect a child's identity and self-esteem, Evans says, "If you can't control your own personal environment, not much can substitute for that."

One important fact about children's homes and behavior is now well established. "If you change housing quality," says Evans, "you change mental health." The link is still unclear but may be as straightforward as the fact that a substandard home is a stressor.

On a more philosophical plane, he adds, "your home reflects who you are. If your house is no good, that raises issues about control and affects how you feel about yourself."

Most things that are bad for children aren't randomly distributed but are concentrated in the houses and apartments of the one in five American kids who grow up poor. They bear the brunt of the asthma epidemic that's linked to substandard homes' dust, inadequate ventilation, and pests. They're the ones who are apt to live in concentrations of low-income people residing in high-rise buildings—a milieu that's strongly linked to more crime and difficulty in supervising the young. "Poor children don't just have the worst housing, but the worst everything," says Evans, "and having multiple environmental risks is where the serious pathology begins. It's not just that rich and poor kids have different opportunities. To a shocking degree, they live in different *worlds.*"

The good news is that even seemingly small things can foster healthy development and boost children's ability to cope with noisy, crowded homes. Designating the area near the entry as "public" space and the zone farthest from the front door as "private," the use of partitions, and seating that allows people to face away from others when desired are simple ways to increase psychological space. Nooks and crannies for enjoying some solitude, reading, or doing homework are more plentiful in homes whose layouts provide depth, such as long, narrow "railroad" apartments. Then too, other family members can agree to "reserve" a particular space, such as the living room or an adult's bedroom, for a child's exclusive use at certain times. According to Evans, "access to such places really functions as a safety valve."

Like the young, the old prosper in homes that provide them with the right balance of support, privacy, and control over their own experience. Elders are the Western world's fastest-growing population. One in eight North Americans is already sixty-five or older, and by 2030 that number will be one in five. This huge group, however, is far from homogeneous, particularly where home life is con-

cerned. Old people overwhelmingly prefer to live in their own homes. Aside from more serious health problems, however, their desire for independence can be frustrated by normal physical decline. Even a person of sixty needs three times more light to do a task than a twenty-year-old, for example, and three in ten persons over sixty-five have serious hearing problems.

The two major reasons that elders leave their homes are trouble with bathing and cooking. This fact underscores the importance of adapting their homes, particularly the bathroom and kitchen, to their greater needs. Supplying helpful equipment, such as grip bars, removing obstacles to safe movement, and other simple interventions could keep one in five residents out of nursing homes.

When elders can no longer stay in their homes, having their own rooms is important. For different reasons—including the child-care crisis that has increased the number of children who live with their mothers *and* grandmothers—some elders move into their adult children's homes. In one study, the negative feelings of adults and kids who live with a disabled elder rose with the amount of time that the elder spent in the shared family space. A researcher recalls her sister's dilemma when her sickly mother-in-law moved in with her family. The grandmother was nearly deaf, and the din from the great room's TV drove everyone crazy. "They felt bad because they wanted to be hospitable," she says. "Had the grandmother been watching TV in a room with a door or had close-captioned TV, there wouldn't have been such a huge problem."

When considering American culture's approach to improving the home for people of every age, Gary Evans sees an analogy in the way we regard the workplace. "To reduce stress there, Americans say, 'Let's teach the employees to meditate, exercise, and watch their diet,'" he says. "In Sweden, they say, 'What's wrong with this environment? It's too noisy, the desk is no good, and the keyboard is in the wrong place.'" Particularly where the young and their homes are concerned, says Evans, "don't just try to change the odds for a child to beat the pathological environment. Change the environment."

By the time the twins who are our fourth and fifth children were born, Mike and I had learned the wisdom of letting kids design their own rooms. At sixteen, Molly painted her walls a bright royal blue that, like her diaphanous beaded drapes, is not to my taste. No less than her protest posters, however, her decor lets her express herself and her growing independence in a benign way. Tom is less interested in colors and textiles than technology. When he pleaded to have a TV in his room, we found a compromise. He got the tube but no cable service, which means he can play video games with his friends—a priority—but can't watch nonstop junk.

One sign that the home was becoming an increasingly child-friendly place by the early twentieth century was the new "finished" basement that served as a recreation area and playroom. This amenity was rooted in the later nineteenth century, when the basement became the high-tech headquarters of the home's plumbing, heating, and electrical systems, known as the mechanicals—a huge transformation from the murky root cellar of yore. A dramatic increase in the do-it-yourself movement means that more Americans are spending time in their basement workshops or tinkering with their mechanicals—or at least fantasizing about it. Intriguingly, for many, the primary motivation is less financial than psychological.

The Basement

Doing It Yourself

Of all the spaces to single out in the extravagant Haas-Lilienthal House, a mansion built in 1886 in San Francisco's Pacific Heights and occupied by three generations of a wealthy Jewish merchant family, it may seem perverse to choose the basement. Compared to the *haute bourgeois* grandeur of the dining room, with its imposing woodwork and suite of chairs dutifully covered in needlepoint by the house's ladies, the cellar is simple. Nevertheless, during an ambitious 1906 renovation, the family engaged in some prescient house thinking that reflected a significant shift in Americans' domestic behavior and turned part of their basement into a pleasant living space.

To create their big new recreational room, the basement's storage and utility area, located in its underground rear section, was partitioned off from the brighter, more attractive windowed front

part, which lies partly aboveground. Here, in what the Haas family called "the ballroom," the three children had a freewheeling play area and their elders a place for the extended clan's frequent musicales, parties, and dances. A simple raised stage in one corner served both the children's dramatic productions and the grown-ups' concerts. The Haas family's ballroom, which seems especially modern compared to the ornate, stuffy salons upstairs, bespeaks a forward-looking family among the first to have what would later be called a rec room.

This flexible, open ballroom-basement illustrates how a shift in behavior—in this instance, turn-of-the-century Americans' desire for more fun, less formality, and greater consideration of children's needs—can change domestic architecture. However, the inventive space also illustrates how technology can enable both architectural and behavioral change. Turning the basement from a quasi-dungeon into a pleasant living space was made possible by advances in the home's mechanical systems, such as the modernization of the furnace and its messy fuel to the point of becoming nearly inconspicuous.

It may not be the home's prettiest place, but the basement—or the garage or utility room—and its mechanicals affect our behavior in important ways. On a practical level, they provide our homes with the predictable temperature and light we need in order to maintain our physical and emotional well-being and to do what we want to do when we want to do it. For the increasing number of do-it-yourselfers, a hands-on relationship with the home's nuts-and-bolts aspect also yields big psychological and financial rewards. Last but not least, the basement, like the attic or garage, is the home's repository for things that we don't use often or may not even need but can't quite get rid of.

Of all the environmental influences on behavior, whether outside or inside the home, heat and light are the most important. When we're really cold, we're just not good for much. If the body's temperature sinks below about 98.6 degrees to, say, 94 degrees, we fall

apart. Speech becomes garbled, then our motor skills and vision begin to fail; at 92 degrees, the brain is dysfunctional, which explains why many victims of hypothermia make disastrous decisions, such as removing clothing while freezing to death.

Even in the nineteenth century, psychiatrists recognized the connection between temperature and mood—specifically, cold's antidepressant and heat's sedative effects. Our cardiovascular system helps link the external temperature and our internal state of mind. When we're cold, our blood vessels constrict to keep the warm blood near our vital organs; when we're hot, the opposite mechanism kicks in to cool us off. Because our muscles produce most of the body's heat, maintaining the right internal temperature is easier if we feel frisky and alert when it's cold and sluggish and withdrawn when it's hot. From this perspective, depression and mania can be thought of as prolonged exaggerations of our normal responses to heat and cold.

A pleasantly cool home that calls for a sweater may keep us alert, but as our ancestors knew, an uncomfortably cold one constrains behavior in many ways, from swaddling us in layers of bulky clothing to confining us to the vicinity of a heat source. We may feel nostalgic at the thought of our forebears passing winter evenings gathered around the family hearth, but the choice was togetherness or a heavily blanketed bed that was often the home's only truly warm place.

The Haas family's warm, clean, dry, spacious basement and its efficient mechanicals would have astonished colonial New Englanders. Their harsh winters inspired them to add a small, partial "root cellar" to their version of the British farmhouse. This underground space, which was accessed from an exterior entrance, buffered the rooms above from chill and damp and also provided cold storage for foodstuffs. For warmth, people relied on the inefficient fireplace, which in a northern winter might barely keep a room above freezing. Practicality dictated little rooms that were easier to warm up and could be separately heated as needed, as well as the sparing use of small windows.

In the mid-nineteenth century, the new, much more efficient cast-iron, mass-produced woodstove had a profoundly liberating effect on domestic behavior. Because it threw off much more heat than a fireplace, the stove accommodated more sitters and activities in a larger area of the home. On the other hand, the stove still required the mess of firewood and the hassles of constant refueling.

Central heating really freed up both domestic behavior and architecture, although it was first enjoyed not by householders but by the inmates of prisons, workhouses, and other institutions. By its advent in the later nineteenth century, the need for storage to accommodate the growing number of consumer goods meant that many houses had full basements with indoor stairs—the perfect place for the new furnace. Soon, homes were employing hot-air systems powered by a furnace that burned coal or wood. Because heat rises, warmed air ascended from the basement through ducts and floor grates into the upper rooms—a process eventually aided by a blower. Later, boilers would propel steam or hot water to radiators throughout the home.

When messy, bulky wood and coal fuels were replaced with tidier oil and gas, the cleaner, emptier cellar no longer had to be restricted to storage and messy household chores, from carpentry to laundry. By the earlier twentieth century, many homes had the kind of waterproofed, heated, well-lit finished basement that could be turned into a "ballroom" ringing with music from the new phonograph. More important, heating technology allowed the home's small rooms to expand into the larger multipurpose spaces identified with the modern house and apartment. Even if it wears a neo-historical disguise, the average new home has the more open contemporary floor plan that efficient heating made possible.

In the centrally heated homes of the modern West, our behavior is likelier to suffer from summer's heat than winter's cold. Particularly when coupled with humidity, hot temperatures make us feel lethargic and grumpy, sometimes even aggressive. It's no coincidence that domestic violence, for example, peaks in summer and is commoner in hotter places. Just as we like to cuddle up when it's

cold, we become less sociable when it's hot, which distances us from the heat of others' bodies.

Staying warm in winter is more essential than staying cool in summer, and the technology for chilling the home lagged accordingly. For most of history, little could be done beyond venting the roof to allow hot air to escape and opening the windows—not necessarily a great option until the mass production of wire mesh allowed for efficient window screens. It's no surprise that the electric fan was one of the first and most popular home appliances. Like central heating, air conditioning initially appeared in institutions, such as movie theaters and department stores, and was only introduced to the home in the 1950s.

Our homes may be warmer in winter and cooler in summer than our ancestors', but we don't necessarily enjoy better indoor air quality. Virtually all of the modern knowledge and regulation of air pollution concerns the air outdoors, where allergens, pollutants, and chemical balances are very different. Compared to outside, a home's ozone level is likely to be lower, for example, but a gas stove will give it higher levels of nitrous oxide. Although most of us spend more than 90 percent of our lives inside, the effects of indoor air quality on our behavior are largely unknown.

Like central heat, electric light had an enormous behavioral impact on the home. We're so accustomed to the meter in the basement or utility room that it's hard to believe that from ancient Rome, when the candle with a wick was invented, until the mid-nineteenth century, the home's illumination depended mostly on windows, fireplaces, and wax or tallow tapers—usually just one per room in the evening. Different kinds of candles burn at different rates and were priced accordingly; beeswax and bayberry cost more than tallow made from animal fat, which made their lavish use a powerful status symbol.

We take them for granted, but before gaslight and electricity, windows were the cost-free utilities that allowed people to take care of much of life's business. In early America most people saved money and conserved heat by getting along with a few small ones.

Panes of glass were luxuries that were either imported from Europe or made here at great expense, so many people repelled wind and rain with oiled paper or shutters.

As Americans became more prosperous, they added more windows to their homes. In wealthier circles, the lighter, airier Federal-style house, with its fine front door flanked by glass sidelights and crowned with a fanlight, replaced the dark, poky colonial farmhouse. When plate glass could be mass-produced later in the nineteenth century, it finally became plentiful and cheap enough to indulge the Victorian house in its many windows.

The window's bright, cost-free light was so precious that curtains only came into vogue in the Victorian era, when the efficient kerosene lamp, followed by the gaslight that could illuminate a whole room, allowed for such extravagance. Like central heat and air conditioning, gaslight was initially used in institutional buildings. One of the first modern home appliances, the "gasolier" wrought numerous changes in domestic behavior, including the more thorough housecleaning that was the bane of the era's housewives and servants during the era's smutty, polluted industrial revolution. On a higher plane, the ability to read comfortably at night increased literacy and book sales.

Where the home and behavior are concerned, it's hard to overestimate the impact of electricity, which turned houses and apartments, not just factories and other institutions, into potentially 24-7 work environments. The ancient human custom of labor by day and rest by night no longer need apply. Suddenly able really to see what they were doing after sunset, householders engaged in more activities more of the time.

Proper illumination is obviously important to our performance of tasks. Just increasing light intensity, however, produces smaller and smaller improvements until it begins to create problems, such as glare. Ideal illumination is neither too dim nor too bright—a complex condition that depends on light's amount, color, and location, plus contrast and reflection.

As the home became increasingly technologically complex,

fewer people built and repaired their own. The tradesmen who could install and maintain heating, electrical, and other mechanical systems became high-priced high priests. Today, some 100,000 building firms in the United States that employ 400,000 workers, construct a million new homes each year—a $50-billion business. Then too, older homes require lots of improvement.

The average North American house is twenty-eight years old, and about a quarter are over fifty. These ages are significant, considering that an aluminum casement window lasts from ten to twenty years, for example, and roof shingles from fifteen to thirty years. As chagrined owners of wooden houses know, depending on whether it's pine, say, or cedar, clapboard siding holds up for anywhere between ten and a hundred years and needs a paint job at least every ten years. Indoors, major appliances are good for about fifteen years—a fact that inspires many a kitchen remodeling, which is America's commonest home improvement.

Practical motivations behind the $200-billion-per-year remodeling industry range from the need to make repairs to the desire to increase property value to coping with a "life event" such as moving, marrying, or having a baby. (As the huge baby boom ages, user-friendly renovations for seniors who want to stay in their own homes and neighborhoods will be a mini-industry in itself.) Many remodelings, however, are experientially inspired by richer, design-savvy householders' desire for change. These hip consumers prefer customization to generic designs and formulas and are up on rapidly changing decorating trends. Whether they want to reshingle the roof or rip out their once stylish butcher-block kitchen and redo it in stainless steel, home improvers can find guidance in some forty shelter magazines and three dozen TV programs, the granddaddy of which is *This Old House.*

Much of the burgeoning do-it-yourself movement that operates out of basement workshops and apartment dwellers' tool boxes alike is motivated by the inner rewards of hands-on work—or even by fantasizing about it. According to Russ Morash, the creative di-

rector and founder of *This Old House*, many people who can well afford to hire professionals prefer the direct approach to home improvement because they enjoy the effort and take pride in their skill. After watching *TOH*'s carpenter, Norm Abram, make a piece of furniture from scratch, he says, "even people with advanced educations can find it perfectly reasonable to take up tools. More than reasonable—mind-expanding!"

In a *very* nicely remodeled, red-painted Massachusetts barn, *TOH*'s master tradesmen—Abram (carpentry), Richard Trethewey (plumbing and heating), Roger Cook (landscaping), and Tom Silva (general contracting)—give their viewers weekly how-to lessons on everything from shopping for new windows to demolishing a wall. Perhaps the most surprising thing about these devoted fans, however, is that *most* aren't do-it-yourselfers in the manual sense.

One big group of householders watch *TOH* primarily because they want to know how a job should be done properly, so they can better deal with their tradesmen. "With the name of a tool or piece of hardware comes understanding," says Morash, "and with understanding comes power." Other viewers are benign voyeurs who simply enjoy seeing real work produce a clear reward—an old-fashioned pleasure not frequently experienced by many office-based knowledge workers (as those whose tasks are more cerebral than manual are now often called). Just as it was fun to watch the late Julia Child cook a complicated dish few people would actually make at home, it's fun to watch *TOH*'s tradesmen, who are known in the red barn simply as "the guys," install cabinets or turn a teardown into a dream house. It's no coincidence that Morash also created both Julia Child's *The French Chef* and the popular *Victory Garden*.

The least common denominator of the *TOH* audience and the legion of Americans who obsess over their homes, says Morash, is their devotion to what he calls "a domestic vision. They're house owners and apartment dwellers who want to make a better home for themselves. One that's more comfortable, beautiful, serene,

useful. They dream of making a well-maintained abode, a garden, a great meal. These shows let you see the ultimate. Then you can say, 'I could do that!' Or 'I don't have the right tools.' Or 'I need to learn more.'"

One warm spring morning, the guys of *TOH* welcome a visitor to the set upstairs in the barn where their how-to demonstrations are filmed. Part hayloft, garage, and basement, the environment is virile but unthreatening. Its bristling tools and old machete are balanced by flower pots and a canoe. Tom and Richard are doing a segment for the show's spin-off program, called *Ask This Old House*, in which the guys solve a viewer's problem, from peeling plaster to a cracked pavement. Sometimes a house call is required: "We'll be right over!"

A few minutes of filming proves that the blue-collar stars excel not just in technical chops but also in giving viewers the confidence to head to the basement and replace a cracked windowpane with a new piece of glass rather than calling a handyman or super. Their demonstrations are highly practical but also quietly psychological, addressing some of our common yet often unexpressed feelings about home, self, and mastery.

When Tom shows Richard how to fix that broken windowpane, he subtly touches on the do-it-yourself novice's awkwardness when attempting a tricky task for the first time. As Tom softens the glazing compound and tamps it into place around the new pane, he says, "You gotta have good thumbs for this job." Looking over Tom's shoulder, Richard speaks for—and relaxes—many viewers when he says, "I'm all thumbs!" Those who are parents may be reminded of the late Fred Rogers, who similarly taught his young fans simple lessons in a way that encouraged them to take on life's larger challenges.

Partly because these guys in work boots and nondesigner jeans are contractors, not actors, virtually all viewers can find in Tom or Norm, Richard or Roger, the good husband or father, big brother or buddy whom we love, miss, or never had. With the encourage-

ment of these benign male icons—strong but kind, expert but patient—even the neophyte do-it-yourselfer is emboldened to try a new, more intimate relationship with the home.

Morash reveals one Freudian source of *TOH*'s psychological undercurrent when he forthrightly explains his own motivation for doing the show. "Subconsciously, I wanted to honor my ancestors and my father, who were skilled tradesmen," he says. "I truly believe that someone who can do what they did is in a sense a god. They never got the recognition that these guys get, so I'm here to celebrate the craftsmanship they all share."

Whoever said that real men don't eat quiche has never had lunch with the alpha males of *This Old House*. Over generous slices, these middle-aged guys with direct gazes and bulging forearms joke around with their guest. When someone mentions the cellar, Roger says, "A great philosopher once said that you spend the first year of your marriage in the bedroom and the rest of it in the basement fixing something."

Where fixing up the home is concerned, the guys agree on what is the householder's commonest mistake—one that can affect our behavior on a daily basis. "People prioritize cosmetics instead of the mechanicals and structural stuff that make up the house's skeleton," says Richard. "That's why seven out of ten Americans hate their heating systems." "You'll be a happier homeowner if you spend on the things you can't see," says Tom, "because they help you live more efficiently and comfortably." In Roger's opinion, "people go about things haphazardly and cost themselves a lot of money by having to do things twice. To pay for the best windows or faux finishes on the walls, but buy all the 'unsexy' plumbing, heating, and electrical on the lowest bid, is like putting lipstick on a pig."

Through the course of lunch, however, the guys don't talk shop as much as they do about the psychological rewards of working on your own home. Regarding the perennial allure of the fixer-upper, for example, they say less about real estate values than about finding meaning in an overly cerebral postmodern world. "So many

people sit at a desk or a computer all day," says Roger. "They can't wait to go home and get their hands on their house." He mentions an industrial study that showed that if an assembly-line worker just punches a widget all day, his productivity is low. But if he follows the widget down the line, works on it in several ways, and then gets to finish the product, both his efficiency and job satisfaction go way up. "A lot of people can't get that finished-product satisfaction at work today," says Roger. "But in an old house, you go wall by wall and room by room, and then you get that end result."

Tom, too, talks about working with his hands in terms of its psychological benefits for the skilled tradesman and novice alike: "There's something that's very pleasingly *tactile* about it. And there's a lot of satisfaction in the problem-solving, from setting up for a foundation to planning a roof. I don't consider what I do to be work, because I love it." Like a good lecturer in Psych 101, he brings the principles of frustration and reward to life when he talks about renovation. "There's a lot of instant gratification in demolition, so many people destroy their houses, then have nowhere to go. They say, 'What did we ever get into this for?'" To avoid this common predicament, Tom advises renovators to begin with the smallest room in the house "and fix it up, soup to nuts, the best it can be. Then lock the door. When you're working on the rest of the house and get frustrated, get yourself a nice bottle of wine and unlock the door. We call it the safe room!"

From personal as well as professional experience, the guys are well aware that the expanding ranks of do-it-yourselfers increasingly include women. In one recent episode of *Ask This Old House*, when Tom shows the owners of a condo how to fix the bulging crack in their bedroom's ceiling, the wife eagerly climbs the ladder and goes to work, while her husband looks on. Men still do about two-thirds of home and garden work, but changing gender roles, smarter technology that requires less sheer brawn, and better instruction mean that many more women are wielding the circular saw and the screw gun. On realizing that women already make 53 percent of purchases at Home Depot stores, the company began to

offer Do It Herself workshops on tiling, patching wallboard, replacing faucets, soldering, and operating power tools.

Seasoned husbands as well as tradesmen, the guys agree that whether women are making home improvements or merely masterminding them, they are, as Tom says, "the driving force when it comes to getting things done in the house. If the woman wants a home to have a particular look, the guy's attitude is, 'Okay, good enough.'" Even with small matters, adds Roger, "it's the woman who notices, say, that the windows are dirty. The male gene says, 'What windows?'" He attributes women's increasing skills not just to changing times but also to their greater willingness to learn: "My wife just needs someone to show her once how to do something, from gardening to hanging blinds. And she's not afraid to ask questions. A man always knows everything." "That's another book," says Tom. "The Mars-Venus thing."

Anyone seeking additional proof that the sexes are from different planets should consult research on how men and women generally react to the basement. To find out where people feel happiest at home, the psychologist Mihaly Csikszentmihalyi used his now widespread technique, called experience sampling, which attempts to quantify our quality of life. His subjects are given electronic pagers that beep at random intervals over a specific period of time. At the signal, they record where they are, what they're doing, and how they feel—happy or sad, engaged or bored. Later, researchers analyze these records, then plot how different situations affected the person's consciousness. By combining data from many subjects, they can also draw informed conclusions about what kinds of circumstances most people, or certain groups, find positive or negative.

To investigate our experience at home, Csikszentmihalyi gave pagers to two hundred men and women, then beeped them throughout the day; each time they were paged, the subjects wrote down where they were and how they felt. "We found that the basement is the part of the home in which men have the greatest number of

positive moods, and in which women have the fewest," says Csik-szentmihalyi. "To a man, the basement is a retreat, a bar, a game or hobby room, a workshop."

One man's personal description of his favorite place supports this scientific perspective on basements: "The ambiance charitably might be described as early twentieth-century American dungeon ... I'm not talking about a rec room with a wet bar and a sixty-inch television. I'm not even talking about the kind of slightly mildewed chamber that is hospitable enough to house a laundry or a sewing nook. I'm referring to a nether world of sewer drains, leaky pipes, tool-strewn workbenches and smoky power plant that only a man could covet. Banished to this subterranean briar patch by the local matriarchy, I secretly howl with joy."

Women may howl in the basement, but rarely with joy. To most females, says Csikszentmihalyi, the cellar is not a place for primal escape but for loading the washing machine, discovering something damp and nasty, or doing something scary to the furnace or circuit breakers. When women seek domestic refuge from children's and husbands' demands, many head to the bathroom, where the beeper study shows they're happiest. Like a guy in his basement, a woman in her tub enjoys "one of the few places where her sex doesn't feel hassled," says Csikszentmihalyi, "where she doesn't feel obligated to do anything but focus on herself."

Research on what Csikszentmihalyi calls "the meaning of things" further explains why men are from basements and women are from upstairs. A woman is likely to have an expressive and social orientation to her home. Thus, she tends to favor rooms where she spends time with family and friends or that harbor so-called contemplative objects, from plants to plates to paintings, that bespeak her personality. A man's typically "instrumental" view of the home, however, inclines him to prefer those places and things that attest to his hard work and mastery. His treasured "action objects" can range from the computer and stereo or guns and fly rods in his den to the tools in the basement, garage, or even a rented space.

Where the basement or the attic itself is concerned, we may

lose something elusive if we go too far in "improving" those dim, dusty, mysterious domestic spaces, which even the set of *This Old House* tries to evoke. Traditionally, cellars and attics, which are leftover spaces produced by a roof that's pitched to shed rain and snow, have served many practical and psychological functions, the most obvious of which is storing out-of-season clothes, holiday decorations, and baby shoes. A study in rural France showed that sprucing up funky cellars and attics for use as storage, play, and work spaces, and thus "claiming" what had been hidden, dark, grungy places, increased their owners' feelings of security, shelter, and privacy. On a deeper level, however, perhaps these repositories for treasures and junk that we may not need but don't want underfoot and somehow can't get rid of are domestic equivalents of the subconscious mind, which stores the flotsam and jetsam of our pasts in a different way.

I don't much care for the basement, but I do know something about the pleasures of working on the home. I can unreservedly recommend painting a room as a surefire cure for the blues and the single best form of housecleaning. Where mechanicals are concerned, albeit the antiquated sort, my expertise is confined to our country schoolhouse. A summer place, it has no running water in the cold months and only a woodstove for heat. I'm the only one in the family who will go there in the winter, not least because I love the anachronistic puttering required. I haul buckets of water from the creek for washing dishes and flushing the toilet and logs from the woodpile to keep the house toasty. Each April I hook up the water again and do a real spring-cleaning. I wish that working on my laptop were so unfailingly gratifying as these homely chores.

At the other end of my domestic technological spectrum lies my urban home office. Made possible by the computer, Internet, and other electronics, such industrial-strength communications centers are fast becoming one of the home's most desirable amenities. A third of the American workforce already plies their trades at home at least part of the time. The physical changes that an office makes to a house or apartment pale beside its primary behavioral effect: turning the home from a private refuge into a high-tech workplace.

The Office

Home Work

Sprawled on a couch in the wood, glass, concrete, and steel expanse of his duplex loft in San Francisco's trendy South Market waterfront, Alexander Lloyd, a young venture capitalist, modern art collector, sports lover, and technophile, says, "When I come home, I'm happy to be here, because this place was designed for me." Gesturing at a huge painting by John Alexander, an electronic hearth mounted above the real one, and a mountain bike propped against one wall, he says, "It's a single guy's place, with lots of toys and electronics."

Some of the most impressive toys in this self-confessed computer nerd's home are downstairs in his state-of-the-art office/media room. One wall in the handsome minimalist space is a giant window that frames the Bay Bridge, and another is covered with custom bookshelves, complete with sliding steel ladder. The third wall

holds Lloyd's desk, computer, and other business-related equipment, which can be concealed behind ceiling-height sliding doors. He sounds faintly surprised when, like an increasing number of Americans, he says, "I don't really *have* to go to the office anymore, except for meetings."

Also like many Americans, Lloyd has an elaborate "home entertainment center." By pressing a few buttons, he can transform his office into an electronic rec room. One touch unfurls a big screen before an overhead movie projector, and another unleashes a powerful sound system. What looks like and functions as a sleek steel coffee table turns out to be a video-game console that lets Lloyd play on the movie screen.

In keeping with the loft's cool modernist sensibility, the hardware that runs its electronic environment is nearly invisible. Behind a closet door, there's a tower of black, blinking machines— tuners, amp control, DVD and VCR players, surround-sound processor, and the like—that was masterminded by an audiovisual consultant, who worked with the architect to reconcile their client's technological and aesthetic needs. The result is a sophisticated example of a new kind of domestic space that blurs distinctions between work and play, office and home.

On the most obvious level, an office physically changes the traditional house or apartment, but its behavioral impact is more profound. After a long period of serving as a private refuge from the public world of commerce and industry, the dwelling is once again a potential workplace, sometimes even an arm of a corporation, in which it's possible to work almost any time—or nearly all of the time—and by extension anywhere, from home to car to weekend place.

Like the "new" great room that harkens back to the old multipurpose hall, the home office is something of a back-to-the-future phenomenon. For most of history, most work, whether that of artisans or aristocrats, was based in and around the home. In fact, the Jeremiah Lee Mansion, built in 1764 in Marblehead, Massachusetts,

for a rich shipowner, merchant, and patriot (and slave owner), is actually two houses. One was devoted to the Lee family's private life and the other mostly to Jeremiah's public life of politics and commerce.

The Lee mansion's front door opens into a large entry space, to the right of which is the door to the family's home. To the left lies the house's public part, beginning with a big assembly room used for dances and dinners; its ornate rococo mantel was considered the finest carving in America. Behind the hall lies a plain but handsome "compting room." Like many colonial men of affairs, Lee used his accounting room as a home office. There's a handsome clock and a large table and chairs for the clerks and apprentices who kept the books for his twenty-one ships. Two smaller private offices, one of which contains Lee's desk and chair, open off this large room. The mansion is celebrated as a fine example of pre-Revolutionary Georgian domestic architecture, yet it was so well suited to business that it later became a bank.

As the nineteenth century unfolded, it was no longer thought proper for the well-off to make money at home, and people of all classes increasingly reported to centralized workplaces. More middle-class dwellings included an office-like library that, with its desk, books, maps, and globe, had long been the province of male aristocrats. To the upwardly mobile Victorians, however, knowledge was a means of ascending the social ladder. Like us, they lived during an information explosion, in which floods of data were suddenly disseminated in history's first wave of cheap, plentiful books. Proliferating public schools, libraries, and adult education programs encouraged even women and girls to demand more education. With this democratization of knowledge, the library became a popular status symbol.

The modern home office, which was made possible by the computer, Internet, and other electronics, is the domain of freelancers as well as a part-time workplace for many traditional employees. This high-tech room, which is often as functional as its corporate equivalent, bears little resemblance to the desk and filing cabinet stuck in

a guest room and mostly used for paying bills that used to pass for a home office. Considering that about 55 million Americans are already working at home at least part of the time (compared with about 40 million in 1995), and that many more want to join them, the just-right office is fast becoming one of the home's most desirable amenities.

Adding an office to the home requires house thinking on multiple levels. First, an office affects the home by claiming some of its space. In some new houses and apartments, the office is a lavish, custom-designed affair. In older homes, an existing room is converted. In some houses, a little-used living room is "repurposed" as an office; its location near the front door and the outer world helps separate professional and personal spaces and lives.

The most satisfactory basic office is a private room that has a door, a nice view, a separate entry for clients if necessary, and proximity to a bathroom and kitchen. The happiest home workers seem to live within walking distance of stores, cafés, and other places that foster the spontaneous social encounters that are built into traditional workplaces. In homes in which two or more members do some work, time-sharing an office, with its printer, scanner, and other equipment, is practical but not popular. When sharing is inevitable, unlike Victoria and Albert, most parties mark off their personal boundaries with furniture.

For reasons from individual temperament to child-care duties, the location of an office that's ideal for one person might strike another as either too public or isolated. Women who do professional work at home are more inclined than men to put their desks and computers in an open space where they can also keep an eye on the household. They're also likelier than men to respond to the clarion calls of kitchen and laundry room, but that reaction doesn't merely reflect their greater sense of responsibility regarding domestic chores. Family members actually perceive a woman's workday differently than they do a man's. In one study, children considered their mothers to be at home when they were busy in their offices,

but they didn't regard fathers as present until the men emerged from behind closed doors.

Once a room is designated as the office, it must be properly furnished. The need for a decent computer "workstation" helped to mainstream the once esoteric field of ergonomics, or the scientific design of user-friendly furniture, tools, machines, and settings. Even in traditional central offices, many of employees' environmental complaints concern unsatisfactory chairs, desks, computer screens, keyboards, and lighting. Problems such as eyestrain, carpal tunnel syndrome, back pain, headaches, and fatigue that are linked to poor office furnishings are likelier to plague home workers inclined make do with whatever pieces are in the garage or storeroom.

Whether their offices are custom-designed technological wonders or recycled attics, people who work at home can support their choice with good arguments from environmental-behavioral science. From its perspective, just as a well-appointed office protects against stiff necks and repetitive stress injury, it also fosters creativity and productivity. Efficiency experts and environmental psychologists aren't the first to try to design such workplaces. In fact, some of their efforts confirm feng shui principles, such as the advisability of facing the office's door in order to avoid being startled; research shows that we do indeed feel better in offices and cubicles that allow us to see others approaching.

As feng shui masters also know, the position of furnishings sends unspoken messages about status and sociability, which are particularly important if associates or clients visit the office. Authority figures such as doctors and lawyers can underscore their gravitas by putting their desks between themselves and their visitors. Professionals who want to project a more collegial air, such as therapists or clergy, could place their desks along a wall and talk with visitors in a comfortable seating area. Both slobs and neatniks might feel that working at home gives them license to take their tendencies to extremes. Supporting feng shui, however, one study

showed that visitors to offices that were very neat (not enough chi), very messy (too much chi), or characterized by "organized stacks" of paperwork (balanced chi) said that the tidy-stacks ambience felt friendlier and more appealing.

The home office's single greatest behavioral advantage is that working under your own roof gives you more control over your experience, which is always something to be desired. Home workers don't have to deal with a tortuous commute or the tedious meetings and aimless socializing that can take up half a day at the traditional workplace. They have lots of flexibility regarding when and where to work, from taking the laptop to bed when ailing to returning calls while making dinner. No one tells them when to eat lunch, exercise, or nap—an increasing need in the new 24-7 electronic, global-village workday—much less dictates their office's heating and lighting conditions.

Judging by one famous, or infamous, study, some employers interested in boosting productivity are not above manipulating the environment of their unwitting workers. In the 1920s, employees of the Hawthorne electric plant near Chicago were divided into a control group that worked under constant illumination and another that worked under changing lighting conditions. Surprisingly, both groups increased their output. Even when researchers only pretended to alter the lighting, workers produced more and expressed pleasure in their "improved" conditions. In a follow-up study, one group maintained productivity even when their light was decreased by 70 percent. The apparently placebo-like "Hawthorne effect" has been attributed to the influences of changing the environment—or even appearing to—and the experimenters' monitoring.

Along with having control over their milieu, home workers avoid many noxious workplace stressors that, according to the International Labor Association, affect about 10 percent of the workforce and cost employers about $200 billion per year. The commonest and worst of these environmental-behavioral nuisances is noise. Because it both distracts and restricts its victim, noise is highly

counterproductive. It's probably no accident that the surge in home offices corresponds to the rise of the open-plan corporate office and its wretched cubicles—sometimes called "veal pens"—which force workers to listen to colleagues' conversations, ringing phones, and other racket. Because it can be so hard to work at work, some employees stagger their hours to avoid the crowd or do some part-time deep thinking at home.

Not only do home workers control their environments and avoid many stressors, but they can also enjoy one of the corporate executive's most cherished perks and status symbols: a personalized office. Taking the trouble to make a workplace that goes beyond serviceable to pleasurable is well worth it, not just in terms of gathering rosebuds where ye may, but also in enhancing your performance.

Work sounds cerebral, but research increasingly reveals how profoundly our thinking is affected by our feelings. Even simple environmental features like sunlight correlate with improved mood, and those good spirits are in turn linked to better decision making, memory, job commitment, and creative problem solving. (Interestingly, one study showed that where job satisfaction is concerned, it wasn't the workplace's level of interior sunlight, but the size of the area it covered, that mattered.)

A trendy advertising agency learned the hard way about the very real behavioral benefits of a personalized office. Its top executives were captivated by the idea of "hot desking," which maintains that laptops and cell phones eliminate the need for an old-fashioned permanent workplace. The firm hired a famous architect to design a wowie-zowie headquarters in which employees picked up their electronics each day, then plopped down wherever. The new space looked great, but the agency eventually had to move because the staff hated having no homes away from home furnished with their photos, mugs, Post-Its, and plants.

Customizing an office in a way that increases productivity, however, means more than choosing your paint color and poster. Achieving the right degree of environmental stimulation, for example,

takes some fine-tuning. Leaving aside accommodations for temperamental differences, research shows that people feel better in a workplace that includes some of nature's sights and sounds or even reproductions of them. This finding is supported by the facts that students and adults in windowless schools and workplaces have more frequent bad moods, and that decorative elements in windowless spaces usually center on nature, from plants to landscape scenes. On the other hand, one experiment showed that although workers preferred a plant-filled office, they performed easy tasks better in a flora-free room. Similarly, quiet is best when doing difficult work, but simple chores go better when we have some external stimulation, such as music. Accordingly, an ideal home office might have microenvironments for different kinds of work, such as a desk with a nice view, a no-frills corner with a radio for routine chores such as sorting mail and collating copies, and a couch for relaxation.

Perhaps the most compelling argument for a personalized office, complete with aspidistra, comes from research on state-dependent learning. Can't concentrate in the living room? Can't write without a soft Number 2 pencil or WordPerfect? Can't think without Earl Grey tea in the blue cup or Bach in the background? Numerous studies show that places, objects, and other environmental stimuli actually help us to remember what we've learned in those settings. That's why we're deeply stirred when we return to a previous home: the setting floods us with sights, smells, and sounds that evoke powerful feelings and stimulate memory.

Where the office is concerned, when we return from lunch or vacation, the room, furnishings, and scribbles on the notepad all ease us back into the cognitive and emotional state that sends us smoothly back to work, thus increasing our efficiency. To capitalize on state-dependent learning, smart corporations fill their offices with environmental cues—"cognitive artifacts" and "displayed thinking," such as posters and whiteboards—that summarize a project's progress to date and speed workers back into the intellectual

slipstream. By the time they've hung up their coats, employees who are surrounded by prompts that silently say "work" have left the domestic mind-set behind. Without knowing quite why, they may have trouble if they try to work at home, which lacks the familiar environmental sparks that jump-start their mental processes.

Compared to traditional employees, home workers must make a big effort to surround themselves with cues that help them access the state-dependent learning necessary for taking care of business. (They must also deflect competing messages sent by a sink full of dishes, say, or the nice fat magazine that just arrived in the mail.) The doodles of yesterday's thinking, the diplomas and awards on the walls, and other reminders of professional identity help evoke the focused mind-set required to hunker down and find the thread of what was accomplished yesterday. Not just things, but also rituals such as shutting the office door, turning on the classical music station, or checking the online stock quotes signal the shift from domestic to professional mode, just as end-of-the-day rites, such as exercising or a cocktail, say "back at home." From the view framed by the office window to a certain pair of slippers, all kinds of stimuli can whisper "get down to work," but each person must figure out which signals are right for him or her.

The luckiest home workers create an environment that invites the intensely focused state called flow, or optimal human experience, which is often described as "losing yourself" in what you're doing. (The term was coined by the psychologist Mihaly Csikszentmihalyi, who studies it using his experience-sampling technique.) Long before the era of the electronic home office, artists, writers, musicians, and other free spirits were enjoying flow in settings where they both lived and worked. The summer home and studio of George Morris and Suzy Frelinghuysen, two of the socially prominent, intellectually adventurous "Park Avenue cubists," is nestled next to Tanglewood in Stockbridge, Massachusetts. The couple were among the first American abstract painters and dis-

cerning early collectors of European artists, including Picasso, Juan Gris, and Georges Braque, as well as fellow Americans, from Arthur Dove to David Smith.

In 1930, George returned from studying art in France to build a Le Corbusier–style studio and *garçonnière* on his portion of a large family estate. He married Suzy, a talented soprano who sang in the New York City Opera and liked to paint, and introduced her to abstract art. They soon sold a Picasso for about $4,000 and added living quarters to the studio building. With its flat roof, jutting skylights, and curved glass-brick walls, their jazzy home/workplace, which was among New England's first such modernist houses, shocked the local gentry and even the builders who constructed it. To our eyes, the house's appeal lies in its winning combination of artistic experimentation and sophisticated, luxury-liner chic.

The most remarkable thing about their studio-home is that George and Suzy didn't just paint there—they painted *it*. To unify the house's two parts from the exterior, George linked the living and working wings with a large, brightly colored abstract mural near the entrance. He and Suzy also frescoed the interior walls. In the entry, the staircase's sexy curve is emphasized by George's sinuous cubist painting, whose bold black lines echo the black iron railing. In the dining room, one wall is a window overlooking the garden, and the others display Suzy's large murals, which riff on musical motifs such as clefs, guitars, and violins.

This country home-as-workplace was the perfect setting and support for Suzy's typical day. She sang in the morning, then gardened, then painted, then played tennis—all activities strongly associated with flow. After examining reports from thousands of people, Csikszentmihalyi concluded that our satisfaction with and response to life very much depend on a close match between our abilities and our challenges. If an activity is too easy, we grow bored. If it's too hard, we feel anxious and overwhelmed. When we have just enough skill to meet the demands, however, we fully engage and begin to flow. This desirable state is also strongly

linked to tasks that, like playing sports or music—or many forms of work—have clear goals and give immediate feedback.

Stunningly, the biggest obstacle to flow is the fact that most of us *don't know* which activities give us the most satisfaction. Many of Csikszentmihalyi's subjects are surprised to learn, for example, that they flow more often at work than at home, where they prefer to be. We're inclined to like places where we feel unconstrained, in control, and able to choose among various activities, which are conditions that often prevail at home. On the other hand, we feel worst when unmotivated or bored, as we also often do at home, but less frequently in the workplace.

As a result, although we might *think* that we enjoy lolling on the couch of a Sunday morning, Csikszentmihalyi finds that on average, this is the unhappiest time in America. We feel better and are more apt to flow when we engage in active rather than passive pursuits, so that working on a hobby—or just plain working—is often ultimately more satisfying than watching the tube or hanging out. Thus, on Sunday morning, lots of us don't feel relaxed as much as aimless and "stuck at home," he says. "Many people just don't know what to do with that time in that place. Instead of taking control of our own experience and choosing a pursuit, we waste a lot of quality time at home, which is something we can fix, thus greatly improving our daily life."

Working at home offers lots of behavioral rewards, but it also poses certain risks. In general, the home as workplace can undermine its traditional role as our refuge from professional demands. In particular, the new home office's electronic tools for communication can decrease the real, live sort.

An unusually large and broad socioeconomic spectrum of Americans—just about everybody under the age of sixty—thinks that the computer is a great addition to our way of life. More than eight in ten people already use one at home or work. Despite academics' talk of "information overload," only about 20 percent of the population feels overwhelmed by electronic communications. Most

people are more concerned about the information's quality than its quantity; more than three-quarters think that the government should somehow regulate the Internet.

Many social and behavioral scientists, however, are less sanguine than Americans in general about the computer's effects on home life. Their major concern is that, as about half of Americans admit, computers cause us to spend less real time with families and friends. In this regard, the computer has a potent predecessor—and competitor—in the television, which by the 1950s was changing both domestic architecture and behavioral patterns. The living room that was the scene of social activities was suddenly devoted to passive watching, then took on the embalmed look of a furniture showroom when the TV helped create the "family room." It's no coincidence that the tube's advent corresponded with an increasingly informal home and manners.

Fifty years later, television's impact on our daily life has lost its power to shock, even as it expands. Once a bulky, small-screened console in a single location that offered three channels, TVs in all sizes and shapes with numberless cable options have migrated throughout the home. As a result, the average household tunes in for about seven hours per day, and the average person for four. A quarter of the population even watches during dinner—traditionally the home's major daily social event.

Like the TV and its apotheosis as the lavish entertainment center, the office and its electronics subtly dematerialize the home by taking us someplace else. Laptops, e-mail, and cell phones enable us to do nearly anything anywhere, and thus be "at home" or "at work" in new ways. As a result, certain places, from houses and apartments to the wilderness, lose some of their traditional meaning. Most ominously, electronic communications test our social bonds by providing more immediate gratification for less effort.

Compared to instant messaging in the peace and quiet of the home office, catching up with fellow householders about the day requires more energy, focus, time, and sometimes frustration. Even

"snail mail" and "live" phone calls increasingly seem quaint, if not taxing. Touted as a way for parents and kids to stay connected, the cell phone can diminish actual contact between them by serving as a new electronic babysitter. Technology's antisocial effects are amplified for the home worker, who lacks the routine encounters with other people that are built into traditional workplaces.

Our growing romance with seductive machines was anticipated by the research psychologist John Calhoun, who studied the effects of overpopulation, coined the term *behavioral sink*, and inspired the children's book *Mrs. Frisby and the Rats of NIMH*. His research convinced him that humans beings evolved to live in small social groups of about a dozen people. As urbanization and population growth caused our social encounters and roles to increase, he argued, our satisfaction with about half of them—and with life in general—correspondingly decreased. The best response, he concluded, is to "try to live your life at any given moment as if you were part of a group of twelve."

Some of Calhoun's most provocative observations concern how the computers, answering machines, and other electronic tools that help us cope with the sheer volume of our information and communications affect traditional patterns of human behavior. Back in the 1980s, he predicted that these high-tech tools and toys would make us increasingly impersonal, and even curb population, because they'd become "so interesting that many people would rather concentrate on information than on raising children."

The temptation to hang out with machines instead of family and friends is not the only risk an office and its sirenlike equipment pose to home life. Eliminating the time clock may be a good thing, but working where you live can lead to working all the time. Many home workers put in more than forty hours per week, and with no colleagues to take coffee and lunch breaks with, they can easily end up isolated and stuck in overdrive. The multitasking computer, which can eliminate the need to walk over to a filing cabinet, much less to a library, greatly enhances so-called workflow, or the seamless shifting from one operation to the next. We are not disembod-

ied brains, however, but flesh-and-blood creatures for whom being glued to a desk is not an unalloyed blessing. Even in traditional offices, many of employees' complaints relate to the increased workloads caused by their own greater, machine-enhanced efficiency, inadequate rest breaks, and insufficient moving around.

The home office that accommodates clients and colleagues may be convenient for its owner, but it can have unpleasant behavioral consequences for others. Beginning with Sigmund Freud, who practiced for years in his residence at Berggasse 19 in Vienna, many psychotherapists have worked in their homes. Therapists gain both emotionally and pragmatically from this arrangement, but their patients and particularly their families, who have to be quiet and invisible at certain times, may dislike the blurred professional and personal boundaries.

Finally, the home office and entertainment center have a deleterious impact on public life by eliminating many traditional everyday social encounters. Home workers already lack colleagues—a rich potential source of friends and fraternization. If they unwind in the evening by watching a film from Blockbuster, which rents 6 million daily, they're also missing the experience of rubbing elbows with neighbors at the local movie theater—or library, park, or café. Observing that many leisure activities that used to happen in public places now take place at home, the environmental psychologist Jerome Tognoli says, "I live near a beautiful beach, but few people use it now because they have pools. We look for isolation and escape. We've withdrawn into the home, with its DVDs and TVs and computers."

For all of its behavioral advantages and risks, the office is the latest example of why, for more than a century, the American home has been the world's most convenient and complex: our eagerness to endow our houses and apartments with the latest technology. Formerly utilitarian necessities, appliances are now high-tech fashion accessories not unlike Rolex watches or BMWs. In the new "smart house," computers can run security monitoring, music systems that play different selections in different rooms, mechanical

systems, appliances controlled by phone or the Internet, and even self-adjusting lights and window shades. "Structured wiring" that's buried in the walls around the home's entire perimeter offers plug-ins and jacks every few feet and handles not just electricity but high-speed Internet access in several rooms, audio and video throughout the house, and computerized lighting and security systems. With an IP (Internet protocol) system, a householder's electronics equipment vastly increases in capacity and "talks" the same language as his or her computer or cell phone, which can operate sound, security, heating, and video systems without loss of audio or visual quality. In 2003, Martha Stewart sniffed that "Bill Gates' house is totally out of date. He built it right before wireless happened. The big tunnels for all his wires—he doesn't need that stuff anymore."

As with the home office, the smart house's appeal lies in its promise to make life easier and save precious time in a society that feels chronically overburdened and rushed. Leaving aside the question of whether more and more "labor-saving" technology necessarily means less work, the premise is that clever machines will free us from chores and allow us to go do something else. Owners of a Roomba, for example, can turn on the small robotic vacuum cleaner, then head for the tennis court—or the home office to do some *real* work. According to Rodney Brooks, a robotics expert at MIT, we need to get over our "tribal specialness" as a species and welcome increasingly sophisticated "artificial creatures" into our homes. These brainy machines, which are more like C3PO than the toaster, will one day accept deliveries, clean the house, mow the lawn, and even summon help if an invalid or elder departs from the daily routine.

At present, however, keeping up with the home's technological bells and whistles requires a constant effort to figure out how each new gizmo works. More than thirty years ago, the cognitive psychologist James Gibson made a deceptively simple observation: we don't perceive an object in terms of its physical characteristics, but in terms of what it affords us—what it means to us or does for us.

Thus, a table isn't a bunch of wooden pieces; it's a thing that we can sit at or put stuff on. The cognitive psychologist Donald Norman, who applies affordance theory to the practicalities of daily life, maintains that our homes should contain user-friendly objects that tell us what to do with them as soon as we see them. Unfortunately, industrial designers often care more about a product's novelty and appearance than about what it does, which is why we must repeatedly master different instructions for operating DVD players, alarm clocks, PCs, and cell phones that all do the same job, thus adding to daily life's needless frustration.

When all is said and done, even the most spectacular home office won't be the best place for most people to work. An environment's behavioral effects can only be understood in the context of the individual who's experiencing them. By reason of temperament, most people simply aren't suited for working in relative solitude and without much supervision or support. Some, however, thrive under just those conditions.

Driven, creative, and private by nature, Nathaniel Hawthorne, the father of the American short story and author of *The Scarlet Letter*, was well equipped to prosper in a home office, and he took great pains to create his ideal one. In 1860, he returned from Europe to Concord, Massachusetts, determined to append a tower to The Wayside, his rambling family home. Of its lofty prototype at the Villa Montanto, near Florence, Hawthorne wrote, "I never in my life saw a place that I should better like for a study than this—so comfortably small, in such a safe and inaccessible seclusion, at that airy height, and with a varied landscape from each window."

Already a literary lion, Hawthorne was strongly identified with the special homes that figured in his books. The House of the Seven Gables in Salem, the Berkshires' Tanglewood, and Concord's Old Manse were Massachusetts landmarks, and The Wayside, with its three-story "tower study," would soon join the list. Hawthorne's funny, frustrated observations on the construction of his study show that like many a modern home worker, he struggled with the

gap between his fantasy office and the real one, the project's ballooning budget, and the shortcomings of his contractor. Hawthorne wrote to a friend, "[I] transformed a simple and small old farmhouse into the absurdist anomaly you ever saw, but I really was not so much to blame here as the village carpenter, who took the matter into his own hands, and produced an unimaginable sort of thing instead of what I asked for." Appalled that what was to have been a $500 venture ended up costing more than $2,000, he wrote, "If I had known how much it was to cost me, I think I should have sold the old house and bought a better one."

Like most people who work at home, Hawthorne hoped that his new office would make his life both more pleasant and productive. A family man, he expected his aerie to give him more peace and quiet, of course, but he also hoped that it would lift his imagination to new heights. To a friend, he wrote that "[I am] meditating a new Romance, which ought to be the most elevated of my productions, since I shall write it in the sky-parlour of my new tower." On a more prosaic level, Hawthorne even anticipated that having to pay for his dream office would motivate him to work hard and help compensate for the loss of his recent carefree traveler's life. After complaining to a friend about the daily grind, he wrote, "I have been building a tower, in the hope that the burthen of it upon my back will keep me from wishing to wander any more."

Hawthorne was not much given to socializing, and the isolation and austerity of the home office that suited him would feel less like a tower than a prison to more convivial souls. (Underscoring the link between working alone and a solitary nature, one study shows that people who like the former also want more personal space outside their workplace than those who don't.) He not only located his study on the tower's third floor, far above his noisy household, but also designed its interior to help focus his mind and eliminate distractions. Despite its Gothic carpentry and vaulted ceiling (which was painted with romantic landscapes only after the writer's death), the study is a Spartan room that's all about work. Five windows offer rural vistas, but Hawthorne positioned his

stand-up writing desk so that his back faced the alluring scenery. Selective regarding his social encounters and disciplined about his writing regimen, Hawthorne turned out *Our Old Home* and other works in the barely three years he spent in his unique home office before his death in 1864.

My family figured out my office's effects on domestic behavior the hard way. When we moved from our loft, where I had to write at a desk in the open living area, to the house, I quickly claimed a former bedroom, shut the door, and thought, "Paradise!" I set about making the space my own by painting the walls adobe red, requisitioning my late godfather's desk, and hanging favorite art and photographs.

Unfortunately, my family was less thrilled than I with my new office and the time I spent there. To harmonize the worlds of home and work, I agreed to limit my hours to weekdays from nine to five. We also added a wall of bookshelves and a couch to the room, so that it could do double duty as our library/den in the evenings and on weekends. After a dozen years, I'm still content with my office and working at home, although I sometimes miss having career clothes and going out for lunch.

When I reach an impasse at my desk, I often take a nature break, in the form of a walk in Riverside Park or a little sunbathing on the roof. Research shows that these brief immersions in the nearby natural world are particularly good for relieving workday stress and the mental fatigue that leads to so-called human errors.

The Garden

Outside or In

At first glance, the ultramodern urban home seems to have very little to do with nature. Its landscape is mostly so-called hardscape and is as minimalist as the house. But the conventional front lawn has been replaced by a lily pond, and the usual paved path to the front door with concrete stepping stones that appear to float among the goldfish. This Los Angeles house's dramatic entry is an aesthetic knockout, yet it was inspired as much by behavioral as artistic considerations.

The landscape architect Stefan Hammerschmidt's first concern was to give his hardworking client a sense of leaving the world behind when he comes home. As he says, "after a long day or business trip, some people don't want to see lots of flowers and colors and things, but just want to clear the mind. A big window that

frames a calm reflection pool or piece of sky can be very satisfying for them. The senses are stimulated in a quieter way. A landscape architect is supposed to make those kinds of dreams come true."

On the East Coast, the term *backyard* may still summon thoughts of a pushcart grill, splintery trestle table, and bug zapper, but on the West Coast, many homes now have a posh "outdoor living room," complete with fireplace, weather-resistant upholstered furniture, special lamps and heaters, and built-in cooking and dining facilities. Like numerous new trends, this nature-oriented, roofless great room is destined to migrate eastward, influencing home design even in more climatologically challenged regions.

In the hardscape of this hip LA home's outdoor living room, nature is represented by water, sky, and hardy, low-maintenance succulents, perennials, and grasses that sprout from the same concrete cubes that serve as furniture modules. Surprisingly, all the tough masonry not only complements the edgy house but also makes the greenery bursting from it seem more vital and vivid.

In his efforts to create natural settings that suit his individual clients and their homes, Hammerschmidt finds that most people are simply unaccustomed to house thinking that includes their outside domestic spaces. "They don't know what to ask for—or even what they want," he says. "To meet their needs, I have to ask lots of questions first. 'Do you entertain much? Spend a lot of time outside? Like to lounge in a hammock?' I have to remind them that you can really live outside here, just like you do in your living room." As a native of Austria, where he learned to garden at his grandmother's farm before studying landscape architecture at UCLA, Hammerschmidt is still delighted by sunny California, "where the house flows out into the garden, and the garden flows back in. Architecture and landscape—you can't have one without the other."

As America's 100 million gardeners know, to paraphrase Hippocrates, the outside of a home is good for the inside of a person. More than a century ago, Helena Ely, a founder of the Garden Club of America, wrote in *A Woman's Hardy Garden* that "the relaxation from care and toil and the benefit to health are great, beyond

belief . . . If the rich and fashionable women of this country took more interest and spent more time in their gardens, and less in frivolity, fewer would suffer from nervous prostration, and necessity for the multitude of sanitariums would be avoided."

Modern research supports Ely's contention that, regardless of our gender, nearby nature—not just gardens but window boxes, pets, houseplants, views—is less a luxury than a psychological necessity. The wilds and wildlife that star in dramatic documentaries are all well and good. However, where our own well-being is concerned, it's the milder local natural wonders that we encounter in and around our homes—small doses of clouds, plants, streams, birdsong—that can regularly slow our metabolism, relieve stress, reverse the mental fatigue that leads to dumb errors, help us heal, and supply insight into our own human nature every day.

Then too, nearby nature is just plain fun to fool around with and in. Past the "happy table" where he nurses friends' sick houseplants back to health, Hammerschmidt's own outdoor living room in Venice is the site for frequent parties. Festive evenings are extravagantly lit by eclectic chandeliers wired for outdoor use that festoon a huge grapefruit tree. A handsome array of art glassware is displayed on shelves attached to the back fence. "To expect the unexpected—I love that!" he exclaims. "Why keep your collections indoors?" Pointing to an exotic-looking plant, he claims, "Look at that cymbidium, with its twenty-four flowers! It's spectacular. People think orchids are so delicate, but here they do fine outside." The most surprising feature of this inventive outdoor living room is that when you're seated there, a living curtain of bamboo blocks your view of surrounding buildings. You're in a densely populated town, yet as Hammerschmidt puts it, "you could be out in the country!"

Whether we live in a country cottage with a garden or an urban condo with a rubber-tree plant, rubbing elbows with nature refreshes us and teaches us subtle lessons about the way life is. In a quiet old residential section of Berkeley, Clare Cooper Marcus, a

writer and retired professor of architecture and landscape architecture at the University of California, has transformed a typical suburban backyard into a riotous Eden that's both her real home and a major food source.

From the fountain at its center, Clare leads a circular tour of her garden, which she has worked on for the past thirty years. She begins with its "wild part," where she likes to read. Next is the shade garden, with its azaleas and rhododendrons. Then comes the fruit area's apple, pear, and nectarine trees and raspberry bushes, followed by the winter vegetable garden, which teems with February's collards, kale, and bok choy. Just past a della Robbia–style orange tree that spills over the fence is Clare's latest project: planting the cracks between the paving stones laid down where she ripped up part of her driveway to make more room for nature.

Clare's favorite part of her garden is a wooden bin off in one corner. Lifting its lid, she reveals the remains of last night's dinner, which emits a faint buzz. "You must listen to my compost heap!" she says. "It sings! Can you hear all those wonderful creatures that sound like a generator? In the spring I'll put all this stuff that would have been wasted into my garden, where it will help my tomatoes grow. The efficiency of it! I can't tell you how happy I am to have a compost heap."

Her intense relationship with the natural world goes back to Clare's British youth and its combination of World War II and family troubles. Because indoors was "not a happy place to be," she says, she spent most of her time outside. Partly to compensate for wartime food shortages, young Clare learned to garden from her beloved Auntie Jean. "Almost every day," she says, "I give thanks for her." A lifetime later, Clare likes her comfortable Victorian house well enough. But nature remains her true home, which she defines as "your one secure center in the universe. The house and the little knickknacks and photos—that's all great, but for me, outside is something completely different. I'm much more attached to my garden and always have been."

Personal history and professional experience have given Clare

some particular insights into how the outdoors enriches our inner lives. First of all, she says, "we're mostly just too blind to see it, but the natural world is an immense teaching tool." For her, its primary lesson is self-acceptance: "Nature just *is*. We don't walk into a natural landscape and say, 'I wish that rock were over there,' and that landscape doesn't expect anything from us, either. There's no posturing, no persona, when you are outside alone. Nature is the way it is, and you can be the way you are. Just as you are."

Nature also teaches us that all living things, including us, go through cycles of growth, decay, and regeneration. "That the fall's rotting compost heap becomes the spring's fertilizer is an amazing lesson," says Clare. "If you garden through the seasons, you absorb the understanding that life and death are a continuum. Nature teaches me that the death and decay of my body are natural phenomena of returning to the earth, and also that on some level, my essence will continue in another season. I personally can't go quite as far as to say that there's life after death, but there *is* a cycle."

Nature's third great lesson is the interdependence of living things, which has become a matter of crucial political as well as personal importance. Just as Clare nurtures her garden, she says, it feeds her body and grounds her mind. "Because it's so physical—I never wear gloves—gardening balances my cerebral work. Auntie Jean really set me up for a lifetime of enormous pleasure and soul sustenance, as well as exercise and good food. Tonight, just before dinner, I'll pick some kale."

The love of nature also draws people together, supporting our increasingly endangered sense of community. Recently Clare attended her first "scion exchange," at which gardeners trade little twigs of rare fruit trees for grafting. "I was entranced by the people, mostly older men, all busy exchanging information about fruit. I wanted a Cox's Orange Pippin apple, which was my childhood favorite, and was thrilled to find some." Even in big cities, apartment dwellers who have access to a garden feel that they have friendlier neighbors and closer communities than those who don't. Tenants in public housing projects who have small plots to culti-

vate personally feel more pride and self-esteem. Their neighborhood also benefits, in that the gardeners' expression of territoriality reduces vandalism. Reassuring bursts of nature in the city even increase urbanites' feelings of safety.

People who don't garden can reap nature's psychological bounty just by nurturing a houseplant or two. Remarking on her "fifty or so," Clare tells the story of *The Plant in My Window*, a favorite book from her youth. A depressed, jobless veteran returns from World War II to a bleak New York apartment that contains nothing but a dying philodendron. One day, he throws a little water on the plant. A few days later, he notices that it has perked up, so he waters it again. Next, he goes to the library to read about philodendrons, and then to learn more at the botanical garden, until he's eventually drawn back into life's current by his involvement with another living thing.

This simple story suggests something of nature's bracing effects on health. In the nineteenth century, urban civic leaders hoped that the first public parks would improve the well-being of the masses by providing temporary escape from the industrialized city's noise, crowds, and bad air; previously, people had sought relief in the cemeteries that doubled as public gardens. Modern research on nature's salubrious effects was jump-started by a rigorous, highly influential study, conducted by Clare's colleague Roger Ulrich, who is an environmental psychologist, that makes the case for nature's ability to alleviate stress. He found that postoperative patients whose hospital rooms had views of a natural scene recovered faster, required less pain medication, and got more positive evaluations from nurses than patients who overlooked, say, a brick wall.

Ulrich's breakthrough inspired lots of experimentation with nature's healing potential. At New York City's Rusk Institute of Rehabilitative Medicine, horticultural therapists teach the handicapped to raise their spirits and increase their manual dexterity by performing simple gardening tasks, such as potting a seedling. Research with patients who must undergo upsetting or painful med-

ical procedures suggest that natural sights and sounds can help reduce their anxiety and discomfort. Nursing home residents who actively care for their own plants are healthier and have fewer complaints than those who relinquish responsibility to the staff. In nursing homes such as those operated by the Eden Alternative, elders who have dogs, cats, birds, and fish as well as plants to enjoy and care for need less medication and feel more satisfied and self-sufficient. As Clare says, plants and creatures "bring a sense of life and the natural into what has become a person's home."

In 1994, Clare's interest in nature's healing effects deepened when she was treated for breast cancer. After chemotherapy sessions, she spent time in the hospital's garden, seated under an old oak that gave her strong feelings of strength and hope. Some research suggests that quiet time in a natural setting may somehow enhance the immune system's potential to fight disease. "No one could say that a garden heals you," says Clare, "but I believe that it's relaxing in a way that allows your body to muster its own forces for self-healing."

To maximize nature's healing powers, Clare also did visualization exercises in which she saw herself on the wildly beautiful island of Iona, in the Scottish Hebrides, whose flora and fauna helped fight the cancer in her body. Looking back on her experience of serious illness, Clare says, "It seems like a cliché, but for me, it truly was a gift that catapulted me to the conscious understanding that the outdoors is the home of my soul. For that I'm profoundly grateful."

As practical as she is spiritual, Clare expresses her gratitude by helping sick people and those who care for them to tap nature's restorative power. She coauthored *Healing Gardens*, a textbook for design and health professionals interested in the therapeutic use of nature, and she advises hospitals and hospices on the subject. The health-care industry is increasingly interested in nature's benefits not only for patients but also for medical professionals, who have high rates of burnout and job turnover. As a nurse who spends long days in a radiation department located underground told

Clare, "I feel like one of the mole people, and then I come out here in the garden and see the sun and hear the birdsong and the fountain. If I didn't have this, I think I'd go crazy."

Her work with therapeutic gardens impresses Clare with nature's ability to encourage an equanimity that transcends illness and suffering. As she puts it, "Nature can help us come to terms with wherever we are in life and make us feel more peaceful about what's happening." Offering an extreme example, she describes a hospice for the disadvantaged in a tough San Francisco neighborhood. When a patient is about to die, he is taken from the ward to the facility's one private room, where the doctor made a garden just outside the window in what had been a derelict old courtyard. Now, says Clare, "there's a trickling Japanese fountain and blossoming jasmine, because sound and smell are the last two senses that stay with us."

Whether from a windowsill or in a sprawling garden, nature's powerful effects on our physical and emotional well-being help make a house or apartment feel like home. Like many people who think of domestic life in behavioral rather than consumer-driven terms, Clare urges everyone to "have the confidence to express who you are in your home and garden. Forget about the experts and the cable shows!" Surrounded by her magical garden, she says, "I can't overemphasize how important it is to see yourself reflected in what is around you. Not in the egotistical sense, but in deep, affirmative one of 'Yes, this is who I am in the world.'"

Houseplants and gardens are fine, but in almost 60 percent of American homes, nature is also represented by one or more pets. According to the American Veterinary Medical Association, these honorary family members include 52 million dogs, 59 million cats, 12.6 million birds, 5.7 million rabbits, 4.8 million rodents, 3.5 million reptiles, and 56 million fish. As these staggering numbers make plain, "animals are very important to many people's domestic surroundings," says the psychologist Gene Myers, who studies how people relate to the natural environment. Regarding our rela-

tionships with animals, he's particularly interested in the fact that we treat them neither like humans nor like objects; moreover, because we make fine distinctions about animals based on the kinds of responses we get from them, we regard fish differently from dogs.

When discussing exactly *why* we're interested enough in animals to invite them into our homes, Myers points out that the things we give names to—cats and boats, R2D2 and Rover—usually can move. He suspects that as small children, we learn to equate motion with aliveness, and that this equation has much to do with our responses to animals. Noting that when patients in a dentist's office watch fish swimming in an aquarium, their blood pressure lowers, Myers says, "Is it the motion of the fish that relaxes us? If so, does it do so in a way that, say, watching a lava lamp doesn't? If so, how does the awareness that something is alive add to its meaning and elicit a more potent response from us?"

If we associate movement with life, active creatures must add vitality to our homes. On the other hand, we don't extend the welcome we give to frisky canines and graceful felines to skittering roaches and droning flies. After watching people watch zoo animals, Myers concludes that to engage us, an animal must not only move on its own but also do it in a way that, like tail-wagging dogs and purring cats, suggests emotion. Our strong negative response to insects, especially inside the home, supports this idea. "Our assumptions of how behavior works just don't seem to apply to bugs, because they don't behave like mammals," he says. "You can yell or do something else that would scare a dog or hamster, but a bug will just sit there." If we perceive an affective response, however, we don't treat the animal as an objective thing but as a subjective "other." Although there are cultural influences on that response, says Myers, "it's pretty strong."

When it comes to animal affect, it's hard to beat man's best friend. Like watching fish, hanging out with your dog lowers your blood pressure, but for more complicated reasons. Dogs not only move in ways that suggest emotion, but also form bonds with us

that don't involve much negative feedback, at least not the verbal sort. "Your dog might convey value judgments about your character and your behavior in a subtle way," says Myers, "but not in linguistic form. When really upset with you, your dog might pout, but your spouse wants a negotiation."

Lots of evidence shows that pets are an integral part of much homelife. A beloved animal's death can cause intense bereavement. Pets can become extensions and representations of the self, as in "Love me, love my dog." Animals also express their owner's status, as fancy breeds of dogs increasingly do in upwardly mobile parts of eastern Europe and China. Pets can be therapeutic for troubled, unsociable people and "transitional objects"—a child substitute for single adults, say, or a surrogate parent for a child.

Many pets enter the home because parents think that caring for an animal is "good for the children's character." This may be especially true for boys, who don't do as much parent-baby play as girls do. Research done by the psychologists Alan Fogel and Gail Melson suggests that because it teaches boys about nurturing, having a pet is an especially important experience for them. Myers's work adds another dimension to the character-building argument. Compared to adults, young children don't make such strong social distinctions between humans and animals, he says, which means that forming relationships with animals, not just people, can be "pretty fundamental" to shaping a child's sense of self. Interactions with another species clarify kids' sense of what it is to be human and affirms their own vitality. Finally, says Myers, "early experiences with pets are also good for nature, in that they can be crucial to our development of environmental ethics."

The nature in our homes includes not just the vegetable and animal forms but the "mineral" sort, too, from water to views of the sky to sunlight. The ninetieth-floor penthouse of the Trump World Tower, adjacent to the United Nations complex, would seem to be about as far from the natural world as you can get. The elevator ride makes your ears crackle and pop as if you were taking

off in a plane. The main attraction of the 5,000-square-foot pent-house, which is for sale at $16 million, is its master-of-the-universe view. All of Gotham lies below—far, far below—in an eye-popping panorama that includes the great landmarks of the Chrysler and Empire State buildings, Manhattan's bridges, and even the distant Catskill Mountains. For many urbanites, such a vista is nature, and they're willing to pay high prices for apartments that provide it.

For much of history, windows weren't just to look out of but also the home's major source of illumination. It's only a three-hour drive from the Trump penthouse, but Cold Spring Village, a re-creation of an early American agrarian settlement near Cape May in southern New Jersey, is a different world. The Jacob Spicer House, which dates to 1702, gives a sense of what home life in general and interior light in particular were like in the colonial era. Spicer was a "proprietor," or recipient of a land grant, who was also a farmer, politician, and merchant, but his frame home is un-pretentious. Its most interesting design feature is the regional preference for "two-ness": two rooms upstairs and downstairs, two fireplaces and chimneys, and two front doors, each flanked by a fine window.

Winters in southern New Jersey are more temperate than New England's, and the Spicers exploited their windows to the full extent. To that end, their furniture wasn't carefully placed in one arrangement, as ours is, but was moved according to changing sources of light and heat. On a bright day, a woman intent on darn-ing or reading would bring a chair to a window, and at night, to a candlelit table or the fireplace.

Around the turn of the twentieth century, as America contin-ued to shift from an agrarian to an urbanized society and homes became temperate, well-lit places regardless of the time of day or year, people underwent a radical if little remarked environmental-behavioral change. Suddenly, they were no longer obliged to live in synchrony with nature in general and the sun in particular, as *Homo sapiens* had evolved to do.

As a result of spending much less time outdoors, where it's

many times brighter even on an overcast day than indoors with all
the lamps on, a third of Americans now suffer from mood and sleep
problems caused by inadequate light. In fact, light is so vital to
mood that if many of us could make just one improvement to our
homes to enhance our well-being, adding brightness would be a
sound choice.

Light's connection to mood is rooted in the fact that like most
creatures, human beings are inclined to be more active and outer-di-
rected by day and slower and more conservative at night, because
we evolved biological responses to the sun's daily fluctuation,
called circadian rhythms. In a complex, not yet fully understood
neurological process, light sets the brain's biological clock, which
tells us when to wake and sleep—two states related to our differ-
ent active-daytime and subdued-nighttime moods. If this clock
malfunctions, as when we're jet-lagged, most of us feel exhausted
and withdrawn—in short, depressed. In the Northern Hemi-
sphere, winter's short, dark days throw off the biological clocks of
the vulnerable, causing problems from a mild malaise to a full-
blown depressive illness.

Where light is concerned, a home's location can have big conse-
quences for mental health. A person who might be clinically de-
pressed in Boston or Anchorage might be fine in Miami or San
Diego. Only 2 percent of the people who live in Florida, say, suffer
from so-called seasonal affective disorder, or SAD, compared to
about 10 percent of the people who live in New England and the
Pacific Northwest. Moreover, about *half* of the population in these
northern zones experience some sort of behavioral slump, or the
"February blahs." The home's lighting is especially important for
those inclined to have mood problems, who are often drawn to the
dim, gloomy places that worsen their state. Someone who might
feel cheerful in a sunny high-rise co-op or a beach house might be
moody in a dim urban brownstone or a woodsy cottage surrounded
by picturesque evergreens.

There's a simple rule for lighting the home to improve mood:

the brighter, the better. Along with adding electrical wattage, trimming foliage around windows, getting rid of heavy curtains and blinds, painting walls in pale colors, and installing skylights in windowless areas all help to lighten up the home and its residents. Good illumination is especially important in the spaces where we spend the most time. A bright, cheery living room does little to lift your spirits if you practically live in a dark paneled den or home office.

Science has established that the quantity of light is important to our well-being but has determined little about the effects of its quality. It makes sense that full-spectrum lighting, which is similar to daylight, should be good for us, and many people prefer it, but even this appealing hypothesis has yet to be proved. Similarly, many people dislike fluorescent lighting and blame it for everything from headaches to bad moods, but research has so far failed to support such complaints.

Because light and views of nature are so important to our well-being, window design alone is a good enough reason to consult an architect before building or renovating a home. In the Northern Hemisphere, most direct sunlight comes from the south, so architects past and present have often positioned the home and its windows to maximize southern exposure. Rugged coastal Maine's vernacular architecture judiciously places windows where they won't rattle during winter's nor'easters. The southern home features cool, deep porches and lots of windows and hallways to catch breezes. Southwestern houses use covered patios, thick adobe walls, and fewer windows to keep out the sun by day and retain its heat in the chilly nights. Unfortunately, modern technology that can heat and cool our homes regardless of their location threatens the wisdom, economy, and seemliness of such regional design features that have evolved over time.

In the 1930s, the architect Richard Neutra designed a modest one-bedroom house and studio in the Palm Springs desert for Grace Miller that handles light and the natural setting in a partic-

ularly sensitive and appropriate way. At one end of its screened porch, which is separated from the living area only by glass panels, there's a small square pool—in this dry landscape, a way of bringing nature in the form of water right into the house. And as its owner observed, "The water tempers the effect of the bright sunshine and sometimes makes beautiful reflections that dance on the ceiling of the living room and porch."

Since the lodges, teepees, and pueblos of the country's first peoples, nature has been a spiritual, cultural, and political part of the American home. As soon as they secured their survival in the New World's unspoiled wilderness, colonial farmers began to plant flowers as well as vegetables. The Vale, in Waltham, Massachusetts, is one of the nation's first and finest estates, created in 1793 in the English naturalistic style of Humphrey Repton and Capability Brown. With this 150-acre country seat, Theodore Lyman, a merchant who had made a fortune in the China trade, established his family's place in Boston society, which already highly esteemed gardening and horticulture.

The Vale exemplifies the era's romantic, upper-class British vision of nature that has been engineered to look more "natural" than nature itself could contrive. The grand Federal-style home is situated in a landscape of rolling meadows, wooded knolls, ornamental water bodies, winding paths, and carefully managed woodlands. The large "pleasure garden" that immediately surrounds the house is separated from the surrounding "wilderness" by a 600-foot-long brick wall, which also fostered espaliered peach, apricot, and pear trees. The Grape House, which may be the nation's first and oldest original greenhouse, provided the family with fruit, and the later Camellia House gave them rare flowers.

In the nature-oriented aristocratic English way, The Vale's two finest rooms extend themselves into this seductive landscape. The two-story columned ballroom, where the waltz was introduced to Boston society, and the more intimate, oval-shaped "bow parlor,"

have triple-hung windows. Because they can be lifted up from the floor to function as doors, the windows allow easy access to the grounds and help blur the boundary between the architectural and natural spaces.

The Vale is an early example of how, like our homes, the edited nature that enhances them reflects both our personal taste and social status. They may not be country seats, but single-family houses in leafy suburban or exurban bowers have been part of the upwardly mobile American dream for more than a hundred years. Like the highfalutin Lymans, "old money" folk still generally prefer their nearby nature au naturel, or seemingly so, while others are inclined to like it tidy.

In a famous study conducted in an upscale exurb, the geographer James Duncan found that denizens of the town's venerable aristocratic section cultivated the "rural sophisticated" look of twisted, unmarked lanes and overhanging trees, old houses and rambling rock gardens. In contrast, the "new money" neighborhood had straight paved streets and symmetrical yards with geometric flowering borders, big neo-Colonial houses, and scenic mailboxes. When at home, it seems that many old-money families, like the Lymans before them, want to feel private and "out in the country," while most others prefer a well-ordered, sociable milieu in which nature, too, is under control.

For an increasing number of Americans, the relationship between home and nature has moral as well as social import. As a result, they prefer a "green" dwelling, or one that conserves energy and otherwise minimizes its impact on the natural setting. One of these environmentalists' patron saints is Henry David Thoreau, a father of American conservation. In 1845, he borrowed a piece of woods overlooking Walden Pond from his friend Ralph Waldo Emerson, then built his own "tight, shingled and plastered house" on it for $28.12½. During his two years there, the young Harvard graduate gardened, read, and wrote. When *Walden* finally appeared in 1854, Thoreau was established as writer and conserva-

tionist, and his former home became a kind of shrine. Walden Pond was the first landscape designated as a National Historic Landmark and still draws 600,000 pilgrims each year.

That nature was more Thoreau's true home than any building seems clear from the reproduction of his house that stands in the park. Like a ship's cabin, his ten-by-fifteen-foot room has a snug, pleasant air of having just what's needed and not one thing more. There's a stone hearth, two windows, and a few simple furnishings, reflecting Thoreau's view that "the more you have of such things, the poorer you are." His preference for the natural world was partly that of the accomplished outdoorsman, but as a New England Transcendentalist, Thoreau also believed that each person can have a spiritual relationship with nature. Just before he moved to the pond, he wrote, "My friends ask what I will do when I get there. Will it not be employment enough to watch the progress of the seasons?"

Considering Thoreau's later identification with wilderness conservation, the most surprising aspect of his quintessential American homestead in the woods is its nearly suburban situation—even back in his day. Most of the local trees had already been felled by industrious farmers; in response, Thoreau himself planted four hundred white pines on the property. The pond had few fish, and the countryside supported only the small mammals, such as squirrels and foxes, that can live in quarters with humankind. Indeed, Concord was only a mile and a half away, and the "hermit" frequently walked to town to see his family and friends. As his home at Walden Pond makes clear, Americans needn't retreat to the wilderness to commune with nature.

Like Thoreau, the architect Mac Gordon is a self-described "rabid environmentalist" who lives in a green home just outside a small New England town. The modern house he designed for Doro Bachrach, his film-producer wife, and himself has a wall of mostly glass that runs through all the living and sleeping spaces. In summer, this panoramic "window" frames a dense bank of purple sage, daylilies, black-eyed Susans, and other perennials, a

hillside meadow bordered and broken here and there by trees, and the blue-green Berkshires rising to a vast sky. There's no sign of the manmade. The only sounds are from birds. This corner of Lakeville, Connecticut, might be Eden on the seventh day.

When discussing why Americans, including himself, are so obsessed with the home these days, Gordon says, "We're destroying the natural environment so rapidly that we want *something* in our lives that's not dispiriting." During his youth on then-rural Long Island, it was "one of the most beautiful places in America," he says. "In two generations, it has become one of the least appealing. In our huge country, we gobble up the environment and throw it away."

If reforestation was already a problem in Thoreau's day, planned development is perhaps the most pressing need in ours. The uncontrolled sprawl made possible by the car, the overwhelming preference for a single-family house in the suburbs, and the traditional notion that we Americans can live wherever we damn well please have taken a serious toll on our nearby nature. There's less land for housing sites, let alone for parks and the like. Supplies of the natural resources, such as timber and water, that are needed to build and support homes are diminishing. As a result, the once radical idea of subordinating the home to its natural environment has entered the mainstream. In 2002, architecture's prestigious Pritzker prize went to Glenn Murcutt, an Australian designer of "sustainable" buildings that are designed to have a minimal impact on nature. According to the *New York Times*, Murcutt's award signaled that sustainability "now overrides aesthetics in the urbanizing world." By way of verification, in 2003, the prize went to Jørn Utzon, another nature-sensitive architect.

As the owner of a 3,200-square-foot house in a former hayfield, Gordon is aware of the irony of his environmental position. "One home on six acres is not a good prototype," he says wryly. However, he tried to compensate by making his home as ecologically sound as possible. First of all, the house was fitted into the sloping site and bermed, so that much of it is underground. The roof is

landscaped exclusively with hardy native plants and spreading junipers, which are also drought- and deer-resistant. Even in a dry, hot summer, there's little need for watering, he says, "because these plants don't have to be babied." During the oil crisis of the 1970s, which popularized innovative energy conservation schemes such as solar heating, Gordon became fascinated by such "earth-sheltered" homes. Three to four feet below ground, the temperature is a consistent fifty degrees, so it was thought that building at or below this level could save on heating and cooling expenses; in Gordon's experience, the earth mantle is more effective as a thermal conductor in summer than as an insulator in winter.

Inside, Gordon's home glows with a soft radiance from white plaster walls impregnated with wax that picks up subtle shades and gleams of light. During a house tour for curious local residents, he reports, people were amazed by how normal the house seems inside—and especially by all the light. When a group of environmentalists recently toured the house, the big attractions were its conservation-minded mechanicals, such as solar/propane heating and a ventilation system that brings in fresh air during the winter without losing warmth. The austerely beautiful, open-plan interior was designed so that there's little distraction from what the house is really about: the great outdoors and keeping it great. As Gordon says, "With a beautiful setting like this, it makes sense to subordinate the architecture to the landscape."

From incubating an avocado pit in a jar over the kitchen sink to mowing the roof to paying top dollar for an oceanfront or penthouse view, we're willing to take trouble and incur expenses to make nature part of our homes. As a result, more communities, including some seemingly improbable ones, are trying to make the most of their natural charms. For decades, the riverfront village of Hastings, a short commute from New York, was cut off from the majestic Hudson rolling past it by factories and railroad tracks. In an ambitious reclamation plan, the town is exploring how to reestablish its ties to the river by cleaning and refitting the former industrial sites for parks, shopping, and low-rise housing with great views.

Most of us claim to "love nature," and investigations into why largely concern a theory that the sociobiologist E. O. Wilson calls *biophilia:* our genetically mediated attraction to and need for nature. From this perspective, in order to survive, our species evolved a taste for the natural places and things that sustain us and allow us to make the most of our peculiarly human skills. Compared to other creatures, we are neither particularly strong nor fast, nor are we great smellers, swimmers, or fliers. On the other hand, we're *very* good at processing information and making things.

To maximize smart but puny *Homo sapiens*'s chances of survival, we evolved a taste for environments that offer ready data to crunch and resources to be exploited, while also protecting us as we go about our business. If asked by researchers to choose our favorite natural settings, most of us pick one that's neither very open, like the desert, nor very closed, like the jungle, but one that provides both a good view of open country and the safety of clumps of trees—in short, the African savannah where we evolved. We endlessly replicate this combination of the grove's mystery and the meadow's clarity in our parks, yards, and gardens, as well as in art.

After conducting some ingenious studies of how people relate to the natural environment, however, Gene Myers thinks that the notion that our response to nature is all about survival is too simplistic. He allows that the biophilia hypothesis is intuitively appealing, and that our species has benefited from being attracted to and fearful of different aspects of nature. Yet he finds that in his real-life research, it's our own human enthusiasm for forming relationships that mostly draws us to plants and animals—so much so that we invite them into our homes. As Myers neatly puts it: "That we want to connect to nature is a function of our own social nature. That position has different implications from just saying it's a 'biological need,' which sounds very concrete and ultimate. Thinking along such simplistic lines underestimates nature's real significance to us."

Fiddling with the relationship between home and nature seems to be part of being human. Anyone who has lived with tribal

people or even in run-down housing "gets a sense that a house is really a very temporary condition between you and the rest of nature," says Myers. "Different cultures have had different ideas about how invulnerable to the external world a home needs to be." In his Pacific Northwest, Native Americans once built sturdy lodges of rot-resistant cedar, but perhaps because their spiritual beliefs didn't distinguish very much between inside and outside, even those homes weren't as solid and permanent as we like ours to be. Nevertheless, says Myers, "if you leave a house alone for ten years, nature will be taking it back, and in fifty or a hundred years, it will be just about gone. The power of wind, rocks, and all the life and bugs underneath it is just phenomenal."

We resist nature's power to reclaim the very earth under our carpeted floors, yet we also invite it indoors, at least on our own terms. As Myers says, "We evolved nature out of the house, but also we want some of it in, so the barrier between the two has become permeable. Think of the prevalence of houseplants, including quite exotic varieties, or the prices we pay for even tiny yards." From a behavioral perspective, one of the home's most important functions is to foster our relationships, and Myers contends that that doesn't mean just human ones. Our social interactions give us feedback about others' responsiveness to us and about our identity, so he wonders, "What does it add to that experience of relationship if the respondent is from a different species? I think it tells us that we are not alone on this earth. Because *Homo sapiens*'s morality and sense of self are so entwined with our social existence, connecting with nature really deepens and broadens our sense of what it is to be human."

One morning, while idling in a bay window upstairs that overlooks a big tree on our city street, I saw a hawk land on a branch perhaps thirty feet above the sidewalk and dine on a pigeon. Passersby below never even noticed the feathers fluttering down through the air. However, I went back to the mundane business of the day feeling as if I had just returned from a week in the Rockies. As this drama of natura naturans' just outside my urban window makes plain, plants and animals are part of our domestic world no matter where we live. Notwithstanding Americans' strong general preference for a detached house in a bucolic natural setting, city dwellers as well as landed gentry and suburban squires enjoy nature's behavioral benefits, such as good views and sunlight, houseplants and pets—and even the occasional Pale Male.

Almost all people who have second homes deliberately choose properties that are especially close to nature, whether an ocean or a brook, high peaks or rolling hills. This proclivity is partly an expression of our longing for the simple, or at least simpler, life that's a refreshing contrast to the busy metropolitan workaday world. Whether we prefer white-water rafting or floating in the pond, our major motivation for outdoor R & R isn't the activity per se or even increased fitness, but psychological rewards.

The Second Home

Domesticity to Go

Where homes are concerned, Chris Haugh has become downright wanton. Her serial love affairs started with her first second home. Buying the ranch in Sun Valley, Idaho, initially made her feel unfaithful to her big stone house back East. At first, Haugh and her family even tried to spend two weeks per month in each place, before finally giving up and settling down at the ranch. Following a divorce, however, she had to decide once again where to call home.

After much deliberation, Haugh chose to stay in Sun Valley and create a house that would be just right for her. In the process, she found a calling that has merged her personal and professional lives. First, Haugh comes up with an idea for a dream house. Next, she

builds it and lives there till every detail is perfect. Then she sells this unique house located in one of America's premier leisure home areas and uses the profit to fund her next project.

From its refreshing novelty to its easier pace, the getaway's greatest benefits are psychological. For Haugh, as for many owners of second—and increasingly third and fourth—homes, much satisfaction lies in dreaming up, then realizing their domestic fantasies. As she says of her first effort, "I had always wanted a Tuscan farmhouse, but I didn't want to move to Italy." Starting with the cheaper-to-build stable, she soon had a big rectangular barn that, in the Italian regional style, is tucked right into a hillside. Haugh liked it so well that she turned it into a house and moved in with her horse. "I saw a magazine article about a woman who put her office in the barn, so her horse could look in on her, which I loved," says Haugh. "*My* horse was in the living room, behind a Dutch door that could be closed or left halfway open." As soon as she finished furnishing the stable-house, a buyer snapped it up, enabling Haugh to start in on the actual Tuscan farmhouse.

Most Americans still experience the getaway's benefits through vacation rentals and trips. As Haugh's experience suggests second homes are a seller's market. Strong demand and limited supply mean that the average getaway that cost $127,000 in 1999 sold for about $200,000 in 2003—a faster rate of appreciation than that of primary residences. Long the province of the super-rich, the second home is now the newest addition to the American dream and a major status symbol. The trend reflects the nation's long spell of general prosperity, of course, but especially the peak income years of the baby boomers and their plans for retirement. According to the National Association of Realtors, 13 percent of homes bought in 2004 were leisure places—an increase of 20 percent from 2003 and a record high. Most of these properties belong to couples, but the number of single owners, particularly women, is rising.

When describing her projects, Haugh speaks for the legions of metropolitan professionals who live for weekends spent renovating

the old farmhouse kitchen or restoring the 1950s beach bungalow. "I love the whole process of getting a house just right," says Haugh. "Finding comfortable couches and making great places to sit, to watch TV, to eat. Getting the perfect sheets, towels, flowers, bowls, platters." Long ago, an aunt who dabbled in real estate told her that people buy a home because something about it—a fireplace in the bedroom, say, or a terrific bathroom—fulfills a fantasy they've always cherished. "In other words," says Haugh, "a house needs a vig. In my houses, I make everything a vig. Why not? It doesn't cost any more money to give full consideration to every room. What I really do is create an atmosphere, an environment, a life for myself. Then someone else buys my life!"

Like some multiple-home owners, Haugh is a little embarrassed by the conflict between what she calls "my drive to create homes and my Taurus drive to put down roots. Is it sick that I don't want to stay in one of these houses? Maybe it's a *little* sick."

Neurotic or not, Haugh has found a way to make her dream homes come true. This cheerful domestic serial monogamist is deeply involved in her next love affair: an Irish-English cottage. "I want to start small," she says. "Then I'll do a guest house, gardens, ponds . . . I think I'll keep this cottage, but you never know. I don't want to close out my creative options."

As the terms *leisure home* and *getaway* suggest, the primary rewards of secondary houses and apartments are behavioral, beginning with the simple contrast to our everyday lives that they provide. Whether it's a little house on the prairie or a beach condo, the second home gives us the sheer novelty of living someplace different. Just being in a different milieu refreshes our senses and helps us see the world anew after a hard week, or season, of the status quo. Then too, "getting away from it all" usually allows us greater control over our experience than we enjoy in our workaday lives. Perhaps the cabin or cottage is the one place that we can make just the way we want it, or where we can check the nine-to-five schedule at the door. George W. Bush has been criticized for

spending so much time at his Texas ranch, but he's hardly the first president to flee Washington's straitjacket whenever possible. During what he called the "splendid misery" of the presidency, Thomas Jefferson spent August and September plus a month each spring at his farm at Monticello. Nor is Bush the first president to find his country place's chop-wood, carry-water way of life a welcome break from his desk job's complexities. Ronald Reagan, too, loved to clear brush at his ranch.

As these presidents' delight in hands-on pursuits suggests, what most distinguishes work from play is not the activity per se, but whether we *choose* to do it. A study of professional and amateur musicians, for example, showed that the pros regarded both practicing and performing as work, while the enthusiasts saw both as leisure. The same principle applies to carpentry, gardening, fishing, and other endeavors. Moreover, whenever we throw ourselves into an activity that's just challenging enough, be it adding to the woodpile or tiling the kitchen, we're primed for that peak experience called flow.

Along with novelty, the second home almost always brings us in closer contact with the natural world. Even the intensely urbane Le Corbusier kept a little cabin in the woods. Urban aesthetes or suburban technocrats may not be aware of it, but one major reason they relish their weekend and vacation places is that they provide the sensory experiences outdoors that human beings evolved to enjoy and now often subliminally miss.

Homo sapiens began as hunters and gatherers, not sedentary media crunchers. If sensitivity to nature weren't written in our genes, our species would be extinct. Our ancestors' lives depended on their ability to process and respond to natural stimuli, from the smell of imminent rain to the sight of an edible plant to the sound of a hungry predator, and whether we develop it or not, we have this potential, too. In the metropolitan sprawls where most of us now live, however, nature's stimuli are sadly reduced.

Along with satisfying our deep if sometimes subconscious cravings for natural sights, smells, and sounds, part of a second home's

magic derives from the possibility that nature could pull a fast one on us, from a lightning bolt to a grizzly bear. Our distant ancestors often faced such life-or-death situations, and more than we may realize, we too derive satisfaction from—or even enjoy—grappling with nature's challenges. Anyone who has ever been snowed in at the cabin or deprived of electricity by a hurricane at the beach has been instantly relieved of postmodern ennui. Suddenly, life has clarity and purpose, whether it's reaching town or finding enough candles to read by. Business as usual is postponed as we snowshoe off for groceries or make dinner in the fireplace. Of course, when we're fully engaged in an activity that gives immediate feedback, we're inviting flow. The rewards of coping with such novel situations, even crises, help explain why psychological distress among survivors stranded by shipwrecks or plane crashes is *lower* than that of ordinary folk going about their usual routines.

For reasons of temperament, different individuals enjoy second homes for different reasons. Some of us look to them for excitement and others, for tranquillity. Some of us want to rock-climb, and others, to gaze at the high peaks from a shaded hammock. Some of us feel a pleasant frisson upon encountering a moose in the woods, and others, fear. Zeroing in on this distinction, one question on a test developed by the University of Minnesota's highly regarded personality researchers asks whether the respondent would rather be caught in a storm at sea or visit a sick relative in the hospital daily for a week.

People who have the so-called novelty- or thrill-seeking temperament read "danger" as "challenge" and prefer the gale to the bedside. Good evidence suggests that they're born that way. A particular genetic variation causes novelty seekers to have slightly longer brain receptors for dopamine, a neurotransmitter that's involved in how we experience pleasure and sensation. These type-T folk would be heavily represented in the ranks of surfers, say, and mountaineers, and the rewards they hope to get from a second home would run accordingly. As the gardening or antiquing spouses and friends of Jack London and Isak Dinesen types well

know, those at the other end of the temperamental spectrum—the sensitive souls who'd rather visit the sick relative—look to their leisure homes for serenity. Rather than hang ten or rappel, they prefer to contemplate or perhaps sketch the seascape or mountains.

In our jumped-up, fast-forward society, however, most people, regardless of temperament, could benefit from more time spent in low-key immersion in the natural world. During the weekday rat race, our nervous systems must process a bombardment of incoming stimuli. Cell phones, e-mail, traffic, advertising jingles—it all adds to our tension and fatigue, causes us to screw up, and contributes to various aches and pains. In contrast to this urbanized milieu, where lots of stimuli move very fast, natural environments contain fewer things that, like trees, branches, and clouds, move much more slowly. These soft, natural stimuli encourage an effortless state of reflection, which the environmental psychologist Steven Kaplan calls *fascination*, which slows our metabolism and helps us feel relaxed and refreshed.

Some research on what used to be termed sensory deprivation suggests that where environmental stimulation is concerned, less is often more. The research psychologist Peter Suedfeld has studied people who have lived in extreme situations, whether a stint in a spaceship or twenty-four hours in a pitch-black soundproofed chamber in his lab, where he examines the effects of what he calls restricted environmental stimulation. Like an extreme version of a getaway, this chamber provides something that's in increasingly short supply in the urbanized world: a chance to hear ourselves think. Shielded from the storm of incoming stimuli that usually obscure their own deep thoughts, feelings, memories, fewer than 5 percent of Suedfeld's volunteers asked to come out before their twenty-four hours were up. Like weekenders leaving the lake or meadow on Sunday afternoon, most wished they could stay longer.

Some of the second home's restorative benefits derive from altitude, weather, and geophysical anomalies that have physiological

as well as psychological effects that contribute to the magical feeling that "there's just something in the air." Scientists have speculated about climate's behavioral influences ever since Hippocrates declared that it affected the body's "humors" and thus a person's disposition. Long before Prozac and snowbirds, doctors prescribed geographic cures to sunny places for melancholy patients. They also observed that certain regional winds, including Europe's Foehn, Mistral, and Sirocco and America's Chinook and Santa Ana, seem to affect health, mood, and performance—and according to some countries' courts, impulsive crimes.

Early students of human behavior from the Roman Vitruvius to the Arab Ibn-Khaldun asserted that geography predicted people's behavior, and that their own locale and culture were superior. Later Western theorists preached that because staying warm requires ingenuity and effort, seasonal change promotes higher civilization. People who have hunting retreats in Alaska or fishing getaways on the bayou may suspect that extreme temperatures can affect our levels of performance and sociability. Modern science, however, has not been able to link much behavior to climate per se.

Where the environmental underpinnings of that Rocky Mountain high are concerned, some of the bliss derives from the vast scale and novelty of the surroundings. In addition, mountains have more intense sunlight and a cooler, drier atmosphere—all mood elevators. At high altitude, the lower barometric pressure also makes us breathe deeper, exhale more carbon dioxide, and send more oxygen to our brains. It's no coincidence that mind-altering breathing techniques used by lamas and yogis evolved in Himalayan cultures.

A cabin in the mountains is great, but a place on the water, whether trout stream or ocean, is even more popular. In fact, about 85 percent of leisure properties are near a beach, lake, or the like. Some of the appeal is recreational. Most of the nation's 135 million swimmers, for example, at least sometimes ply natural waters. Then too, the enduring popularity of Europe's venerable health spas supports the notion of water's restorative powers, as does the

location of many of its medieval cathedrals on top of ancient healing springs.

Some modern research maintains that a leisure home near crashing waves, a rushing stream, or even a spraying fountain lifts our spirits by filling the air with negative ions. The hypothesis is that these molecules of air have acquired an electrical charge from moving water, and that in the process of trying to shed the extra electrons, negative ions somehow perk up our nervous systems. Positive ions, which try to pick up electrons, abound in certain artificial places such as airplanes and megastores, where we're likely to feel poorly, which lends some anecdotal support to the thesis. Some studies show an ion-mood effect, but others don't, so the theory remains to be proved.

Places where many people have had unusual perceptions, such as UFO sightings or spiritual or healing experiences, dramatically illustrate how geophysical peculiarities in our natural surroundings can affect our behavior. Certain popular areas for vacations and second homes, such as Santa Fe, New Mexico, and Sedona, Arizona, have been renowned for their nearly psychoactive atmosphere since the days when tribal societies used "spirit geographies" to determine where to go—or not go—when seeking certain experiences. "Haunt zones" or "sacred places" are usually located in regions that have lots of seismic and geomagnetic activity, large underground water bodies, or conductive soil sediment. These natural phenomena generate electromagnetic energy, which in turn can produce strange lights and noises. Tectonic strains that subject quartz to intense pressure, for example, can create explosive sounds, glows, and electromagnetic radiation, which helps explain why shamans often used the rock in their rites. Some places that are riddled with geophysical anomalies, such as the caves and mountaintops long sought by hermits and mystics, seem also to lower the threshold for extraordinary perceptions.

The long history of the haunted house, which in legal parlance belongs to a category known as stigmatized homes, suggests that dwellings, too, can be affected by geophysical anomalies. In 1992,

Don Hill, a Canadian radio producer, and his wife were thrilled when they found a big, strangely affordable house near popular Banff National Park in the Canadian Rockies. Soon after moving in, they understood why their home was a bargain and had changed hands so often.

The Hills' house emitted strange noises and had odd cold spots. Power surges kept disabling its phone lines and appliances. A series of technicians, however, failed to find mechanical sources for these problems. Worse, the Hills began to feel chronically apprehensive and fatigued; even their pets were fretful. When Hill encountered a bloblike, cloudy, well, *thing* in the basement, the family acknowledged that their dream house was a nightmare. No one in their town, however, was particularly surprised by the spooky goings-on. Their piece of the Rockies has long been linked to Indian legends of local good and evil spirits and UFO reports alike. After he sold the property, Hill kept a reporter's eye on events at the troubled house and noted that it soon changed hands twice more.

Loath to blame supernatural causes—after all, exorcism hadn't worked—Hill turned to science for an explanation. Dr. Michael Persinger, a Canadian neuroscientist who studies how the brain generates experience, explained that when its temporal lobes are electromagnetically stimulated in the lab, subjects can experience strange phenomena, including imagery, memories, feelings of ecstasy and dread, mystical perceptions, and mysterious presences. The fact that five of the earth's major fault lines converge at Banff near Hill's former house could account for surges of seismic activity that could affect the brain. Moreover, the house sits on top of some large underground water bodies—a situation particularly linked to cold spots and electrical problems.

What people in white coats can demonstrate in the laboratory is much harder to pin down in a natural setting. The anomalous geophysical conditions that incline the brain toward bliss or terror, spirits or UFOs, are highly unpredictable, localized, and short-lived. Two minutes later or two feet away, nothing is happening.

To test Persinger's theory, Hill volunteered for an experimental session in the lab. While his brain was stimulated electromagnetically, he had an experience eerily similar to the one he'd had in his former basement.

Most of us choose second homes and vacation rentals that are somehow closely related to nature, but from the nation's earliest days, we've differed over how to behave there. Nearly all Americans like to do *something* outside, and the growing popularity of outdoor recreation helps explain the increase in second homes. One large study showed that in the course of a year, a stunning 97.5 percent of Americans sixteen years and older participated in activities including watching birds or wildlife (50 percent of the population), gathering berries or other natural foods (33 percent), kayaking (3 percent), and surfing (1 percent). The most popular activities require little skill, money, equipment, or even stamina: walking (87 percent) and outdoor gatherings (76 percent).

The most interesting and surprising aspect of Americans' embrace of outdoor recreation is that we're motivated less by the activities themselves than by various psychological rewards. That is, the major benefits of fishing, mountain climbing, or camping aren't big bass, technical skill, or a good night's sleep in the fresh air as much as the relaxation, excitement, bonhomie, and other inner states those outdoor activities invite. From a behavioral perspective, recreation in general is no trivial pursuit but the source of nine psychological rewards, ranging from the catharsis wrought by jogging or hiking to the "expressive compensation" of camping or canoeing. Regarding outdoor recreation in particular, common behavioral benefits include a feeling of freedom, improved self-esteem, aesthetic appreciation of nature, and especially, bonding with other people.

The idea of being alone in nature sounds noble and romantic, but in practice, like camping trips, few second homes are primarily solitary retreats. The vast majority of people enjoy the outdoors with

companions. Research shows that what most of us want in a natural setting isn't real isolation but minimal interactions with strangers. Like a hiker who encounters another hiker on a remote trail, a leisure homeowner who can see a neighbor's lights or hears his snowmobile can feel crowded in a very uncrowded place.

America has always been of two minds about how best to live with the great outdoors. The New England Puritans, who were stuck with poor, rocky soil and long, hard winters, saw the natural world as a hostile place that, according to their reading of the Bible, should be beaten into submission. Rather than trying to conquer nature, the Quakers, Catholics, Anglicans, and mellower Protestants of the mid-Atlantic and southern colonies paid more heed to the biblical injunction to be its good stewards—an amiable philosophy inspired by their kinder environment. Like Thomas Jefferson, they wanted to understand and conserve nature, but also like him, they preferred it pastoral rather than wild.

Later in the nineteenth century, America, like Europe, embraced romanticism, which celebrated unspoiled nature as the antidote to the industrial society's ills. Enthusiasm for the wilderness increased, at least among the intellectual and artistic elite. The Old World might have its dirty cities and degenerate art. America had its virgin forests, rivers, and mountain ranges, all glowingly portrayed by Thomas Cole, James Fenimore Cooper, and their peers. Outside the salon, however, the folk who were actually doing the hard work of settling the Wild West of song and story maintained a more adversarial approach to nature.

Our schizy national tradition of linking nature to health, beauty, and spirituality on the one hand, and seeing it as plunder, danger, and the source of ungodly pantheism on the other is alive and well. Now as in colonial times, Americans' view of the nature of nature and its purpose is divided between the "dominion" camp, which puts humanity above the rest of nature and sees its resources as nearly infinite and exploitable, and the stewards, who see people as part of nature, resources as finite, and growth as requiring limits.

Continuing this old American tradition, second-home owners divide into those who see the outdoors as a setting for subdivisions, snowmobiles, and power boats and take a me-first approach to sharing it, and those who prefer an unspoiled refuge of peace and quiet and cooperative "green" solutions to environmental problems.

What feels right to one person can be all wrong for the group, and not surprisingly, the problem of how to get a society of rugged individualists to share life in the great outdoors has inspired considerable behavioral research. Enjoying a lake, beach, or forest in a leisure-home area without someone "ruining it for everybody" is a classic example of pitting short-term personal interest against the long-term needs of the group. Here, the stick may turn out to be a stronger motivator for good behavior than the carrot: environmental education isn't as effective as direct prompts, such as fines and the signs, litter baskets, and awards employed by Keep America Beautiful. Something of the complexity of such an organization's task comes across in an experiment on littering. Researchers found that the more debris was already on the ground, the more people added to it; in fact, 40 percent did so. However, the turf least likely to be despoiled wasn't totally pristine—nearly 20 percent of subjects littered there—but ground sullied by a single piece of trash. Only 10 percent of the those observed could bring themselves to add to it.

There's a growing consensus that environmental health is beyond any individual's ability to control and demands a cooperative effort. Air pollution is a good example and no longer just an urban one. In rural areas, agribusinesses build vast livestock facilities that send huge amounts of manure into open "lagoons," stinking up the air and polluting groundwater; one large hog factory can produce as much annual waste as Los Angeles. Working collectively to solve such problems can be hard, but it's not impossible. In fact, one study of the use of toxic garden chemicals showed that if their neighborhood's prevailing view was that pesticides should be used on weeds and insects, individuals tended to do so.

When neighbors learned about the educational and health benefits of coexisting with backyard flora and fauna, however, they took a more ecological approach.

One of the subtle yet profound effects of the increase in leisure homes—sometimes more than one per owner—is a change in the traditional definition of *home* itself. Once a specific address, for a growing number of people, home is becoming a state of mind, a domestic experience that can happen in a number of places. One vivid example is a popular getaway in the literal and figurative senses: the RV, or recreation vehicle, that already claims 30 million enthusiasts. "Towables" are simple camper trailers, but motor homes range up to "type A" McMansions that can cost $500,000 and up.

In the back country of Wyoming's Washakie Wilderness area, Earl Ross, an experienced hiker, horseman, and woodsman, has parked his RV for a summer of serving as one of the understaffed national park system's volunteer "hosts." A vigorous bear of a man whose sound investments enabled him to retire early, Ross also personifies the new RVer's more upscale profile. Stereotype notwithstanding, the typical owner is a middle-aged person who has an above-average annual income of $56,000, owns a home, and travels for a month annually; Ross is now single, but the average RVer is married. Baby boomers comprise the largest and fastest growing group of enthusiasts, and younger Gen Xers show a similar inclination. These fussy consumers are accustomed to all the latest domestic comforts and conveniences, and Ross has loaded his RV with features such as solar power and satellite TV.

Like the few other visitors at this primitive camping and fishing site, which looks like a piece of scenery from the film *A River Runs Through It*, Ross comes here to savor the peace and quiet, breathe the clean, piney air, catch cut-throat trout, and hike through the mountains and river valleys. When his knee acts up, he rides the trails on horseback. As he says, "I love places where there's no one there, so that it's almost eerie."

The real allure of the home on wheels, however, is the footloose domestic life it allows. Part of the year, Ross dwells where the wild things are—winters at a horse refuge in South Dakota, summers in Wyoming. He devotes spring and fall to Florida beaches and visits to his far-flung children. "My RV is my home," he says, "and it's a good rig. I like to go slow and stay in a nice location for a while. But then I move on."

Most getaways are rooted to one spot, but their owners, too, increasingly have expanded ideas of the meaning of home. Many middle-aged Americans who are thinking ahead to an active retirement see their second homes as eventually becoming their permanent addresses. They've helped to make certain recreational and scenic areas, such as Santa Fe, Ashland, Oregon, Killington, Vermont, and Nags Head, North Carolina, especially popular. Indeed, some owners who are still committed to a primary residence and job in a metropolitan area find that their country or beach place already feels like their "real home."

From a different perspective, the home lives of blue-collar residents of fast-growing communities whose natural beauty and recreational potential draw second homeowners, such as Jackson Hole, Wyoming, and Scottsdale, Arizona, are threatened by the demand for and price of houses. In Nevada—the nation's most transient state, in which only one in five residents was born—costly vacation homes abound, but affordable housing is scarce and wages remain low, even as living expenses rise. In contrast, the states whose populations are most stable—only one in five Louisianans was born elsewhere—offer well-paid jobs for blue-collar workers, who can afford to stay put and thus enjoy family connections and neighbors' support.

If some Americans can't wait to live full-time in their leisure places, still others find that they never quite feel at home there. With its kayaks, hunting dogs, and cross-country skis, the lakeside house of Charlie and Ginger Alden, in Wausau, Wisconsin, has many of the features of a full-fledged getaway. When these frisky empty-nesters in their mid-fifties want to get away from it all,

however, they head for some golf and tennis at their sunny condo on Kiawah Island, South Carolina, or for some skiing, hiking, or fishing at their place outside Red Lodge, Montana.

Ginger has complicated feelings about her three homes. In the second and third, she relishes the freedom from jobs, mail, phones, and community work. Then too, she says, "there's a chance to have dominion over the space and achieve an orderliness that's never possible in Wausau." She and Charlie also enjoy doing different things at their different addresses. Red Lodge is all about the great outdoors, while Kiawah means more socializing as well as sports. Because Red Lodge was their first second place, Ginger says, it has more of the little personal touches that say "home" than Kiawah does.

That said, Ginger believes that deep down, only one residence can feel like home to her. "When I delve into why one place is 'home' and others aren't, I think of words like territory and dwelling," she says. "To me, the home has living, breathing extensions of ourselves—our dogs, plants, and garden as well as our children and neighbors. It's where the spirit dwells, where the deeper memories are, where the precious stuff remains. I suppose those things could be true of second homes, but I don't think I can really *dwell* in two places."

Their different, more aesthetic concept of house thinking allows Matthew and Yolanda Hranek—he's a photographer, she's a photo editor—to feel at home in both their New York City apartment and their country place. After they bought their 140-acre wooded Catskills property, they deliberated before choosing a 1,500-square-foot prefab house, designed by the Austrian architect Oskar Kaufman. In this rural part of the world, *prefab* is far likelier to mean a trailer than a house that Hranek describes as "more Breuer than Mies."

While waiting for their house to be delivered, the couple weekended in their snug bathhouse/guesthouse, which Hranek designed and a local carpenter built. With its unpainted hemlock barn siding and dramatically angled roof, the bathhouse looks like

a chic utility shed. Inside, the austere two-room cedar-paneled space has a sauna-like feeling in keeping with its pièce de résistance: a deep rectangular wooden bathtub that nearly empties the fifty-five-gallon water heater. To Hranek, the small building is a "Scando-Japanese homage to the American hunting cabin."

When talking about what makes a home, the Hraneks focus on design that emphasizes nature and simplicity—an exacting yet portable sensibility that pervades both their apartment and country place. "Nothing is more aggravating," says Hranek, "than staying in a place that's aesthetically upsetting." In the city, their Scando-Japanese milieu is "more urban, partly because there's more art and a collection of post-1940s pottery," he says. "Here, we have a much more expansive space, a more organic look." When Hranek thinks about the location of their "real home," he mentions his parents' house upstate, where they also spend time, the urban apartment, the bath-and-guest house, their vintage Airstream, and the prefab. With a growing number of Americans, he concludes, "We see ourselves as having lots of homes."

If I needed any persuading about our second home's beneficial psychological effects, seven months of treatment for breast cancer convinced me. A former 4-H'er, I've always taken my joys and troubles to Mother Nature, yet I was surprised by how vital our country schoolhouse's brooks, clouds, and dirt roads were to my recovery. Rural sounds, sights, and scents provided balance to harsh but necessary medical treatments. Experiences such as watching the trees shed their leaves as I lost my hair, and seeing both return in the spring, were more comforting and sustaining than any words.

Whether we live in the city, suburbs, or country, our homes should help us connect with our neighbors as well as with nature. For that matter, in most of the world, home doesn't mean a residence as much as a village or neighborhood. Throughout history, we human beings have depended on the community for many of the relationships that support our daily routine, shield us from stress, and make life worth living. In the twenty-first century, however, for reasons ranging from our high mobility to our increasing dependence on the car, America's community life is under assault.

The Neighborhood
No Home Is an Island

But for the hum of unseen traffic, Peacock Farm, a planned suburban community outside the historic town of Lexington, Massachusetts, might be out in the country. It's hard to believe that sixty-five houses are blended into the hilly, wooded, south-facing forty-two-acre site that was once farmland. The homes are variations on a model created a half-century ago by the architect Walter Pierce. This split-level, open-plan house, which has an asymmetrical pitched roof, broad eaves, and horizontal bands of windows, won an award from the American Institute of Architects in part because of the way it can be turned to suit a particular site. As a result of this flexibility, Peacock Farm has a pleasingly serendipitous, nature-loving look that's very different from the monotonous rigid grids of most new suburbs.

Back in 1952, Pierce and his colleague Danforth Compton de-

cided to create a domestic world that suited modern American living. To encourage residents of their new development to relate to nature and each other, they set aside eight acres of land for a commons, which included a marsh, pond, and swimming pool. They understood that an affiliative spirit and a willingness to look out for your neighbors can be encouraged by design decisions, and they were determined to make Peacock Farm a community in both senses of the term: a group of people who share a territory *and* common interests. The resulting feeling of being at home beyond your front door or driveway is missing or endangered in much of America today.

The house where Walter and Marianne Fisker Pierce still live is set above a wooded cul-de-sac dominated by a splendid maple tree, which adds to the house's Japanese-pavilion quality. Discussing Peacock Farm's roots, Pierce says proudly, "We believed then that modern architecture would lead to better lives." He and Compton were also influenced by New England's long tradition of the town commons and utopian living experiments; indeed, Peacock Farm is one of the area's dozen or so modern residential communities with commonly owned land.

Alternative suburbs such as Peacock Farm encouraged the young professionals and families whom they attracted to share recreation facilities and their natural surroundings—property lines were discouraged—and also cultural interests and family life. Recalling the community's early, heady days, when there were few cars and children could roam freely, Marianne Pierce says, "We were close to town, but the kids had lots of nature to play in. With the pool, we felt no need for a summer house. We knew everybody. We felt very safe." Her husband agrees that "most people loved the lifestyle. There have been many enduring friendships here because there was a social as well as architectural dimension to the project."

A community, whether Peacock Farm or Greenwich Village, is based on a territory, which behavioral scientists define as a place that's owned or controlled by a person or group and is usually

home-centered, visible, stationary, and large. Our territory is often our neighborhood, or an area that has distinctive characteristics. For many Americans, it's a suburban or exurban subdivision; for the Lubavitcher Jews of Brooklyn, it's a network of relatives' homes and the kosher shops, shuls, yeshivas, ritual bathhouses, and other facilities particular to their way of life. Like athletes who benefit from the very real "home court advantage," we enjoy a greater sense of control, well-being, and ease when we're on our own turf. Even when people live in institutional "homes," such as residences for the aged, hospitals, and prisons, those who can personalize their bit of territory are more sociable and content than those who can't.

Manifesting our territorial feelings about our homes and environs isn't just "nice"; it's important to building and maintaining a sound community. As at Peacock Farm, design can play an important role in encouraging this social behavior. People who live in cozy cul-de-sacs enjoy more neighborly ties than those from grid-like blocks, for example, and they're also more inclined to show their esprit de corps, as in elaborate holiday decorations.

Research by the environmental psychologist Ralph Taylor shows that the more we express our proprietary feelings in the "near home" places that bridge our private and public worlds—porches, lobbies, hallways, stoops, yards, alleys, sidewalks, driveways—the less likely we and our neighbors are to be plagued by malingerers, trash, vandalism, and other social problems. Posted names and addresses, attractive entries, window boxes, and birdbaths may seem like small things, but they proclaim to locals and outsiders alike that we have high standards and expect good behavior in our community. In contrast, homes and neighborhoods that attract crime tend to have a no-man's-land look that offers little evidence of individual or communal territorial feelings.

At a time of rapid change, the erosion of traditional social supports, and increased environmental concerns, the design of communities that connect us to neighbors and nature should be a far more important public issue than it is. Even Peacock Farm has

been affected by the combination of a more individualistic, career-oriented, highly mobile culture and soaring real estate prices; houses there that sold into the 1960s for under $20,000 now go for between $450,000 and $700,000. Most new owners are less interested in modern architecture, neighborhood life, and the development's history than in just getting a home, says Pierce. "But they still like the common land and the pool."

Largely for behavioral reasons, most Americans, like the residents of Peacock Farm, prefer suburban living. They apparently disagree with housing experts who maintain that what's best for working adults and families, to say nothing of the environment, is high-density low- or high-rise housing that's near mass transit, jobs, and services in towns, cities, and inner-ring suburbs. What most people want, however, is a big single-family home in suburbia or exurbia, which are inconveniently distant from daily destinations, hard on natural resources, and the cause of much of the unsightly, poorly planned development known as "sprawl." Academics have also theorized that these car-dependent communities encourage social isolation and consequent mental health problems, but a major study of 8,600 people in thirty-eight metropolitan areas across the nation, conducted in 2004 by the Rand Health Policy Research Organization, found no differences in the rate of depression, anxiety, and psychological well-being between urban and suburban residents.

One reason suburbia is a happier place than by some social critics' lights it should be is that it confers several important behavioral advantages. First and foremost, this way of life provides the most control over the environment and the most distance from annoyances for the least inconvenience. According to the "environmental spoiling" theory, our feelings about our home and neighborhood are closely tied to our proximity to sources of irritation—a major problem in high-density urban life. Freedom from seemingly petty vexations such as neighbors' noisy quarrels or music, unruly dogs, and litter is even more important to people than supposedly more

significant factors, such as municipal services. Reducing daily life's aggravations by throwing distance at them is perhaps suburbia's greatest strength.

Then, too, most Americans *choose* to live in suburbia, and choice plays a big part in our satisfaction with our homes and communities. One study that compared two groups of similar army families, one of which lived in apartments and the other in mobile homes, found that the freedom to pick their residences was even more important than the housing's physical amenities. Despite their very different ways of living, each with its pluses and minuses, both groups of householders were generally content because they had selected their own quarters. Indeed, they regarded their homes as better than their previous ones and as good as or better than their friends'—another important factor in our domestic satisfaction.

That so many choose suburbia also reflects a traditional American aversion to the city that goes back long before the era of Ozzie and Harriet and John Updike's couples to the mid-nineteenth century, when the industrial revolution sullied urban life. As agrarian America began to urbanize, cities had to accommodate the sudden need for factories and office buildings, and housing for the hordes of new workers. As a result, urban living grew increasingly crowded, unhealthy, and generally disagreeable. One reaction was the City Beautiful movement, also called the American Renaissance, which produced Boston's Copley Square Library, San Francisco's Civic Center, New York's Metropolitan Museum, and other great neoclassical public spaces, buildings, and parks.

The other response to the plight of the industrialized city was suburbia, which was first made possible by new railroad and steamboat lines that allowed commuting. (In 1857, the architect Alexander Jackson Davis designed Llewelyn Park, America's earliest true subdivision, in West Orange, New Jersey.) Suddenly, Americans could enjoy the city's cultural and economic resources while living in a modern, spacious "country villa" in a manorlike setting just outside town. Riverside, for example, was only a twenty-minute commute from Chicago. Despite their advantages,

however, these suburbs weren't true villages, in that they lacked a community core; indeed, their most important public spaces were often their railway stations. In time, however, even these communal gathering places were undermined by the car.

The decision to tie the American home to the car has profoundly altered daily life not just in suburbia but also in our cities and towns. Saratoga Springs, New York, has long been known for its high-society summer horse-racing scene. Many of its huge Gilded Age homes are bed-and-breakfasts now, and Union Avenue's once stately charm is compromised by four lanes of whizzing traffic. Just off the attractive main artery of Broadway, the facade of handsome old shops and buildings gives way to the car culture's usual tacky tangle of McDonald's, Dunkin' Donuts, and parking lots. Largely thanks to Skidmore College, however, Saratoga Springs has a vitality and prosperity that many of the Northeast's fine old towns fallen on hard times must envy.

If America's community life has an Elijah, he might be James Kunstler, author of *The Geography of Nowhere* and a proud, voluble citizen of Saratoga Springs. There's very little about his town that Kunstler doesn't know and want to share. While still standing in the doorway of his Federal-style home, he explains that shops, restaurants, and a fine library are a short walk away, and that just next door is the former house of ill repute of Madame Jumel, the wife of Aaron Burr.

Seated in his high-ceilinged parlor before a crackling fire, Kunstler offers his perspective on our endangered community life. Most Americans have never liked cities, at least partly because only a handful of ours have a pre-industrial past, he says: "There's no medieval Cleveland or Renaissance St. Louis." This anti-urban bias really blossomed when the constraints imposed by the Depression and World War II were lifted, and floods of automobiles made suburbia more accessible. "There was a strong public consensus on both the left and right about how to use the car to create

a living environment," says Kunstler. "Neither Kerouac nor Eisenhower was against the car."

As suburbia swelled, the traffic jams, parking nightmares, and pollution caused by cars made the midcentury city even nastier. Urban life was reduced to the image of Ralph and Alice Kramden's apartment in *The Honeymooners* TV show, says Kunstler: "That's what most Americans still think city life is—the dreary airshaft, the crummy linoleum." Yet suburbia's quality, too, was already declining. To find enough land, developers penetrated deeper into the countryside, which meant long drives to work and most other destinations and highways and street grids that cut up social and natural environments. The slow, varied growth that created the attractive older suburbs gave way to huge, rapidly constructed subdivisions produced by big developers who stamped out cookie-cutter houses such as the Cape Cods and ranches that William Levitt offered for $7,900. By the 1950s, the new suburbia was less about villas in a bucolic setting than what Kunstler calls a "cartoon of country living in a cartoon of a country house that used wagon wheels, phony shutters, and lawns as totemic expressions of the ranch or the farm."

Fifty years later, the car is an even more dominant factor in American domestic life. Indeed, the country now has more cars than licensed drivers. More than three-quarters of us drive to work, and in the suburbs, almost everywhere else, too. Three in five households have two cars, and half have a garage or carport. In the 1950s, many Americans converted garages into family rooms or other living areas. According to the National Association of Homebuilders, rather than relinquishing a garage, many now add on to it.

To be fair, even from a behavioral perspective, the car has its good points. In the ability to be "auto-mobile," or self-moving, the psychologist Mihaly Csikszentmihalyi sees "an expression of Eros in the broadest sense, a need to demonstrate that one is alive, that one matters, that one can make a difference in the world." At a time

when both parents and children have tightly scheduled activities and often must drive or be driven to them, the car can serve as a mobile family room that allows some togetherness. Indeed, technology has made it a nearly sentient being that offers many of the comforts of home, including microwaves and DVD players. Research on flow shows that of our daily "maintenance" activities, such as housework, driving gets a positive rating, especially from men.

That said, bonding the home to the car exacts a serious toll on our everyday experience, from quantifiable health problems to the subtler quality of life. Motor vehicles produce half of all air pollution, and a drive of twenty-five miles dumps a pound of toxins into air—a sobering fact, considering that Americans drive an average of twenty-eight miles per day. Moreover, bad traffic is strongly linked to both physiological and psychological stress, which vary according to the driver's personality. Regions such as metropolitan Atlanta that largely consist of suburban sprawl have such traffic congestion that some commuters stagger their working hours or do part of their jobs from home.

Obesity is increasingly linked to the car culture. Simply put, the more we drive, the fatter we are. Americans are in the car more than ever, and more than 60 percent of adults and 20 percent of kids are overweight. Europeans weigh less and live longer than we do partly because about a third of their trips are pedestrian, compared to fewer than 10 percent of ours. A study of some 200,000 Americans shows that residents of the most compact, walkable counties, including New York City's boroughs, San Francisco County, and New Jersey's Hudson County, weighed about six pounds less than residents of the most sprawling counties, such as Goochland, outside Richmond, Virginia, and Geauga, near Cleveland, Ohio. In response, some new suburbs are programming fitness into their design. Colorado boasts of being the leanest, friskiest state, and in Denver, the new 4,700-acre Stapleton development aims to attract 30,000 active residents with its parks, trails, and pedestrian routes for errands.

Being overweight isn't good, but adding years to your chronological age can be worse. The large Rand study of 8,600 people in thirty-eight metropolitan areas shows that after factors such as age and economic status were accounted for, a person who lives in the car-dominated sprawl of Winston-Salem, North Carolina, or Connecticut's Bridgeport-Danbury-Stamford region, for example, is likely to have the health profile of someone four years older who lives in a more compact community, such as Boston, Portland, and Milwaukee. The chronic problems linked to sprawl include high blood pressure, arthritis, headaches, and breathing difficulties.

Health and fitness issues aside, the fact that many people drive everywhere, often leaving from and returning to their garages without ever really being outside, has also changed our physical and social environment. Cars enable single-use zoning, which strictly separates residential from commercial and institutional property in most suburban areas, making it impossible to get to most daily destinations on foot; by mandating lots of low-rise commercial buildings with parking lots, this zoning also increases architectural monotony and sprawl. The need to drive everywhere means that neighbors' paths cross less frequently in corner stores and school yards; indeed, many developments now dispense with sidewalks altogether. In newer suburbs, streets often aren't laid out to promote neighborliness, but to provide plenty of maneuvering room for big SUVs. When there are no pedestrians or street life, even a once active neighborhood becomes a ghost town.

Despite the big Rand study that showed no differences in the psychological well-being of urban and suburban people, Kunstler insists that many Americans just don't know what they're missing. "Once, Main Street was an outdoor public room where people met and socialized," he says. "Now we just have 'antiplaces' where cars go—that are just on and off ramps, fried-food shops, and car dealers. We've conditioned three generations not to care about their larger surroundings and to have zero expectations for them. Average citizens have suffered tremendous human losses that they're not even aware of."

Inside the home, too, Americans are affected by the decline in community in ways they might not realize. The lack of a larger social network puts pressure on the family to furnish all of our emotional needs, Kunstler observes, "to be everything. But your spouse or your kids can't replace colleagues, buddies, neighbors, groups. We've lost our old associational habits, so it's bowling alone, as Robert Putnam put it, or watching television. The whole home experience becomes 'Do you have a five thousand dollar, forty-inch liquid plasma screen?' My pet crank theory is that we're *becoming* TV. Our national experience is just a big show that we watch."

Within the next ten to twenty years, Kunstler foresees a back-to-the-future revolution in America's domestic life, as car-oriented suburbia is increasingly challenged by a decline in cheap, reliable oil supplies. "The oil crisis of the 1970s knocked the economy on its ass for ten years," he says. "When it happens again, our assumptions about what's the normal way to live will be severely challenged." His solution to the geography of nowhere is to pick up and move somewhere: "Get close to the center of things. Find a small town or a city, which have wonderful amenities of their own."

If there's one group of people who seemingly ought to prefer urban or small-town life, it's working mothers. Suburbia and exurbia are the opposite of what would work best for them, in terms of easy access to the workplace, child care, and goods and services, all of which are distanced from their homes by single-use zoning. It's not yet clear why so many women continue to live in communities that seem so ill-suited to their everyday lives, but history shows how women got to suburbia to begin with.

Back in the nineteenth century, when the first commuters took the train to the new centralized urban offices and factories, upper- and middle-class women were left in the "perfect house in the suburbs." Home and workplace became separate worlds, and distinctions between private and public, city and suburb, and male and female also sharpened. When shopping became middle- and upper-

class ladies' only acceptable public urban activity, the first turn-of-the-century department stores lured them with tearooms, clean lavatories, and reading rooms—the same fantasy of a comfy, genteel home away from home that's now promoted by Barnes & Noble and Starbucks stores.

The vision of the home as a retreat from the male, public city, where the real work was done, had important social implications. By extension, the labor that went on in the female, private home could not be considered work at all, nor could it be communally shared. Moreover, if the home was a sanctuary, it could not harbor bad behavior, such as alcoholism and abuse. Over time, these Victorian assumptions became institutionalized, particularly in the suburbs, and persist long after women's and men's lives have been otherwise transformed.

In 1984, in *Redesigning the American Dream*, Dolores Hayden, a professor of architecture and American studies at Yale, examined the way in which the mid-twentieth century vision of the suburban home as haven works against the development of housing that supports the lives of women and families. Twenty years later, when revising her book, Hayden expected to see improvement. After all, most women now work, families are smaller, and there are more single-parent households—significant changes that logically should be reflected in shifts in housing choices and child care. Instead, Hayden found that recent developments such as PCs and fast food have further reinforced the notion of suburban home as sanctuary. Indeed, she says, "what are really increasing are private gated suburbs, bigger McMansions, and people who work in suburbs and live in exurbs in search of a more countrified experience."

One reason so many working women live in communities that don't support their needs is that in most of the country, the new jobs are in suburban industrial parks, malls, and office developments. There's already more office space in northern New Jersey than in lower Manhattan, for example, and many Connecticut residents don't commute to New York, but to Greenwich or Stamford. Then too, Hayden questions how many women, particularly moth-

ers, move to suburbia because that's where they really want to live, rather than for its schools, backyards, and other amenities for children. For similar reasons, she suspects, many suburban mothers "choose" to work at home or part-time. One thing that *is* certain, says Hayden, is that over the past twenty years, women have doubled their driving, mostly in others' service: "The new term is taxi parent."

Rather than blaming individuals for a way of life that's hard on society in general and women in particular, Hayden lists some cultural, aesthetic, and political as well as economic reasons for America's suburban bias. First, there's the old tradition of individualism and having a place to call your own—increasingly one that's so well equipped for work and play that there's little need for leaving it. Most Americans are also still leery of apartments, much less new styles of domestic architecture, and prefer the familiar neohistorical houses that predominate in suburbia.

More important, suburban sprawl didn't just happen but was created by powerful industrial forces and governmental decisions. As Hayden says, "The home in the suburbs plays a big role in the American economy." Builders, developers, and realtors have some of the nation's oldest, biggest, and best-organized trade lobbies, "and they have policies and a product—the single-family house—that they've pushed very effectively," she points out. "They've never cared for multifamily housing designed by architects for urban settings, which is why we don't have a lot of *that*."

The same powerful lobbies, local zoning regulations, and federal tax policies that have contributed to suburban sprawl are aggravating America's two worst housing problems: homelessness and a scarcity of affordable houses and apartments. (In bureaucratese, affordable housing means homes for people who earn 50 percent or less than their area's median income and spend no more than 30 percent of their income on rent or a mortgage; most such homes are in some way subsidized by the government or nonprofit developers.) Rather than addressing these crises, says Hayden, "the government helps the group that owns the McMansions and

second homes in the form of mortgage tax write-offs. It's not fair!" If she could, she would cancel the mortgage subsidy and spend the resulting hundred billion dollars in tax revenue on affordable, low-rise, multifamily housing of two stories in cities and older suburbs. "That kind of development is infinitely preferable to building on farmers' subdivided fields," says Hayden. "You can talk about 'family values' in terms of making cookies or whatever, but what about affordable housing?"

The number of America's city dwellers is declining, but certain people still thrive on urban life. Many American cities have improved, and some even compete with Europe's by offering destination markets, outdoor cafés, pedestrian malls and plazas, attractive waterfronts like Baltimore's Inner Harbor, and lively public spaces such as New York's rejuvenated Times Square. Although the 2000 Census shows a strong preference for suburban and exurban living, it also reveals some growth in the downtown populations of particularly appealing cities. Those likeliest to enjoy living there are young singles who need housing they can afford, such as shared apartments, and easy access to work and entertainment. They've helped to revive many older, shabbier neighborhoods in big cities like San Francisco and New York, as well as their "inner ring" suburbs, such as Oakland and Hoboken. Older empty-nesters are also increasingly attracted to urban activities, convenience, and smaller, easily maintained apartments. Partly because of these child-free city dwellers' enthusiasm and the trendy shops, restaurants, and services they attract, urban life has become too expensive for many families who need larger homes. As a result, the populations of attractive cities such as Seattle, Miami, Boston, and Portland are among those with the lowest percentage of children.

They may be a minority, but some families, too, delight in urban life. From the outside, the prewar apartment building on Manhattan's West End Avenue looks sober, perhaps even a little forbidding, but on a rainy Halloween just past the doorman's stand, witches and superheroes queue up for vertical trick-or-treating.

Their younger siblings are downstairs in the building's basement play room, enjoying a party organized by their parents. In nice weather, most of the little kids spend part of the day over at one of the playgrounds in Riverside Park that they consider home away from home. Many children feel the same way about several apartments in their building, where they enter unannounced through unlocked doors to visit friends.

The mothers and fathers of West End Avenue know all about the city's dearth of fancy public schools and private backyards, but like their single neighbors, they think that the city's advantages—stimulation, transportation, diversity, convenience, and choices, from green markets to hospitals, museums to jobs—more than compensate for its drawbacks. They cherish their easy commutes, exotic takeout, and delivery of everything from videos to Thanksgiving dinner. Their apartments are smaller than the typical house, but more of their lives take place outside the residence, on the streets and in parks, theaters, restaurants, and laundromats.

From a behavioral perspective, the major gripes concerning city living are that it's stressful and unfriendly. The stressors are obvious enough, from noise and crowding to traffic jams and grime. Where personal interactions are concerned, the city dweller's challenge is to preserve peace and privacy while maintaining enough contact to feel safe and socially supported. At first glance, most research suggests that city people are indeed less friendly, in that they engage in less eye contact, hand shaking, and helpfulness with strangers. However, it's more accurate to say that according to the environmental load theory, urban folk are bombarded by so many stimuli, particularly the social kind, that they learn to limit their exposure by shielding themselves from strangers. This self-protective attitude also reflects the fact that although crime rates are falling significantly in some cities—and rising in parts of suburban and rural America—urbanites remain more concerned about crime.

The city may be less hospitable to newcomers, but those who stay on soon find that it has its own style of sociability. Most resi-

dents don't experience "Boston" or "LA" on a daily basis, after all, but the so-called urban villages within these big cities where they live and work. In these enclaves, the population can be quite homogeneous, and many people, from the owner of the newsstand to the deli delivery guy, cease to be strangers. Then too, in the apartment-filled city, renters, who are often second-class citizens in the country and suburbs, can bond around their common interests and form powerful lobbies as well as friendships. In a study done at the famous Watergate apartment complex in Washington, residents were friendliest with those who lived closest, starting with the next-door neighbors; however, they also fraternized with people from other floors who had mailboxes adjacent to theirs in the lobby.

There's even a special kind of urban friendship that exists only in the mind. A Proustian study of city folk at their train or bus stops determined that they recognized an average of four "familiar strangers," whom they observed during travel, thought about, and would be disposed to help. Intriguingly, these odd couples are likeliest to meet when away from their usual territory.

Most Americans may not be city people, but if for no other reason than that sprawl is not infinitely sustainable, we need more inventive, appealing ways to create high-density communities and multi-family housing. One step in that direction is so-called new urbanism, which is best known for the Florida developments of Celebration and Seaside. The movement, which was founded by the architects Andres Duany and Elizabeth Plater-Zyberk and emerged in the 1980s, upholds many of the venerable principles of classical civic planning that produced some of our most beautiful older cities and neighborhoods.

Rather than creating more sprawling subdivisions that ruin the countryside and have no there there, new urbanism tries to combine the best elements of town and suburban life. The core idea is a pedestrian-oriented community in which quiet residential streets surround a busy public square. There, residents can gather to so-

cialize and find goods and services that are no more than a five-minute stroll from home. This combination of "walkability" and mixed-use zoning ensures that, like villagers of old, residents en route to jobs, schools, shops, and recreation will have the spontaneous social encounters that build neighborhood feeling. The movement's hundreds of projects include regional development, brand-new towns, and the renovation of sections of older ones, including Bethesda, Maryland, and Boulder, Colorado.

One of new urbanism's icons is the front porch. This architectural extra doesn't cost much, yet it adds to a home's "curb appeal," boosts informal socializing, and gives family members a place to be at home yet not indoors. The porch goes back to antiquity, but Americans since Washington and Jefferson have embraced it with special gusto. The so-called piazza was first popular in the South, where it provided cool shade. In former Dutch colonies such as New York, people sat on steps or benches on their *stoep*; in time, the stoop grew larger, acquired a roof, and became a porch. The Victorian period, which venerated both fresh air and pale complexions, was the golden age of porches, which also showed off the era's "gingerbread" carpentry.

Until the 1950s, the front porch was America's sitting room on the street. Then changes from the telephone and television to stripped-down modern domestic architecture and the surge in working women gradually undermined its social power, turning it, like the parlor, into a little-used relic. Backyards, decks, and patios became more important—and less sociable—ways to extend the home's living area. Until the advent of new urbanism, the front porch was an endangered species.

Like the porch, new urbanism has much to recommend it, particularly compared to a soulless, anonymous c.s.d., as conventional suburban developments are called. The movement has also helped focus attention on housing and suburbia as public issues. Some developers are co-opting the new urbanism label and adding a few of its bells and whistles, such as nature areas and paths for schoolkids and bikers, to what are essentially the same old car-oriented,

sprawling tracts, but that's not all bad. Some critics, however, protest that new urbanism's architecture, which often borrows heavily from the vernacular styles of the past, is overly nostalgic. Others complain that its larger developments tend to be homogenous, squeaky-clean fairylands for the well-off, which is why Seaside was the setting for the film *The Truman Show.*

If Seaside lies at the high end of the spectrum of alternative housing schemes, at the other sits Albany Village, an affordable complex in Berkeley that offers 392 two- and three-bedroom apartments for rents of about $1,000 per month. The attractive, variegated tan, red, and green townhouse-style homes were designed for the University of California's students with families. The widening gap between average income and rent or mortgage payments means that there's an acute need for such subsidized homes in much of America. In addition to the problem of finding the necessary funding, however, many communities are increasingly anxious about including people who are "poor" or "not our kind" and don't want anything to do with affordable housing.

Long accustomed to the public's adverse reaction to a serious national problem, Sam Davis, a Berkeley professor of architecture and Albany Village's designer, traces the attitude back to the infamous high-density, low-income housing projects of the 1950s and '60s that fostered crime. "We do multifamily housing much better now," says he, "and I wish we could get over this negative perception, as Europeans did a long time ago. Otherwise, we'll have more suburban sprawl and social isolation."

One of the best ways to change multifamily housing's bad image is to make it look and feel as much as possible like single-family homes. To that end, each family in the Albany complex has its own private front entrance and address, an outdoor deck or a patio, and a shared rear entry to a backyard. As Davis puts it, a tenant "can point and say, '*That's* my home.'" Inside, too, the apartments have many features of a single-family house, such as cross-ventilation, good light, elbow room for kids, and "interior zoning." As Davis says, "You shouldn't have to go into a public space like the

living or dining room to in order to get to the bathroom."

From a behavioral perspective, Albany Village has something important that many ritzy new suburban subdivisions lack: esprit de corps. Careful planning to accommodate pedestrians in general and children in particular means that there are lots of people outdoors, from chatting neighbors to kids traveling to and from school and cavorting in play areas. "The graduate students, who come from all over the world, love it here," says Davis, "because there's a strong sense of community."

Just down the road from Albany Village lies Creekside, which is a much smaller, affordable townhouse complex that Davis designed for tenants, some of whom are handicapped, who earn between $20,000 and $30,000 per year. It too has many of the features that say "private home" rather than "public housing," such as individual garages and attractive landscaping—even the eponymous creek. Although the handsome development replaced a derelict motel turned crack house, the process of securing funding and the necessary permits and community permissions delayed its construction by six years.

If providing housing for low-income people is difficult, finding homes for the million Americans who are homeless each night is a mind-boggling problem. The causes are both systemic, such as stagnant incomes and rising housing costs, and individual; about 30 percent of the homeless are mentally ill, and 30 percent have histories of substance abuse, with some overlap between the two groups. Surprisingly, the so-called chronic homeless, who are noticeable as such on the streets, comprise only 15 to 20 percent of the total number. Although the images of the hobo and "bag lady" persist, says Davis, 40 percent of the homeless are now families with children.

Creating affordable, dense, homey housing such as Creekside and Albany Village is one of America's major social challenges. In 2005, for the first time, an existing (as opposed to new) home's median price rose above $200,000, according to the National Association of Realtors. That this unprecedented increase in cost has

expanded the market for affordable housing to include not just poor people but members of the middle class gives Davis some hope for the future. "At public meetings for my projects, the community members say, 'We don't want those people here.' But increasingly, those people include teachers, police, and firemen—the very people you want in your neighborhood."

One reason many of our communities are so disappointing is that with a little thought, they could easily be better—as were many suburbs in the past. It's hard to believe today, but Forest Hills Gardens, in New York City's bustling borough of Queens, began in 1910 as a suburb. Concerned about the housing shortage, the need for urban planning, and the rapidly expanding bourgeoisie's taste, the Russell Sage Foundation commissioned Frederick Law Olmsted Jr., the great landscaper's son, and the architect Grosvenor Atterbury to turn the 147-acre Queens site into a handsome, organized community of modest Arts and Crafts–style suburban homes. The asymmetric village of varied, mostly attached housing, curving streets, a "green," and the medieval-looking Station Square—still a model public space—was first served by the Long Island Railroad and today by the subway. Forest Hills Gardens is such a pleasant place to live that some of its increasingly well-off families have stayed there for generations.

It's easy to find people who are eager to bash either the city or the suburbs, but Renee Chow, a professor of architecture at Berkeley, prefers to rethink those terms. Suburbia is usually defined geographically, as a residential metropolitan ring around a core city. To Chow, however, a suburb is a neighborhood that's mostly made up of single-family detached houses. Thus, parts of Charleston, South Carolina, San Francisco, and other attractive older cities are "urban suburbs" that can teach us how to do suburbia better, especially by increasing its density and reestablishing the home's traditional connections to its social and physical environment.

We should feel "at home" not only when we're inside behind locked doors but also when we're out and about. In Charleston,

part of that comfortable feeling derives from the fact that its classic "Single houses," with their porchlike piazzas and gardens, were based on a typology—a basic architectural form and its variations—rather than on a prototype—a model that's simply cloned. Like many early suburbs, Charleston was built by small developers who each constructed from one to several houses, creating an architectural symphony of different yet harmonious notes.

After World War II, however, the big new suburban developers put commercial considerations ahead of behavioral and architectural ones and rejected old-fashioned housing typology for industrial prototypes. As a result, America has ended up with lots of dull homes and bland communities, in which each house is plunked in the middle of its lot facing the street, separated from its neighbors by a landscape that Chow likens to a moat: "These homes are just boxes that get put anywhere, completely ignoring house-to-house and house-to-site relations." This problem didn't happen by itself, nor will it heal itself, she says: "How much a home engages with its setting is a choice—and for architects and planners, a design issue."

One of suburbia's leading attractions is the way it insulates neighbors, but Chow insists that there are other ways to ensure privacy. Only a room wide and three rooms deep, Charleston's Single house turns one of its narrow windowless sides to the street and its broad front, entry, and piazza to its garden, which is entered through a solid door. The result is a home that protects its residents' privacy while maintaining strong ties to the larger worlds of garden and street. "High-density living doesn't have to mean that other people are just thrown in your face," says Chow. "Good design enables you to control your privacy while also having more of a sense of connection with your neighborhood."

There are many ways in which suburbs could invite us to have better social and environmental relationships. Instead of having one home per plot, for example, so-called flag lots accommodate one house in the front of the property and another in the back. Each home has privacy, but twice as many people travel back and

forth from the lot to the street, which increases the sense of liveliness and community and also conserves increasingly high-priced space. Suburbs could also include more row houses—a flexible, energy-efficient form that can function as one large home or be divided into apartments. "We have such shallow ways of thinking," says Chow, "but the potential is there for the suburbs."

Offering a distinctly down-to-earth example, Chow cites Levittown. The huge development started out "pretty bad and uniform," she allows, but over time, homeowners individualized their houses a great deal, which gave the community more texture and variety. Surprisingly, the feature that allowed them to do so was included by the developer for an entirely different reason. Levittown's homes aren't centered on their lots, as most houses are, but are shifted to one side to leave room for a car—or an addition. Partly because the space allows residents to do what they want, says Chow, "they really like living there. They also have more sense of neighborhood than most new suburbs."

Giving our homes and communities some extra dimensions that make them more flexible means they're better able to accommodate social change. As baby boomers age, for example, they will need ways to reprogram their big suburban houses, which poorly suit the elderly. Chow lists some possibilities, such as installing a full bathroom on the first floor, so that owners won't have to move when the stairs become too much of a challenge, and creating a rental unit that allows owners on fixed incomes to stay in their big homes. "That kind of flexibility is still missing from most modern suburban houses," she says. "We can dwell wherever we're at, but some places help us to do that more than others. If we could just think a little bit ahead . . ."

An architect who has long thought ahead about the home in general and its connection to behavior in particular, John Johansen has designed twenty-six houses, as well as public buildings such as the Clark University Library and the U.S. embassy in Dublin. His homes are very different, but all are characterized by an organic

connection to the larger world. At a tribute to his contribution to domestic architecture, organized by the American Institute of Architects in 2005, Johansen showed slides of his own home in New York State and talked about the experience of living there. Originally designed as a weekend place closely integrated with nature, the house sits lightly on its wooded site. In fact, with rigid translucent flaps that may be raised and lowered often replacing traditional walls, the building seems more like a tent than a traditional house. As he has grown more attuned to the natural environment, said Johansen, "I couldn't live again in a house with solid walls."

Inside the luminous, plant-filled house, there's a biomorphically shaped tub that Johansen built himself when he couldn't find what he wanted on the market. After a country tramp on a cold day, he and his wife like to fill the big bath, turn on their favorite music, grab a martini, and enjoy a good soak. If they submerge, they can listen to their heartbeats. Of such a small but inimitable experience, Johansen says, "This is an example of what a home can do."

Because it has been mine for more than twenty-five years, during which I moved four times in the city, my country schoolhouse gives me the deepest feeling of being rooted in a home's larger social and natural worlds. I know the terrain of my long walks nearly as well as my own small property. We country neighbors don't socialize as intentionally or as much as city friends do, yet we look out for each other. When the creek floods our dirt road every few years, someone will haul our old truck up onto the lawn and even pick the fish out of the grille. We also give witness to each other's lives over time—an increasingly rare phenomenon in our hectic mobile society—and to our love for our old homes.

After three years of working on this book, my family and I feel much more at home at home. When we don't, we do something about it. If the entry's welcome is obscured by debris, we remove it. When the living room takes on a generic quality, we do some editing so that it feels like ours again. To curb the clutter that can quickly overtake the bedroom, we cull our possessions three times a year. I've even stopped nagging Mike about our basement, because I finally accept that he likes it that way.

In short, we've learned that with some house thinking, your home may not look like the ones in the magazines, but much more important, it will support your identity, foster both privacy and sociability, buffer you from stress, and connect you to the larger world. Because this kind of home satisfies you on evolutionary, personal, and cultural levels, it invites you to feel both relaxed and interested, sheltered and fascinated. The first step toward such a house or apartment is a decision to think of it in a new, behavior-inspired way: as your partner in a relationship that, like your closest human ties, is meant to fulfill your deep inner needs and make you feel at home in the world.

REFERENCES AND SUGGESTED READING

Introduction: Why There's No Place Like Home

xiv The solution to. . . . Winifred Gallagher, *The Power of Place: How Our Surroundings Shape Our Thoughts, Emotions, and Actions* (New York: Poseidon Press/Simon & Schuster, 1993; New York: HarperCollins, 1994.)

xvii The new field of environmental psychology. . . . Robert B. Bechtel and Arza Churchman, eds., *Handbook of Environmental Psychology* (New York: Wiley, 2002).

1. Home: When We See It, We Know What We Like

1 The Maybeck house in the Forest Hill section of San Francisco is currently owned by the architect Paul Bessieres and his wife, Sandy.

5 To survive, the first human beings . . . : Stephen Kaplan, "Aesthetics, Affect, and Cognition: Environmental Preference from an Evolutionary Perspective," *Environment and Behavior* 19 (1987).

5 As an architect, Hildebrand wanted to identify . . . : Grant Hildebrand, *The Origins of Architectural Pleasure* (Berkeley: University of California Press, 1999).

6 With colleagues at the University of Washington at Seattle . . . : Jay Appleton, *The Experience of Landscape* (London: John Wiley, 1975; rev. 1996); Judith Heerwagen and Gordon Orians, "Humans, Habitats, and Aesthetics," in *The Biophilia Hypothesis*, ed. Stephen R. Kellert and Edward O. Wilson. (Washington, D. C. : Island Press, 1995).

6 As a Wright expert . . . : Grant Hildebrand, *The Wright Space* (Seattle: University of Washington Press, 1991).

7 In a complementary study of paintings . . . : Heerwagen and Orians, "Humans, Habitats, and Aesthetics."

7 In nature, this feeling is evoked . . . : Kaplan, "Aesthetics, Affect, and Cognition."

10 He created the so-called Music Studio House . . . : Penelope Rowlands, "House Music: A Composer Rearranges a Maybeck Masterpiece," *Metropolis* (January 1999).

11 The home and the other . . . : F. W. Putnam, "Altered States," *The Sciences* (1992).

11 We like to think of the self . . . : Winifred Gallagher, *Just the Way You Are: How Heredity and Experience Create the Individual* (New York: Random House, 1996).

11 In a more extreme example . . . : Bessel A. van der Kolk, Alexander McFarlane, and Lars Weisaerth, eds., *Traumatic Stress* (New York: Guilford Press, 1996).

11 A place that's associated with drug use . . . : S. Siegel, "Heroin Overdose Death: The Contribution of Drug-Associated Environmental Cues," *Science* (1982).

14 (To avoid such nightmares . . . : Robert Herschberger, *Architectural Programming and Predesign Manager* (New York: McGraw-Hill, 1999).

14 As we moved up in the world, we developed . . . : Amos Rapoport, *House Form and Culture* (Engelwood Cliffs, NJ: Prentice Hall, 1969).

15 Home as we understand it . . . : Witold Rybczynski, *Home: A Short History of an Idea* (New York City: Viking Penguin, 1986).

15 America's first homes . . . : Merritt Ierley, *Open House: A Guided Tour of the American Home* (New York: Henry Holt, 1999).

16 (Stone and brick houses . . . : E. K. Sadalla and V. S. Sheets, "Symbolism in Building Materials," *Environment and Behavior* 25 (1993).

16 The environmental psychologist Jack Nasar takes a scientific approach . . . : J. L. Nasar, "Symbolic Meanings of House Styles," *Environment and Behavior* 21 (1989).

17 In a classic experiment . . . : S. Milgrim, *The Individual in a Social World* (Reading, MA: Addison-Wesley, 1977).

17 By design, America's first iconic home . . . : Robert E. Dalzell and Lee Baldwin Dalzell, *George Washington's Mount Vernon: At Home in Revolutionary America* (New York: Oxford University Press, 1998).

19 The later nineteenth century also gave birth to an American home . . . : Elizabeth Cromley, *Alone Together: A History of New York's Early Apartments* (Ithaca, NY: Cornell University Press, 1999).

21 Albeit smaller than a McMansion, America's typical home . . . : National Association of Homebuilders, http://www.nahb.com; U.S. Department of Housing and Urban Development, http://www.hud.gov.

21 Particularly important from a behavioral perspective . . . : U.S. Census Bureau http://www.census.gov.

22 Most people don't necessarily want ...: T. R. Herzog and T. A. Gale, "Preferences for Urban Buildings as a Function of Age and Nature Context," *Journal of Environmental Psychology* 12 (1992).

22 In fact, in Jack Nasar's research ...: J. L. Nasar, "Symbolic Meanings of House Styles," *Environment and Behavior* 21 (1989); J. L. Nasar, *Environmental Aesthetics* (Cambridge, England: Cambridge University Press, 1988).

22 Other research, too, reveals a gap...: G. W. Evans and J. M. McCoy, "When Buildings Don't Work," *Journal of Environmental Psychology* 18 (1998); J. Lang, *Creating Architectural Theory: The Role of the Behavioral Sciences in Environmental Design* (New York: Van Nostrand Reinhold, 1987). Tom Wolfe, *From Bauhaus to Our House* (New York: Farrar, Straus, and Giroux, 1981).

23 American households are becoming smaller...: U.S. Census Bureau, http://www.census.gov.

23 As the noted architect ...: R. A. M. Stern, "Dreamhouse," *Life*, 1994.

23 Like his biblical namesake, the architect Jeremiah Eck ...: Jeremiah Eck, *The Distinctive Home* (Newtown, CT: Taunton Press, 2003).

2. The Entry and Plan: Who You Are Is Where You're At

29 The glorious experience of Monticello ...: Jack McLaughlin, *Jefferson and Monticello: The Biography of a Builder* (New York: Henry Holt and Company, 1988); William L. Beiswanger, (architectural commentary), *Monticello in Measured Drawings* (Chapel Hill, NC: University of North Carolina Press, 1998); William L. Beiswanger, Peter J. Hatch, Lucia Stanton, and Susan R. Stein, *Thomas Jefferson's Monticello* (Chapel Hill, NC: University of North Carolina Press, 2002).

33 Some of the best—and most overlooked—research ...: R. G. Barker, *Ecological Psychology: Concepts and Methods for Studying the Environment of Human Behavior* (Stanford, CA: Stanford University Press, 1968); Harry Heft, *Ecological Psychology in Context: James Gibson, Roger Barker, and the Legacy of William James's Radical Empiricism* (Mahwah, NJ: Lawrence Erlbaum, 2001).

33 We like to think of ourselves ...: Winifred Gallagher, *Just the Way You Are: How Heredity and Experience Create the Individual* (New York: Random House, 1996).

35 (Examining Victorian prissiness ...: Elan and Susan Zingman-Leith, *The Secret Life of the Victorian House* (New York: Viking Studio, 2000).

37 To illustrate, Jan Jennings ...: Jan Jennings, *Cheap and Tasteful Dwellings* (Knoxville, Tennessee: University of Tennessee Press, 2005); Jan Jennings and Herbert Gottfried *American Vernacular Interior Architecture* (New York: Van Nostrand Reinhold, 1993); "Sitting or Receiving," *Journal of Interior Design* 20 (1994).

37 To illustrate, Jan Jennings . . . : F. W. Putnam, "Altered States," *The Sciences* 1992.

41 The McMansion trades quality . . . : Matt Holland, "Small Is Beautiful: Houses for the Small Household," *Context* (Spring 1993).

44 Indeed, the true heart of a house or apartment . . . : Donlyn Lyndon et al., *The Place of Houses* (Berkeley: University of California Press, 2000); Donlyn Lyndon et al., *The Sea Ranch* (Princeton, NJ: Princeton Architectural Press, 2004).

3. The Living Room: *Decoro Ergo Sum*

51 This hard-to-categorize yet harmonious room . . . : Lea Winerman, "Designing Psychologists," *Monitor on Psychology*, July-August 2004; Constance Forrest and Susan Painter, "Design Psychology," *Research-Design Connections* (Winter 2004).

53 Taking a more sanguine view, Carl Jung . . . : Carl Jung, *Memories, Dreams, Reflections* (New York: Pantheon, 1963).

54 Modern research on memory . . . : Eric R. Kandel, *In Search of Memory* (New York: W. W. Norton, 2005).

54 To investigate the emotional bonds . . . : Clare Cooper Marcus, *House as Mirror of Self* (Berkeley: Conari Press, 1995).

55 According to environmental psychologist . . . : L. C. Manzo, "Beyond House and Haven: Toward a Revisioning of Emotional Relationships to Place," *Journal of Environmental Psychology* 23 (2003).

57 It may not be possible to psychoanalyze . . . : Denis Wood and Robert J. Beck, *Home Rules* (Baltimore: Johns Hopkins University Press, 1994).

62 Scientists wrangle over the number of personality . . . : Winifred Gallagher, *Just the Way You Are: How Heredity and Experience Create the Individual* (New York: Random House, 1996).

64 Bold Oscar and delicate Felix . . . : J. F. Wohlwill, "Human Response to Levels of Environmental Stimulation," *Human Ecology* 2 (1974).

64 This special room's contents . . . : Mihaly Csikszentmihalyi and Eugene Rochberg-Halton, *The Meaning of Things* (Cambridge, England: Cambridge University Press, 1981).

68 Then, too, you might stick a sixty- or seventy-five-watt bulb . . . : K. J. Gergen et al., "Deviance in the Dark," *Psychology Today* 7 (1973).

69 Research shows we feel more comfortable . . . : D. E. Campbell "Interior Office Design and Visitor Response," *Journal of Applied Psychology* 64 (1979).

69 and that the good mood induced by being in a pleasant setting . . . : D. R. Sherrod et al. "Environmental Attention, Affect, and Altruism," *Journal of Applied Social Psychology* 7 (1977).

69 Even in a hospital . . . : C. J. Holahan and S. Saegert, "Behavioral and Atti-

tudinal Effects of Large-Scale Variation in the Physical Environment of Psychiatric Wards," *Journal of Abnormal Psychology* 83 (1973).

69 We link certain shades ...: M. S. Sanders and E. J. McCormick, *Human Factors in Engineering and Design* (New York: McGraw-Hill, 1993).

70 Perhaps the classic proof ...: Abraham Maslow, "Effects of Esthetic Surrounding," *Journal of Psychology* 41 (1956).

4. The Kitchen: Woman's Work Is Never Done?

76 In fact, new insights into women's history ...: Sarah Stage and Virginia B. Vincenti, eds., *Rethinking Home Economics: Women and the History of a Profession* (Ithaca, NY: Cornell University Press, 1997).

76 In 1990, the Cornell historian ...: Joan Jacobs Brumberg, in ibid.

78 For women urban and rural, rich and poor, home economics became the intersection of science ...: Margaret W. Rossiter, *Women Scientists in America: Struggles and Strategies Until 1940* (Baltimore, MD: Johns Hopkins University Press, 1982).

81 Stressing the differences ...: Elizabeth Cromley, "Transforming the Food Axis," *Material History Review* (Fall 1996).

85 On average, we make only about a third of our dinner entrees ...: Jerry Adler, "Takeout Nation," *Newsweek*, February 9, 2004.

85 Time pressures are especially acute ...: R. G. Barker, *Ecological Psychology: Concepts and Methods for Studying the Environment of Human Behavior* (Stanford, CA: Stanford University Press, 1968).

85 Even in two-partner homes, despite their professional gains...: U.S. Bureau of Labor Statistics, *American Time Use Survey*, September 2004.

87 As a peek into the postmodern kitchen suggests ...: Jerome Tognoli, "Residential Environments," in *Handbook of Environmental Psychology*, eds. D. Stokols and I. Altman (New York: John Wiley, 1987).

87 Fred Carl, founder of ...: Molly O'Neill, "The Viking Invasion," *New Yorker* July 29, 2002.

88 The exploding kitchen is a good example ...: Jamie Horwitz, *Eating Architecture* (Cambridge, MA: MIT Press, 2004); Jamie Horwitz "Working Lunch," *Architectural Design* (January 2003).

89 Much of the production of affordable ...: Jeffrey Kluger, "Inside the Food Labs," *Time*, October 6, 2003.

5. The Dining Room: Status and Stuff

97 In his extensive analysis ...: Michael Marmot, *The Status Syndrome* (New York: Times Books/Henry Holt, 2004).

98 The Princeton psychologist ...: Daniel Kahneman, *Well-Being: Foundations of Hedonic Psychology* (New York: Russell Sage Foundation, 2003).

98 A famous study conducted ...: Gerry Pratt, "The House as Expression of

Social Worlds," in *Housing and Identity*, ed. James Duncan (London: Croom Helm, 1981).

99 We may sometimes be . . . : William James, *The Principles of Psychology* (New York: Henry Holt, 1890).

100 As an expert on the relationship between us and our stuff . . . : Russell Belk, "Possessions and the Extended Self," *Journal of Consumer Research* September 1988. *Collecting in a Consumer Society* (New York: Routledge, 1995).

100 This new field . . . : Virginia Postrel, *The Substance of Style* (New York: HarperCollins, 2003).

101 Certain institutions, such as prisons . . . : Erving Goffman, "Symbols of Class Status," *British Journal of Sociology* (December 1951).

101 One study of victims . . . : Beverly McLeod, "In the Wake of Disaster," *Psychology Today*, October 1984.

105 The anthropologist Grant McCracken's . . . : Grant McCracken, *Culture and Consumption: New Approaches to the Symbolic Character of Consumer Goods and Activities* (Bloomington: Indiana University Press, 1991).

107 This kind of inappropriate acquisitiveness . . . : Robert Arkin and LinChiat Chang, "Chronic Self-Doubters Tend to be More Materialistic," *Psychology & Marketing* (August 2002).

108 Comparing her Fifth Avenue duplex . . . : Hamish Bowles, "Lee's New Leaf," *Vogue*, August 2003.

110 The boomers' special brand of. . . : David Brooks, *Bobos in Paradise* (New York: Simon & Schuster, 2001).

110 In the 1960s . . . : Scott and Helen Nearing, *The Good Life* (New York: Schocken, 1990).

110 In response, in the 1980s . . . : Duane Elgin, *Voluntary Simplicity* (New York: Harper Paperbacks, 1998).

6. The Great Room: Same Time, Same Place

116 Moreover, barely half . . . : U.S. Census Bureau, http://www.census.gov.

116 The architect Mark Mack . . . : D. Y. Ghirado and M. Mack, *Mark Mack* (Tübingen, Germany: Wasmuth, 1994).

118 The most remarkable feature . . . : Margaret Henderson Floyd, "HH Richardson, Frederick Law Olmsted, and the House for Robert Treat Paine," *Winterthur Portfolio* (Winter 1983).

119 As the Yale architectural historian . . . : Vincent J. Scully, *The Shingle Style and the Stick Style* (New Haven, CT: Yale University Press, 1971).

119 By the 1940s . . . : James Ford and Katherine Ford, *Classic Modern Homes of the Thirties* (Mineola, NY: Dover, 1989).

122 In an era of tremendous cultural change . . . : Harry Heft, "Affordances of Children's Environments," in *Directions in Person-Environment Research and*

Practice, eds. J. L. Nasar and W. Preiser (Aldershot, England: Ashgate, 1999).

123 Summing up some of . . . : Ronald C. Kessler, et al., *How Healthy Are We?: A National Study of Well-Being at Midlife* (Chicago: University of Chicago Press, 2004).

123 Judging by the amount of time . . . : Arlie Hochschild, *The Time Bind: When Work Becomes Home and Home Becomes Work* (New York: Owl Books: 2001).

124 Over the past twenty to thirty years . . . : U.S. Census Bureau, http://www.census.gov.

125 Sheer propinquity—parents in the school yard . . . : R. A. Baron and D. Byrne, *Social Psychology* (Boston: Allyn and Bacon, 2000).

125 Referring to his colleague . . . : Robert D. Putnam, *Bowling Alone: The Collapse and Revival of American Community* (New York: Simon & Schuster, 2001).

126 In one intensively studied tragedy . . . : G. Gleser, et al., *Prolonged Psychosocial Effects of Disaster* (New York: Academic Press, 1981).

127 Behavior-setting studies of so-called open-planned schools . . . : P. V. Gump, "School Environments." In *Handbook of Environmental Psychology,* ed. D. Stokols and I. Altman, eds. (New York: John Wiley, 1987).

128 To Irwin Altman . . . : I. eds., Altman and C. M. Werner, *Home Environments* (New York: Plenum, 1985).

128 In a wide-open great room . . . : Irwin Altman and A. M. Vinsel, "Personal Space," in *Human Behavior and Environments,* eds. I. Altman and J. F. Wohlwill (New York: Plenum, 1977)

128 In an especially inventive investigation of the subject . . . : R. D. Middlemist et al., "Personal Space Invasions in the Lavatory," *Journal of Personality and Social Psychology* 33 (1976).

129 Research showed that in an urban ghetto's . . . : A. E. Scheflen, "Living Space in an Urban Ghetto," *Family Process* 10 (1971).

130 After investigating what he calls . . . : Robert Sommer, *Design Awareness* (San Francisco: Rinehart, 1972).

131 If there's one thing we can do . . . : R. Sommer and H. Ross. "Social Interaction on a Geriatrics Ward," *International Journal of Social Psychiatry* 4 (1958).

7. The Bedroom: Behind Closed Doors

135 This hardworking socialite . . . : Edith Wharton and Ogden Codman, *The Decoration of Houses* (New York: W. W. Norton, 1897).

137 Gaillard Lapsley, a close friend . . . : Percy Lubbock, *Portrait of Edith Wharton* (New York: Krauss, 1969).

138 Primate research at a rural station . . . : S. J. Suomi, "Early Stress and Adult

Emotional Reactivity in Rhesus Monkeys," in Gregory Bock, *The Child-hood Environment and Adult Disease* (New York: John Wiley, 1991).

139 Imbued with the idea . . . : Elizabeth Collins Cromley, "History of the Bed-room," *Perspectives in Vernacular Architecture* 4 (1991); "Sleeping Around," *Journal of Design History* 3 (1990).

143 A specialist in how places and spaces . . . : Kathryn Anthony, *Design Juries on Trial: The Renaissance of the Design Studio* (New York: John Wiley, 1991); Kathryn Anthony, *Designing for Diversity: Gender, Race, and Ethnicity in Ar-chitectural Profession* (Urbana IL; University of Illinois Press, 2001).

144 Feng shui masters would approve . . . : Sarah Rossbach, *Interior Design with Feng Shui* (New York: EP Dutton, 1987).

147 In his introduction . . . : Joel Sanders, ed. *Stud: Architectures of Masculinity* (New York: Princeton Architectural Press, 1996).

147 Like its *Playboy* predecessor . . . : Steven Cohan, "So Functional for its Pur-poses: Rock Hudson's Bachelor Apartment in Pillow Talk," in Sanders, ed., *Stud*.

148 Visual and spatial acuity . . . : Jerome Tognoli, "Differences in Women's and Men's Responses to Domestic Space," *Sex Roles* 6 (1980).

149 Of course, in other cultures . . . : Sanjoy and Shampa Mazumdar, "Religion and Place Attachment," *Journal of Environmental Psychology*, September 24, 2004.

150 As the psychologist Susan Painter . . . : Susan Pointer "An Interesting Career in Psychology," *Psychological Science Agenda*, November-December 2002; Lea Winerman, "Designing Psychologists," *Monitor on Psychology* (July-August 2004).

8. The Bathroom: Mirror, Mirror on the Wall

160 (The invention was perhaps . . . : Jennifer Schueser, "Hello, Dolly!" *New York Review of Books*, February 13, 2003.

160 The housewife as hygienist . . . : Nancy Tomes, "The Gospel of Germs," *Rethinking Home Economics*, eds., Sarah Stage and Virginia B. Vincenti (Ithaca and London: Cornell University Press, 1997).

161 When the Cornell architecture professor . . . : Alexander Kira, *The Bath-room* (New York: Viking, 1976.)

162 Part of the recent phenomenon . . . : Mokoto Rich, "Nightmares on Mold Street," *New York Times*, December 11, 2003.

162 Average Americans, too . . . : Howard Markel, *When Germs Travel* (New York: Pantheon, 2004).

163 Thus ensuring personal daintiness . . . : Winifred Gallagher, "High Anxi-ety," *Rolling Stone*, March 12, 1987.

164 Not coincidentally, the Cornell historian . . . : Joan Jacobs Brumberg, *Fast-ing Girls: The History of Anorexia Nervosa* (New York: Vintage, 2000).

165 When she examined . . . : Joan Jacobs Brumberg, *The Body Project: An Intimate History of American Girls* (New York: Vintage, 1998).

165 In one study, young men . . . : "University of Central Florida Showed 158 Male College Students Some TV Commercials, Then Tested Their Mood," *Time*, April 27, 2004.

165 Most of us know . . . : American Psychiatric Association, *Diagnostic and Statistical Manual of Mental Disorders*, 4th ed. (Washington, D.C.: American Psychiatric Association, 2000).

166 A study of 200 households . . . : J. Meer, "The Strife of Bath," *Psychology Today* (May 1986).

167 Environmental psychology has several conceptual models . . . : Paul Bell et al., "Theories of Environment-Behavior Relationships, " in *Environmental Psychology* (Belmont, CA: Thomson Wadsworth, 2001).

169 If the roommate is . . . : Martin Seligman, *Learned Optimism* (New York: Free Press, 1998).

9. The Child's Room: A Place to Call One's Own

175 The child's home has improved . . . : J. F. Wohlwill and Harry Heft, "The Physical Environment and the Development of the Child," in eds. D. Stokols and I. Altman, *Handbook of Environmental Psychology* (New York: John Wiley, 1987).

175 A survey of twelve cultures . . . : Sheridan Bartlett, "Housing as a Factor in the Socialization of Children," *Merill-Palmer Quarterly* (April 1997).

177 As the environmental psychologist Gary Evans . . . : G. W. Evans, "Environmental Stress and Health." in eds. A. Baum et al., *Handbook of Health Psychology* (Mahwah, NJ: Erlbaum, 2001).

177 In some important ways, a child's room . . . : Louise Chawla, "Homes for Children in a Changing Society," in eds. Ervin Zube and Gary Moore, *Advances in Environment, Behavior and Design* (New York: Plenum, 1991).

179 As with the rambling Alcott girls . . . : S. Kaplan and R. Kaplan, *The Experience of Nature* (Cambridge, England: Cambridge University Press, 1989).

179 Boys tend to like . . . : R. A. Hart, "Children's Participation in Planning and Design," in eds. C. Simon and T. David, *Spaces for Children* (New York: Plenum, 1987).

180 Their emotional dependence . . . : Katherine Anthony, "Bitter Homes and Gardens," *Journal of Architectural and Planning Research* (Spring 1997).

180 Adolescents require privacy . . . : Dirk Johnson, "Students Still Sweat. They Just Don't Shower," *New York Times*, April 22, 1996.

181 Although they need . . . : Denise Grady, "Sleep Is One Thing Missing in Busy Teenage Lives," *New York Times*, November 11, 2002.

182 The influential psychoanalytical . . . : Karen Horney, *Our Inner Conflicts* (New York: Norton, 1992).

182 For a baby ...: Myron A. Hofer, *The Roots of Human Behavior* (New York: W .H. Freedman, 1981).

183 When too much ...: A. F. Korner, "The Use of Waterbeds in the Care of Preterm Infants," *Journal of Primatology* (1984).

183 The computer is the latest and most potent source ...: "Children and Computer Technology" issue, *The Future of Children*, a publication of the Woodrow Wilson School of Public and International Affairs at Princeton University and the Brookings Institution. 2000.

184 The pioneering environmental psychologist Daniel Stokols ...: D. Stokols "Toward an Environmental Psychology of the Internet," in eds. R. Bechtel and A. Churchman, *Handbook of Environmental Psychology* (New York: John Wiley, 2002).

185 One carefully staged experiment ...: K. E. Matthews et al., "The Influence of Level of Empathy and Ambient Noise on the Body Buffer Zone," from the Proceedings of the American Psychological Association, Division of Personality and Social Psychology, 1974.

185 Much research shows that ...: S. Cohen et al., *Behavior, Health, and Environmental Stress* (New York: Plenum, 1991).

186 Crowded homes in which children ...: L. E. Maxwell, "Multiple Effects of Home and Daycare Crowding," *Environment and Behavior* 28 (1996).

186 To see how growing up ...: G. W. Evans, "The Environment of Childhood Poverty," *American Psychologist* 59 (2004).

186 One simple reason ...: A. Baum and S. Valins, "Architectural Mediation of Residential Density and Control," in ed. L. Berkowitz *Advances in Experimental Social Psychology*.

186 "If you change housing quality ...: G. W. Evans, N. M. Well, and N. M. Moch, "Housing and Mental Health," *Journal of Social Issues* 59 (2003).

187 Like the young, the old prosper ...: Avi Friedman and David Krawitz, *Peeking through the Keyhole* (Montreal, Quebec: McGill-Queen's University Press, 2002).

10. The Basement: Doing It Yourself

193 Even in the nineteenth century ...: Thomas Wehr and Norman Rosenthal, "Seasonality and Affective Illness," *American Journal of Psychiatry* 146:7 (1989).

197 Today, some 100,000 building firms ...: National Association of Homebuilders, http://www.nahb.com.

202 To find out where people ...: Mihaly Csikszentmihalyi, *Flow: The Psychology of Optimal Experience* (New York: Perennial, 1991).

203 One man's personal description ...: Michael Segell, "Beauty and the Basement," *Chicago Tribune*, March 7, 1999.

204 A study in rural France . . . : P. Korosec-Serfaty, "The Home from Attic to Cellar," *Journal of Environmental Psychology* 4 (1984).

11. The Office: Home Work

210 The happiest home workers . . . : Sherry Ahrentzen, "A Place of Peace, Prospect, and . . . a PC," *Journal of Architectural and Planning Research*, Winter 1989; Sherry Ahrentzen, "Managing Conflict by Managing Boundaries," *Environment and Behavior* 22 (1990).

210 Family members actually perceive . . . : Jamie Horwitz, "Working at Home and Being at Home," (Ph.D. dissertation, Graduate Center of the City of New York, 1986).

211 Both slobs and neatniks . . . : P. C. Morrow and J. C. McElroy, "Interior Office Design and Visitor Response," *Journal of Applied Psychology* 66 (1981).

212 The home office's single greatest . . . : G. Evans and S. Cohen, "Environmental Stress," in *Handbook of Environmental Psychology*, eds. D. Stokols and I. Altman. (New York: John Wiley, 1987).

212 Judging by one famous . . . : W. M. Roethlisberger, *Management and the Worker* (Cambridge, MA: Harvard University Press, 1939).

213 Even simple environmental features like sunlight . . . : M. R. Cunningham, "Weather, Mood and Helping Behavior," *Journal of Personality and Social Psychology* 37 (1979).

213 (Interestingly, one study showed that . . . : P. Leather et al., "Windows in the Workplace," *Environment and Behavior* 30 (1998).

214 This finding is supported by . . . : J. H. Heerwagen and G. Orians, "Adaptions to Windowlessness," *Environment and Behavior* 18 (1986).

214 On the other hand . . . : L. Larsen et al., "Plants in the Workplace," *Environment and Behavior* 30 (1998).

214 Numerous studies show that places . . . : Frank W. Putnam, *Dissociation in Children and Adults* (New York: Guilford Press, 1997).

216 The term was coined by . . . Mihaly Csikszentmihalyi, *Flow: The Psychology of Optimal Experience* (New York: Perennial, 1991).

217 An unusually large and broad socioeconomic spectrum. . . : "Children and Computer Technology" issue, *The Future of Children*, a publication of the Woodrow Wilson School of Public and International Affairs at Princeton University and the Brookings Institution. 2000.

218 Fifty years later, television's impact . . . : Avi Friedman and David Krawitz, *Peeking Through the Keyhole* (Montreal, Quebec: McGill-Queen's University Press, 2002).

219 Our growing romance . . . : J. B. Calhoun, "Plight of the Ik and Kaiadilt Is Seen as Chilling Possible End for Man," *Smithsonian Magazine* (1972).

221 In 2003, Martha Stewart . . . : "People," *Time*, May 12, 2003.

221 According to Rodney . . . : Rodney Brooks, *Flesh and Machines* (New York: Pantheon, 2002).

221 More than thirty years ago . . . : James Gibson, *An Ecological Approach to Visual Perception* (Boston: Houghton Miflin, 1979).

222 The cognitive psychologist . . . : Donald Norman, *The Psychology of Everyday Things* (New York: Basic, 1988); Donald Norman, *The Design of Everyday Things* (New York: Basic, 2002).

222 By reason of temperament . . . : Winifred Gallagher, *Just the Way You Are: How Heredity and Experience Create the Individual* (New York: Random House, 1996).

222 Of its lofty prototype . . . : Nathaniel Hawthorne, *English Notebooks*, ed. Thomas Woodson and Bill Ellis (Columbus, Ohio: Ohio State University Press, 1997).

222 Hawthorne wrote to a friend . . . : Nathaniel Hawthorne, *Selected Letters of Nathaniel Hawthorne*, ed. Joel Myerson (Columbus, Ohio: Ohio State University Press, 2002).

223 (Underscoring the link between working alone . . . : R. Gifford and P. Sacilotto, "Social Isolation and Personal Space," *Canadian Journal of Behavioral Science* 25 (1993).

12. The Garden: Outside or In

229 Modern research supports Ely's contention . . . : R. Kaplan, "Nature at the Doorstep," *Journal of Architectural Planning Research* 2 (1985); S. Kaplan, "The Restorative Benefits of Nature," *Journal of Environmental Psychology* 15 (1995).

231 Even in big cities, apartment dwellers . . . : R. Kaplan, "Nature at the Doorstep," *Journal of Architectual Planning Research* 2 (1985).

231 Tenants in public housing projects . . . : C. A. Lewis, "People-Plant Interaction," *American Horticulturist* 52 (1973).

232 Reassuring bursts of nature in the city . . . : F. E. Kuo et al., "Transforming Inner City Landscapes," *Environment and Behavior* 30 (1998).

232 Remarking on her "fifty or so" . . . : Ross Parmenter, *The Plant in My Window* (New York: T. Y. Crowell, 1962)

232 Modern research on nature's salubrious effects. . . : R. S. Ulrich, "View through a Window May Influence Recovery from Surgery," *Science* 224 (1984).

232 Ulrich's breakthrough inspired . . . : S. Kaplan, "The Restorative Benefits of Nature," *Journal of Environmental Psychology* 15 (1995).

233 In nursing homes such as . . . : M. Stermer, "Notes from an Eden Alternative Pioneer," *Nursing Homes* 47 (1998).

233 She coauthored . . . : Clare Cooper Marcus and Marni Barnes, *Healing Gardens: Therapeutic Benefits and Design Recommendations* (New York: Wiley, 1999).

235 When discussing exactly *why* . . . : O. E. Myers, *Children and Animals* (Boulder, CO: Westview, 1999).

237 As a result of spending much less time outdoors . . . : D. F. Krupke et al., "Phototherapy of Non-Seasonal Depression," in C. Shaguss et al., *Biological Psychology* (New York: Elsevier, 1985).

238 Where light is concerned, . . . : L. N. Rosen, et al. "Prevalence of Seasonal Affective Disorder in Four Latitudes," *Psychiatry Research* 1990.

238 Only 2 percent of the people . . . : T. A. Wehr and N. Rosenthal, "Seaonality and Affective Illness," *American Journal of Psychiatry* 1989.

241 In a famous study . . . : James Duncan, "The House as Symbol of Social Structure," in eds. I. Altman and C. Werner *Home Environments* (New York: Plenum, 1985).

245 Most of us claim to "love nature" . . . : R. S. Kellert and E. O. Wilson, eds. *The Biophilia Hypothesis* (Washington DC: Island Press, 1995).

245 We endlessly replicate this combination . . . : R. Kaplan, "Some Methods and Strategies in the Prediction of Preference," in *Landscape Assessment*, eds. E. Zube and R. Brush (Stroudsburg, PA: Dowden, Hutchinson, & Ross, 1975).

13. The Second Home: Domesticity to Go

250 According to The National Assoication of Realtors, . . . : National Association of Realtors, http://www.realtor.org.

252 A study of professional and amateur musicians . . . : S. Juniu et al., "Leisure or Work?" *Journal of Leisure Research* 28 (1996).

252 Along with novelty, . . . : S. Kaplan and R. Kaplan, *The Experience of Nature* (Cambridge, England: Cambridge University Press, 1989).

253 The rewards of coping with such novel situations . . . : P. Suedfeld, "What Can Abnormal Environments Tell Us about Normal People?" *Journal of Environmental Psychology* 18 (1998); P. Suedfeld, "Stressful Levels of Environmental Stimulation." in *Stress and Anxiety*, eds. I. G. Sarason and C. D. Spielberger, (Halstead, 1979).

253 For reasons of temperament, different individuals enjoy . . . : Winifred Gallagher, *Just the Way You Are: How Heredity and Experience Create the Individual* (New York: Random House, 1996).

254 These soft, natural stimuli encourage an effortless state of reflection . . . : S. Kaplan. "The Restorative Benefits of Nature," *Journal of Environmental Psychology* 15 (1995).

254 Some research on what used to be termed sensory deprivation suggests . . . : P. Suedfeld, "The Benefits of Boredom," *American Scientist* 63 (1975).

254 Some of the second home's restorative benefits derive ...: Winifred Gallagher, *The Power of Place: How Our Surroundings Shape Our Thoughts, Emotions, and Actions* (New York: Poseidon Press/Simon & Schuster, 1993; New York: HarperCollins, 1994).

256 Some modern research maintains ... : R. A. Baron, "Effects of Negative Ions on Cognition," and "Effects of Negative Ions on Interpersonal Attraction," *Journal of Personality and Social Psychology* 52 (1987).

256 Places where many people have had unusual perceptions ...: M. A. Persinger, "Geophysical Variables and Behavior," *Perceptual and Motor Skills* (1989, 1985, 1983).

256 The long history of the haunted house ...: From a transcript of "Haunted House, Haunted Mind," a three-part program produced by Don Hill and aired on the Canadian Broadcast Corporation's *Radio One* on October 16, 23, and 30 in 1998.

258 Nearly all Americans like to do *something* outside ...: National Survey on Recreation and the Environment (1999–2000), conducted by the U.S. Department of Agriculture Forest Service and the University of Tennessee, Knoxville, Tennessee.

258 From a behavioral perspective, recreation in general is no trivial pursuit ...: H. E. Tinsley and D. J. Tinsley, "A Theory of the Attributes, Benefits, and Causes of Leisure Experience," *Leisure Sciences* 8 (1986).

258 Regarding outdoor recreation in particular, common behavioral benefits ...: B. L. Driver et al., *Nature and the Human Spirit* (State College, PA: Venture, 1996).

260 What feels just right for one person can be all wrong for the group ...: G. Hardin, "The Tragedy of the Commons," *Science* 162 (1968).

260 Something of the complexity ...: Cialdini et al, "A Focus Theory of Normative Conduct," *Journal of Personality and Social Psychology* 58 (1990).

260 In fact, one study of the use of toxic garden chemicals showed ...: C. M. Werner, *Changing Environmental Attitudes and Behaviors* (Salt Lake City: University of Utah Press, 2000).

14. The Neighborhood: No Home Is an Island

268 A community, whether Peacock Farm ...: I. Altman, *The Environment and Social Behavior* (Monterey, CA: Brooks/Cole, 1975).

269 Like athletes who benefit from the very real "home court advantage" ...: B. Schwartz and S. P. Barsky, "The Home Advantage," *Social Forces* 55 (1977).

269 People who live in cozy cul-de-sacs ...: C. M. Werner, et al. "Inferences about Homeowners' Sociability," *Journal of Environmental Psychology* 9 (1989).

269 Research by the environmental psychologist Ralph Taylor ...: R. B. Taylor,

Human Territorial Functioning (Cambridge, England: Cambridge University Press, 1988).

270 What most people want, however, is a big single-family home . . . : U.S. Census Bureau, http://www.census.gov.

270 Academics have also theorized that these car-dependent communities . . . : Rand Health Policy Research Organization. "Suburban Sprawl and Physical and Mental Health," *Public Health*, October 2004.

270 According to the "environmental spoiling theory" . . . : E. B. Ebbesen et al., "Spatial Ecology," *Journal of Experimental Social Psychology* 12 (1976).

270 Freedom from seemingly petty vexations . . . : S. E. Merry, "Crowding, Conflict, and Neighborhood Regulation," in *Neighborhood and Community Environments* I. Altman and A. Wandersman, eds. (New York: Plenum, 1987).

271 Then, too, most Americans *choose* to live in suburbia . . . : M. Cooper and M. C. Rodman, "Accessibility and Quality of Life in Housing Cooperatives," *Environment and Behavior* 26 (1994).

271 One study that compared two groups of similar army families . . . : P. B. Paulus et al., "Environmental and Psychological Factors in Reactions to Apartments and Mobile Homes," *Journal of Environmental Psychology* 11 (1991).

272 If America's community life has an Elijah . . . : James Kunstler, *The Geography of Nowhere* (New York: Free Press, 1994).

273 Fifty years later, the car is. . . : U.S. Census Bureau, http://www.census.gov.

273 To be fair, even from a behavioral perspective, the car . . . : Mihaly Csikszentmihalyi, *Finding Flow* (New York: Basic Books, 1997).

273 In the ability to be "auto-mobile" . . . : Mihaly Csikszentmihalyi and Eugene Rochberg-Halton, *The Meaning of Things* (Cambridge, England: Cambridge University Press, 1981).

274 That said, bonding the home to the car exacts a serious toll . . . : D. Stokols and R. W. Novaco, "Transportation and Well-Being," In *Transportation and Behavior*, ed. I. Altman et al. (New York: Plenum, 1981).

274 Obesity is . . . : Study by the National Center for Smart Growth, *American Journal of Public Health*, September–October 2004

275 Being overweight isn't good, but adding years . . . : Rand Health Policy Research Organization. "Suburban Sprawl and Physical and Mental Health."

276 If there's one group of people . . . : Dolores Hayden, *Redesigning the American Dream: Gender, Housing, and Family Life* (New York: Norton, 2002).

279 The number of America's city-dwellers . . . : U.S. Census Bureau, http://www.census.gov.

280 At first glance, most research . . . : McCauley et al. "Commuters' Eye Contact with Strangers," *Environmental Psychology and Non-Verbal Behavior* 2 (1977).

280 Most residents don't experience "Boston" or "LA" on a daily basis . . . : H. J. Gans, *The Urban Villagers* (New York: Free Press, 1982).

281 In a study done at the famous Watergate apartment complex . . . : S. E. Merry, "Crowding, Conflict, and Neighborhood Regulation," In *Neighborhood and Community Environments*, eds. I. Altman and A. Wandersman.

281 There's even a special kind of urban friendship . . . : S. Milgrim, *The Individual in the Social World* (Reading, MA : Addison-Wesley 1977).

281 One step in that direction is so-called new urbanism . . . : Andres Duany, Elizabeth Plater-Zyberk, and Jeff Speck, *Suburban Nation: The Rise of Sprawl and the Decline of the American Dream* (New York: North Point, 2001).

282 This architectural extra doesn't cost much . . . : B. B. Brown et al., "Neighbors, Households and Front Porches," *Environment and Behavior* 30 (1998).

283 Long accustomed to the public's adverse reaction to a serious national problem . . . : Samuel Davis, *Designing for the Homeless* (Berkeley: University of California Press, 2004).

285 It's easy to find people who are eager to bash either the city or the suburbs . . . : Renee Chow, *Suburban Space: The Fabric of Dwelling* (Berkeley: University of California Press, 2002).

287 An architect who has long thought . . . : J. M. Johansen, *John M. Johansen* (Milan: Areaedizioni, 1996).

WEB RESOURCES

Information about and illustrations of many homes mentioned in this book are posted on the following Web sites. Please be advised that such addresses are subject to change.

1. Home: When We See It, We Know What We Like
Bernard Maybeck houses
www.architectureweek.com/2001/0328/culture_2-1.html

Frank Lloyd Wright's Edwin Cheney House, Oak Park, Illinois, and other homes
www.geocities.com/SoHo/1469/flwbuild.html
www.oprf.com/flw/cheney.html

Maybeck's Music Studio House, Berkeley, California
www.handprintseries.com/maybeck.html

Mount Vernon, Mount Vernon, Virginia
www.mountvernon.org/virtual/index.cfm/ss/2

History of home styles
www.architecture.about.com/od/periodsstyles/

Robert A. M. Stern
www.ramsa.com/

Jeremiah Eck
www.jearch.com/

2. The Entry and Plan: Who You Are Is Where You're At
Monticello, Charlottesville, Virginia
www.monticello.org/house/index.html

Emlen Physick House, Cape May, New Jersey/ Frank Furness
www.state.nj.us/travel/virtual/capemay/physick.html
www.capemaymac.org (click on Physick Estate)

Melanie Taylor
www.melanietaylor.com

Katsura pavillion
www.zebu.uoregon.edu/~imamura/japan/kin-ryo-ara.html

Donlyn Lyndon / The Sea Ranch, Sonoma County, California
www.greatbuildings.com/buildings/Sea_Ranch_Condominium.html

4. The Kitchen: Woman's Work Is Never Done?
Presidential birthplaces, Quincy, Massachusetts
www.nps.gov/adam/
www.discoverquincy.com

Cornell University's Home Ec Web site
www.rmc.library.cornell.edu/homeEc/

5. The Dining Room: Status and Stuff
Henry Wordsworth Longfellow house, Cambridge, Massachusetts
www.nps.gov/long/

Beauport, Gloucester, Massachusetts
www.historicnewengland.org/visit/tour/beauport.asp

Historic New England
www.historicnewengland.org/

Ephrata Cloister, Lancaster, Pennsylvania
www.phmc.state.pa.us/bhsm/toh/ephrata/ephratacloister.asp?secid=14

Tryon Palace, New Bern, North Carolina
www.newbern.com/tryon/

6. The Great Room: Same Time, Same Place
Mark Mack
www.markmack.com/flash.html

Stonehurst, Waltham, Massachusetts
www.stonehurstwaltham.org

Charles and Ray Eames's house, Pacific Palisades, California
www.loc.gov/exhibits/eames/preview.html

7. The Bedroom: Behind Closed Doors
The Mount, Stockbridge, Massachusetts
www.edithwharton.org/

Roos House, Presidio Heights, San Francisco, California
www.sunsite.berkley.edu/findingaids/dynaweb/calher/flamm/figures/1001473
9B.jpg

8. The Bathroom: Mirror, Mirror on the Wall
Old House, Quincy, Massachusetts
www.nps.gov/adam/

The Body Project
www.thebodyproject.com

9. The Child's Room: A Place to Call One's Own

David Gamble House, Pasadena, California
www.gamblehouse.org

Ati's room in the Gropius family house, Lincoln, Massachusetts
www.spnea.org/visit/tour/house.asp?floororder-3

Orchard House, Concord, Massachusetts
www.louisamayalcott.org/rooms.html

10. The Basement: Doing It Yourself

Haas-Lilienthal House, Pacific Heights, California
www.sfheritage.org/house.html

www.thisoldhouse.com

11. The Office: Home Work

Jeremiah Lee Mansion, Marblehead, Massachusetts
www.marbleheadmuseum.org/LeeMansion/

George Morris and Suzy Frelinghuysen's house, Stockbridge, Massachusetts
www.frelinghuysen.org/

The Wayside Tower study, Concord, Massachusetts
www.hawthorneinsalem.org/architecture/housesinconcord/thewayside/images.html

12. The Garden: Outside or In
Cold Spring Village, Cape May, New Jersey
www.hcsv.org

Richard Neutra's house for Grace Miller, Palm Springs, California
www.meylerandco.com/millerhouse.html

The Vale, Waltham, Massachusetts
www.historicnewengland.org/visit/land/mass.htm

13. The Second Home: Domesticity to Go
Le Corbusier's cabin, Roquebrune Cap Martin, France
www.wallpaper.com/design/375

Sacred places
www.sacredsites.com/

RVs
www.nrvoc.com/

14. The Neighborhood: No Home Is an Island
Llewelyn Park, West Orange, New Jersey
www.hometown.aol.com/cdarnold01/indexarnold4.html

Saratoga Springs, New York
www.discoversaratoga.org/

Levittown, Levittown, Pennsylvania
www.tigger.uic.edu/~pbhales/Levittown.html

Urban apartments
www.nyc-architecture.com/UWS/UWS.htm

New Urbanism: Celebration and Seaside, Florida
www.newurbanism.org/pages/416429/index.htm

Albany Village, Berkeley, California
www.housing.berkeley.edu/livingatcal/universityvillage.html

Forest Hills Gardens, Queens, New York
www.queens.about.com/library/weekly/bl-forest_hills_gardens1.htm

Charleston, South Carolina
www.ccpl.org/content.asp?name=Site&catID=6053&parentID=5405

ACKNOWLEDGMENTS

First, I wish to thank George Raptis, Alisan Goldfarb, and Leo Keegan, who made this book and so much else possible.

For their contributions to our understanding of how our homes and other important places affect our lives and for sharing their knowledge with me, I'm deeply grateful to Sally Augustin, Ginger and Charlie Alden, Gretchen Bachrach, William Beiswanger, Joan Jacobs Brumberg, Russell Belk, Walter Bogner, Mihaly Csikszentmihalyi, Nancy Carlisle, Sam Davis, Jeremiah Eck, Gary Evans, Constance Forrest, Roger Cook, Renee Chow, Nadia Ghaleb, Mac Gordon, Bryan Grunwald, Jan Jennings, Grant Hildebrand, Jamie Horwitz, Dolores Hayden, Stefan Hammerschmidt, Chris Haugh, Matthew and Yolanda Hranek, Bruce Irving, Robert Ivy, Ron Kessler, James Kunstler, Donlyn Lyndon, Alexander Lloyd, Gregory Moore, Clare Cooper Marcus, Lynne Manzo, Mark Mack, Sanjoy Mazumdar, Russ Morash, Gene Myers, Jack Nasar, Dennis Pogue, Susan Painter, Walter Pierce, Jean Robinson, Jean Roos, Ann-Judith Silverman, Robert Sommer, Joel Sanders, Daniel Stokols, Melanie Taylor, Richard Trethewey, and Denis Wood.

For their individual insights and generosity in reading the entire manuscript or large parts thereof, I especially thank Drs. Kathryn Anthony, Elizabeth Cromley, Harry Heft, and Jerome Tognoli.

Acknowledgments

I am grateful to the owners and curatorial staffs of the many homes, both public and private, whose stories enliven these pages.

Finally, I thank Gail Winston, my editor; Kristine Dahl, my agent; and Katherine Hill, Vicki Haire, and the HarperCollins team for their erudition, hard work, and kindness.

INDEX

Insights,
Interviews
& More . . .

About the author

About the book

Read on

Meet Winifred Gallagher

WINIFRED GALLAGHER was born in Philadelphia and raised in its environs. Her first homes were in that city's Arcadian prewar suburbs. In summer, her family went "down the shore" and eventually established a second home in Stone Harbor, New Jersey. When she was thirteen, her parents succumbed to her horse-crazy importuning and moved to a farm in country familiar from Andrew Wyeth's paintings. These three early environments inspired her lifelong interest in the under-remarked relationship between people and places—especially their homes.

In school, Gallagher liked reading and writing, which were simply called

"English." Her journalism career began with an engraved fountain pen, won in an essay contest, presented by the editor of the Pottstown *Mercury*, the local daily newspaper, who offered her a summer job.

After a somewhat eccentric education by nuns whose idea of modern literature stopped with Lord Byron, Gallagher attended the University of Pennsylvania. She studied design and the history of art, particularly that of Greece and Rome, and spent two summers camping

throughout Europe and Greece. After receiving her B.A., she studied architecture for a year at Penn's Graduate School of Fine Arts, then switched to painting. She moved to New York, where she made deconstructed landscapes from cut-out shapes, painted in different patterns, that were hung in constellations.

Along with many more or less starving artists, actors, and writers, Gallagher worked part-time in the editorial department of Time Inc. Observing that a person could actually be paid for thinking of a fascinating subject, talking to experts about it, and musing about it in print, she began to contribute feature stories about human behavior to the company's science magazine *Discover*. Her articles have since appeared in many national publications, including the *Atlantic Monthly*, *Rolling Stone*, and the *New York Times*. She has written six books.

Gallagher's main subject is "why we are the way we are, and what we can do about it." Her books examine that question from different vantage points. From religion's perspective, *Working on God* describes the inner lives of educated people torn between skepticism and belief. *Spiritual Genius* examines how ten remarkable people reflect and affect five major faiths.

From science's very different viewpoint, *Just the Way You Are: How Heredity and Experience Create the Individual* (a *New York Times* Notable Book of the year) uses the nature-versus-nurture debate to examine how we develop our unique personalities. ▶

> " After a somewhat eccentric education by nuns whose idea of modern literature stopped with Lord Byron, Gallagher attended the University of Pennsylvania. "

(Gallagher concluded that our social and physical environments "mold our inherited temperaments into what is in effect a 'second nature.' ")

In two books, Gallagher explores our lives using the places we frequent. She shares the perspective of environmental-behavioral research, which maintains that a person can only be understood in his or her physical as well as social context. This concept was considered self-evident, she says, until the convergence of two revolutions—the industrial and the psychoanalytic—"caused people both to retreat indoors and to look inside themselves for answers to questions about the quality of their lives."

The Power of Place: How Our Surroundings Shape Our Thoughts, Emotions, and Actions looks at the physical environment through a wide lens, examining the many ways in which different settings—the womb and Alaska's climatic extremes, urban ghettos and the wide open spaces—affect how we feel and function. In the course of her research, Gallagher came up with her own recipe for good spirits: places that are high, dry, cool, and bright—all natural antidepressants.

Gallagher enjoys reading, yoga, hiking, and rehabilitating troubled houses with her husband, the writer and editor Michael Segell. The parents of five children, they live in a row house in Manhattan, a schoolhouse in upstate New York, and a semirenovated barn in Wyoming. ∽

> ❝ In the course of her research [for *The Power of Place*], Gallagher came up with her own recipe for good spirits: places that are high, dry, cool, and bright— all natural antidepressants. ❞

How to Give Your Home a "Psychological Renovation"

SINCE *HOUSE THINKING* APPEARED, I've often been asked if there are any relatively easy and inexpensive ways to give a home a "psychological renovation," which makes a house or apartment not just look better, but *feel* better. Happily, because I've experimented with my own house, I know firsthand that every room can benefit from just this sort of remodeling job. I'd like to share some of my hands-on research with you.

Begin at the beginning. Your home's entrance sets the stage for the experience to come. Is yours a private haven or a dumping ground for junk mail, coats, and unsightly gear? If the latter, remove the clutter.

Install a rack for sorting the mail and tidy bins for recycled products. Highlight the entry's appealing features, such as a nice door or window. Finally, add something that sets the tone for your home: a plant, a painting, a musical instrument.

Your living room isn't meant for a photo shoot for a shelter magazine, but to be the space that expresses who you are and what you care about. First, think about the parlors of your past—particularly from childhood—which can haunt your present one. Weed out any elements, from a chair to an entire furniture arrangement, that remind you of bitchy Aunt Ida or your parents' ▶

> " Your living room isn't meant for a photo shoot for a shelter magazine, but to be the space that expresses who you are and what you care about. "

5

divorce. What matters here are things you associate with happy times, like those Moroccan pillows that evoke your hippie days, perhaps, or the Shaker pieces that make you feel you're in the country. Skip the generic prints and vases from the big-box stores. Instead, highlight a watercolor you painted, the bowl your son made in ceramics, and other mementoes, photos, and art you love, including the bronzed baby shoes. Furniture lined up around the walls says "funeral parlor." Warm up your social life by pulling the furniture into a friendly, circular "sociopetal" arrangement that invites socializing.

What kind of kitchen really suits your needs best? Throughout history, the kitchen has evolved in tandem with women's lives. When they had little status, the kitchen was dirty, dangerous, and inefficient. Today, many women are well-off professionals, and, not coincidentally, the kitchen is often the home's most lavish room. But female lawyers and doctors are usually too busy to spend much time in their $100,000 mega-kitchens!

Fortunately, there are now more options for both women and their homes. Are you a home-and-hearth person? You'll thrive in the home's most elaborate and busiest room—a room used not just for cooking, but also for socializing, paying bills, and doing homework. Are you a busy professional who mostly eats out or orders in? A big super-kitchen may feel wasteful, even judgmental. A closet-sized space with a microwave,

mini-fridge, and hot plate may be just right for you, allowing you to use your resources in another room or for travel.

The dining room was invented for the display of life's finer things, so use your nice china, silver, linens, wines instead of hiding them or saving them for Thanksgiving. Research shows that such "good materialism"—versus mere conspicuous consumption—has profound effects on our well-being, even our longevity. Gather up some related objects scattered around your home—bits of '40s pottery, figures of Buddha, pretty teacups—and arrange them on a shelf in the dining room table. Voila! Your flotsam and jetsam become a rewarding collection.

If you live in a newer house or apartment that has a big "great room," remember Frank Lloyd Wright's rule: a home should have spaces for both cozy "nesting" and outward-oriented "perching." Many great rooms offer only a wide-open expanse. If you and your family are extroverted by nature, a big, sociable space may be a perfect habitat. If you're quiet, reflective sorts, however, smaller, more private havens may serve you better; an alcove with glass doors or some ells could add some "stimulus shelter" to your great room.

In our supposedly "sex-crazed" culture, we pay little or no attention to creating a romantic atmosphere in the bedroom—the very place where we mostly have sex. Even architects say that clients never ask for a sexy bedroom. What would that ▶

> " The dining room was invented for the display of life's finer things, so use your nice china, silver, linens, wines instead of hiding them or saving them for Thanksgiving. "

look like? Not a bordello, but a serene room that's clutter-free, soundproof, deeply comfortable, and directly connected to a bathroom. A beautiful view and a fireplace are nice additions, but get rid of that TV and exercise equipment.

To be sure, the bathroom is a great addition to the home, but the proliferation of technology, from doctor's scales to illuminated magnifying mirrors, corresponds to a spike in psychiatric problems such as anorexia, bulimia, and body dysmorphic disorder. After all, for most of history, few people had the privacy or technology for much monitoring of their appearance and weight. If you'd prefer a peaceful sanctuary-spa to a high-tech beauty lab, get rid of bathroom equipment that makes you feel unhappy, like the scale that reminds you each morning of the five pounds you're never going to lose. Replace it with things that give pleasure, from a magazine rack to a candelabra.

If you have a child, bear in mind that privacy and sense of control over the immediate surroundings are more essential to developing a healthy identity than the latest "educational" toys. Kids who grow up in noisy, crowded homes with no place to call their own are at risk of feeling powerless and getting more input than their immature nervous systems can handle. Even in a spacious McMansion, PCs, TVs, cell phones and the like can overwhelm "wired" kids and keep them from essential activities like exercise

> 66 In our supposedly 'sex-crazed' culture, we pay little or no attention to creating a romantic atmosphere in the bedroom— the very place where we mostly have sex. 99

and playing outdoors. American culture assumes that kids are happiest in groups and getting lots of "stimulation," but research suggests that for kids, less social and environmental input is often more.

Thanks to the communications revolution, more and more Americans do some or all of their work at home, turning our private refuge into a potential workplace—a huge cultural change. Before you quit your job, consider whether you're temperamentally suited for working in solitude without supervision or camaraderie; most people just aren't. Then too, although a high-tech office means more control over your life, which is always a good thing, being able to work almost anytime (or nearly all of the time) and anywhere (from dwelling to car to weekend place) can be a mixed blessing.

Finally, whether you're a country or city mouse, add more nature to your home. Outward Bound is fine for some, but everyday wonders—houseplants, pets, views of trees and sky, birdsong—can supply you with the nature you need to reduce your stress level, remind you about life's cyclical patterns, and help you heal. In a world dominated by electronic communications, a brief nature break can relieve the "mental fatigue" that causes you to make silly mistakes.

Making these psychological home improvements requires more thought than effort or money, but the benefits can outweigh the most lavish but impersonal renovation. ⌣

" Thanks to the communications revolution, more and more Americans do some or all of their work at home, turning our private refuge into a potential workplace—a huge cultural change. "

An Excerpt from
The Power of Place

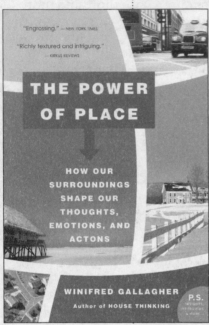

The Power of Place *offers stunning insights into the many ways we can change our lives by changing the places we live. Winifred Gallagher explores the complex relationships between people and the places in which they dwell, love, and work. Drawing on captivating research from behavioral and environmental science, she examines our reactions to light, temperature, the seasons, and other natural phenomena and explores the interactions between our external and internal worlds. Her broad and dynamic definition of place includes mountaintops and the womb, Alaska's hinterlands and Manhattan's subways; she relates these settings to everything from creativity to PMS, from jet lag to tales of UFOs.*

"Engrossing." —New York Times

"Entertaining and convincing."
 —Booklist *(starred)*

Environmental Addictions

LIKE OUR INTIMATE SOCIAL BONDS, particularly the first, our relationship with the larger world is built from

66 In a very real sense, the places in our lives get 'under our skin' and influence our behavior in ways that we often don't suspect. 99

countless sensory interactions between us and our settings. In a very real sense, the places in our lives get "under our skin" and influence our behavior in ways that we often don't suspect.

In the 1960s, an era of experimental thinking, Roger Barker had a particularly wild idea. He decided to chronicle entire days in the lives of children, recording all their interactions not only with people but with places and things. After examining his data, the psychologist came to a startling and most un-American conclusion: their settings were more important determinants of his subjects' behavior than their personalities.

Broadening the study of what he called "psychological ecology," Barker went on to analyze and contrast the doings of entire small towns in both Kansas and Yorkshire, England. The more he watched all sorts of people go about their business in shops, playing fields, offices, churches, and bars, the more certain he became that individuals and their inanimate surroundings together create systems of a higher order that take on a life of their own. When we enter one of Barker's "behavior settings"—a school, restaurant, gas station, hospital—everything in that environment encourages us to maintain the status quo. In a sense, we are no longer quirky individuals, but teachers and students, proprietors and customers, doctors and patients. Simply by the way it positions its hours, displays its merchandise, and situates the vendor, even a corner newsstand determines that business will be transacted in a predictable way: just ▶

66 Simply by the way it positions its hours, displays its merchandise, and situates the vendor, even a corner newsstand determines that business will be transacted in a predictable way: just about any clerk or customer will do the right thing. 99

about any clerk or customer will do the
right thing. For similar reasons, this year's
second grade at P.S. 6 functions pretty
much the same as last year's, even though
the kids and maybe even the teacher are
different.

We unconsciously rely on this Platonic
dualism of behavior settings to supply
much of the stability of our social
institutions. Under its influence, we
line up to buy movie tickets rather than
clubbing our way to the window, stop
at red lights, and lower our voices in
libraries, museums, and churches.
Sometimes we even gang up with others
to enforce a setting's rules, as when we
join in shushing whisperers in theaters
or giving the cold shoulder to the
neighbor who doesn't keep up his yard.
Even as small children, we work hard to
secure the stability of our settings, and
later in life, we're particularly eager to
do so in the workplace. In an office that's
temporarily understaffed, for example,
Barker discovered that most employees
will do whatever is required to maintain
the established order of things, including
working more themselves and upbraiding
those who won't. When it comes to
business as usual, behavior settings
are the *sine qua non*.

On the other hand, behavior settings
have a dark side that we brush up against
whenever we contemplate changing the
positioning of the furniture in the living
room, say, or try to get the people we live
with to hang their coats in the closet

instead of dumping them on a chair. We find that what started out as "a way" has somehow turned into "the way," becoming so entrenched that otherwise competent people are reduced to paying a professional to find a better spot for the piano or to bribing their children to use hangers. It seems that once the environmental particulars of a *modus operandi* work their way into the nervous system, they help close our minds to better options and incline us toward knee-jerk reactions. This insidious tendency to accept familiar behavior settings without question ensures that, for example, no matter how many people cogitate over how a community's adolescents should be educated, the solution is invariably a big regional high school, rather than another possibility, such as several smaller, decentralized buildings, that research shows better serve children.

The more we experience a behavior setting, the greater its power to alter our perception of the "real world." If a child puts on a pair of eyeglasses fitted with special lenses that are flat on one side and wavy on the other, the skewed information delivered to his retina will disorient him, even in a familiar setting. When an adult dons the same glasses, however, he finds that the world looks quite normal, because his brain quickly reorganizes the aberrant input into what he *expects* to see. "Sometimes when a familiar environment has been ▶

"It seems that once the environmental particulars of a *modus operandi* work their way into the nervous system, they help close our minds to better options and incline us toward knee-jerk reactions."

changed—your office has been painted
while you were on vacation—you don't
even notice, because you correct for it,"
says Myron Hofer. "This same tendency
can make it hard to see anything new in a
scientific experiment. We find confusion
hard to tolerate, but it allows us to see
things the way they really are. One thing
that distinguishes artists may be the
retention of that childhood ability to
see the world afresh."

On the other hand, our ability to
put mind over matter when it comes
to our settings gives us some powerful
advantages. In one experiment, a person
is rotated in the dark for several hours
and told to imagine an object rotating
with him. Responding to this suggestion,
his brain will keep his eyes focused on
the thing's supposed location. The skill
at internalizing environmental cues and
settings enables athletes to improve
their performances by going through
imaginary sports events in their minds,
"sensing up" as much as psyching up.
That we can not only reorganize "wrong"
sensory input into the "right" setting
but also change our unconscious
physiological reactions by imagining
a setting puts a new twist on an old
metaphysical question: What *is* the
real world? ⌁

Have You Read?
More by Winifred Gallagher

IT'S IN THE BAG: WHAT PURSES REVEAL—AND CONCEAL

The time is perfect for a short, smart purse book. The "good bag" has nudged out shoes, jeans, and jewelry as the must-have fashion possession. Despite price hikes—$1,445 for a Prada bowler bag that once cost $940—the craze for high-end purses helps fuel the booming luxury-goods market and, via knockoffs, hugely influences the $6-billion-a-year mainstream handbag industry. But purse mania isn't just an outgrowth of a strong luxury-goods market—human thoughts, feelings, and dreams are involved, too. As Nadia, a high-powered interior designer says, "My cell and my big Tod's purse—that is my life."

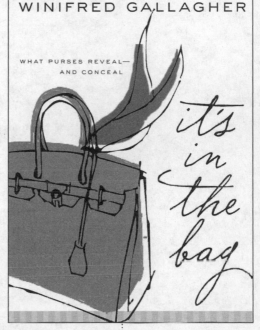

In *It's in the Bag*, noted journalist Winifred Gallagher explains what it means for a purse to be a life. This cultural history of the handbag borrows from psychology (Freud noted that

sometimes a purse is a vagina—which is perhaps why the first "handbags" were carried by men!), sociology (a purse as a "status symbol"), and even economics (Why have prices gotten so steep?). Researched and erudite yet always fun, Winifred Gallagher offers a charming theory of modern identity as seen through one of our keenest obsessions.